AESTHETIC PAINTING
in BRITAIN AND AMERICA

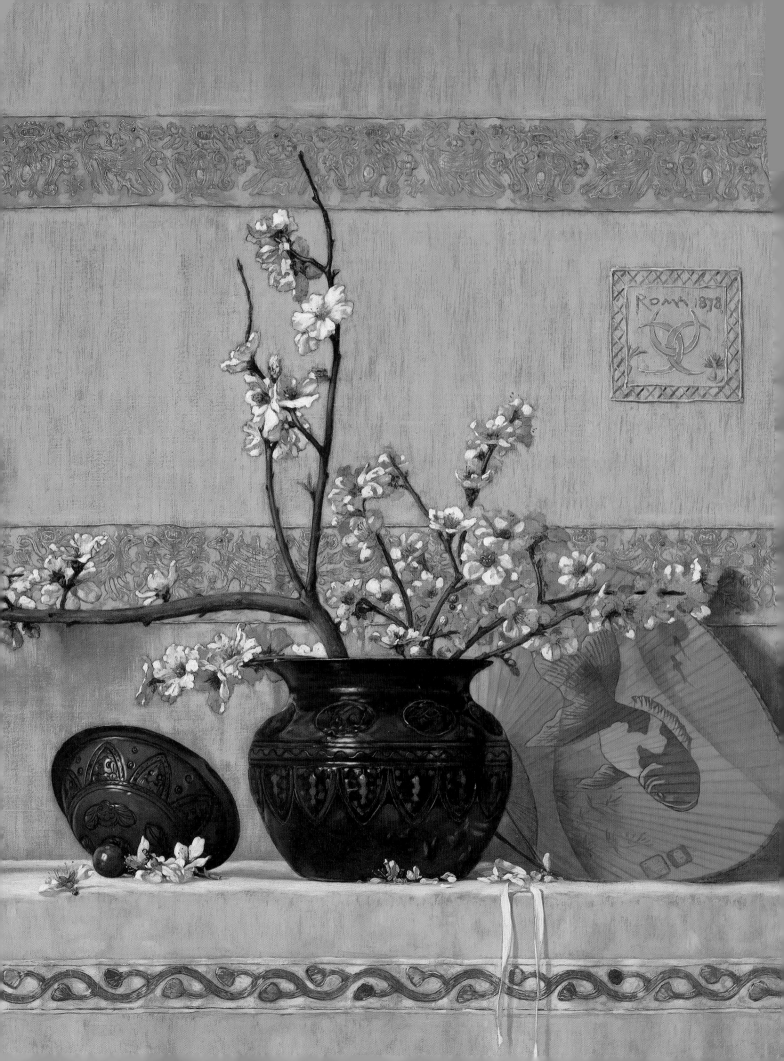

AESTHETIC PAINTING IN BRITAIN AND AMERICA
Collectors, Art Worlds, Networks

Melody Barnett Deusner

PAUL MELLON CENTRE FOR STUDIES IN BRITISH ART

Distributed by Yale University Press · New Haven and London

First published in 2020 by the Paul Mellon Centre for Studies in British Art
16 Bedford Square, London, WC1B 3JA
paul-mellon-centre.ac.uk

ISBN 978-1-913107-14-7 HB
Library of Congress Control Number: 2020935730

British Library Cataloguing-in-Publication Data
A catalogue record for this book is available from the British Library

Designed by Bobby Birchall, Bobby&Co.
Origination by Evergreen Colour Management Ltd
Printed in China through World Print Ltd

Image on p. i Thomas Wilmer Dewing, *Summer*, 1890 (see fig. 96).
Frontispiece Charles Caryl Coleman, *Quince Blossoms*, 1878 (detail of fig. 76).
Image on pp. iv and v George Aitchison, *Design for the Interior Decoration of
15 Berkeley Square, Mayfair, London*, 1873 (detail of fig. 52).

CONTENTS

ACKNOWLEDGMENTS

As I have learned over fifteen years spent working on this topic, a network has no definite end point. Neither does the constellation of individuals and organizations who have shaped and supported this project, from dissertation to book, in large and small ways. Above all I wish to thank my University of Delaware dissertation co-advisors, Nina Athenassoglou-Kallmyer and Michael Leja, for expanding my visual world, offering precise editorial guidance, and remaining committed to a lifetime of encouragement and advisement. Dissertation committee members Margaret Werth, Wendy Bellion, and Marc Simpson also provided crucial instruction and friendship over the years, as did Perry Chapman, Mónica Domínguez Torres, Ann Gibson, Lawrence Nees, Lauren Petersen, Vimalin Rujivacharakul, and David Stone. Many ideas for this project emerged during their graduate seminars and in conversation with my Delaware cohort, especially Jobyl Boone, Lorena Bradford, Laura Cochrane, Adrian Duran, Ellery Foutch, Nikki Greene, Julie Henderson, Dawn Hershberger, Anna Marley, Dorothy Moss, Tanya Pohrt, Sarah Powers, Kerry Roeder, Adam Rudolphi, Anne Samuel, and Pepper Stetler. Beyond Delaware, Brady Potts helped me lay the sociological foundations of this study.

The Terra Foundation for American Art supplied the external dissertation funding that launched this project, and continues to underwrite fellowships, conferences, exhibitions, and publications essential to the study of American art in an international context. A Terra Predoctoral Fellowship at the Smithsonian American Art Museum (and subsequently a Luce/ACLS Dissertation Fellowship) expanded my research support network to include curators, librarians, archivists, and staff at SAAM, the Freer Gallery of Art, and the Archives of American Art. Cynthia Mills, William Truettner, Lee Glazer, Amelia Goerlitz, Ann Gunter, Liza Kirwin, and Ellen Miles provided crucial guidance at this formative stage, as I discussed my evolving thinking on Aesthetic painting with a stimulating group of

fellows: Marie-Stephanie Delamaire, Adam Greenhalgh, Caroline Hannah, Wendy Ikemoto, Adrian Kohn, Asma Naeem, Prudence Peiffer, Jennifer Raab, Emily Eliza Scott, Dalila Scruggs, Helene Valance, Jennifer Van Horn, Riccardo Venturi, David Bjelajac, Kenneth Haltman, and Glen Willumson. My time in Washington, D.C., also brought me into the scholarly orbit of Linda Merrill, Susan Hobbs, Thom Brunk, John Ott, Ross Barrett, Jennifer Greenhill, Angela Miller, and Alan Wallach, for which I am grateful. In New York, a Douglass Foundation Fellowship at the Metropolitan Museum of Art enabled helpful conversations with curators H. Barbara Weinberg, Beth Carver Wees, Alice Cooney Frelinghuysen, and especially Daniëlle Kisluk-Grosheide; and with fellows Catherine Holochwost, Kevin D. Murphy, Margaret Laster, Marden Nichols, and Alison Stagg. Catherine Lewis, Tom Carson, Mike Long, and Nina Gray also provided essential support during these years.

My early research abroad was sponsored by the Kress Foundation and carried out with the gracious assistance of the staffs at the British Library, National Art Library, London Metropolitan Archives, Fitzwilliam Museum, National Archives of Scotland, National Museum of Scotland, and University of Glasgow, among others. I thank Lizzie Terry and Keith Surridge for helping me navigate these sites and resources. Crucial phases in transforming the dissertation into a book occurred during my 2016 tenure as a Fulbright/University of Birmingham Scholar, where, thanks to the efforts of John Fagg, I was able to discuss my project with scholars in American and Canadian Studies, English Literature, and Art History, namely Francesca Berry, Rex Ferguson, John Holmes, and Kate Nichols. I am grateful to Alice Barnaby, Brian Linn, Toby Manning, and Robin Veder for their insights and encouragement during this time.

Essential early career support was provided by the Terra Foundation's Northwestern University Postdoctoral Fellowship in American Art, where thoughtful colleagues and graduate students helped me to refine my arguments in the classroom and on the page; many thanks to the Alice Kaplan Institute for the Humanities and the Art History Department (Huey Copeland, Stephen Eisenman, Jesús Escobar, Hannah Feldman, Shirin Fozi, Christina Kiaer, Robert Linrothe, Claudia Swan, Krista Thompson, David Van Zanten), and above all to Holly Clayson for her critical insights, shared enthusiasms, and warm hospitality.

I thank also those who invited me to share my work in progress and provided such excellent suggestions for its future directions at College Art Association panels in 2009 and 2013; at the University of York's symposium on Anglo-American art (David Peters Corbett, Sarah Monks, Michael Hatt, Alex Nemerov, David Lubin); the Newberry Library Seminar in American Art and Visual Culture (Sarah Burns, Diane Dillon, Erika Doss); the Tate Scholars' Day on International Pre-Raphaelitism at the Paul Mellon Centre for Studies in British Art (Tim Barringer, Paul Greenhalgh, Morna O'Neill); the Visible Hands workshop at Tate Britain (Alex Taylor, Jo Applin, John Davis); and the International Museums Day lectures sponsored by Aristotle University, Thessaloniki (Lia Yoka, Matoula Scaltsa). Over the course of several years, Anne Helmreich, Jennifer Roberts, Jennifer Jane Marshall, Sarah Burns, Lara Kriegel, Julie Codell, Caroline Arscott, and Elizabeth Prettejohn served as essential sounding boards for this project.

Since 2012, my work has been sponsored by Indiana University. I am particularly grateful to Sarah Bassett, Michelle Facos, Faye Gleisser, Margaret

Graves, Giles Knox, Diane Reilly, Bret Rothstein, Jeffrey Saletnik, and Julie Van Voorhis; also to Dawna Schuld and Phil Ford. My Bloomington network also includes friends to whom I extend deepest personal thanks: Ryan Powell, Tim Bell, Andrew Moisey, Athena Kirk, Joanna Woronkowicz, Scot Ausborn, Jooyoung Shin, David Brent Johnson, Kate Crum, and Robert Quinby.

This manuscript reached its final form thanks to incisive and insightful editing by Celia White. I remain indebted to Mark Hallett for encouraging me to send this project to the Paul Mellon Centre for Studies in British Art; to Emily Lees for patiently shepherding the book to completion; and to Nancy Marten for her careful copy-editing.

This book is dedicated to my many families: to the Barnetts and the Deusners; to David McCarthy and Marina Pacini; and, above all, to Stephen.

Aesthetic Painting in a Networked Age

What was the Aesthetic Movement in British and American art and design? Over a decade ago, seeking a clear and direct answer to this question, I visited one of the only complete surviving decorative interiors associated with that late nineteenth-century artistic phenomenon in order to learn from the object itself. James McNeill Whistler's Peacock Room (1876–7), originally designed as a dining room for the London home of Liverpool businessman Frederick Leyland, is preserved intact at the Smithsonian Institution's Freer Gallery of Art in Washington, D.C. (fig. 1). Following the imperatives of visual and material culture analysis, I began the lengthy, painstaking process of looking closely and translating what I saw into words, using this direct encounter as a tool for generating deeper research questions.

1

James McNeill Whistler, *Harmony in Blue and Gold: The Peacock Room*, 1876–7. Oil and gold leaf on canvas, leather, and wood, 421.6 × 613.4 × 1,026.2 cm (overall). Freer Gallery of Art, Smithsonian Institution, Washington, D.C. Gift of Charles Lang Freer, F1904.61.

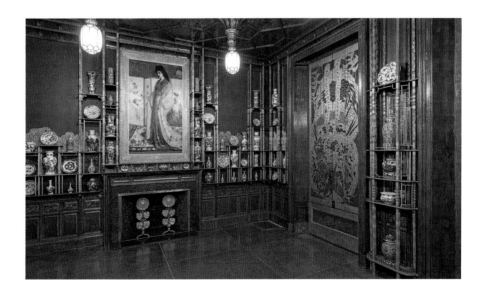

2a and b

James McNeill Whistler, *Harmony in Blue and Gold: The Peacock Room*, details of the wall and ceiling.

As I moved from one gold patterned blue leather wall panel to another (fig. 2), scanning the lattice of gilt wooden shelves and inspecting the framed painting that anchored the whole (fig. 3), I attempted to parse the compositional logic of the space, which Whistler had christened with a title as though it were itself a single work of art: *Harmony in Blue and Gold*. The room was daunting in its complexity, but gradually a descriptive language for it began to surface: harmonious, yes, but also rhythmic, organic, shimmering, extending, totalizing, coordinated, interconnected, incorporated, networked.

I paused at this last word, which, to my ears, struck a discordantly anachronistic note. Surely "networked" constituted an intrusion of my twenty-first century experience into this historical environment? Back at my desk, using the digital tools available to scholars in our thoroughly networked age, I conducted keyword searches in historical books and periodicals, attempting to determine when the word first appeared and how it was used. I was surprised to discover that the word "network" first took on its present connotations of systematic interconnection and control in the mid-nineteenth century, when the spread of

3 (Opposite)

James McNeill Whistler, *La Princesse du pays de la porcelaine*, 1863–5. Oil on canvas, 201.5 × 116.1 cm. Freer Gallery of Art, Smithsonian Institution, Washington, D.C. Gift of Charles Lang Freer, F1903.91.

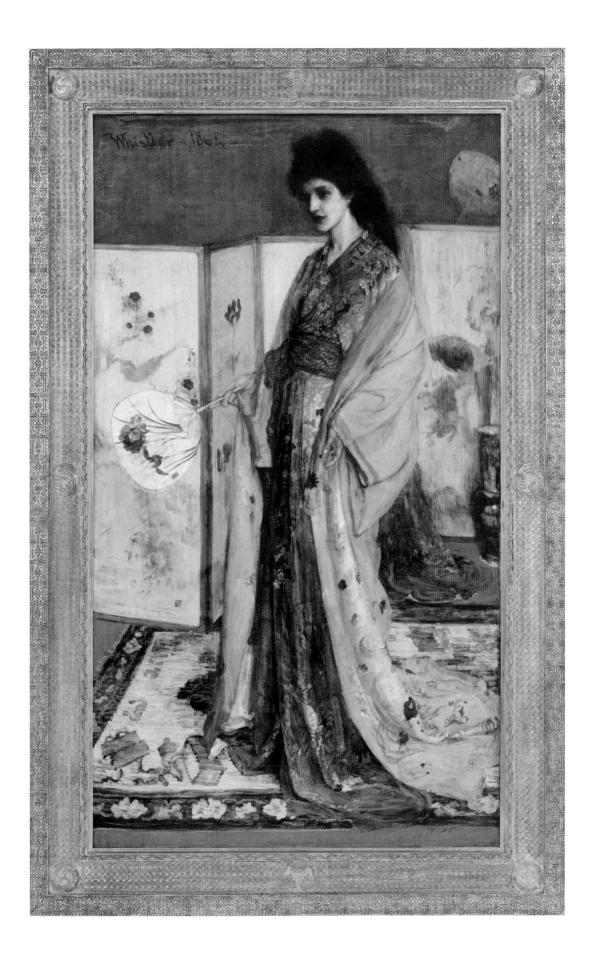

railroad tracks and telegraph wires forced English speakers across the western world to grapple with transformative changes in their time much as I was grappling with them in mine. The University of Glasgow's online compendium of Whistler correspondence even revealed the artist himself to have used the phrase "network of telephone & telegram" in a letter discussing his own investments.[1] Years later, I would find my initial impressions of the Peacock Room validated by the poet and critic Arthur Symons's 1906 account of his visit to the space, whose decorations, he wrote, were woven into "a web or network of almost alarming loveliness."[2]

These among other discoveries suggested that an analysis of the art of Whistler and his cohort within the context of the networked nineteenth century was a valid pursuit. But as I delved deeper into historical criticism and modern scholarship surrounding the Aesthetic Movement, I found the general tone of it to be drifting in the opposite direction: rather than highlighting these artifacts' roles in establishing connections between people and things, the language coalesced around concepts of negation, withdrawal, erasure, refusal, and escape. This tendency was as old as Aestheticism itself. In one particularly vivid example, the English art critic Cosmo Monkhouse launched a defense of the painter Albert Moore (fig. 4) in 1885 by acknowledging the common complaints of his detractors: that Moore's pictures "have no 'subject' to speak of",

4

Albert Moore, *Pomegranates*, 1865–6. Oil on canvas, 25 × 36 cm. Guildhall Art Gallery, London. Bequeathed by Cecil French, 1954. © City of London Corporation.

they tell no tale worth mentioning, they have no connection with any legend or history, they represent no incident from real life, they are unconnected with our experience and our reading, they do not raise (except by merest accident, perhaps, now and then) any vision of the past, they awaken (unless by still rarer chance) no dream of the future: they are, to put it shortly, as far removed from the realities of our lives, and from our personal human sympathies, as it is possible for representations of beauty (human or otherwise) to be, or, to generalize still more tersely, they are outside of us altogether.[3]

Leaping forward a few months in the same English art publication, we encounter Claude Phillips, wrestling with a similar set of challenges as he struggles to describe pictorial designs by Edward Burne-Jones. Here Burne-Jones's *Wheel of Fortune* (fig. 5), resolves itself into an inventory of absence: Fortune ("listless, unknowing, and uncaring") holds in her hands the fates of the poet, king, and slave ("unresisting victims"). Like Burne-Jones's subjects generally, these figures "are touched with no Promethean fire…; in their strange visionary woes humanity takes no part." Instead, this artist, "despairing of the world as it is … turns away from it and from humanity, and seeks to create for himself a beautiful world 'twixt heaven and earth, and to people it with children of his own imagining – neither mortal nor divine."[4]

Moving across the Atlantic to the exhibition of New York-based painter Thomas Wilmer Dewing's *The Days* (fig. 6) at the National Academy of Design in 1887, we find one sympathetic critic writing for the *Nation* praising the painting on its own terms – he judged it "easily among the best things in the exhibition" – but also unable to square it with his art historical standards. "The picture is by no means realistically treated. There is no attempt at outdoor effect as it is understood by the followers of the modern school … There are no facts – there is only fancy." He ultimately concluded that however successful it might be as a "decoration," "it is not a picture."[5]

These are only three examples among many that indicate something was happening in certain quarters of the Anglo-American art world of the mid-1880s. Contemporary commentators discussing these artists as well as pictures by Whistler, Frederic Leighton, and Lawrence Alma-Tadema in Britain and John La Farge, Dwight Tryon, and Abbott Thayer in America often found it easiest to account for them by articulating what they were not. Yet art historians remain convinced that there is something here that needs to be accounted for: a distinctive body of pictorial work produced by British and American artists around the turn of the century that, though stylistically heterogeneous, seems to embrace a shared set of formal interests and priorities. These are generally understood to be the interests and priorities of the Aesthetic Movement – but here again we find ourselves on shaky ground as we try to pin down what "Aesthetic" might mean when used to bundle together a group of paintings and decorative objects (and stories, poems, plays, philosophical critiques, caricatures, and fashion designs) that span a wide range of "fine" and "mass" cultures, are conjoined by no manifesto statements, and are fenced in only by shifting and porous chronological and geographical boundaries.[6]

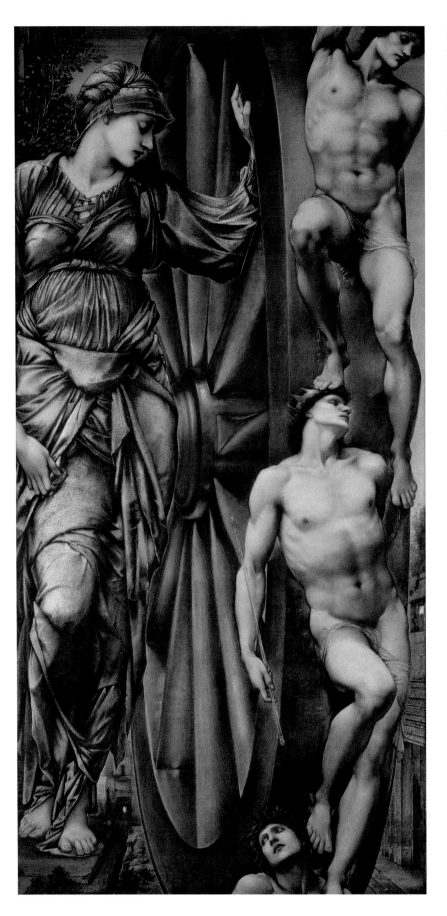

5

Edward Burne-Jones,
The Wheel of Fortune, 1875–83.
Oil on canvas, 200 × 100 cm.
Musée d'Orsay, Paris.
© RMN-Grand Palais / Art
Resource, N.Y., RF1980–3.
Photo: Gérard Blot.

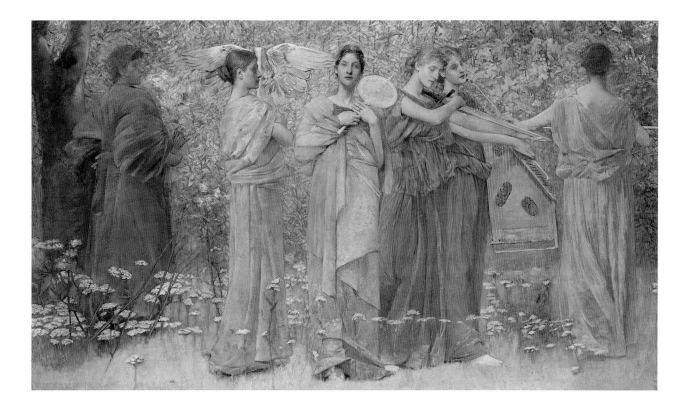

6

Thomas Wilmer Dewing,
The Days, 1884–6. Oil on
canvas, 109.7 × 182.9 cm.
Wadsworth Atheneum
Museum of Art, Hartford,
Conn. Gift of the estates of
Louise Cheney and Anne W.
Cheney, 1944.328. Photo: Allen
Phillips / Wadsworth
Atheneum.

Scholars over the past three decades have been steadily working toward setting Aesthetic painting and the concept of "art for art's sake" with which it was associated on a firmer historical and theoretical footing – a welcome alternative to more traditional approaches that consigned Aesthetic pictures to a realm of dream and mystery and interpreted them primarily as keys to the artists' biographies and psychologies. And here is where a reconsideration of Aestheticism through the historical lens of the "network," as first suggested by my initial encounter with the Peacock Room, has the potential to broaden our understanding of these artifacts even further. Attending to visual interconnections helps us recognize that the concept of "art" that these artists may have been pursuing for its own sake was typically configured as exceeding the limits of the frame: as modular, multiple, and coordinated with its installation environment. Artistic projects of such scale and scope necessitated the repeated return to a sympathetic circle of patrons and collectors, through the pursuit of explicit commissions or by working with the implicit promise of future purchases. The case studies that anchor the chapters that follow show patronage to be an integral, rather than ancillary, component of Aesthetic artmaking, and the production of "art for art's sake" to be a far from isolated process.

Not only were Aesthetic objects conceived as components of larger decorative systems, these decorative systems were themselves used as spaces for the coordination and consolidation of social and business networks, at a historical moment when new technologies were interlinking people, places, and things across the globe in radically new ways. This book shows how Aesthetic paintings, born into this networked world, were deployed by their patrons and collectors as tools of interconnection. It tracks these developments as they occurred on a transatlantic

scale, and examines the experiences of those who benefited from the management of these systems as well as those who found themselves entangled in them.

Fundamentally, this book is predicated on the contention that the Aesthetic painting, in its commitment to a visual and conceptual language of systemic organization and connection, is more *like* than *unlike* the historical moment that produced and nurtured it, and offered an avenue through which its makers, viewers, and owners could interface with and even shape (rather than merely escape) their world.

In embarking on this new approach to Aesthetic painting, it is useful to begin with a case study that highlights the key concerns involved in reorienting the discussion to focus on issues of installation and ownership as they operated in a transatlantic context. And so we return to Whistler's Peacock Room, that most famous and yet most idiosyncratic of Aesthetic interiors with which we began. This well-documented, carefully preserved, and publicly accessible artifact serves as an appropriate backdrop against which to consider recent contributions to Aesthetic art scholarship, and points the way toward the broader considerations of patronage, networks, and the operational use of Aesthetic paintings that this study will address.[7]

The essential contours of the story of the Peacock Room's commission are as follows: Frederick Richards Leyland, a shipping executive primarily based in Liverpool, purchased a London town house at 49 Prince's Gate in 1874, and soon after hired the architect and designer Thomas Jeckyll to transform its dining room into a cabinet for the display of his blue-and-white Chinese porcelain.[8] Jeckyll covered the walls with Dutch gilt leather and lined them with an elaborate shelving system, organizing his design around the room's pictorial centerpiece, a painting by Leyland's longtime artist friend, Whistler, *La Princesse du pays de la porcelaine* (see fig. 3). In late 1876, when Jeckyll's installation was almost complete, he consulted Whistler regarding the painting of the room's shutters and other woodwork, at which point Whistler decided that more work was needed to integrate the *Princesse* into its new decorative environment. Whistler secured Leyland's permission to retouch the floral designs on the leather and add a painted wave motif to portions of the paneling, a project that quickly expanded beyond his and his patron's expectations. Once Whistler's experiments had evolved into an all-encompassing scheme inspired by the colors and shapes of peacock feathers – extending over the walls and ceiling to include a total repainting of the expensive leather and the gilding of Jeckyll's shelves, as well as the addition of four large peacock paintings for the shutters – Leyland protested that he had never asked for such an elaborate and expensive design. When he refused to pay the full amount that Whistler demanded for this work, and, in the process, failed to express adequate appreciation for the artist's efforts, Whistler launched an elaborate public relations campaign designed to embarrass his patron. Christening the space *Harmony in Blue and Gold: The Peacock Room* (as though it were itself a painting), he hosted press conferences, tours, and teas in the room while Leyland was away on business, and installed a decorative mural of fighting peacocks on the south wall, *L'Art et l'argent*, a thinly disguised allegory of their highly publicized dispute.

The *Princesse* serves as a suitable starting point for this discussion of paintings in interiors, as it provides the anchor for Whistler's Peacock Room decoration, and has become quite literally a textbook example of Aesthetic painting. It also allows me to set the analytical tone for the object-based analyses that follow, in which I have eschewed the language of absence and negation that has so often clung to Aesthetic objects (as it did to the paintings of Moore, Burne-Jones, and Dewing in their own time), attempting instead to articulate what the Aesthetic picture is and does, what kinds of ideas it proposes and suggests, what types of experiences it encourages and frames, within the context of the late nineteenth- and early twentieth-century private art collection and domestic interior. The *Princesse* depicts a woman dressed in Japanese (or Japaneseque) robes and surrounded by an array of decorative objects: Japanese fans and screens, a Chinese rug, a blue-and-white Chinese vase. The gray wall behind her does little to place the scene in a specific location, and although the title suggests a possibly exotic and faraway realm (the "land of porcelain"), there is nothing to indicate that we are seeing anything more extraordinary than an artist's studio, his props, and his model.

If there is little here that invites our imaginative engagement, there is much to attract and stimulate our visual attention. Warm touches of bright rose catch the eye and lead it from one surface to the next, playfully echoing floral forms across the model's robe, sash, and fan, and spilling over onto the screen behind her. Another visual rhyme crosses the picture in the opposite direction, in a chain of color notes that link the rug, the model's dress, and the porcelain vessel at the right edge of the composition. It should come as little surprise that Whistler occasionally exhibited the picture under the alternate titles *Variations in Flesh Colour and Blue* and *Arrangement and Flesh Colour and Grey* – he seems to have set up a strictly limited and tightly controlled display, and worked to create a unified compositional whole within those conditions.[9]

Our sense of the "arrangedness" of the picture stems from both its suggestion of a highly selective studio environment and the artist's compression of this environment into a very shallow pictorial space. Large patches of color on the rear wall and the floor (which rises up as though to meet the wall at a sharp angle) reinforce the fact that the picture is indeed as two-dimensional – and perhaps also as decorative – as the fan, rug, or, especially, the Japanese screen, which occupies a zone parallel to the picture plane. This flatness is further emphasized by the cropping of the rug on one side and the vase on the other, and by the strict horizontality of the screen and the rear wall. Whistler's brushstrokes are neither slick nor bravura, but rather blended, diluted, soupy. Some touches of color are allowed to remain precisely that – touches of the brush – but the overall effect of the artist's wet application of paint is to soften the details and edges of the objects and figure and to bind them together, background and foreground, as a single pictorial unit.

The *Princesse* conflates, almost completely, the practice of arranging objects and models into a studio display and that of choosing and placing lines, shapes, and colors on a canvas to create a painted composition. We might argue that it builds, out of essentially familiar materials, an ideal realm (the "land of porcelain," say) where everything is coordinated, a delicate balance is constructed, every decorative object and every pictorial component occupies just exactly its "right"

place. Whistler gives us a glimpse into life (and art) configured as a perfectly harmonious system.

And part of the pleasure offered to us as viewers, as we probe the mechanics of this visual system, is thinking about how things might be different if something was changed. The *Princesse* presents itself as not just an arrangement, but a provisional arrangement, a proposition, a compositional "what if." (The *Variations* title, of course, further declares its contingency.) The elements that reinforce the two-dimensionality of the picture – the cropped objects and the uninterrupted horizontal bands of floor, screen, and wall – also suggest that there is something more, some further iteration, more space, more objects, more correspondences, in a limitlessly extensible visual universe of which we see only a part.

The *Princesse* is not, in other words, a *closed* system. And it further opens a window into one key vein of artistic experimentation that was being undertaken in the early 1860s, when it first became evident to attentive observers that a number of artists working in London were adjusting their pictorial practices along similar lines: setting up carefully defined scenarios or conditions through which to explore a series of formal and conceptual variations. Dante Gabriel Rossetti, building on his *Bocca Baciata* (1859, Museum of Fine Arts, Boston), began configuring and reconfiguring half-length female figures against floral backgrounds and accenting them with various accessories, pushing his viewers to consider how intimate visual and tactile engagement with a person might compare to engagement with a painting (fig. 7). Moore, meanwhile, was combining classical forms and draperies with organic elements and decorative objects to create narrowly focused studies in color and composition (see fig. 4). By 1867, the English critic Sidney Colvin was citing these artists, together with Burne-Jones, Frederic Leighton, Simeon Solomon, G. F. Watts, Arthur Hughes, and George Heming Mason, as exemplifying a discernibly new commitment to the pursuit of "perfection of forms and colors" as "the prime object of pictorial art": a commitment that would be designated by the phrase "art for art's sake" from 1868, and "Aesthetic" in subsequent years.[10]

As Elizabeth Prettejohn has pointed out, "art for art's sake" as a "non-theory" or an "anti-theory" did not constitute a strict series of rules prescribing the outcome of a picture, but rather signaled an openness to the capturing of particular, specifically pictorial beauty – perhaps not conventional, perhaps not ideal – in whatever form that beauty might take. The flexible nature of this Aesthetic investigation accounts for the diversity of results it produced, from the "soft" paintings of Whistler to the firmly outlined stylizations of Burne-Jones. Within the wide range of possible answers to the "art for art's sake" question, however, Whistler and Moore represent a particularly systematic approach to artmaking and compositional organization, as recent scholarship by Prettejohn, Robyn Asleson, and Marc Simpson has emphasized.[11]

We find critical support for these artists' prioritization of composition over content in the writings of Walter Pater and Charles Augustus Swinburne, who were also, in the 1860s and early 1870s, suggesting that the art object with its constitutive parts functioned as a system – as a complex of forces of assertion and restraint, in Pater's analysis of Michelangelo's sculpture; or as an orchestration of "cadence[s] of colour," according to Swinburne's description of paintings by Rossetti.[12] The ultimate artistic system, for both Pater and Swinburne, was the

7

Dante Gabriel Rossetti, *The Blue Bower*, 1865. Oil on canvas, 84 × 70.9 cm. The Henry Barber Trust, Barber Institute of Fine Arts, University of Birmingham. Photo: Bridgeman Images.

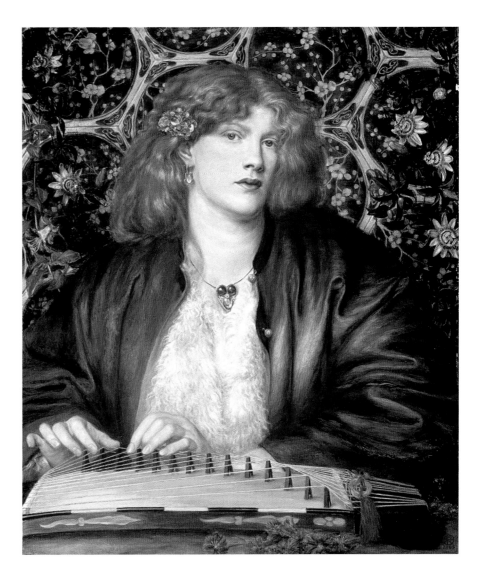

purely formal system of music, which they proposed as an analog for a purified visual art that embraced form "as an end in itself."[13] Whistler, who most influentially embodied and extended these ideas in his art and art theories, adapted musical titles to guide viewers toward the "key notes" of his compositions (purple and rose, black and brown, opal and silver, and so on).[14]

We have been cautioned not to take Whistler's interest in "arrangements" and Moore's compositional geometries as representative of the aims of Aesthetic artists as a whole. Prettejohn wisely warns against treating "art for art's sake" as a monolithic entity, and emphasizes the need to develop more complete and thorough accounts of each artist's unique pictorial project and its philosophical and theoretical basis. But it also seems that if the category of "Aesthetic painting" is to be truly useful, we ought to be able to make some sense of it *visually*. If we shift our focus from stated "art for art's sake" intentions to outcomes – to the visual evidence directly before us – do the paintings typically associated with this movement still make sense as a group? They do, in fact, share a number of the formal characteristics and compositional structures we saw in the *Princesse* – visual qualities that encourage us to see the picture surface as an interlocking

system, or, as Monkhouse put it in his perceptive analysis of Moore, as "an organised whole in which the beauty of each thing should interweave with the beauty of every other thing, and the result should be a harmony of many beauties."[15] If Aestheticism cannot be reduced to a single style, it might be thought of as a manifestation of system *as* style. The chapters that follow have been designed to demonstrate the applications and consequences of this visual, system-based reorientation of the "Aesthetic."

The remainder of this introduction will provide a conceptual basis for the study as a whole by drawing out the different types of systems that run through and organize the Peacock Room, and by looking at the history and use of the term "network." It will then provide a brief overview of the case studies that comprise this book, in which the concept of network is used as a tool to secure a richer understanding of the transatlantic dimensions of this movement.

Patronage and Aesthetic Systems: From Studio to Collection and Interior

The Peacock Room's *Princesse* is located at the intersection of several systems: the interlocked compositional and formal harmonies of its picture surface, its place as one among a number of serial experiments in a similar vein undertaken by Whistler in the mid-1860s, and its position as the keystone anchoring Leyland's dining room decoration (as both conceived by Jeckyll and elaborated by Whistler). As coordinated decorating projects by these and other artists and designers began to attract greater public attention, their techniques would be codified and adapted to the needs of a wider range of householders by writers like Mary Eliza Haweis, who reminded her readers in 1881 that a "room is like a picture; it must be composed with equal skill and forethought" and that "furnishing ought to be carried out on some sort of system."[16]

In its decorative capacity, the *Princesse* fuses the content of the picture (with its blue-and-white vase from the "land of porcelain" and complementary carpet) and the function of the room as a porcelain cabinet; it proposes a conceptual alignment between the processes of selecting, placing, and comparing compositional elements in the painting and the activity of choosing and arranging plates and vessels in the collection of china. The picture was not commissioned for this purpose by Leyland: Whistler painted it for exhibition in 1864, and it passed through the hands of at least one other patron before it came to Leyland.[17] When Jeckyll redesigned the dining room in 1876, he did so with Whistler's picture in mind, using it as the keynote of his decorative scheme.[18] This was not merely a felicitous pairing: Whistler and Jeckyll belonged to a circle of artists, dealers, collectors, writers, and others who had shared an enthusiasm for acquiring and decorating with pieces of blue-and-white porcelain since about 1860.[19] Through these artists and decorator/dealers like Murray Marks, this fad spread outward to the homes of their patrons and collectors in the 1870s. There was dense overlap between these groups, as Whistler, Rossetti, and others collected blue-and-white and featured it in their works while also sharing some of the same patrons, including Leyland, William Graham, and members of the Ionides family, who amassed their own holdings of Chinese porcelain. Whistler could, therefore, paint a picture like the *Princesse* and be fairly certain that someone within or closely tied to his artistic community could be found to purchase it. The *Princesse*,

8

James McNeill Whistler, *Caprice in Purple and Gold: The Golden Screen*, 1864. Oil on wood panel, 50.1 × 68.5 cm. Freer Gallery of Art, Smithsonian Institution, Washington, D.C. Gift of Charles Lang Freer, F1904.75.

then, serves as an important reminder of an issue that will be explored throughout this book: Aesthetic artists knew their audience, and it is difficult to disentangle the activities of production, patronage, and collecting in this self-reinforcing small-world system.[20]

It has now become a commonplace to observe that the taste for blue-and-white exhibited by art patrons like Leyland constituted an appropriation of the artist's studio into the realm of the bourgeois residence. For Whistler, like many of his like-minded peers, the home served as both an extension of and a showplace for the studio's pictorial experiments, and many decorative trends of the late nineteenth century have been interpreted as the decorator's and householder's attempts to domesticate (and take vicarious share in the pleasures of) the eclectic bric-a-brac of bohemia.[21] The *Princesse* conceptually fits with its installation environment so seamlessly because the patron had already imbibed this studio culture (at least in the form of Chinese blue-and-white). But it is also worth noting that the *Princesse*, like other paintings by Whistler from that time such as *Caprice in Purple and Gold: The Golden Screen* (fig. 8), demonstrates that Whistler was himself in this period working in a particularly connoisseurial mode. These paintings imply that the artist's ability to make a pleasing picture is fundamentally predicated on his ability to choose, acquire, and arrange fine things, and to discern the most advantageous way in which to represent them (a kind of connoisseurship of form). Consequently, the comparative looking that lies at the heart of

connoisseurship – the ability to distinguish the particular beauty of one thing from that of other similar things – is also the proper framework for appreciating the Aesthetic painting. Instead of characterizing patrons' relationships with Aesthetic culture as chiefly imitative or aspirational, then, this study focuses on the ways that these pictures and decorative objects often embodied a remarkable fusion of the artist's and the collector's roles and cognitive processes, in the realm of connoisseurship and beyond.

Although the *Princesse* was conceived and exhibited as a stand-alone easel painting, it serves in Leyland's dining room as a cornerstone of Aesthetic decoration on a room-sized scale. A large percentage of Aesthetic pictures produced in Britain and America shared its hybrid character. One of the primary challenges in dealing with an Aesthetic picture involves attending to both its independent identity and its ensemble function without giving either half of this equation disproportionate weight.

Aesthetic scholars tread carefully around the concept of the decorative, mindful of its tendency to consign these paintings to the realm of "mere decoration" and deny them their hard-earned place as intellectually and philosophically grounded, problem-oriented *pictures*.[22] This may account for the longtime tendency to segregate Aesthetic painting from furniture, textiles, wallpapers, and glass – even when designed by the same artists – in many exhibition catalogs and other scholarly studies. This practice, fortunately, has begun to change. In a 2011 exhibition jointly curated by the Victoria and Albert Museum and the Fine Arts Museums of San Francisco, *The Cult of Beauty: The Aesthetic Movement in Britain, 1860–1900*, paintings and other objects remained thoroughly and productively interspersed on the gallery walls as well as in the pages of the catalog, and so avoided implying that either operated in isolation.[23] But the true innovations here are to be found in the work of Caroline Arscott, who consistently opens up new possibilities for thinking about how artists (particularly Burne-Jones and Morris) pursued their Aesthetic experiments across a range of media and in collaboration over an extended period of time.[24] Arscott insistently returns our attention to the visual specificity and materiality of Aesthetic paintings and designed objects as registering and inviting the fully embodied experiences of makers and viewers in a physical world, where compositions and ornament share the potential to communicate a range of ideas – even construct a worldview – through resemblance, metaphor, and analogy.

What interests me, in attempting to pin down the "look" and function of Aesthetic paintings more broadly, is the assertiveness with which they formally invite or even demand installation in coordinated spaces and/or groups. Again, the *Princesse* and the Peacock Room provide a revealing case in point. The artist/patron dispute for which the room is now famous arose when Whistler attempted to bring Jeckyll's renovations into harmony with the *Princesse*, but he apparently found it difficult to achieve the same delicate tonal and compositional balance in the room that he had already achieved in the picture. Linda Merrill evocatively describes the evolution of the Peacock Room as Whistler's "struggle" to create a new harmony while "dismantling" the "aesthetic coherence" of Jeckyll's initial

design.[25] Each change Whistler made – gilding the woodwork, painting the red out of the pattern on the gilt leather wall coverings, applying a wave design to the dado and cornice – seemed to require yet another corresponding adjustment, until the decoration, in Whistler's words "alive with beauty," had grown and proliferated across the entire room, overtaking everything that stood in its path (see fig. 2).[26] History has at times regarded the rapidity and vigor with which Whistler overstepped his bounds as a decorator as an indication of arrogance, hubris, or Barnumesque showmanship; Merrill, however, has demonstrated how consistent this all-embracing décor was with Whistler's totalizing conception of his art.

A thorough account of Aesthetic painting must also necessarily consider how artists' personal pictorial projects and patrons' decorative and installation requirements mutually shaped each other. One particularly well-known incident involves Leyland and his long-term arrangement with Rossetti, according to which the artist was expected to produce pictures of a certain general size and containing a certain number of female figures (or "heads") for a continually evolving installation in Leyland's drawing room (fig. 9). While we might once have been inclined to focus on the oppositional artist/patron tensions that arose as Leyland rejected some pictures and asked Rossetti to change others, Kathy Psomiades encourages us to take into account "the *productivity* of patronage": that is, how pictures like Rossetti's *Lady Lilith* (1866–8, altered 1872–3, Delaware Art Museum, Wilmington) come into being through ongoing negotiations between artist and patron.[27]

As Leyland's contract with Rossetti suggests, there were multiple ways in which Aesthetic paintings might be considered to constitute a series, and in this regard we note that there is often little to distinguish stand-alone Aesthetic canvases, compositionally or thematically, from bespoke series by the same artists designed for ostensibly decorative purposes. It is certainly true that, as Sarah Burns

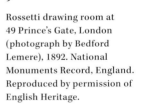

9

Rossetti drawing room at 49 Prince's Gate, London (photograph by Bedford Lemere), 1892. National Monuments Record, England. Reproduced by permission of English Heritage.

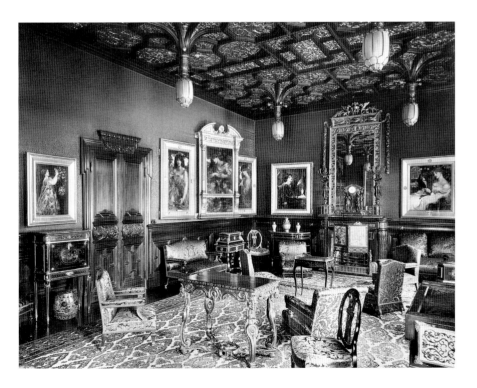

has pointed out, the repetitive nature of some Aesthetic pictures contributed to the creation of a "branded" visual style that artists could rely upon to appeal to the tastes of their most reliable patrons and collectors.[28] But it is also worth paying attention to the mechanics of how this happened. It is precisely because the "art for art's sake" project, however it was pursued, tended to result in similar formal characteristics – flattened, fully integrated surfaces that might conceptually be extended beyond the edges of the canvas – that a patron or collector could build up a unified art collection or domestic decorative scheme by combining stand-alone and serial pictures created by the same artist with a variety of pictures painted by different artists who shared the same essential priorities. Aesthetic pictures, I argue in this book, were configured as open-ended modules that could be slotted into and harmonized with various art collections and domestic interiors. This configuration naturally had a commercial benefit for artists and also gave collectors the opportunity to reinvigorate their holdings by periodically reshuffling and reinstalling them. Aesthetic pictures were made – some of them quite overtly and explicitly – to be collected and displayed in groups and arrays, and recognizing this predestination will help to expand rather than trivialize our conception of the "art" that these artists were pursuing.

A further set of pressing questions for this study, related to the Aesthetic object's hybrid decorative identity and seriality, are those concerning its social function. Although the manner in which that Whistler's "arrangements" were carried out displeased his patron, the end result was still what Leyland had been working toward from the beginning: a fully coordinated decorated space for dining and entertaining, with the *Princesse* as its centerpiece (fig. 10). Whistler's mural of fighting peacocks, which faced the *Princesse* across the room, was apparently

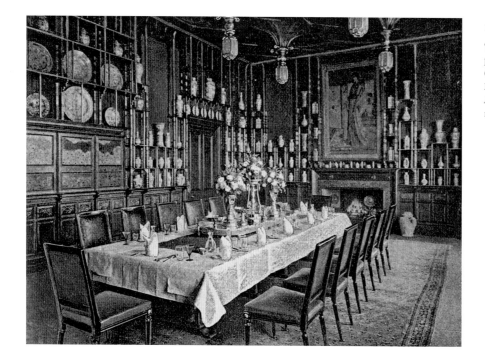

10

The Peacock Room in 1890, photographed for Theodore Child, "A Pre-Raphaelite Mansion," *Harper's New Monthly Magazine* 86, no. 487 (December 1890): 85.

designed to undermine precisely this convivial experience: Merrill notes Whistler's fantasy, recorded in an unsent letter, of Leyland sitting at his dining table, forced to face "the Cartoon opposite you at dinner."[29] It was a social/pictorial revenge that Whistler particularly relished, according to his contemporaries.[30] And just as the mural's scandalous nature was rooted in its strategic inversion of the room's function as a social stage, Whistler's decision to host unauthorized receptions and press conferences there while Leyland was out of town essentially amounted to a kind of burlesque of the patron/collector's proprietary right to annex an artist's creative work into his own public relations maneuvers.

These incidents call for revisiting because they so strongly contrast with most of our current rubrics for thinking about Aesthetic perception: a one person/one painting model in which focused engagement with a picture takes the patron out of his daily experience and offers him a kind of psychic completeness – nervous, spiritual, or even in some cases erotic – that mitigates the fragmentations of self in a constantly changing and anxiety-producing world.[31] While evidence shows that Aesthetic objects sometimes did fulfill this transcendental function, too narrow an emphasis on their escapist potential has tended to lead to discussions of Aestheticism in which pictures have only a negative value: they become tools of displacement, distancing, and isolation, ultimately prized for what they do not depict or evoke. This model has little to say about the role these art objects might play in social situations, and is ill suited to addressing their insistent interconnectedness, their visual and conceptual reaching *out* – a concern that is central to aspects of this study.

While the "mind cure" model of Aesthetic interpretation is oriented primarily toward the illumination of individual experience, an equally popular countervailing theoretical approach poses the risk of overvaluing (or at least overdetermining) the social. In this case Aesthetic taste is not something that is experienced so much as it is something that is exhibited; it constitutes a performance and projection of "status" directed not just to the patron's family and associates, but to an entire social class or range of social classes. Replacing or elaborating a Marxist view of the Aesthetic object as commodity fetish, this interpretative framework relies on Pierre Bourdieu's sociology of "distinction" to cast Aesthetic paintings and interiors as markers of difference and tools of class consolidation.[32] Viewed through this lens, the value of Aesthetic taste as conspicuously displayed "cultural capital" lies in the messages that it sends outward, and downward: the Grosvenor Gallery, Sir Coutts Lindsay's London showplace for Aesthetic painting, "defines" as its "mission" the legitimization of social differences, and Aesthetic interiors project the "hegemonic right" of a class "to control cultural life."[33] Whistler is often singled out as an "elitist" exemplar of this exclusionary aspect of Aestheticism: "The viewer's capacity to discern 'pure beauty' to Whistler's mind differentiated the elect individual from the bourgeois masses and imputed to that individual a self-refinement that in turn justified a superior social status."[34]

Late nineteenth-century critical commentary is filled with references to Aestheticism as a visual language that not everyone could (or wanted to) understand and appreciate, and there is no question that its operations and reputation were thoroughly bound up with issues of class: Aesthetic art patrons belonged – like late nineteenth-century art collectors generally – to the growing

financial elite that earned its fortunes through business activities and investment rather than inheriting them. In pushing through these important lines of investigation, however, art historians have sometimes treated the status-oriented, differentiating effects of cultural consumption as though the social performance of distinction constituted the sole interest and use value of Aesthetic material for its collectors and viewers. One thing that has largely been missing in applications of Bourdieu's terminology and schema to the study of Aesthetic painting, collections, and displays is that author's conviction that a taste for a particular type of art represents only one facet of an individual's larger worldview.[35] This book takes up the challenge of sketching out the larger constellations of cultural preferences and day-to-day experiences within which a love of "art for art's sake" was situated, relying more upon a close, granular analysis of individuals and communities and less upon broad-based generalizations about the perceived needs and anxieties of an entire social class.

The art history of Aestheticism is in fact already in the midst of a turn toward studying communal and collaborative artmaking and (to a lesser extent) patronage and collecting practices. In addition to the above-cited studies by Prettejohn and Arscott, which illuminate the artistic dialogues and exchanges through which paintings and decorative objects were produced, the past three decades have seen a number of books and essays dedicated to documenting the tightly interlocked art worlds through which Aesthetic painters and their partisans circulated. The Grosvenor Gallery is no longer merely the butt of a Gilbert and Sullivan joke, but is treated as a thriving ecosystem and cross-section of elite London society.[36] Merrill's account of the Peacock Room locates it at an intersection of decorative projects undertaken by Jeckyll, Whistler, Burne-Jones, Walter Crane, and others; Charlotte Gere and Caroline Dakers have also produced richly detailed histories of the art collections and houses associated with the Holland Park Circle and the Wyndham family.[37] Artist colonies and patronage circles continue to draw the attention of American scholars, with as much of this documentary work conducted in dissertations as in published volumes.[38] This book builds upon the important work that has been done to bring these and other artistic and social relationships to light, pressing new questions of what it meant for certain social and family groups to gravitate toward Aesthetic paintings, William Morris wallpapers, and William de Morgan lustreware, among other touchstones, as components of a shared visual culture with transatlantic applications. How are we to understand the experience and value of being so vividly and specifically connected to other individuals and families through the objects one collected and commissioned? And leaving aside broad assumptions about competition and one-upmanship, what was the long-term impact of living with these thoroughly interconnected and highly associative works of art?

What the *Princesse*, the Peacock Room, and 49 Prince's Gate graphically demonstrate is the need for an approach to Aesthetic painting that is agile, flexible, capable of keeping its objects of investigation constantly suspended between these intersecting demands of artistic praxis, decorative function, individual perception, and social engagement. We need a way to keep these interlocking systems connected and alive for us, as they were for the communities that made, collected, and lived with them and gathered in their presence. Developing such a framework,

as this study attempts to do, involves shifting Aestheticism out of a discourse primarily oriented toward isolation, inwardness, stasis, and unreality, and into one that accommodates its dynamic connectivity, its commitment to system, and its multivalent associations. The word that best seems to capture these formal and conceptual systems is "network": the Aesthetic painting as a networked system offers an ideal vision of a fully interconnected world, wherein (to return to Monkhouse's phrasing) "each thing should interweave with … every other thing," reinscribing in microcosm both the systemic priorities that govern its installation and the essential character of the densely overlapping artistic and social communities in which it moves and makes its meaning.

Notes on the Visual and Conceptual Culture of Network

"Network," of course, is a word that springs easily to the twenty-first-century tongue. It has been appearing, unselfconsciously, with greater and greater frequency in Aesthetic scholarship. When we observe late nineteenth-century artists and patrons making strategic professional use of their social contacts (and vice versa), we call it "networking"; when we can almost palpably sense the organic proliferation of Whistler's peacock feathers, Morris's acanthus leaves, or Tiffany's stained-glass foliage, we find in "network" a suitable expression of their density and vital intensity.[39] Wading into the complex cross-currents of Aesthetic poetry, with its refusal of one-to-one interpretive stability, we use "network" to describe its multivalent structure and fluid symbolic possibilities.[40] "Network" characterizes the turn-of-the-century Arts and Crafts community, with its utopian ambitions and thoroughly integrated systems of production, just as effectively as it evokes that community's opposite other, the target market of Victorian middle-class consumers linked by their shared tastes for mass-produced home décor.[41]

Scholars working in a variety of fields are increasingly looking to the nineteenth century to locate many of the essential preconditions of our twenty-first-century networked experience. Viewing the nineteenth century through the lens of "networks" has become an increasingly familiar strategy for linking up several different strands of historical investigation – particularly the construction and spread of transportation, communication, and corporate and political/imperial administrative systems that might otherwise be studied separately – into a larger global picture, through which the overlaps and intersections between these systems emerge. It is, by necessity, an interdisciplinary view of the past that (at its best) bundles together the systematic and the social: network-oriented histories treat as a single organism the physical, technological infrastructures that collapsed space and accelerated time (railroads, steamships, streetcars, telegraphs, telephones) and the connections between people that these structures depended upon, facilitated, exploited, and manipulated.

As practiced by Armand Mattelart, this type of investigation takes advantage of the clarity and abstraction offered by historical distance to reduce what must have felt at the time like a series of rapid and almost incomprehensible changes into broad lines of order, so that the evolution of communication systems, for example, can be contemplated on a global scale.[42] Other scholars are taking a more focused approach to investigating how day-to-day, on-the-ground experience was affected

by living in this increasingly networked world.[43] In literary studies, for example, Laura Otis has been looking at how "web" imagery interpenetrated nineteenth-century fiction, with special emphasis on how British writers used "webs" and "nerves" to understand new communication technologies like the telegraph; these instruments, in turn, changed how people understood their own bodies in relation to others.[44] For art historians, the study of technological networks in this period complements investigations already undertaken by Barbara Maria Stafford (whose work is positioned at the intersection of fine art, science, and medicine) and Kate Flint (who has examined the shifting Victorian boundaries between the visible and the invisible).[45] Others are using "network" principally as a vehicle for tracking the circulation of artists, objects, and ideas in an increasingly interconnected world.[46]

One of the chief aims of this book is to draw Aesthetic painting, with its networked visual language and its interlocking communities of production and consumption, into the context of a nineteenth century coming into an awareness of itself *as* networked. In order to do this, it is necessary to understand how visual materials operated in this increasingly interconnected world. Although the field as yet lacks a thorough history of what might be called the visual culture of network, what follows is a brief attempt to recover something of the late nineteenth-century experience of looking at, thinking about, and managing complex systems – a category of experience to which Aestheticism, I will argue, inescapably belonged.

If we treat "network" as a keyword in Raymond Williams's sense of the term, its changing use over the course of the nineteenth century reveals a growing awareness of the interconnected character of social, economic, and political life.[47] Beginning in the 1850s, we see a steadily increasing deployment of "net-work" and "network" in major British and American publications (fig. 11). We also see significant shifts in its meaning, as it is first used to refer to concrete, visible linkages, then, gradually, to invisible and even conceptual ones.[48]

From the early to mid-nineteenth century, English-language publications continued to use the hyphenated "net-work" to refer primarily to a thing – typically the reticulations of fishing or embroidery nets – rather than to mediated representations of that thing. But it appears to have been the development and rapid spread of railroads in the 1830s and 1840s that vaulted "network" as metaphor into the world of everyday language. In England, in parliamentary discussions of proposed reform acts in the 1840s, a number of ministers pointed out that the country would soon be, in their words, "covered with a network of railways" or "networked over."[49] In the United States, as well, it became a vivid shorthand for describing the railroad's branches and interstitial spaces (fig. 12). In this capacity, "network" evoked a complex blend of the visible and the invisible. The ever-present railroad seems to have touched off a much more widespread and versatile deployment of "network" to describe several different facets of late nineteenth-century life.

The coming-into-visibility of networked space was a central factor in the stiff competition between various agents of the pictorial press in Europe and America, as a boom in illustrated newspapers coincided precisely with the expansion of railroad and telegraphic technologies.[50] The illustrated magazine and the

11

Uses of "network" or "net-work" per year, 1851–1925. Compiled by the author.

12

G. W. & C. B. Colton & Co., route of the Continental Railway and its connecting lines, United States, 1873. 50 × 90 cm. Library of Congress, Geography and Map Division, Washington, D.C.

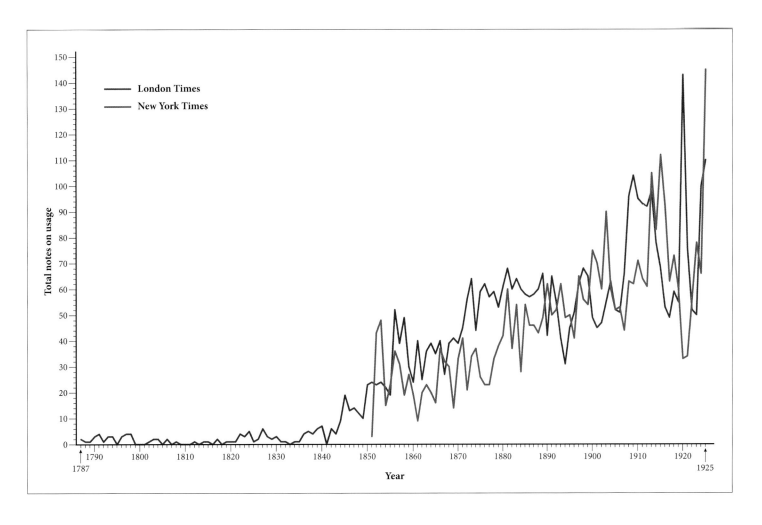

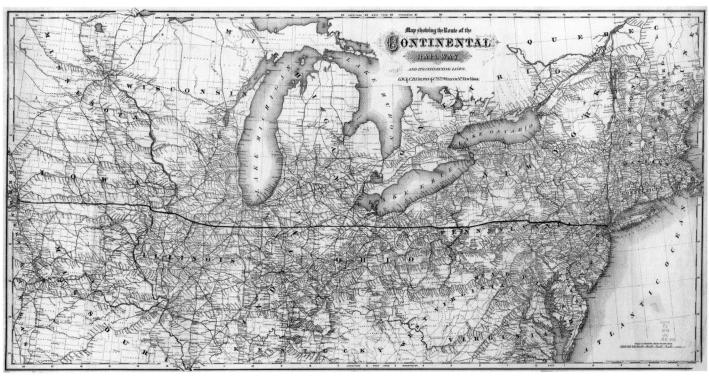

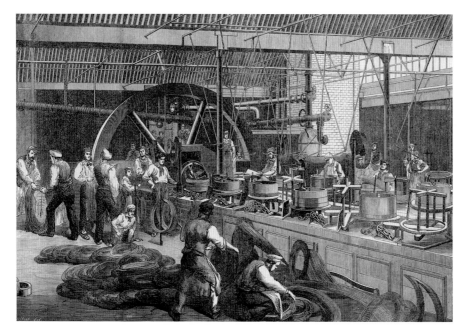

13

"Making the Steel Wires for the Atlantic Telegraph Cable of 1865," *Illustrated London News* 49, no. 1389 (September 15, 1866): 256.

networked world evolved in parallel, and as publications like *L'Illustration*, the *Illustrated London News*, and *Harper's Weekly* (among many others) competed with each other and sought to attract readers through state-of-the-art wood engraving techniques, the emergence of new industrial and technological networks provided an array of intricate, challenging subjects through which they might prove their skills. Readers could scarcely open a journal without being confronted with attempts to expose the inner workings of all manner of technological feats, especially dramatic accounts of transatlantic telegraph cable construction and installation in the 1850s and 1860s (fig. 13).

These technological innovations brought an array of networks directly to the householder's door.[51] "At the present time we have a perfect network of gas pipes and water pipes throughout our large cities," a young Alexander Graham Bell explained in a letter to potential British investors in 1878. "In a similar manner it is conceivable that cables of telephone wires would be laid under ground, or suspended overhead," uniting residences and businesses to a central office that would facilitate point-to-point communication.[52] As the context of Bell's letter suggests, these new tangles of pipes, wires, and rails were accompanied by equally complex networks of investors, trusts, and government bureaus essential to their construction and management. Increasingly, from the 1870s, we read of "networks of business enterprise," of offices, of a "close commercial network covering the whole country."[53] Even as early as 1868 one visitor to the Lloyd's brokerage office in London scanned an international array of newspapers laid out for inspection, and observed, "Thanks to this arrangement, the reader can embrace at one glance the state of commerce in every part of the earth. The innumerable threads of the vast net-work of business which spreads alike over continents and oceans are thus, as it were, brought together to one point for the use and profit of the habituees of Lloyds."[54]

The power implied by this commercial network, as viewed from the center, certainly had political as well as economic implications. For British politicians,

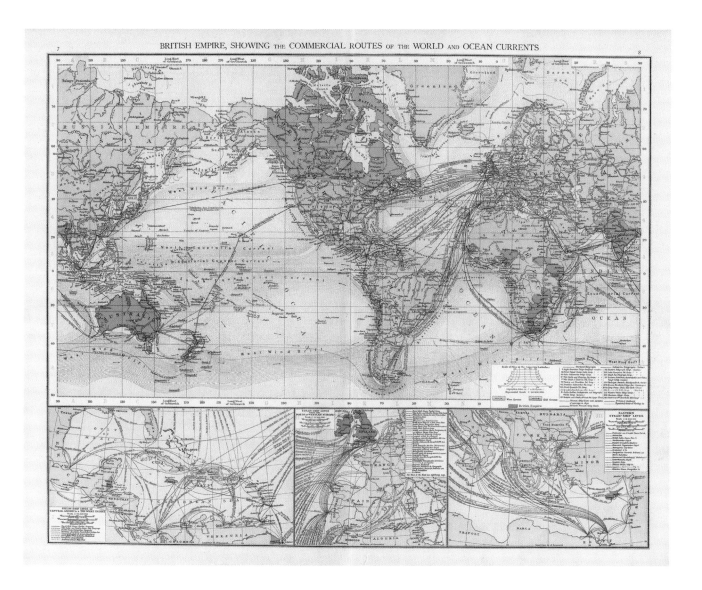

14

Richard Andree, "British Empire, Showing the Commercial Routes of the World and Ocean Currents, (with) Steam-ship lines of Central America & the West Indies, (with) Steam-ship lines from ports of Western Europe, (with) Eastern Steam-ship lines Mediterranean and Black Seas. Published at the office of 'The Times,' London, 1895." (London: Cassell & Company, 1895). Map, 38 × 47 cm. David Rumsey Map Collection 1010.005, www.davidrumsey.com.

notably Conservative M.P. and colonial administrator Sir George Smyth Baden Powell, commerce created "a network of vested interests of varied character" binding the far-flung precincts of the empire (also conceptualized as a network) closer to England (fig. 14).[55] The tightening and consolidation of England's imperial network through instruments such as wires, rails, and defense flotillas, as well as commercial markets, was felt and remarked upon even in America, where by the 1890s Captain Gilbert P. Cotton observed forebodingly that "the annihilation of space by steam and electricity has drawn the meshes of the great network of empire closely around us on every side."[56] America was similarly consumed with the extension of its own transportation, communication, and trade networks to bring the West (and, eventually, Caribbean and other territories) into the commercial fabric of the nation as a whole.

In an environment where corporations ballooned to gigantic proportions (subject to considerably less regulation than in England), day-to-day experience for the highly placed American businessman involved negotiating the operations of internal and external networks: that is, both the increasingly formalized

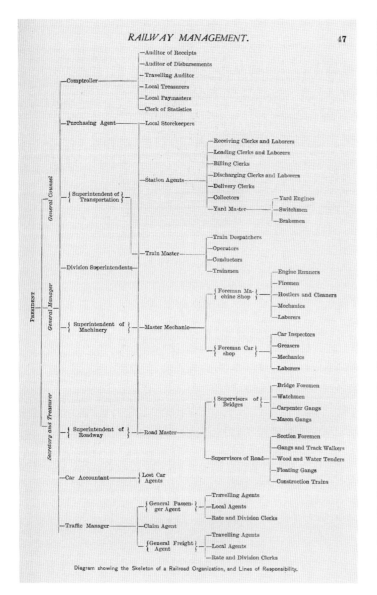

RAILWAY MANAGEMENT. 47

Diagram showing the Skeleton of a Railroad Organization, and Lines of Responsibility.

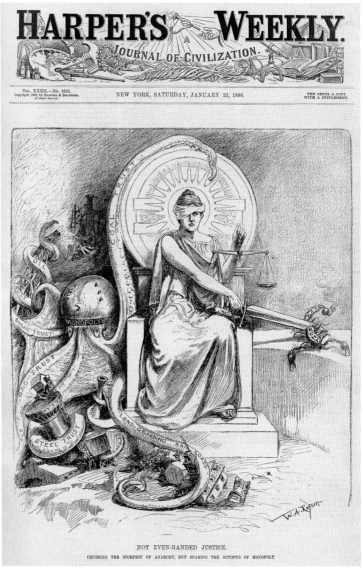

NOT EVEN-HANDED JUSTICE.
CRUSHING THE SCORPION OF ANARCHY, BUT SPARING THE OCTOPUS OF MONOPOLY.

subdivisions of departments and offices within a corporation (fig. 15), and the tangled web of mergers, trusts, and pools that linked corporate units together into centralized, vertically and horizontally integrated structures.[57] Systems management became an increasingly important part of corporate life at every level.

In Britain and America, corporations that built and controlled technological networks relied on the visibility of advertising to illustrate the extent of their systems to their customers. Most telegraphs, for example, were printed on tickets or receipts that included an updated map of the telegraph company's system, which, like corporate railroad maps, served as tools of persuasion acting to cultivate customer interest and loyalty. With the expansion of great systems, however, came fear of monopoly control, critics of which developed their own visual vocabulary (often the octopus or the spider web) to illustrate the strangling, limiting, all-encompassing, trapping aspects of network (fig. 16).[58] In the business and political spheres, centralized power began to fall under particular scrutiny and criticism. Many corporations, for example, found it more advantageous to

15

E. P. Alexander, diagram of railroad organization, "Railway Management," *Scribner's Magazine* 5, no. 1 (January 1889): 47.

16

William Allen Rogers, "Not Even-handed Justice: Crushing the scorpion of anarchy, but sparing the octopus of monopoly," *Harper's Weekly* 32, no. 1622 (January 21, 1888): 37.

17

John Atkinson Hobson, graph of interlocking directorates, in *The Evolution of Modern Capitalism: A Study of Machine Production*, rev. edn. (London: Walter Scott, 1906), 272.

cooperate with each other than to destroy themselves through litigation fees, competitive price-cutting, and other profit-reducing strategies.[59] In 1894, English economist John Hobson published the first study of "interlocking directorates," a phenomenon in which leaders of related industries served on each other's boards of directors, creating behind-the-scenes cooperative arrangements beyond the reach of antitrust legislation. When he revised *The Evolution of Modern Capitalism* in 1906, he illustrated this concept with one of the first network diagrams (fig. 17).[60]

A number of British and American writers were turning an inquisitive eye toward the private social realms in which politically and economically advantageous concentrations were forged. In this context, "network" was used to point to invisible chains of unofficial but influential relationships, articulating what we now commonly refer to as strategic "social networking." One writer in 1889 tells us, for example, that "the whole net-work of social life is interwoven with clubs."[61] In a flattering light, clubs, business associations, labor unions, and other private organizations cultivated, in the "cultured gentleman," an understanding of his own place within "a network of human interrelations."[62] According to a more critical view, close ties between families, friends, and select social circles could encourage the formation of a "network of cliquism and favoritism," or a "network of secret associations."[63]

Convergence: Aestheticism in a Networked World

What has all of this – networked technologies, nations, empires, classes: in short, networked life – to do with Whistler, Leyland, and the Peacock Room specifically,

or Aesthetic painting and interior decoration more broadly? Tempting as it may be to draw literal connections between, for example, the implied organic grids of Morris's wallpapers or the branching foliage of Charles Caryl Coleman's still lifes (see figs. 35, 46 and 76) and the physical appearance of late nineteenth-century railroad maps and communications systems, to do so would be misleading, and would skirt too closely the edge of an outmoded "reflection theory" of visual objects and their relationship to the societies that produced them.[64] It would also allow a merely superficial similarity between these visual materials to distract us from what is in fact a much deeper conceptual connection between these art objects and their age: what we are witnessing in the realm of Aesthetic painting and interior design is the product of a remarkable convergence between the problems and challenges that artists were pursuing *for their own sake* through the creation of harmonious, unified visual systems, and the substance and shape of the world that art patrons and collectors faced daily in their business, political, and social lives, where systems management and network-building skills were becoming essential tools for success and survival. Aesthetic artworks, as we have seen, foreground and thematize the activities of selection, comparison, and arrangement as the true substance of picture-making (and of interior decoration); the people who collected and commissioned them, typically men serving in managerial roles, cultivated similar competencies. Their carefully selected and harmoniously arranged artistic holdings encouraged the pleasurable exercise of – and testified to their possession of – these perceptual and organizational skills, while also serving as nodal points around which powerful communal identities were formed and reinforced.[65]

Returning to Leyland's patronage, beyond his commission of the Peacock Room, as a means of illustrating this interpretive framework as it will be understood and applied throughout this book, a first line of investigation would be to probe the relationship between Leyland's art collecting and his lifelong career as a builder and manager of systems. Starting as bookkeeper, clerk, and, eventually, partner in John Bibby & Sons, a family-operated shipping line based in Liverpool, Leyland bought out his partners and rechristened the fleet the Leyland Line in 1872.[66] In the 1880s, he turned his energies and investment capital toward the burgeoning fields of electricity and telephony in London. As an active director of the Edison Electric Light Company, he was tasked with the challenge of merging its assets with the Swan United Electric Light Company in 1884, where his service on the corporate board continued.[67] By the following year, he was also attending shareholder meetings of the United Telephone Company.[68] After his ascent to directorship at United, he was tapped yet again to help organize a major merger, this time between the three largest telephone companies in England. As president of the newly consolidated National Telephone Company, he managed its communications monopoly, enlarged its network, and served as its public spokesman. In each of these industries, Leyland established himself as an ambitious, sometimes ruthless, agent of technological and corporate expansion.[69]

Leyland the system-builder might seem like a prime candidate for nervous anxieties of the type outlined by George Beard in his well-known neurasthenia studies. In 1881, Beard worried that "the heightened activity of the cerebral circulation which is made necessary for a businessman since the introduction of steam-power, the telegraph, the telephone, and the morning newspaper" was

causing excessive strain on another network, that of the human nervous system.[70] Many art historians have made use of Beard to define the Aesthetic interior, and paintings like Whistler's, as offering a zone of retreat for the active and engaged businessmen (and, to a lesser extent, politicians) who collected them.[71] A conviction that Leyland longed for "retreat and reverie" informs Dianne Sachko Macleod's contention that "the beleaguered shipowner and chairman of the National Telephone Company found in his art-filled home a sanctuary where he could attain a sensual as well as a spiritual release through his art collection."[72] But this type of analysis frequently imputes to art patrons and collectors a certain distaste for networked life: in fact, directing the actions and interactions of complex systems was precisely the activity at which most of these men excelled. Should we necessarily assume that their central motivation was to distance themselves from those fine-tuned competencies, even in their leisure hours?

Alternatively, consider technological historian Thomas Hughes's description of the mindset that system builders like Leyland were forced to cultivate: "Electric power systems demanded of their designers, operators, and managers a feel for the purposeful manipulation of things, intellect for the rational analysis of their nature and dynamics, and an ability to deal with the messy economic, political, and social vitality of the production systems that embody the complex objectives of modern men and women."[73] Although Hughes is discussing these activities as they relate to the electrical industry, his comments might be said to apply across many different types of technological and administrative systems at the turn of the century. Merging and then running the Edison and Swan companies, for example, required Leyland and his fellow directors to understand the subtle differences between a bewildering array of internationally patented devices (from light bulbs to telephone receivers), the number of customers a networked system could safely support, the comparative merits of overhead versus underground wiring systems, and the complex patchwork of public and private properties through which such wires had to pass, and knowing how one communications or power network related to all the others.

Whether or not Leyland could be proven to have envisioned his home as an escape from these demands, the aesthetics (or Aesthetic) of such a retreat evidently operated according to similar conceptual rubrics and cognitive processes as those activated by his working life. The paintings he commissioned, collected, and carefully installed by Rossetti, Whistler, Moore, and Burne-Jones (not to mention the dining room as conceived first by Jeckyll and then by Whistler) exulted in the "feel for the purposeful manipulation of things"; savoring their pictorial beauties necessarily involved engaging in a more or less conscious "analysis of their nature and dynamics," as the harmonious selection, arrangement, and organization of forms was the fundamental nature of the beauty on offer. The art dealer Charles Augustus Howell famously dismissed Leyland as a cold, calculating man of commerce, driven by systematic impulses so that he "only buys a thing when he wants it for a certain place," yet the tendencies Howell is describing arguably tell us about something more than Leyland and other patron/collectors of his class; they tell us something about Aestheticism itself and its particular fitness for the networked mindset of the turn-of-the-century manager and administrator.[74]

A related issue that will shape this study is the role that Aesthetic paintings played in consolidating tightly networked (and network-building) communities, like those through which Leyland's commercial affairs were conducted in both Liverpool and London. In Leyland's case, important research has already placed him within a group of art-collecting industrialists in his hometown of Liverpool, where his cultural tastes were shaped through his contact with shipping magnates John Miller and the Bibby brothers, John and James.[75] In one remarkable and illuminating incident, Leyland joined Miller for a visit to view Liverpool banker George Rae's freshly acquired Rossetti, *The Beloved* (Tate Britain, London) in 1866; Miller would eventually introduce Leyland to the artist himself, sparking a faithful, if sometimes frustrating, patronage relationship that would last over fifteen years.[76] At Leyland's death in 1892, John Bibby would acquire at least eight paintings, including three Rossettis, from the collection of his former shipping partner.[77]

Much can be done with this type of data, but a question that surprisingly has not been asked concerns the more immediate and practical value of cultivating and consolidating a business community through cultural means. These men knew each other and each other's collections, and the connections between their pictures were sometimes even publicly articulated in the art press.[78] These paintings therefore do more than testify to the possession of a certain kind of "cultural capital" or connoisseurial discernment: they form a circuit of aesthetic relationships, a kind of virtual collection that is larger than any one gallery or interior, constantly giving back to the picture owners a reflected image of the other people and paintings that constitute the patronage network to which they belong. This is a consequence of the Aesthetic artist's serial project, of his repeated use of a small circle of recognizable models in various related configurations, of the late nineteenth-century exhibition catalogs and artistic monographs that place the names of the same picture owners side by side, again and again.[79] Just as a railroad map had the potential to evoke a swarming mass of passengers and workers, or a telegraph message collapsed the space between two people across a wire, these paintings served as points of contact whether men like Leyland, Bibby, and Rae were standing in each other's parlors or simply registering the presence of echoed and related images at a distance.

If the concept of network raises new questions and points toward new discoveries about patronage and the Peacock Room, what else might it reveal about other Aesthetic artifacts and the people who commissioned and collected them? This book sets out to answer those questions by probing the relationship between Aesthetic painting and the networked political, social, and technological character of late nineteenth- and early twentieth-century British and American life. It begins with a consideration of the Aesthetic Movement as it originated in England before turning to the production, collection, and museum curation of Aesthetic objects in the United States, with a transatlantic chapter transitioning between them.

The case studies selected for these chapters explore different kinds of late nineteenth-century networks and different roles that Aesthetic objects played or had the potential to play within them. Generally speaking, they enable us to study three types of convergences and their consequences. The first of these is largely

centered on the art world. The rise of the Aesthetic Movement happened concurrently with significant changes in the art buying public in Britain and America, as new money earned through industry jostled with old money in artists' studios, galleries, and auction houses. But rather than seeing the purchasing and commissioning of paintings as moves in a contest for "status," I have found it more useful to ask what specific purposes these objects served. As the following chapters on London's Grosvenor Gallery (Chapter 2) and Aesthetic painting in New York (Chapter 4) and Detroit (Chapter 5) make clear, the particular formal qualities of Aesthetic paintings facilitated the construction of systematic, harmonious art collections, and underscored their owners' perceptive abilities as connoisseurs.

On a related note, Aestheticism provided an answer to another key question of the period as phrased by Clarence Cook in 1881: "What shall we do with our walls?"[80] From the renovation of city and country homes for the British elite to the boom in American construction that followed the Civil War, there was a widespread need for works of art and decorative schemes to fill these dwellings. Although there are countless such objects and projects worth studying in this period, I was particularly interested in examining cases where the artists' and their patrons' needs converged, resulting in ambitious, unified decorative schemes for rooms that were actively used by their owners. Burne-Jones's *Perseus* series (1875–89), created for the London music room of Conservative M.P. and future Prime Minister Arthur James Balfour (Chapter 1), and Dwight Tryon and Thomas Wilmer Dewing's decorative schemes for industrialist Charles Lang Freer's Detroit hall and parlor (Chapter 5), offer opportunities to reflect on the relationship between Aesthetic visual harmony and the activities that occurred within these spaces.

The second type of convergence studied here is a rather literal one: of new networked technologies and Aesthetic paintings. The history of the Grosvenor Gallery allows us for the first time to examine the collision between these system-oriented pictures and electric lighting as an illuminant and a business (Chapter 2). Meanwhile, a transatlantic bridge chapter studies the transportation of Aesthetic art and ideas to the United States by tracing things in transit via steamship, telegraph, railroad, and publications networks (Chapter 3). The question of the impact of such technologies on late nineteenth-century art worlds could and should be asked of all kinds of cultural artifacts, and its relevance is not limited to those associated with Aestheticism. But studying Aesthetic paintings' entanglement in these networks through these and other case studies gives us a blueprint for what this line of inquiry can produce.

The most important convergence considered here, however, is that of artists working on serial, modular projects for their own reasons, on one hand, with individuals seeking to combine and collaborate as groups, on the other. Again, there are countless communities that could be studied under this heading, but I have selected London's Souls (Chapter 1), members of New York's men's social clubs (Chapter 4), and railroad car manufacturers and investors (Chapter 5), because the Aesthetic objects that connected them, largely drained of narrative specificity, were particularly susceptible to being filled up with new associations. Aesthetic paintings became nodes in these networks, visually and materially linking members that sought not only interconnection but influence. In this regard,

considering how these Aesthetic projects were directed outward and beyond the art world has, I believe, the greatest potential to transform our understanding of objects and patrons associated with the movement.

This study was inspired by these historical convergences between network building and use and system-oriented Aesthetic artifacts. What is its relationship to network theory as it is practiced today? Let us conclude this introduction with a note on the relationship of my project to other methods of historical investigation in which the concept of the network plays a central role: namely, network theory and social network analysis in the sociological field, and the study of objects as agents in the anthropological realm. Following the proposals of Georg Simmel and Emile Durkheim, and the insights of Linton Freeman and Mark Granovetter, among others, network theorists would find a rich field of study in the multifaceted and intersecting communities of artists and designers, patrons and collectors, dealers and museum trustees, politicians and society hostesses and clubbable businessmen who serve as the primary focus ("actors") in this book.[81] Key concepts used in network theory have immediate application here; as we shall see in the chapters that follow, some patrons and collectors do emerge as more centrally placed in their social/institutional networks than others, serving as influential mediators, circulating works of art and information via groups to which they are variously connected through strong or weak ties. But, for the moment, it is the idiosyncratic actions of the players within this system that interest me, rather than the stand-alone power dynamics and parameters of the system itself. A social network analyst using these concepts to transform my cache of anecdotal information into a quantifiable and analyzable data set would find its highly individualized "network[s] of relationships surrounding particular artworks in specific interactive settings" more likely to occlude than reveal larger structural formations.[82]

That latter phrase – "the network of relationships" – is drawn from the writing of Alfred Gell, and signals the potential applicability of his anthropology of art to the questions I am pursuing here.[83] Anthropology proposes alternative ways of thinking about the connections between people, communities, and things, and in Gell's scheme, objects sometimes play roles comparable to human agents (a primary contention of literary "thing theory" as well). Gell evocatively defines an object as "the visible knot that ties together an invisible skein of relations, fanning out into social space and social time": a quite powerful and, in many ways, appropriate way of thinking about the Aesthetic painting and its dense accretions of personal associations as embedded in a social context.[84] His procedures for diagraming object production and exchange (Gellograms) organize these complex functions into a simplified order, and have been adapted most effectively by Michelle O'Malley to map the commission of Benozzo Gozzoli's *Virgin and Child Enthroned among Saints and Angels* altarpiece (1461) by a specific confraternity in Renaissance Florence.[85] But as the partial formulation "Medici" → "Benozzo Gozzoli" → "Purification Altarpiece" → "Dominicans" implies, Gell's method aspires to be fundamentally predictive, and remains, like a number of sociological models, preoccupied with the mapping of causal forces and deduction of motivations from larger structural patterns in a manner not well suited to negotiating the multivalent convergences considered here.[86]

Like other scholars taking up the digital humanities, I have made informal use of maps and algorithmically generated diagrams as a tool of discovery in the course of my research. I see them as highly subjective, incomplete, and unbounded; as the beginning, and not the endpoint, of my analysis. They have simply been a means of tracking complex simultaneous movements of people and things, and for raising new questions about them. I have tried to remain cognizant of the distortions as well as the discoveries produced by keyword-searchable digitized archives and image databases, through which, to the twenty-first-century eye, history emerges as a tantalizing array of tightly packed interconnections; after all, it is impossible to search for gaps or absences. And this is why I have tried to keep in mind the warnings of Bruno Latour, who insists in his well-known critique of sociology that there is no map, no network, no "social context" beyond the specific, individual connections that can be patiently traced between one point and another, whether between people or things: "To the convenient shorthand of the social, one has to substitute the painful and costly longhand of its associations … you have 'to follow the actors themselves.'"[87]

LA CONSILIO · PALLAS · MOVET · INSTRVIT
NE · PRIVATAE · MONSTRANT · PENETRALIA
HARVM · HINC · ALES · PLANTAS · CAPVT · OBDITV
ONA · MORTALEM · DE · NON · MORTALIBV
FERIT · GEMINAE · SVRGVNT · VRGENT · QVE · S
VS · EN · ATLAS · CAESO · QVE · EREPTA · DR
OMEDA · ET · COMITES · IAM · SAXEA · CORPORA
RGO · HORRENDAM · IN · SPECVLO · MIRATA · M

CHAPTER 1

Networks of Power:
Balfour, Burne-Jones, and the Souls

The paintings of Edward Burne-Jones might seem to sit awkwardly within a concept of systematic Aestheticism weighted toward the more purely formal arrangements of Albert Moore and James McNeill Whistler. Unlike the typically non-narrative products of the latter two, Burne-Jones's works cling to the realm of myth, legend, dream. They operate along a wide continuum that runs from the longing and languor of *Laus Veneris* (fig. 18) to the near-mathematical crystalline clarity of the *Golden Stairs* (fig. 19). Some present themselves as medieval or Renaissance costume pieces; others occupy a placeless, abstract zone.

Yet certain characteristics bind these pictures into a coherent visual *oeuvre*. The "Burne-Jones type" of woman remains instantly recognizable: a tall, slender-limbed but wide-hipped, auburn-haired figure with large eyes and creamy white skin (which was sometimes given a greenish cast by the jewel-toned hues favored by the artist). When placed alongside Burne-Jones's armored, questing men, the differences between the masculine and feminine collapse into a single adaptable, if not androgynous, form. Deeply informed by the dictates of illustration (economy) and decoration (harmonious coordination), these figures are typically brought up close to the surface of the picture plane, arranged along a low ground line as though in a procession or frieze. They are frozen in pregnant moments against planar architecture, stratified landscapes, or dense organic growth. These compositional and formal consistencies mediate the differences between the artist's works, whether they are approached in isolation or in series, as executed in the medium of painting, stained glass, woven tapestry, or printed illustration. They suggest the motivating power of an evolving "art for art's sake" project, the priority of a set visual program to which all other narrative and evocative concerns must conform.

Victorian viewers keenly sensed this systematic quality of Burne-Jones's art. Some reacted negatively, accusing the artist of cultivating a deliberate artificiality

Edward Burne-Jones,
Perseus and the Graiae, 1878
(detail of fig. 21).

and (like Rossetti and Swinburne) raising a personal and idiosyncratic *non-natural* standard against which to judge its own success. They saw in his repetitive figures a poverty of imagination and complained about the dubious elitism accrued by audiences who versed themselves in his visual language. The artist's advocates, meanwhile, insisted that his pictures opened up new paths through a reworking of traditional forms and tropes, and admired the purity of an artistic project that sought to define its own limits rather than bow to public expectations. Yet Burne-Jones's critics and his supporters were essentially calling attention to the same thing: to the pictures' insistent referring back to the artist's painted *oeuvre*. These works do not register merely as something "other" than real life, but rather affirm

18

Edward Burne-Jones, *Laus Veneris*, ca. 1873–5. Oil on canvas, 122.5 × 183.3 cm. Laing Art Gallery, Newcastle upon Tyne. © Tyne and Wear Archives & Museums / Bridgeman Images.

19

Edward Burne-Jones,
The Golden Stairs, 1880. Oil on
canvas, 269.3 × 116.8 cm.
Tate Britain, London.

their membership within a distinct and, for late nineteenth-century viewers, increasingly familiar universe of the artist's own making. This insularity has often been interpreted as constructing an escape from modern life; I want to argue, alternatively, that we might understand this quality as creating an Aesthetic network that is threaded through contemporary experience and overlaid upon it.

This is the aspect of Burne-Jones's work that is emphasized and developed in this chapter, which treats his art as a vehicle of interconnectivity. In it I explore the proposition that to look at, and most certainly to collect and live with, the paintings of Burne-Jones was to engage with a network of distinctive images whose points of access were distributed across the British Empire and the western world – a network whose connective material was aesthetic, but whose utility extended into social, political, and economic realms. My central case study is the *Perseus* series painted for the British politician Arthur James Balfour. Carving out a place between the two main strands of Burne-Jones scholarship – the tendency either to read the pictures as a field for the artist's working out of his personal and professional anxieties, or to discuss their relationship to broader Victorian attitudes (toward masculinity and femininity, race, heroism, and victimhood) – I consider how they operated within a specific community of viewership and discourse. In order to avoid treating them as passive instruments of social consolidation, however, I also want to interrogate the worldview that the pictures describe in form as well as content, and ask what might have been the consequences of interfacing with life through the mechanism of this self-consciously artificial Aesthetic art.

The *Perseus* Series and the Problem of Patronage

The *Perseus* project was one of several serial, decorative commissions undertaken by Burne-Jones in the 1870s that allowed him to make use of designs he had originally created for an illustrated edition of William Morris's epic poem *The Earthly Paradise*. Burne-Jones's preliminary designs for Morris's book provided him with an almost endless fount of ideas that he adapted for other projects, including multiple versions of the *Pygmalion* story and the *Cupid and Psyche* frieze he produced for George Howard's dining room, beginning in 1872.[1] In this way the illustrated *Earthly Paradise*, lamented as the "book that never was," in fact took on an atomized, virtual existence as a series of richly illuminated rooms rather than pages, geographically dispersed throughout the homes of England's economic and cultural elite.[2]

In 1875, Arthur James Balfour, a twenty-seven-year-old Scotsman who had just moved to London to begin his political career in the House of Commons, offered Burne-Jones the opportunity to "story" his drawing room at 4 Carlton Gardens.[3] The Perseus theme was an appropriate selection for Balfour on at least two counts. Consistent with Burne-Jones's broader interest in "questing" narratives, it featured a young protagonist who set out to fulfill his foretold destiny: in this case, saving his mother Danaë from imprisonment by the jealous and fearful Acrisius, and in the process rescuing the maiden Andromeda from the jaws of a sea serpent. Perseus begins this journey much as a young parliamentarian might, unarmed and unprepared, but gradually develops confidence as he overcomes a series of

obstacles. At the same time, the figure of Perseus had long been associated with art patronage, and had been adopted by families like the Medici as something of a personal emblem.[4] This association would have been particularly powerful as the concept of the Italian Renaissance merchant prince was being revived by late nineteenth-century commentators in England and America as the ideal prototype of a wealthy and powerful but cultured civic leader. The figure of Perseus would have signaled the young patron's commitment to the arts – one underscored by the series' intended placement in Balfour's spacious drawing room, which served primarily as a music room.

But it was Burne-Jones, not Balfour, who chose the theme for the commission, which was a primary reason why Balfour's identity as an art patron and the functions that the Perseus paintings may have played in shaping his private life, public self-image, and social interactions have been overlooked, if not dismissed, by his biographers and art historians.[5] The following analysis uses previously neglected documentary material about Balfour's home and collections to fill out a broader picture of him as an art patron, to consider how the *Perseus* series operated within a larger network of Burne-Jones paintings, and to examine the role Aesthetic culture played in the construction of Balfour's public reputation.

The *Perseus* commission initially came about as the result of Balfour's desire to decorate and personalize his recently acquired London town house. He had purchased the residence at 4 Carlton Gardens in 1871, when he was twenty-two years old; he vacated it in 1929 at the age of eighty.[6] No photographs of its interior during Balfour's tenure have as yet emerged, an evidentiary gap that has both obscured his identity as an art patron and contributed to some confusion over which room, exactly, held the *Perseus* paintings. But floor plans of the house do survive, and these – cross-referenced, as will be done here for the first time, with new details gleaned from the 1929 auction of its contents, Balfour family papers in London and Edinburgh, and scattered published descriptions by assorted residents and visitors – provide a more complete picture than we have previously been able to obtain of Balfour's house and collections.

As related in an often-cited anecdote, the *Perseus* commission originated with a dinner hosted by Balfour in 1875, attended by, among others, Blanche Ogilvy, Countess of Airlie, related by marriage to George Howard, friend of Burne-Jones and satellite figure in Balfour's burgeoning London social circle. When the conversation turned to art and decoration, Lady Airlie offered to introduce Balfour to the artist.[7] The connection between the two men was apparently enthusiastic and immediate. Balfour later recalled that "I at once fell a prey both to the man and to his art," and asked Burne-Jones to design a series of "characteristic" pictures for his long, well-lit drawing room. "The subject I left entirely up to him."[8] Burne-Jones shortly thereafter produced a detailed gouache plan mapping out the series and suggesting how the *Perseus* panels might appear when installed in the room.[9]

The series, which was to alternate painted canvases and compositions in low relief, begins with the *Call of Perseus*, *Perseus and the Graiae*, and *Perseus and the Sea Nymphs* (fig. 20).[10] Based loosely on the story as told by Morris in *The Earthly Paradise*, these scenes introduce Perseus as he prepares to find and kill the Gorgon

Medusa, a challenge he has accepted in hopes of freeing his mother Danaë from the imprisonment of King Acrisius. The second scene in the sequence was actually the first picture the artist completed (fig. 21), in 1878, and depicts Perseus forcing the Graiae (sisters of the Gorgons) to aid him in his quest by holding as ransom the single eye that the old women share between them, passing it from hand to hand.[11] This unusual fusion of oil paint, bronze plates, and silver leaf over gesso on oak was also the only panel of the story to contain extensive explanatory text (in Latin), which perhaps accounted for its priority, as it would have served as a kind of wall label orienting viewers to the unspooling of a tale already in progress.[12] The other

20

Edward Burne-Jones, *Call of Perseus, Perseus and the Graiae, Perseus and the Sea Nymphs*, 1875–6. Gouache, gold paint, and ink on paper, 36.7 × 102.7 cm. Tate Britain, London.

21

Edward Burne-Jones, *Perseus and the Graiae*, 1878. Oil, gold leaf, and silver leaf on gesso on oak panel, 152 × 169 cm. National Museum Wales, Cardiff.

22 (Opposite)

Edward Burne-Jones, *Perseus and the Sea Nymphs*, 1877. Oil on canvas, 153 × 127 cm. © Staatsgalerie Stuttgart.

two paintings in this initial group remained unfinished at the time of the artist's death (fig. 22). Balfour acquired them from Burne-Jones's family at the sale of his studio's contents in 1898.[13]

In the subsequent panels, Perseus, armed with supernatural gifts supplied by the goddess Athena and the sea nymphs, seeks out Medusa: the *Finding of Medusa*,

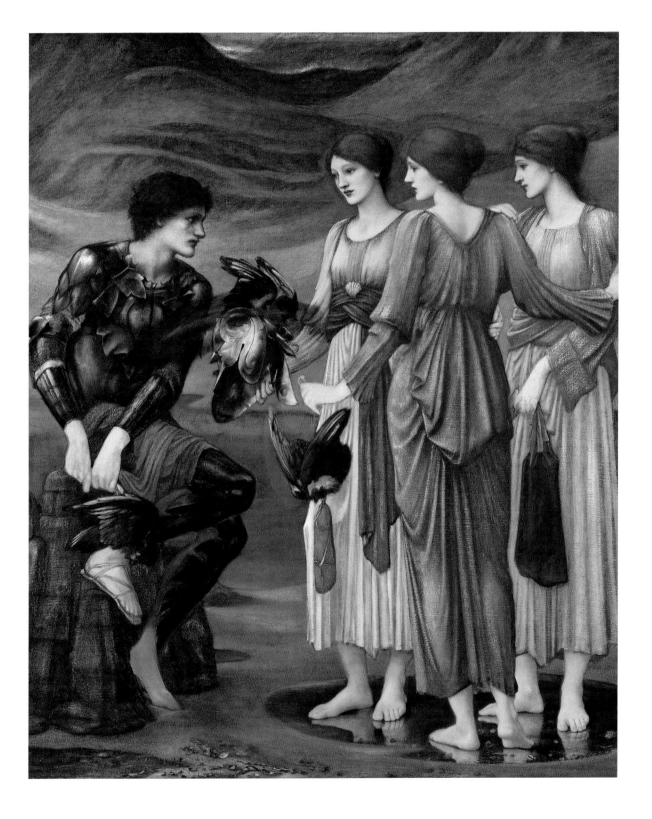

the *Death of Medusa*, and *Perseus Pursued by the Gorgons* (fig. 23). Although prepared to battle Medusa while following her reflection in Athena's mirror, Perseus catches her in an unguarded moment and beheads her. From her lifeless body spring her children, Pegasus and Chyrsaor, a scene that Burne-Jones planned to interpret in relief. As Medusa's immortal Gorgon sisters wake, they pursue Perseus, who flies from their clutches with the aid of Hermes's sandals. None of the scenes in this second group appear to have been a primary priority for the artist: the *Death of Medusa*, for instance, was not developed beyond the large-scale cartoon.[14]

The final four paintings were to depict Perseus's adventures following Medusa's death (fig. 24). The scene in which Perseus unveils the Medusa head and turns the Titan Atlas to stone is known today only in its full-scale cartoon form, and was never added to Balfour's group.[15] But the following sequence of events did absorb a great deal of the artist's time and attention. He was captivated by the portion of the story in which Perseus passes through the land of Joppa, spies the maiden Andromeda chained to a rock, and descends to rescue her, only to discover that she has been abandoned there by her own parents, Cassiopeia and Cephus, as an offering to Poseidon, whose monster he must slay to save Andromeda. For this Burne-Jones experimented with multiple compositional formats, first following his initial plan to condense these events into a single scene, then ultimately breaking the action into two separate panels, which he titled the *Rock of Doom* and the *Doom Fulfilled* (figs. 25 and 26).[16] The previous year Balfour's collection had been enlarged by the addition of the *Baleful Head*, the story's concluding scene, in which Perseus accedes to Andromeda's request to show her the terrifying face of Medusa, but only as a reflected image (fig. 27).[17] The planned relief in which Perseus turns his rival Phineus into stone was abandoned by the artist at an early stage in the project. In the end, then, Balfour received only half of the paintings in their finished oil

23

Edward Burne-Jones, *Finding of Medusa, Death of Medusa (Birth of Pegasus and Chrysaor), Perseus Pursued by the Gorgons*, 1875–6. Gouache, gold paint, and ink on paper, 36.8 × 128.4 cm. Tate Britain, London.

24

Edward Burne-Jones, *Atlas Turned to Stone, Rock of Doom and the Doom Fulfilled, Court of Phineas, Baleful Head*, 1875–6. Gouache, gold paint, graphite, and chalk on paper, 36.7 × 148.7 cm. Tate Britain, London.

25 (Opposite)

Edward Burne-Jones, *The Rock of Doom*, 1884–8. Oil on canvas, 155 × 130 cm. © Staatsgalerie Stuttgart.

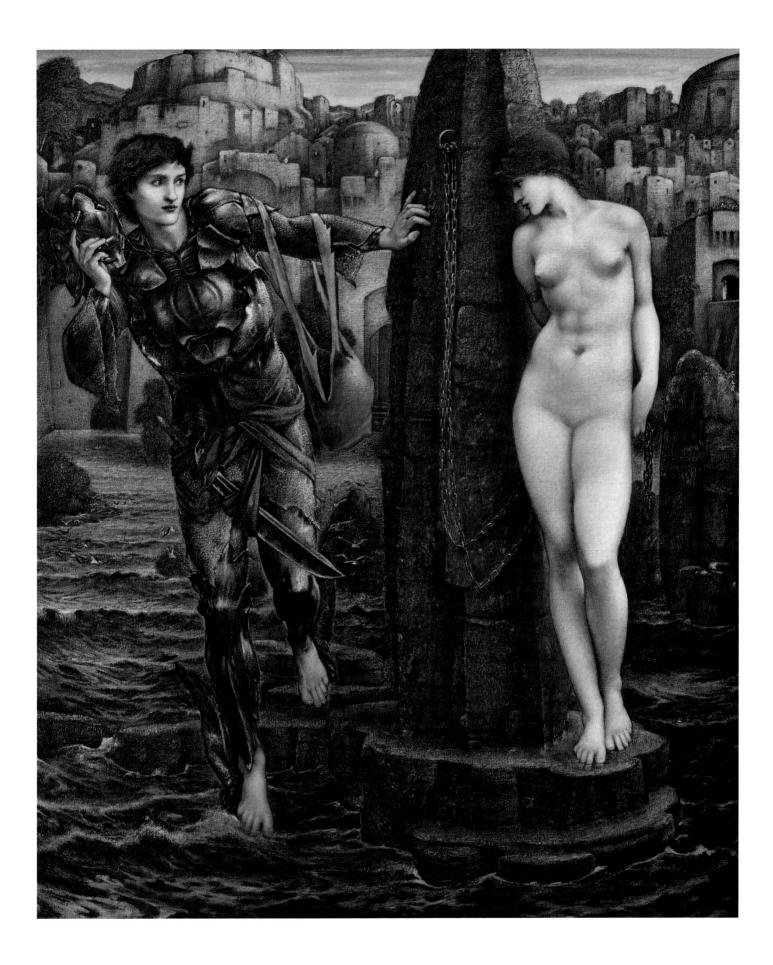

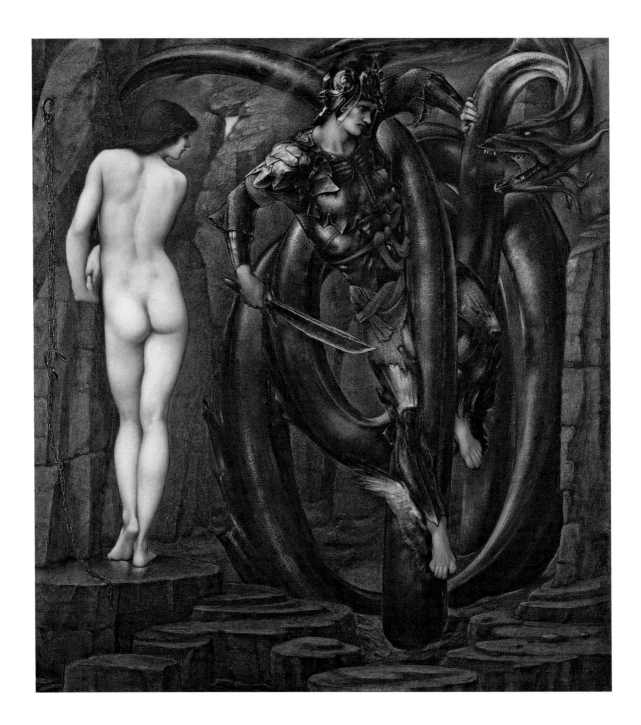

versions, together with two other canvases and two works on paper in various states of completion acquired after the artist's death.

 The preparatory installation sketches that guide our understanding of the series (now held by Tate Britain, London), along with Burne-Jones's correspondence with his patron, provide the only surviving evidence of the artist's original vision for the project.[18] It is useful, however, to integrate this information with the original Carlton Gardens architectural plan, despite the fact that the dimensions of some rooms changed as a result of renovations undertaken at different moments in its history (figs. 28 and 29). The ideal installation as Burne-Jones described and sketched it embraced every aspect of Balfour's first-floor drawing/music room

26

Edward Burne-Jones, *The Doom Fulfilled*, 1888. Oil on canvas, 155 × 140.5 cm. © Staatsgalerie Stuttgart.

27

Edward Burne-Jones,
The Baleful Head, 1885–7.
Oil on canvas, 155 × 130 cm.
© Staatsgalerie Stuttgart.

(marked "gallery" on Henry Hope's original plan, see fig. 29), from the parquet floor to matching oak-paneled walls, beveled-glass window panes, Morris-designed (or inspired) ornamental surrounds in woodwork or raised plaster, pendant light fixtures, candelabra, and, of course, the *Perseus* pictures themselves.[19] The artist hoped to reduce the natural light in the room as much as possible, replacing it with "a coruscation of candles" and lamps that would have sparkled against the gold and

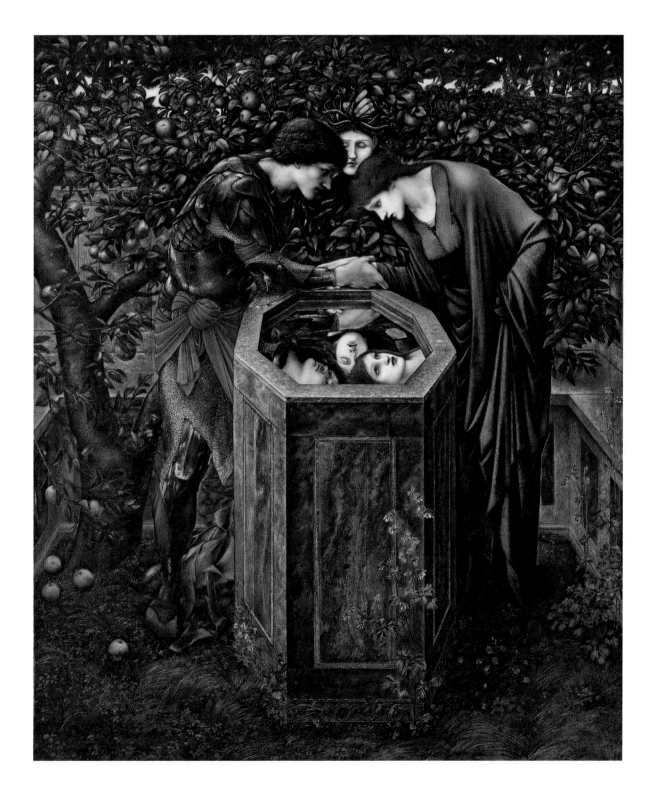

Plan of the Ground Floor.

Plan of the Principal Floor.

silver panels and acanthus-leaf ornamentation; in this configuration the glowing reliefs would have effectively replaced the room's actual windows (of which, to Burne-Jones's dismay, there were many) and created the optical sensation that light was emanating from within the pictures themselves. The artist warned his patron that accomplishing this plan would require several expensive renovations, but that this was necessary to ensure that "the whole room should be in harmony and the whole should look as if nothing was an afterthought but all had naturally grown together."[20]

With this end in mind, Burne-Jones cultivated a formal unity among the scenes by arranging the figures along a near-continuous horizon line as they make their way through the locations described in the legend. At the same time, the wallpaper's organic forms encircling and binding together the separate picture panels would have complemented the visual progression of the narrative, in which Perseus's forward-marching quest is periodically diverted or turned back on itself by looped encounters with various groups: the Graiae, the sea nymphs, the Gorgons. From a thematic and decorative standpoint, however, it should be noted that the doubled and trebled forms establish a lyrical theme-and-variations structure that suits the paintings' function as decorations for a music room. The pictures were created, after all, during a cultural moment in which Pater, Whistler, and others were calling special attention to the analogical relationships between musical and visual artistic forms and modes of perception.

Although the documentary record outlining the Balfour/Burne-Jones collaboration is sparse, sufficient evidence survives to indicate that the artist was familiar with the needs that the room was expected to fulfill. It featured two pianofortes that were played by Balfour, his friends, and invited performers at both informal gatherings and publicly announced concerts.[21] Burne-Jones suggested that paneling the room in oak to harmonize with both the pictures and the parquet floor would have acoustical as well as aesthetic benefits.[22] The two men's close

28

Henry Phillip Hope, *Adrian Hope's House I: Plan of the Ground Floor*, undated. Pen and black ink, graphite on slightly textured, medium, cream wove paper, 21.3 × 19.5 cm. Yale Center for British Art, New Haven, Conn. Paul Mellon Collection, B1977.14.4814.

29

Henry Phillip Hope, *Adrian Hope's House I: Plan of the Principal Floor*, ca. 1837–46. Pen and black ink, graphite on slightly textured, medium, cream wove paper, 19.1 × 18.4 cm. Yale Center for British Art, New Haven, Conn. Paul Mellon Collection, B1977.14.4810.

mutual friend, Mary Gladstone, described the early state of the space as follows: "Everything in the room was subverted to sound, no carpet, curtains made of paper, hardly any furniture."[23]

While there is no firm evidence that Burne-Jones's all-encompassing decorative scheme was ever carried out, records indicate that Balfour remained committed to preparing the room for the eventual arrival of the *Perseus* pictures and spent several years fitting it out with appropriate furnishings. At some point he decided to modify its acoustical austerity through the introduction of a number of Aesthetic textiles and wall coverings. In 1881, for example, he purchased a luxurious set of curtains made by the Royal School of Art Needlework for the astonishing sum of £653 2s. 0d. Lady Alford in her 1886 book *Needlework as Art*, identified these curtains as being designed for Balfour's "music gallery," made of "blue silk, appliqué, velvet, and gold" in an Italian style.[24] The room's color scheme also featured strong notes of green (plush curtains) and red (Axminster carpet and Persian rugs).[25] In addition, it contained at least three large embossed leather panels in a William Morris birds-and-foliage design, enclosed in gilt frames, perhaps to fill the empty wall spaces between the *Perseus* pictures, much as the artist's original plan for ornamental foliage would have done.[26]

The curtains and leather panels have not been recovered, but the *Perseus* paintings Balfour did receive would have worked toward the creation of an aesthetically unified totality, despite the incomplete nature of some individual scenes. If Balfour followed the artist's original plans for installation, the room would indeed have been lined with coordinated pictures, fulfilling the fundamental goal of the commission, and we can believe the assertion made both by Balfour's family and by the artist's son that the patron was content with the final result.[27]

If we take a more thorough account of the house and its contents, however, we can see that Balfour's commitment to Burne-Jones's art not only extended to the creation of a suitable environment in his music room, but spilled over into other areas of the dwelling as well. Across the hallway, in a smaller octagonal sitting room filled with flowers and light (marked "drawing room" in fig. 29), Balfour hung two additional Burne-Jones drawings, *North Wind* and *South Wind*, originally executed as preparatory studies for his *Sponsa de Libano* (1891, Lady Lever Art Gallery, Port Sunlight, Wirral).[28] This room, which also included a Steinway boudoir grand pianoforte, served as one of the home's many showcases of pottery and porcelain, mingling Chinese blue-and-white, Dresden and Sevres ware, and lusterware vases and bowls by William De Morgan, a friend of the Balfours whose work Arthur had been collecting since at least 1882.[29]

Even more remarkable, however, given Balfour's reputation as an "indifferent" patron of Burne-Jones, was his devotion of the ground-floor dining room (see fig. 28) entirely to the artist's paintings. Records indicate that this more public room showcased a number of large Burne-Jones compositions over the years. The first appears to have been *Angeli Laudantes* (fig. 30), a chalk cartoon for a stained-glass window at Salisbury Cathedral, which Balfour purchased from the artist during its exhibition at the Grosvenor Gallery in early 1881.[30] The next picture placed in the dining room was another Burne-Jones Grosvenor Gallery showpiece, the *Wheel of Fortune* (see fig. 5).[31] A composition several years in the making, related to a larger (but never completed) triptych on the subject of Troy, this picture may have been

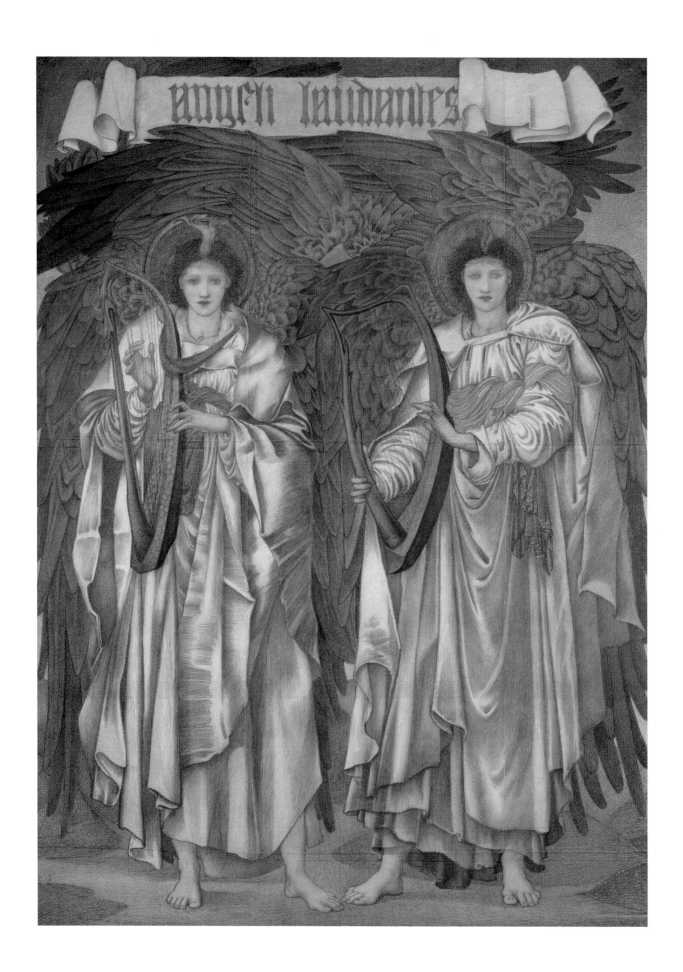

30

Edward Burne-Jones, *Angeli Laudantes (Salisbury Cathedral)*, 1878–81. Colored chalks on paper, stretched over a canvas-covered frame, 210.8 × 153.7 cm. Fitzwilliam Museum, Cambridge, museum accession number 699.2. © The Fitzwilliam Museum, Cambridge.

familiar to Balfour from his first visit to the artist's studio in 1875.[32] As with *Angeli Laudantes*, Balfour apparently purchased it fresh from the Grosvenor Gallery walls, this time during the spring exhibition of 1883.[33] Compared to the relatively sunny and reassuring paradisiacal *Angeli*, the *Wheel of Fortune* must have seemed a much darker image, both tonally and thematically; in it, Burne-Jones drew from medieval illuminations as well as Michelangelo's painted and sculpted figures to create a tense, packed composition in which the hand of fate controls the cyclical fortunes of poet, slave, and king.[34]

At some point, Balfour added yet another Burne-Jones picture to this room: the *Perseus and the Graiae* relief (see fig. 21). Sometime after its installation in the drawing room, the surface of this experimental multimedia composition had cracked, and Burne-Jones apologetically replaced it with an oil on canvas version in 1892 (now Staatsgalerie, Stuttgart).[35] The original relief then was relocated to the dining room and positioned above the mantelpiece.[36] Here, its shimmering surface was complemented by a 6-foot- (1.8 meter-) high screen covered in one of Walter Crane's embossed wallpaper designs, featuring gilded peacocks and foliage over a green ground.[37]

These pictures indicate that throughout the period in which Balfour was waiting for the completion of the music/drawing room cycle, his enthusiasm for this artist's work never waned. But unlike the *Perseus* series, whose pictorial components were made to fit together, the works hung in the dining room formed a coordinated group simply by virtue of issuing from the same artist's hand. Moreover, all three dwell in a realm that exists outside or beyond linear earthly time, from the heavenly music of the angels and the dark ministrations of Fortune to Perseus's interventions in the "gray" country of the Graiae, "untrodden yet by any son of man."[38] Visually and conceptually they serve as extensions of the circuit of imagery installed in the sitting and drawing rooms upstairs.

This Burne-Jones/Aesthetic circuit also included Balfour's country estate at Whittingehame, in East Lothian, Scotland.[39] One of Balfour's first alterations to the property in the early 1870s was the installation of a sandstone sundial on the home's southern terrace, bearing an inscription from the *Rubaiyat of Omar Khayyam*: "The Bird of Time has but a little way To fly – and Lo the Bird is On the Wing."[40] In choosing decorative accents for its interior, he again drew inspiration from the Aesthetic circle gathered around that well-known illustrator of the *Rubaiyat*, Burne-Jones. He selected a peacock wallpaper that may have been collaboratively designed by Burne-Jones and Morris for one of its bedrooms; yet another Morris & Co. pattern was chosen for the dining room in 1887.[41] Nearby, in his private study, a bound copy of *The Earthly Paradise* rested on a small octagonal table next to the hearth he had surrounded with De Morgan tiles in 1881.[42] When he could not oversee the adjustments at Whittingehame personally, Balfour managed them from afar, dictating instructions to his sister Alice as to the proper rehanging of its paintings, sketching out plans and alternate plans for her to follow in their distribution throughout the house, providing further evidence that he consciously thought about the role that pictures had to play in the construction of a domestic environment.[43]

The most dramatic aesthetic adjustment Balfour made to the interior decoration of Whittingehame – and one that had direct bearing on the *Perseus*

series at Carlton Gardens – involved his purchase and installation of a large brightly colored overmantel by Alexander Fisher depicting the *Garden of the Hesperides* (fig. 31), which in style and subject served as a kind of pendant to, or lost scene from, the Perseus story.[44] Balfour's attraction to the Perseus saga and the stylized, lyrical rhythms and repetitions of decorative Aestheticism – exemplified by Morris prints, Burne-Jones paintings, De Morgan tiles, and Fisher enamels – was made manifest, we can now recognize, in both his city and country residences, where these elements were inescapably threaded through his leisure hours during the full cycle of the calendar year. But the best proof of the thoroughness of his commitment to Aesthetic art is evident in his decision – apparently without parallel in English political history – to hang some if not all of the *Perseus* pictures at 10 Downing Street during his years of residence there.[45] He and Alice, who served as his housekeeper and personal assistant, first moved to the official government lodgings in 1898, when Balfour was named Chief Lord of the Treasury in service of the prime minister, his uncle Lord Salisbury. Even before Balfour became prime minister in 1902, he had installed the *Call of Perseus* (despite its unfinished character) in the State Dining Room, where ministerial dinners were held and the queen's annual speech read.[46] An additional photograph reveals that *Perseus and the Sea Nymphs* and one of the two versions of *Perseus and the Graiae* were placed there as well (fig. 32).[47] It is difficult to imagine that Balfour would have hung the two unfinished canvases in this public setting without their other comparatively more important counterparts, although it is possible that the Carlton Gardens drawing room series was left untouched. Reports only tell us that "several" Burne-Jones paintings were installed very publicly and prominently at Downing Street

31

Alexander Fisher, *Overmantel: Garden of the Hesperides*, 1899–1900. Copper alloy, silver foil, enamels, semi-precious stones, and other materials, 98.5 × 168 × 35.5 cm. National Museum of Scotland, Edinburgh. © National Museums Scotland.

during Balfour's residence there.[48] When Balfour returned to Carlton Gardens at the end of his premiership in 1905, his sister Frances noted that he was "happy to be back in his own house …, and so delighted with his Perseus set," which could be an indication that the full sequence of eight pictures was not assembled until that date.[49]

"Lived in" Pictures

What this series of events and this circuit of decorated interiors proves is that Balfour, far from being an uninvolved or indifferent patron of Burne-Jones and Aesthetic art, sustained a lifelong fascination with this visual culture, and used it to frame his public and private self-presentation for almost half a century.

Given the prominence of these pictures in Balfour's life and domestic arrangements, we are naturally compelled to ask what this type of art meant to him. Balfour's remarks on his own collections, and on visual art in general, are scarce. On a practical level, he indicated in letters to Alice that he appreciated the sentimental associations that attached to pictures, valuing his family's old landscape paintings and portraits as heirlooms if not necessarily as aesthetic objects, and his will proves that he expected his own pictures and furnishings to be handed down and treasured by subsequent generations.[50] He did his best to organize the heterogeneous decorative material he inherited and purchased into coordinated environments at Carlton Gardens, Downing Street, and Whittingehame, where he gave priority to the arrangement of the "best pictures" – those of the greatest "artistic merit" – in his drawing rooms.[51] As we have seen, he viewed the architectural decoration and adornment of his living environments as an ongoing project, and held out hope that he might eventually find the time and funds to upgrade his picture collections. Although he sat for a number of portraits,

few of these seem to have been commissioned by him or his family, and he never engaged another artist in a serial project comparable to that of the *Perseus* cycle. Correspondence suggests that he evidently enjoyed showing his paintings to art collectors and other visitors, and soliciting their opinions.[52]

Balfour's philosophical essays do provide some insight into why he would choose to commission artwork from a contemporary painter rather than purchase older works of established historical, cultural, and monetary value. In these texts he insisted on more than one occasion that art was most essential to life at those points where it intersected with the outlook and experience of the people who created it. In his 1895 metaphysical treatise on *The Foundations of Belief*, he asserted that artists "whose gifts are in harmony with the tastes of their contemporaries will produce their best."[53] This special connectedness between an artist and his audience was not merely circumstantial, however, but reciprocal and required active cultivation by the creative agent: only an artist who possesses a "special turn of genius" is capable of "producing a public taste in harmony with his powers."[54] If some select few historical works seem to us "immortal," Balfour argued, it is "because they live in our affections, not because they lie honorably embalmed in the dusty recesses of our museums."[55]

Elsewhere, in the course of his discussion of the relative value of paintings and music, Balfour does sketch out the ideal (if necessarily the only) conditions under which paintings should be properly encountered and understood: pictures in public galleries "are not in their original setting," and therefore "they lose something. They lose also by the very fact that they are merely gazed upon by the stream of passers-by. *They are not lived in, as pictures ought to be.*"[56] His personal manner of living with pictures consisted, as we have seen, in cultivating fully three-dimensional decorative environments for and through them. His philosophical remarks on the subject suggest that he found the pleasures of the visual arts to be both immediate – "speak[ing] directly to the hearts of their fellow men, evoking their tears or laughter, and all pleasures, be they sad or merry, of which imagination holds the secret" – and perpetual, gradually and patiently unfolding over time. Naturally, he believed that these varieties of aesthetic pleasure were so personal, subjective, and bound up with the vagaries of historical and geographic circumstance that they, much like the mysteries of religion, could never be explained by science or codified as dogma.[57]

How, then, were Balfour's Burne-Jones pictures "lived in"? It has been suggested, by Balfour's contemporaries and by more recent scholarship, that the *Perseus* paintings provided something of a "cloistral retreat," erecting a buffer between the man and the pressures of public life.[58] But I find this characterization unsatisfactory in Balfour's case on at least two counts. First, as his own lightly sketched aesthetic theories suggest, Balfour must have felt that the pictures he commissioned touched on something vital and relevant to contemporary life and experience. Second, and perhaps more importantly, they were installed in such a manner as to blur the boundaries between private contemplation and public presentation, greatly complicating any attempt to "escape" from one realm into the other.

There is no question that Burne-Jones was working with highly charged imagery in the *Perseus* series, especially considering its destination in the parlor of

a politician. The paintings depict an armed hero overcoming a series of dangers to save a helpless woman, and this paradigm, as many scholars have noted, touched on a number of fears and desires needling the late Victorian mind. The Perseus and Andromeda myth offered an analog for the Saint George and the dragon story, itself a familiar encapsulation of the "civilizing mission" of empire.[59] Under the banner of Christian chivalry, the hero takes it as his duty to save Andromeda/woman – the perpetually defenseless victim – and bring her under his benevolent but firmly patriarchal domain. In doing so, he preserves or restores her innocence and purity, here literally embodied in the form of classical Greek sculpture, thereby demonstrating his capabilities as guardian of the western cultural tradition. His victory is accomplished through the confrontation and suppression of dark (dangerous, feminine) and uncontrollable sexual/animal forces that stand in the way of his progress from vulnerable youth to a confident masculine selfhood.[60]

These themes of heroism and rescue emerge in Burne-Jones's art time and again, not only in the *Perseus* series, but also in his *Saint George* paintings, *Briar Rose* cycle, and others. However, the artist's deeper fascination with the complexities of love, longing, and selfhood often results in pictures that cannot be easily resolved as straightforward paeans to muscular Christianity and imperial dominance. His Perseus, for instance, hesitates and seems at times consumed with self-doubt; his Gorgons and Graiae are not hideous but darkly beautiful, and the conflation of roles suggested by the disjointed reflections of the *Baleful Head* caps the story with an open-ended question rather than a fixed conclusion.[61] For these and other reasons it is difficult to construct an interpretation of the *Perseus* pictures (and of Burne-Jones's art in general) that ties the story's themes, however suggestive, directly to Balfour's life.[62] If we view the Conservative politician as a staunch defender of empire and suppressor of Irish dissent, Burne-Jones's hesitant heroes appear to offer these convictions weak support. Furthermore, considering Balfour's famously philosophical and indecisive attitude toward making policy decisions – an aspect of his personality for which he was frequently ridiculed in the press – the *Perseus* pictures only seem to call undue attention to this procedural fault. Any interpretation of them from a political perspective must also contend with the fact that they were known to appeal equally both to Balfour and to his party's chief rival, the Liberal William Ewart Gladstone.[63]

And yet there is also no doubt that Burne-Jones's paintings played a prominent role in framing Balfour's private and public interactions. For this reason, our analysis here must consider their operations within contexts of group viewership, instead of restricting their impact only to the confines of the artist's or the patron's psychic frame. To accomplish this, let us now enlarge our discussion of the *Perseus* series beyond the scope of its content to address more directly the ideological implications of decorative form. Although the pictures do not necessarily project a unified and consistently legible message, they do construct a distinct visual universe, and the laws by which that universe operates have direct bearing on the "real world" outside the frame. As we shall see, the pictures enable and encourage certain types of interactions among viewers that would have been indisputably beneficial for Balfour and his cohort among the Victorian social and political elite.

Balfour, Burne-Jones, and the Souls

With Balfour's move to London and his commissioning of the Burne-Jones series in the mid-1870s, he was bridging two social groups: a cluster of school and family friends linked by their ties to Eton and Cambridge, and a largely aristocratic group bound by intermarriage and shared cultural tastes, geographically anchored in Kensington and Westminster but radiating out into a large country house network across the British Isles. These two groups merged in the 1870s and early 1880s, their youngest members forming a "gang" of close friends (as they called themselves) distinguished by their lively intellectual conversations, inside jokes, and slang, and by the late 1880s had crystallized into a social set known (largely by outsiders) as "the Souls." Within this highly influential group, a number of whose members achieved prominent positions in Parliament and imperial administration, Balfour took on a central role – "King Arthur," they jokingly dubbed him – hosting London entertainments at Carlton Gardens, country house party weekends at Whittingehame, and lunches and teas at the House of Commons.[64]

Balfour's interest in the art of Burne-Jones dovetailed with and cemented his belonging to this social group. Burne-Jones himself was an "occasional Soul" who attended some of their social gatherings and corresponded with a number of them personally.[65] His paintings and drawings provided the keynote for a broadly shared Souls taste in Morris fabrics; paintings by Edward Poynter, George F. Watts, John Singer Sargent, and William Blake Richmond; and the architecture of Philip Webb, Edwin Lutyens, Detmar Blow, and Eustace Balfour. Conspicuous examples of their taste for Aesthetic art and decoration included Clouds, the Philip Webb-designed country home of Madeline and Percy Wyndham, which was adorned with Burne-Jones angels and Morris patterns (such as Burne-Jones's *Poesis*, 1880, National Gallery of Victoria, Melbourne; and Morris & Co.'s *Greenery*, 1892, Museum of Fine Arts, Boston), a combination also echoed at Stanway, the Gloucestershire estate of the Wyndham's daughter Mary and her husband, Hugo Charteris, Lord Elcho (see Edward Poynter's *Lady Elcho*, 1886, private collection).[66] Large cartoons for stained glass and tapestry that had been elaborately reworked by Burne-Jones were prominent features not only of Balfour's London dining room and Clouds, but also of Mells Park (the estate of John and Frances Horner, daughter of Burne-Jones's patron William Graham; see *Love*, ca. 1880, Victoria and Albert Museum, London) and the home of Lord and Lady Windsor.[67]

Burne-Jones, in fact, was chosen to memorialize a central and tragic event around which the group's identity crystallized, the 1886 death of Laura Tennant Lyttelton, the young bride of Balfour's school friend Alfred Lyttelton. Laura had served as something of a social lynchpin for the Souls before she died in childbirth; her sisters and friends drew closer after her passing, which was lingered over with melancholy introspection and served as a point of shared emotional experience among the group. Burne-Jones consulted several of them as he developed the design of his peacock tablet, one version of which was placed in the church at Mells, while another remained in the artist's studio (fig. 33).[68] The artist also gave Lady Elcho one of his gouache studies related to the project.[69] The proud bird perched among the leaves of the laurel springing from Laura's tomb was meant to evoke triumphant life, and the memorial further inscribed the visual art of Burne-Jones at the center of the group's self-conception. This was only one

33

Edward Burne-Jones, *Memorial Tablet – A Peacock*, 1886. Oil and gilt gesso on wood, 237.5 × 133 cm. Victoria and Albert Museum, London.

NON·EST·HIC·SED·SVRREXIT·RECORDA
MINI·QVALITER·LOCVTVS·EST·VOBIS

instance in which his works were exchanged among members of this tightly knit circle. Before she died, Laura Lyttelton bequeathed a Burne-Jones-designed brooch to Frances Horner's daughter.[70]

Other Aesthetic artists were drafted into this circuit as well. When Madeline Wyndham became a patron and pupil of enamellist Alexander Fisher in the late 1890s, she helped him place his works in the collections of her friends. It was in this context that Balfour commissioned Fisher's *Christ Crucified on a Vine or Tree of Life* (National Museum of Scotland, Edinburgh) as a gift for her in 1897, and purchased the *Garden of the Hesperides* overmantel for himself (see fig. 31).[71] He hung one of Fisher's watercolors in the octagonal sitting room at Carlton Gardens alongside Burne-Jones's drawings.[72] Meanwhile, Balfour's Royal School of Art Needlework curtains in the music room served as another reminder of the taste he shared with the Wyndhams, who had helped found that organization; Madeline's peacocks-and-vines dado was singled out for special praise in Lady Alford's *Needlework as Art* alongside Balfour's curtains and a set of textiles for a bedroom at Panshanger, another Souls haunt, belonging to Lord and Lady Cowper.[73] Katie Cowper, who passionately and publicly defended the "real and true" idealism of Burne-Jones, Watts, and Leighton in an 1894 essay, cited Burne-Jones's *Love Disguised as Reason* (1870, South African Cultural History Museum, Capetown) from the collection of her fellow Souls, the Pembrokes, in support of her arguments.[74] Her own holdings included the artist's mid-1870s treatment of *Saint George* (fig. 34), acquired from the 1886 sale of the William Graham collection, in which the reflection in the sainted knight's shield quite literally appears to mirror the action taking place in Balfour's *Perseus* paintings.

These are only a few of the many Aesthetic connections linking the Souls and their homes. Their general fascination with Burne-Jones's art was noted at the time and has since been remarked upon by historians and art historians, but until now its particular attractions and, more importantly, its potential effects have been insufficiently analyzed. The Souls' taste in art and

34

Edward Burne-Jones,
Saint George, 1873–7.
Oil on canvas, 155 × 57 cm.
Wadsworth Atheneum,
Hartford, Conn. The Ella
Gallup Sumner and Mary
Catlin Sumner Collection
Fund, 1961.448.
Photo: Allen Phillips /
Wadsworth Atheneum.

architecture is most commonly interpreted as the expression of a desire to lead "a more artistic or literary existence" than the lives of some of their peers.[75] Their embrace of the works of Burne-Jones and Morris is characterized as broadly oppositional to other artistic trends of the moment, a conspicuous way of setting themselves apart from the hunting-and-racing "smart set" gathered around the Prince of Wales.[76] Certainly some skeptical contemporaries occasionally bridled at what they felt was the Souls' elitist advocacy of an exclusionary visual culture.[77] But to overemphasize this externally performative aspect of the Souls' art appreciation would be to place too much weight upon how their homes and collections related to others, as though their aesthetic (and Aesthetic) taste was primarily and self-consciously directed toward sending messages outward rather than toward satisfying, at least in equal measure, the needs of the individuals within their social group.

In terms of the content of Burne-Jones's art, two aspects of his work have been highlighted as relevant to what might broadly be called a Souls' worldview: its spiritual and chivalric themes. On the first, while it is not difficult to imagine that the Burne-Jones angels at Clouds might have indeed served as devotional aids and offered the devout Madeline Wyndham "a way through to her spiritual world," as Caroline Dakers has suggested, this paradigm is less helpful in making sense of other pictures in the Souls' visual universe (like those comprising the *Perseus* series), and does not account for the widely varying attitudes toward religion among the Souls.[78] At what might seem at first to occupy the opposite, and decidedly more secular, end of this interpretive spectrum, Mark Girouard has noted that the poetry of Morris and the paintings of Rossetti and Burne-Jones legitimized a particular kind of courtly love that was nurtured in Victorian drawing rooms: precisely the kind of passionate but (theoretically) Platonic relationships that were embraced by the Souls.[79] In this sense the paintings become a kind of furniture for play-acting, as "King Arthur" and his associates passed among Burne-Jones's knights in armor and heralding angels. The paintings' romantic medievalism appropriately captures the tone of the letters exchanged between these often romantically entwined pairs, who regarded the closeness of their friendship connections as something akin to spiritual experience.

But elaborate romantic entanglements constituted only one aspect of the Souls' interrelationships. More significant is the way that they were able to cooperate with each other to exercise outsize social and political influence from bases in Britain's drawing rooms and estates, surrounded by Burne-Jones pictures and Morris textiles, at a moment when, as one hostess recalled, "matters of high importance to the State were constantly decided between Liberals and Conservatives in the country houses of England."[80] The Souls' political influence took two forms: they matched like with like, enabling Balfour, for example, to draw from a pool of Conservative intimates in building up his own administration; they also self-consciously constituted their group as a salon in which members of opposing political points of view could come together to work out compromises "without heat and without reporters."[81] As I will demonstrate in what follows, any consideration of the role that Burne-Jones's pictures played in the lives of the Souls – and at Carlton Gardens and Downing Street – must take this multivalent political networking into account.

Elective Affinities and Pure Interconnection

The Souls described themselves as an "elective affinity" – a phrase that was both casually bandied about and heavily freighted with meaning in the late Victorian era.[82] It referred most famously to the Goethe novella *Die Wahlverwandtschaften*, which had been first translated into English as *Elective Affinities* in 1854 by J. A. Froude, also an occasional intimate of the Souls circle.[83] The story's exploration of romantic love and attachment as manifested outside the bonds of marriage was so controversial that Froude first published his translation anonymously. Its subject would have held obvious interest for the highly literary Souls, whose own marriages were complemented by deep, sometimes romantic attachments with others among their group. The broader context for the phrase was scientific: Goethe's characters dissect their own relationships using metaphors of chemical attractions and magnetism, and the phrase had recently been resurrected by Charles Darwin to describe processes of cellular division and reproduction.[84] So the Victorian vision of elective affinity referred not only to one's carefully chosen associations, but also to the mysterious, instinctual impulses of nature that lay beneath those seemingly independent choices. The concept returns to us again through modern sociology, in the form of Pierre Bourdieu's well-known definition of "taste":

> The social sense is guided by the system of mutually reinforcing and infinitely redundant signs of which each body is the bearer – clothing, pronunciation, bearing, posture, manners – and which, unconsciously registered, are the basis of "antipathies" or "sympathies"; the seemingly most immediate "elective affinities" are always partly based on the unconscious deciphering of expressive features, each of which only takes on its meaning and value with the system of its class variations … Taste is what brings together things and people that go together.[85]

"Elective affinity" is an evocative and apt metaphor for understanding the Souls because it captures a complex network of relationships and preferences that intersect at multiple points, without implying complete homogeneity of political opinions, literary preferences, philosophical outlooks, or any other single aspect of taste among the group as a whole. In this light, one could point to Aesthetic culture as one thread in this connective material of elective affinities that bound the Souls together and enabled them to construct a collective identity. But this, I believe, is only the beginning of the story. What one deduces from reading the Souls' letters, diaries, memoirs, and histories is that it was the experience of *pure connectivity* – the attachment of each to another as a deliriously enjoyable sensation in its own right – from which this social group derived so much of its power and pleasure. The works of Burne-Jones and Morris were not simply cultural preferences shared by many members of the group, but in fact constituted a form of visual art that illustrated and actualized the concept of *interconnection* itself.

I would like to deal with the subject of William Morris first, as Caroline Arscott has written revealingly on the networked language of his wallpaper and textile designs. Attending closely to their subtle geometries, she highlights their visual rhetoric of pulsing, organic growth and interconnection. In such patterns as Morris's "Acanthus" (fig. 35), which Burne-Jones had originally selected to fill the

35

William Morris, "Acanthus" wallpaper design, published 1875. Block-printed in distemper colors on paper. Victoria and Albert Museum, London.

wall spaces between his *Perseus* pictures, she writes, "overwhelming geometric emphasis is set aside as the writhing movements of the plant forms are focused upon and the interweaving and overlay of elements are allowed to interfere with the viewer's understanding of the geometric scheme … Pattern elements are crowded together, creating a dense mesh … Little dotted blossoms and looping, undulating stems dance in these constrained spaces, creating an energetic infill."[86] The purpose of her larger analysis is to explain how dense, complex pattern designs like this one exemplify Morris's dedication to the creation and nourishment of non-hierarchical socialistic communities, which he occasionally described as "organisms." In gazing into patterns like "Acanthus," she argues, "the experience is of looking into a system and (partially) apprehending its multiple levels … There is an all-overness that is supported by the idea of profuse multi-directional growth."[87]

Granting that Morris's own interests and intentions were undoubtedly oriented toward the achievement of parity between classes and the rejection of centralized bureaucratic structures, what are we to make of the implantation of this visual language of network in the houses of the elite: at Clouds, Carlton Gardens, and Whittingehame? The field of Morris studies has long wrestled with the apparent contradiction between Morris the craftsman-revolutionary and Morris the designer of high-end furnishings who worked closely with his wealthy clients to personalize their domestic environments. Here, however, the issue under consideration is somewhat different: would not Morris's visual rhetoric of entanglement and interconnection have had the potential to reinforce, in these contexts, the position of the socially, economically, and politically engaged art patron who also stands at the convergence of these power networks – who holds, so to speak, their outspreading threads in his very hands – and enjoys manipulative control within them? Given the thoroughness with which technological and organizational networks had become interwoven with a language of organicism in the Victorian age, it is equally possible that Morris's patterns – spreading with no discernable beginning or end across floors, walls, and furniture – embody the fundamental energies of precisely that mechanistic and bureaucratic world Morris believed he was struggling against.

"Wherever a Soul meets a Soul, there is sweet converse," supposed one satirical analyst of this mysterious social clique.[88] In fact, wherever a Soul met a Soul, in their country and city habitations, they were likely to be brought face to face with designs like "Acanthus," "Honeysuckle," and "Wandle," which were much more than status symbols or signs of elective affinity: they articulated an ideal vision of interconnectivity that knew no limits, Morris's skillfully hidden repeats implying endless extension. The magazine *Fun* overstated the group's political homogeneity when it described the Souls as strictly Conservative, but it was correct in identifying them as "connected with interests imperial": a description that applied to anyone engaged in public life in Victorian Britain. With economic and military commitments dispersed across several continents, Liberals and Tories alike were intensely occupied with making decisions on a global scale. The increasingly pressing issues of Irish independence and imperial defense forced both parties into a detailed consideration of "the mode in which empires, nations, and political societies are bound together."[89] Whether one counts Balfour, for example, as an "arch-imperialist" or as rather a conservative defender than an extender of empire,

there is no question that his administrative attention as chief secretary for Ireland and especially as prime minister was geographically dispersed, devoted to maintaining all of the parts of this immeasurably complex system in working order.[90]

The Souls used their social gatherings to reinforce personal connections within their group and to facilitate the placement of their intimates at the head of this imperial administrative structure. The historian Nancy Waters Ellenberger has traced an astounding array of friendly appointments in which the Souls drew from their own pool to staff important political positions.[91] As George Curzon told George Wyndham, "that little dinner at your house has not done badly for itself: 2 Sec. of State, 1 Viceroy, 1 Irish Secretary, 1 Finance Secretary to Treasury, 1 Undersecretary for Foreign Affairs … Well there you all are now, ruling the Empire. Do it nobly and with courage … It is a splendid responsibility, a glorious task."[92] On another occasion, the Souls' famous parlor game playing descended into politics, as they took up "the Cabinet game," filling out ideal rosters under Souls leadership.[93] In this way the organization and arrangement of the microcosm (dinner parties) and the macrocosm (nation and empire) converged.

"One very noticeable thing about these parties," recalled Balfour's niece of the Souls' gatherings, "was the amount of 'arranging' that went on about the simplest things, such as who should be Uncle Arthur's partner at garden golf, and who should go for a walk with whom."[94] Aesthetic painting and decoration, as we have seen, offered a field for a similar kind of controlled organization and reorganization, as at Clouds, where, Dakers tells us, "Morris patterns were mixed up in every room, just as the designer intended."[95] Linking surface to surface and house to house, Morris patterns and Burne-Jones paintings mapped an idealized image of total aesthetic and social coordination.

In Arscott's analysis, the vital energy and rejuvenating cycles of life that vivify Morris's art are set in relief by Burne-Jones's pictures, which depict human bodies as fragile and threatened, often by proliferating organic material (such as vines and thorns) that echo the vibrant nature of his collaborator's wallpaper and textile designs. Yet viewed from another perspective, we can see that Burne-Jones's paintings propose their own visual language of connection and continuity. As echoed and layered lines of "Burne-Jones" heads dance across the panels of the *Perseus* series like music notes, they set up rhythmic resonances with further iterations of his pictures dispersed throughout his patrons' homes. The effect is one of crowded presence and profusion, not of isolation. One senses the same actors appearing in potentially endless tableaux, configured and reconfigured, as though Fortune need only turn her wheel to transform slave into king, Perseus into Saint George, nymphs into angels, and so on. "A Soul meets a Soul" and is everywhere greeted by the same faces – especially in cases where the artist's portraits of Souls merged them into his universe of familiar types (fig. 36).[96]

As suggested above, one of the consequences of Burne-Jones's use of repeated and reflected forms in the *Perseus* cycle is that thematically, the individual questing experience is reconfigured as an act of passage through a series of communities. Once one has become attuned to it, this communal sensibility begins to emerge as a common thematic structure governing many of Burne-Jones's works. Although Burne-Jones's *oeuvre* is certainly punctuated by lone contemplative figures, it

boasts a near-equal measure of processions, banquets, and other gatherings, especially in the artist's serial projects, where they are vital to securing the decorative unity of a complete installation. Princess Sabra of the Saint George legend, for example, is always pictured with her bevy of attendants, even in her moment of abandonment; Psyche's intimate encounters with Cupid are counterbalanced by the crowds that accompany her to the *Mountain of the Monster* and the *Portals of Olympus*.[97]

These pictures, like the panels in the *Perseus* series, are marked by a formal commitment to the interweaving of figures with nature and with each other, in a manner that often mitigates the anxieties and confrontations inherent in the stories themselves. Consider, for example, Perseus's encounter with the Graiae, versions of which were prominently featured in the drawing and dining rooms at Carlton Gardens. The Graiae (see fig. 21) do not appear, as the *Earthly Paradise* would have us believe, as "crones" whose "faces were carved all about with wrinkles of despair," but rather as elegant and classically robed beauties. Instead of recoiling in horror, we, like Perseus, are invited to bend closer, immersing ourselves in the circular, rolling rhythm of their songs.[98] As befitting their intended function as social domestic décor, the Graiae pictures do not suggest a shrieking confrontation, but rather set an appropriate tone for conversation and fellowship.

Additionally, if Burne-Jones's *Perseus* pictures and Morris's "Acanthus" design can be considered as complementing rather than contrasting with each other, then we might see the evolving forms of the hero's organic armor as integrating him ever more thoroughly into the room's pictorial scheme as he progresses, step by step, toward his union with Andromeda. It is in the final image, the *Baleful Head* (see fig. 27), that the decorative and the narrative are most completely fused into a single organic whole, as Perseus, his fingers tangled in the snaky locks of the Medusa head, is woven into the foliated background with his rescued bride. Below them, the reflected image put forth so prominently and strangely in the water of the well conjures up a host of meditations on oneness and blending. Although this densely evocative reflection has been extensively discussed in relation to well-known Victorian obsessions with mirroring and narcissism – that is, with an emphasis on the formation of individual subjectivities – what I wish to emphasize here, in the context of patronage and interpersonal connection, is the manner in which Balfour's social community was reflected on the surfaces and woven into the very fabric of Burne-Jones's works.[99]

The golden *Graiae*, for example, served as a kind of index or precis of a number of Balfour's interests and associations in the late 1870s when the *Perseus* commission was first begun. Its Latin text was provided by Richard Jebb, a Cambridge classicist whom Balfour and his extended family knew from debating clubs associated with the university, the Cambridge Conversazione Society, the Apostles, and the Metaphysical Society.[100] Burne-Jones, meanwhile, collaborated with the metal craftsman W. A. S. Benson, Eustace Balfour's colleague at Basil Champneys's architectural firm, to produce a model of Perseus's fancifully ornamented armor from which to draw, and to develop a process for applying metallic materials and colors to the plaster relief. (The two artists had recently met by chance, when Burne-Jones approached Benson's sister Margaret to serve as a model for Medusa in the *Perseus* pictures.) Balfour would eventually purchase

Aesthetic firescreens and lamps from Benson to accentuate his interiors, and would hire him to wire the Whittingehame property for electric light. The tangle of relationships between Burne-Jones, Benson, and the Balfours is one that still demands further investigation, as Arthur and his brothers were heavily invested in the mining and processing of metals (namely aluminum) at precisely this time, and the *Graiae* constituted an experiment in the application of metal plates to plaster relief that Burne-Jones would never attempt again.[101]

Personal resonances were not confined to the *Graiae*, however. Frances Horner (see fig. 36), a member of the Souls, modeled for the artist's *Perseus and the Sea Nymphs* (see fig. 22), thereby imbricating the Souls community directly into the substance of the pictures that were to adorn their Carlton Gardens gatherings. Similarly, when they met at Clouds and at Mells Park, they were surrounded by Burne-Jones works that Souls had actually had an active hand in creating, as Madeline Wyndham and Frances Horner had embroidered large tapestries based on the artist's designs. Burne-Jones's *oeuvre* is marked by several parallel incidents in which the acts of patronage and artmaking were fused, as in the *Roman de la Rose* textile series embroidered by the family of Isaac Lothian Bell for their home at Rounton Grange (now at William Morris House, Walthamstow). In cases where this happens, the art patron becomes not merely sponsor but also producer, and the Aesthetic environment thus created becomes a reflection of his or her generative power. For introspective friends who tended to describe themselves and their relationships in terms of being bound or stitched together – as "a centre connecting the widely scattered members of the cousinhood," for example, "by a spiritual link … banded," "interwoven" – such hybrid objects must have been powerful signifiers.[102]

Ellenberger has persuasively argued that it was the Souls' self-conscious cohesiveness as a social group that proved most useful to them in navigating the competitive and changing world of London politics and society in the late Victorian age.[103] Their cultivation, even fetishization, of the intimate bonds of friendship was itself the material that kept them together, more than any one constellation of political, religious, or philosophical preferences, which were subject to change and sometimes in conflict; that is, it was often the *fact* more than the *substance* of their "elective affinities" that mattered most to them. Similarly, I would argue that the works of Burne-Jones and Morris foreground and embody an experience of interconnectivity that constituted a powerful social tool in its own right, aside from the other connotations – romantic, martial, or mystical – that might have become attached to these objects.

In Victorian responses to and modern analysis of the *Perseus* paintings, their decorative and narrative aspects are often perceived as being at war with each other. Perseus pauses, frozen and hovering, in the series' climactic encounters. "It is," wrote the critic for *The Times*, "… not so much action as the spirit of action, action made statuesque and robbed of all its violence."[104] The ambiguities of this ornamental violence, poised somewhere between action and decoration, generated a number of conflicting descriptions from contemporary observers. Cosmo Monkhouse, that eloquent defender of Albert Moore's Aestheticism, contended that Burne-Jones's Perseus and Andromeda scenes "would be easy enough to admire … if we regarded

these compositions as purely decorative, mere arrangements of form and colour suggested by the story," but that as narrative scenes, in which one expected to encounter drama and feeling, they presented too many "contradictions to experience – from the ornamental coils of the sea serpent to Perseus's "useless" armor and Andromeda's passive serenity.[105] Other commentators similarly observed a lack of emotion in the pictures, but found compensation in the artist's inventiveness of design and richness of effect.[106] More recently, Arscott phrased the problem this way: in the *Perseus* series, "character, action, interaction, narrative development and narrative resolution" – the traditional mechanisms of history painting – "are all undermined by Aesthetic movement priorities."[107]

In Burne-Jones studies, this hesitant hero has become something of a stand-in for the artist, embodying his anxieties over his health, his relationships, his inability to carry ambitious projects like the *Perseus* series through to completion. He devoted so many sketches to working out these Perseus encounters, second-guessing himself and reworking his drafts, that the artist and his subject almost seemed to merge. These paintings, for all their art historical references, room-sized scope, and complex compositional rhythms, are frequently discussed in terms of failure, disappointment, and irresolution: hence the sense that they have been "undermined" in some way by Burne-Jones's struggle to resolve the decorative and the narrative in the compositions. Yet as we have seen, it is possible that the pictures' open-ended and provisional character – the result of the artist's bringing the story to a full and ornamental stop at crucial points – posited its own advantages, operating according to its own logic within the discursive environment of Balfour's home and the Souls' social interactions.

One of the key features of the Souls' group that set them apart from other British cliques was their "love of good talk" – conversation raised to an art form and performance, a love of philosophical and literary debate for its own sake.[108] Laura Lyttelton described the atmosphere of a Souls' country house weekend to Mrs. Humphry Ward as follows: "A beautiful place paradoxical arguments ideals raised and shattered temples torn and battered temptations given way to newspapers unread acting rhyming laughing ad infinitum."[109] Conversation topics ranged over philosophy, music, literature, history, and politics: "We debated the rights and wrongs of blood sports, votes for women, monogamy, vivisection, bull-fights, and censorship."[110] Often, these discussions were facilitated by pencil and parlor games.

It is worth considering the structure and content of the Souls' games, as they relate to the consolidation of group identity, to the playful deployment of practical skills (namely, debating and extemporaneous speaking), and, I would argue, to the particular aesthetic of Burne-Jones's paintings. Dumb Crambo and Charades – both widely popular and favorites of the Souls – required players to act out rhyming syllables to be guessed by their friends.[111] The Souls' Dumb Crambo, however, evolved into miming imaginary conversations between historical characters, and their take on Charades, in which syllables were staged as tableaux, was elaborately costumed. Such games, as Nancy Ellenberger points out, require and instantiate an intimate familiarity with the speech and thought patterns of one's social circle, and favor the suppression of individuality in the interest of group cohesion.[112] But they also depend upon and sharpen the ability to read visual cues. They draw upon, in

Emily Bryan's words, a "network of associations" that attach to various encounters, colloquialisms, and morals of stories.[113] These games, when played in Burne-Jones-adorned town houses and country estates, suggest yet another way in which this artist's richly referential and yet suggestively open-ended compositions interfaced with the Souls' way of being in the world.

Some outside observers accused the Souls of merely pretending to intellectualism in these free-flowing games and discussions; others saw their conversations as deliberately elitist and exclusive.[114] The Liberal Lord Haldane, however, though not a Soul himself, felt that the "brilliant" atmosphere of Souls' parties presented "an advantage" for him, as it established an environment in which he felt comfortable collaborating with Balfour on cross-party initiatives.[115] The art of Burne-Jones was a key component in building up these discursive spaces and setting an appropriate tone – informed but (productively) unresolved – for this lively social and political intercourse. In this context his paintings served not as escapist tools but rather as potential channels through which networked power might operate.

Burne-Jones, it must be recalled, was periodically a guest at Souls gatherings, and had the opportunity to dine with Balfour and sample the flavor of his family and friends' social intercourse before he began the *Perseus* series.[116] As a close friend of the Wyndhams, Frances Horner, and Mary Gladstone, among other Souls, Burne-Jones would certainly have had a sense of the lively and engaged intellectual environments in which his paintings were to be installed. I do not mean to suggest that pictures painted for and purchased by the Souls required him to make any specific adjustments to his creative process or decorative strategies in order to accommodate these discursive contexts, but rather that his art was particularly well suited to the dynamics of this group and to those of the Balfour household. This casts what has previously been seen as Balfour's passive uninvolvement in the *Perseus* project in a different light. It seems highly probable that the Souls found themselves drawn to Burne-Jones's work not only for its courtly romance or its medieval spiritualism, but also for its richness of layered artistic and literary references and its interpretive flexibility.

Perseus in the Public Eye: "Artful Arthur"

In a patronage study, the central question under discussion is usually how an artist's entanglement with outside interests came to direct or influence the production of a particular aesthetic object. In the case of Burne-Jones and Balfour, the inquiry also needs to proceed along the opposite vector, because although Balfour is merely a marginal note in most accounts of Burne-Jones's life, Balfour's interest in the painter had a significant effect on the public image of his political career. The dominant narrative of this career was summed up by the *New York Times* headline appended to Balfour's March 1930 obituary: "Balfour a Leader for Half a Century. Rose to the Premiership in Career that Really Began in 1878 at Congress of Berlin. Politician Despite Tastes. Philosopher and Aristocrat, He Was Marked for His Work by Birth – Never Caught Public Fancy."[117] As for these doubtful "tastes," another post-career assessment framed them this way: "Balfour Suspected of Caring Too Much about Blue China."[118] When he was under consideration for the premiership in 1901, one commentator had flatly declared that "a partiality for the works of Sir Edward

Burne-Jones bespeaks a delicate palate out of harmony with a traditional taste for government."[119]

Balfour's Aesthetic tastes were well known during his lifetime, which encompassed roughly fifty years of political activity. Throughout this long career, his admirers were inclined to bundle the artistic side of his character together with his interests in metaphysics, Handel, and Shakespeare, as proof that Balfour was a learned and well-rounded leader, capable of considering divisive political issues like Irish Home Rule and tariff reform from a dispassionate point of view. In this respect, Balfour's continual refinement of his debating skills in the company of the Souls served a useful political purpose. His detractors, meanwhile, saw in the same cultural preferences and philosophical bearing evidence that Balfour was merely a political dilettante, a shallow aristocrat for whom government leadership was little more than a pastime or game, a horrifying embodiment of a ruling class out of touch with the interests and experiences of the masses. Although they have not heretofore been examined as such, the Burne-Jones paintings Balfour collected were swept up in these ongoing assessments of his political leadership and were, I contend, unavoidably a significant part of his public persona.

It can be rather difficult to trace exactly how Burne-Jones's paintings became embroiled in Balfour's political life, largely because one particular account of the Conservative politician's career – that his accession to the position of chief secretary for Ireland in 1887 was a trial by fire that transformed the languid aristocrat into a ruthless guardian of imperial order – so came to dominate his reputation that it irreversibly skewed the recollections of even those who knew him in his younger days. He was publicly identified as the sponsor of Burne-Jones's *Perseus* project as early as 1878, when *Perseus and the Graiae* was exhibited at the Grosvenor Gallery during its second season. As we have seen, in keeping with the Aesthetic taste of the period Balfour supplemented his painted décor with Morris & Co. wallpapers and cretonnes, a Liberty flower stand, and an assortment of European and Asian ceramics, all of which were displayed within view of those admitted to his London home. His musical enthusiasms were already well established in the 1870s, as the concerts he had hosted at Carlton Gardens were large and significant enough to be discussed in the press.[120]

Late career and postmortem accounts of Balfour as an Aesthete seem to be rooted not in his political debut in the House in the 1870s but rather in his activities and affiliations of the early 1880s.[121] It was at this moment that he and a handful of other Conservative backbenchers dubbed themselves the "Fourth Party" and set out to stymie the progress of Gladstone's agenda in the House and to frustrate the efforts of the aging and insufficiently ambitious "goats" in their own party.[122] The tactics and tone they embraced as they transformed themselves into a humorous but antagonizing disruptive force aligned quite closely with the already established caricature of the Aesthetic male. The purpose of the "Fourth Party" was avowedly obstructive rather than constructive. They sat (and slumped) together on a front bench in the House below the gangway, interrupting debates to assert obscure points of order, yawning theatrically, cracking jokes, and using their bodies to make their general objection to Gladstonian proceedings publicly visible.[123]

A few years later, as chief secretary for Ireland, Balfour's peculiar fusion of aristocratic Aesthetical aloofness with harsh coercive policies would reportedly

37

"The Irish Mr. Balfour, by an English Artist," *St. Stephens Review*, November 15, 1890, reprinted in "Character Sketch: November. The Right Hon. A. J. Balfour, M.P.," *Review of Reviews* (November 1891): 469.

lead William Gladstone to call him "Artful Arthur."[124] This "artfulness" would make it difficult for his enemies to get a fix on him. Which was the real Balfour: the impotent, limp Aesthete conjured by critics in the *Freeman's Journal*, or the heartless, bloodthirsty torturer depicted in the *Weekly Freeman* and *St. Stephens Review* (fig. 37)?[125] When Balfour's much maligned portrait by Lawrence Alma-Tadema (1891, National Portrait Gallery, London) – even Balfour hated its "simpering" expression – was exhibited at the Royal Academy in 1891, the *Aberdeen Weekly Journal* noted "that he does not look like Coercion at all, though the Irish critic may rejoin that that is the artfulness of him."[126]

Balfour's public demonstration of an interest in Burne-Jones, that most "languid" and "esoteric" of Aesthetic artists, while no doubt sincere, was a key component of his oppositional self-fashioning. Of Balfour's fascination with this painter and his cultivation of a decorative domestic environment, the *Pall Mall Gazette* wrote, "Here is the key to much Distinction, dignity, aloofness, half-

contemptuous good-humour; these gifts come easily to the over-refined, over-cultivated, over-educated aesthete … These are sources of both strength and weakness."[127] Throughout the period in which Balfour's apparently aristocratic hauteur, "Aesthetic" languor, and controversially coercive tactics were most thoroughly scrutinized and dissected by the press, his name was brought up again and again as the patron of Burne-Jones's *Perseus* paintings. After a space of nearly a decade in which no additional iterations in the series had appeared, the artist suddenly brought forward the *Baleful Head* at the Grosvenor Gallery in 1887 – reviewed during the same week that Balfour was made Irish chief secretary – and the climactic *Rock of Doom* and *Doom Fulfilled* at the New Gallery the following year. It is surprising in this context that art writers did not seize these opportunities to weigh in on the subject of the hotly contested self-presentation and actions of Balfour, opting instead to read the paintings only in relation to Burne-Jones and his uniquely stylized art. But the public exhibition of these pictures at this sensitive political moment did suggest and sustain a connection between the chief secretary and the Perseus legend that was explored by political commentators in other contexts. In March 1888, for example, *Punch* published a poem that described Balfour as a "black," "snaky" menace who has "shackled and coerced" the "maiden" Hibernia. She is saved by Gladstone, who heroically strikes a blow against the hateful Tory beast.[128] Though the *Punch* poem is not strictly a retelling of any specific legend or story, its deployment of heroes, villains, and victims was consistent with what the *Fortnightly Review* would call the "Perseus-and-Andromeda version of the circumstances in which Gladstonianism originated," the "graceful and pathetic myth … according to which Mr. Gladstone saw that Erin was a prostrate damsel, and like a true paladin of politics, was moved to espouse her cause."[129] The *Speaker* used the same legend to cast Balfour as "a new Perseus come forth to slay the monster" that was "loathed and feared" by the Tory elite.[130]

By 1895, Balfour's public image had become so thoroughly yoked with that of Burne-Jones that the *Westminster Budget* saw fit to recycle the artist's *Depths of the Sea* (1886, private collection), nearly forgotten since its appearance at the Royal Academy almost ten years before, to illustrate its contention that the political machinations of Joseph Chamberlain were dragging down Balfour's entire party.[131] More complex, however, was another critical image issued by the *Westminster Gazette* that year (fig. 38). Here Balfour's identity as an art collector – indicated by the caption, "Mr. Arthur Balfour showing Mr. Gerald [Balfour] round his Coercionist Museum and Picture Gallery," and the catalog in Balfour's hand – is conflated with his habit of making policy decisions behind closed doors among his tightly networked cohort of family, friends, and political advisers. When Balfour refused to give a public explanation for the Irish policy he and his associates were developing, he was accused (in the words of this caption) of "conducting … rehearsals in private" without admitting the public to see the play. One of the paintings on the wall behind Balfour depicts the Irish chief secretary as a spider sitting at the center of this web of overlapping and mutually reinforcing interests.

In a broader sense, the language used to describe and criticize Balfour often aligned rather precisely with that used to characterize the paintings of Burne-Jones: both were accused of deliberately effecting a "mannered" style in order to appeal to an exclusive, fawning audience; both were regarded as "caviare to the general."[132]

XIX.—IN THE PROPERTY ROOM.

THE TORY POLICY FOR IRELAND.

(Mr. Arthur Balfour showing Mr. Gerald round his Coercionist Museum and Picture Gallery.)

38

F. Carruthers Gould,
"In the Property Room:
The Tory Policy for Ireland,"
Westminster Gazette, July 8,
1895, reprinted in *Cartoons
of the Campaign* (London:
Westminster Gazette,
1895), 21.

Each challenged the expectations of heteronormative Victorian masculinity in a way that made some observers palpably uncomfortable. But one astute commentator, Henry Lucy, noted as early as 1889 that Balfour's exaggerated "aristocratic" demeanor served as a political weapon in its own right. Balfour was "an aristocrat to his fingertips," wrote Lucy, but since, "for the moment, England is governing Ireland on aristocratic principles, … in Mr. Balfour she has found an aristocrat who might have been created expressly to serve her purpose."[133] Lucy interpreted Balfour's charming, polished, unflappable, elegant demeanor as a rebuke to Irish resistance.

Balfour the aristocrat may have been precisely what the English public seemed to demand, consciously or not, in 1889. But in the early years of the twentieth century, when Burne-Jones's art was increasingly regarded as the artifact of an earlier age, Balfour's attachment to it was used by his detractors to suggest that his tastes, his politics, his aristocratic caste were not only exclusive but also retrograde. The political functionary and commentator Humbert Wolfe used the *Perseus*

paintings, which he had been shown by an elderly Balfour, as a weapon: "Shall we go upstairs and see my pictures?' [Balfour asked]. I wandered round the gallery in increasing dismay. I tried to speak words of praise but they stuck in my throat. I looked miserably at all their foolish curves and (to me) imbecile colours. 'How could he have bought the things?' I groaned inwardly. 'But,' I consoled myself, 'even the greatest can't be great all the time in all directions."[134] Balfour, as we have seen, made no secret of his admiration for the Burne-Jones's work, installing it as a backdrop to his social and political self-presentation at both Carlton Gardens and Downing Street. The politician's identity as an Aesthete persisted, for better or for worse, for the rest of his career.[135]

———

For Balfour and the Souls, the art of Burne-Jones and Morris drew their group closer together amid a democratizing and expanding social world, and provided interactive points of reference for their intellectual salons. The pictures and patterns that constituted their aesthetic environments embodied a visual rhetoric of networked unity that would have been particularly powerful for these individuals in terms of politics (Unionism and empire) and interpersonal relations (friendship ties strong enough to withstand factional divisions). In these respects Aesthetic painting and design answered a number of social and political needs for a specific section of the Victorian elite.

But, viewed from the outside by those who neither collected Aesthetic art nor belonged to the Souls' circle, Burne-Jones's paintings seem to have confirmed what many critical observers feared about the constitution and behavior of that ruling elite. The "cult" of Burne-Jones (of which the Souls, as we have seen, were considered a conspicuous part) was often accused of narcissism and derided for its inclinations toward androgyny. Might these accusations have been at least partly directed toward a kind of communal narcissism and political (or ideological) androgyny?[136] In the case of the former, the repetitive nature of Burne-Jones's visual style and the steadfast allegiance of his circle of patrons and promoters evoked an echo chamber in which a cadre of influential elites was listening only to itself. Even more frustrating to outsiders – as one detects in the commentary surrounding Balfour and his Burne-Jones collection – was the possibility that this elite might have "no settled convictions."[137] Its decisions were subject to the changeable whims of abstract and rarified philosophical discussions. Conferring in drawing rooms and on golf courses, the Souls and their associates were apt to modify their party allegiances in ways that were difficult to track, predict, or hold to account. Burne-Jones's hesitant, "unmanly" heroes and "philosophical" paintings apparently touched a sensitive nerve in this regard, pricking network-oriented anxieties among observers wary of forms of concentrated social, political, and economic power as they coalesced in the later years of the nineteenth century.

CHAPTER 2

Sweetness and Electric Light
at the Grosvenor Gallery

On the evening of January 4, 1888, a man stood before a rapt audience in central London and solemnly invoked the presence of mysterious forces connecting the souls in that room to persons and places unseen, strangers scattered about the metropolis. As he spoke, the auditorium surged with a glowing light. "We are to-night connected in this room with the Grosvenor Gallery in Bond-street," he announced. "The Grosvenor Gallery has a central station where a very large dynamo is at work, from which electricity is supplied to different parts of London; many thousand lamps are fed in a great many clubs, theatres, and private houses; they are all lit up by the currents generated underneath the Grosvenor Gallery."[1]

The speaker's repetitive intonation may have sounded mystical, but his purpose was revelatory. This lecture, delivered to young people at the Royal Society of Arts by engineer William Henry Preece, was the second in a series of presentations introducing them to the workings of modern technology. The connections he outlined were not supernatural but in fact immediately physical: Preece warned that "if anybody were deliberately to put one wire in his mouth, and the other in his hand," he would face instant danger and death, but sought to reassure them that the equipment was perfectly safe if handled correctly. Restoring the safety fuse, he calmly, tantalizingly explained, "The switch has now been turned, and by it the current from the Grosvenor Gallery has been brought within our reach."

This lesson in the mechanics of conductivity would have tremendously benefited another juvenile, seventeen-year-old tobacconist's errand boy Richard Grove, had he heard it one year earlier. When a fire broke out at a neighboring Regent Street florist on January 3, 1887, Grove was dispatched to halt the electricity flowing into the premises – also supplied by the Grosvenor Gallery – by climbing onto the roof and cutting the wire with scissors. The current surged into his body with such force that he was thrown from the building, through a skylight, and down to a cellar 60 feet (18 meters) below. At the inquest, the gallery's representatives

William Morris "Pomegranate" wallpaper from the Yellow Bedroom at Cragside, Northumberland (detail of fig. 46).

theorized that Grove was killed by the fall rather than the shock.[2] The *Telegraphic Journal and Electrical Review* objected that "the engineer in the service of Sir Coutts Lindsay … appears to have hazy notions, to say the least of it, regarding the nature of the unseen forces with which he has to deal."[3]

Electricity has remained more or less an "unseen force" in the story of Lindsay's Grosvenor Gallery ever since, at least as far as the field of art history is concerned. Although the gallery's landmark identity as London's first central power station is well known to technological historians – for whom its role as the world's premiere showcase for Aesthetic painting is merely incidental – the artistic and electrical histories of the Grosvenor have thus far been tracked separately.[4] The goal of my investigation into this venue, this technology, this art, and this historical moment in this chapter is to reintegrate these parallel histories, revealing a remarkable case in which the fortunes of Aesthetic painting and decoration, artificial lighting, and speculative investment became strongly and strikingly interdependent – at least for a time. Viewing the Grosvenor through the lens of the "network" helps us to understand not only its physical position as a hub of cultural and technological development, but also the complex, intersecting artistic, social, and financial commitments that both sustained and entangled it, eventually leading to its demise.

39

First-floor plan, the Grosvenor Galleries and Restaurant, 1889. London Metropolitan Archives, GLC/AR/BR/19/0002.

A Network of Lights and Shadows

The story of the Grosvenor Gallery is an essential part of our understanding of the Aesthetic Movement: its crystallization in Britain and its international diffusion. This privately run exhibition venue, founded by artist-aristocrat Sir Coutts Lindsay in 1877, offered a home for artists who did not receive as much attention at the Royal Academy or elsewhere. Throughout its brief but influential decade-long career as the exhibitionary center of the Aesthetic Movement, the Grosvenor distinguished itself as a place where lighting arrangements were pursued with the utmost care. In 1876, before construction had begun, much discussion attended Lindsay's stated intention to orient the top-lit galleries north and south (fig. 39), a move designed to ensure optimal distribution of natural light and avoid interference from other nearby structures.[5] This orientation came at a cost to New Bond Street neighbors like chemists Savory & Moore, who found their light and air circulation diminished by the new building and brought a suit demanding modification of its design.[6] While the case awaited trial, Lindsay's contractors worked through the night, completing the 14-foot- (4-meter-) high gallery wall before construction could be legally halted.[7] *Savory & Moore v. Lindsay* was only the first in a series of legal actions prompted by Lindsay's various attempts to illuminate the Grosvenor naturally and artificially. The incident serves as a useful starting point for a consideration of this institution as rooted in the interconnected, often reciprocal, material

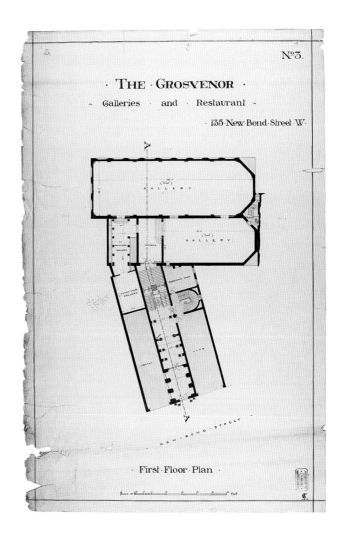

40

"The Grosvenor Gallery,"
Illustrated London News 70,
no. 1973 (May 5, 1877): 419.

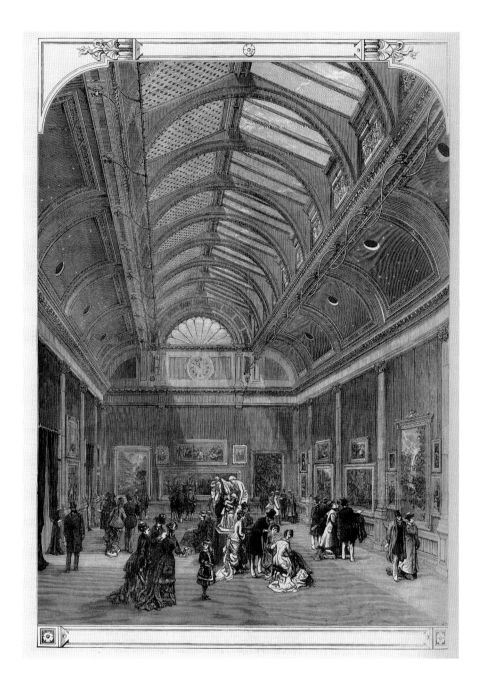

conditions of the modern urban world: here, one man's desire for light casting another into full shadow.

In designing the building, Lindsay and his architect, William Sams, reviewed precedents offered by the Royal Academy's reconfigured rooms at Burlington House as well as London's most recent example of purpose-built and custom-lit gallery construction, the Sheepshanks and Vernon Rooms at South Kensington. As at the latter, the Grosvenor's large West Gallery featured a centrally placed lantern roof with diapered glass designed to diffuse sunlight evenly throughout the room, although the well-known *Illustrated London News* depiction of the gallery published in the month of its grand opening shows considerable variation in the light's direction and intensity (fig. 40).[8] In the smaller East Gallery, a velarium offered

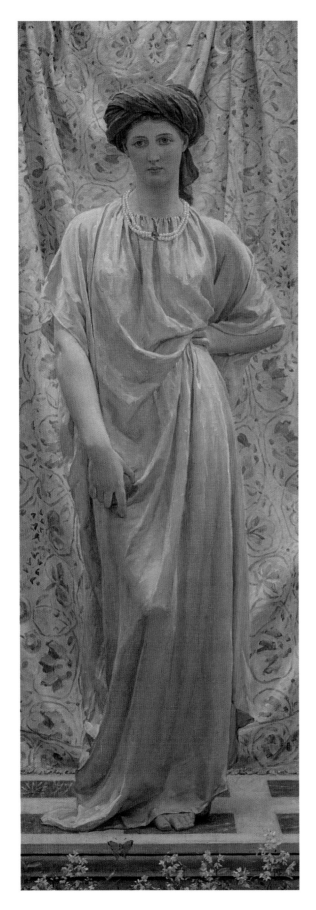

some manual control over the illumination.[9] These measures helped channel and distribute the sometimes meager London sunlight – so variable by season and weather – for optimal effect, its powers and patterns of movement underscored by a mural tracking the phases of the moon across the ceiling.

Lindsay's efforts underpinned his larger campaign to distinguish the Grosvenor as a place where artists (by invitation only) would enjoy presentation space comparable to that which they would arrange in their own studios.[10] As a practicing artist, Lindsay surely sympathized with his fellow painters and sculptors' need for good light by which to work and to introduce patrons and critics to their productions. Daylight hours were severely curtailed in winter, and frequently the much-anticipated studio Show Sundays were ruined by storms or fog.[11] At the Grosvenor, at least, artists could count on the best use of available light, directed across gallery walls on which each contributor's works were shown together, situated within the artist's own *oeuvre* (again, as in his or her own workspace).

When the gallery opened in 1877, the natural light was a significant source of positive commentary about the venue.[12] One visitor observed, "it is equally apportioned and so softly tempered as to do justice to every picture exhibited."[13] Featured prominently in the West Gallery, three canvases by Albert Moore – *Marigolds* (1877, private collection), *End of the Story* (1877, private collection), and *Sapphires* (fig. 41) – must have appeared as extensions of the lighting scheme itself. The latter two especially exemplify the clear, bright, diffuse top-lighting that came to be regarded as a hallmark of Moore's work.[14] In *Sapphires*, soft light picks up the drapery folds and the alternating projections and recessions of the model's body within the tightly compressed space of the Liberty-fabric-swathed composition.[15] Far from creating dramatic chiaroscuro, this illumination casts faint shadows on the floor, allowing Moore to explore variations in value alongside pattern and restricted color combinations across the flat, dry surface of the canvas. Hospitable lighting arrangements must have made the Grosvenor a particularly attractive exhibition venue for Moore, whose work had been subjected to unflattering over-illumination (and equally harsh criticism) at the Academy.[16] Some viewers had difficulty adjusting to the decorative compositional all-overness of canvases by

41

Albert Moore, *Sapphires*,
1877. Oil on canvas,
154.8 × 54.5 cm. Birmingham
Museums and Art Gallery.

Moore and Whistler, which rejected conventional cues of perspective and depth, relying instead upon what one critic characterized as "a heterogeneous network of lights and shadows."[17]

In the roster of contributors to the Grosvenor's inaugural exhibition one repeatedly encounters artists whose works were characterized by a diffuse rather than sharply delineated, directed light. Indeed, this quality appears to have marked the work of many of these "outsiders" as pursuing a new kind of beauty in decorative, self-conscious composition (rather than window-on-the-world realism). Moore's pictures shared the West Gallery with Aesthetic paintings by Edward Burne-Jones, Walter Crane, and James McNeill Whistler. These were in fact ideal pictures to hang in a gallery striving for – whose identity, in fact, partially depended upon – softened, evenly dispersed lighting effects. Neither produced the other, but both stood to benefit from their fortuitous convergence and mutual reinforcement.[18] As in other cases examined in this book, we see that Aesthetic paintings, depending upon their installation context, had the potential to testify to or endorse certain conditions outside their frames. At the Grosvenor, these flat, expansive, modular canvases quite literally highlighted the presence of two amenities that Lindsay actively cultivated in order to make his new gallery a competitive entrant into the London scene: diffuse lighting effects and a coordinated decorative environment.

If art critics are to be believed, the general experience of gallery-going in the late nineteenth century was one of abject exhaustion. Lindsay's judiciously distributed natural lighting played a key role in the amelioration of this optical fatigue, as did his decision to hang works by each artist together with approximately 1 foot (30 cm) between them. Critics reported, by comparison, an adverse reaction to other galleries, including the Academy and the Salon, where works of art were crowded together in a "terrible jumble of style, color, subject, and size" apt to "tyrannize over the vision of the spectator."[19] At the Grosvenor, however, "you are not in a gallery … where the eye is wearied by yards upon yards of canvas and gilt frames, packed so close together that there is nothing on which to repose."[20] Many others praised the Grosvenor's "harmonious decorations," using the same language to affirm the visual coordination of the gallery and the compositional relationships constructed within individual works of art on view inside it.[21]

It is notable that while Lindsay's decorative choices were not "Aesthetic" per se (no Godwin furniture, no Morris patterns), critics took it as their annual task to gauge whether the gallery as a whole lived up to the fully coordinated ideals embodied by the Burne-Jones, Moore, and Whistler paintings on display.[22] But Lindsay's selection of bright wall hangings and gilt furniture also announced another referent at work, noted by both period commentators and modern scholars: the home of the gentleman art patron. As a showroom, the gallery gave a sense of what the pictures might look like installed in a well-appointed domestic interior. Summarizing Lindsay's goals for the Grosvenor, *The Times* explained that "a picture is never enjoyed as it is when seen by itself in the quiet of the studio or in the chosen light and retirement of a richly furnished room" – although it should be noted that these spaces are not precisely equivalent.[23]

In fact, had these galleries been designed purely to meet the requirements of artists, artificial lighting would hardly have been included at all; most reported that they never worked by it.[24] And with the exception of the Grosvenor's first summer

show, which was open until 10:00 p.m., Lindsay apparently elected not to display the contemporary paintings by gaslight.[25] But private homes and sale showrooms would have been lighted by gas, and during winter months, when fogs and early sunsets curtailed visibility, Lindsay had to resort to gas in order to illuminate the Grosvenor's Old Master and monographic exhibitions, extending business hours into the darkened evenings. From its debut winter display, gas was used to make the Grosvenor an attraction superior to competing art venues, which were dependent solely on the vagaries of natural illumination.[26]

Gas presented its own difficulties, however.[27] Burning it heated the rooms, so Lindsay's plans included a networked interior ventilation system designed to maintain comfort levels in the gallery.[28] Still, with heat and crowds came the problem of smells, as winter coats and furs warmed to produce an "odious atmosphere," especially when blended with cooking odors from the restaurant kitchens below.[29]

A significant gain in illumination might have justified these costs to comfort, but some critics complained that the gas was still less than ideal for seeing the pictures.[30] The *London Evening News* was skeptical that anyone could have credibly reviewed the Joshua Reynolds exhibition that opened amid terrible fogs in the winter of 1883: "True there was gas, and plenty of it, … but will any one pretend that the most brilliant illumination of that sort is one in which pictures, and above all the pictures of a colorist, can be seen, least of all judged?"[31] Even when gas succeeded in mitigating the darkness of fog, it did nothing to combat the latter's corrosive properties; in fact, it exacerbated them. An 1881 *Times* editorial stressed the connection between the destructive effects of fog and gas, noting that it was the burning of coal to produce gaslight that rendered London's fogs so toxic.[32]

Many agreed that glazing was necessary to protect pictures from the effects of fog and gaslight, and some artists believed that this gave their works a lustrous, saleable sheen – but this strategy, too, had its drawbacks, and was consequently prohibited at the Royal Academy.[33] At the Grosvenor, meanwhile, the *Morning Post* complained that glass over oil paintings "gives back an obtrusive reflection, mocking the spectator with the semblance of his own face and figure as though in a mirror."[34]

Unsurprisingly, then, Lindsay elected not to show the contemporary pictures by gas. But by the summer of 1884, a particularly dismal press preview suggested that the viewing conditions at the gallery had become untenable: "Perhaps Iceland or Siberia may suit the purpose; certainly London, from October to June, is no place for seeing pictures, or indulging in any other pleasure of the eye."[35] There was a clear need for a better illuminant.

Sparking Interest

As early as November 1881, Lindsay let it be known that he was interested in pursuing electrical lighting for the Grosvenor.[36] Indeed, the history of this technology overlays the gallery's history quite precisely, placing it squarely in the midst of what Hollis Clayson describes as a late nineteenth-century international "illumination discourse."[37] In 1875, when Lindsay was mulling over his plans for the venue, powerful arc lighting was being tested to illuminate some streets and large-scale indoor spaces across London. But it was not until later that decade that more

manageable, portable incandescent bulbs were discussed as a practical reality, bringing the advantages of "subdivided" electric lighting to more intimate institutional and domestic spaces. In 1878, just one year after the Grosvenor's founding, Joseph Swan and Thomas Edison announced separate and near-simultaneous improvements in the filaments and sealed vacuums of their incandescent bulbs (or "lamps"), fuelling a flurry of international patent filings and the chartering of independent electric lighting companies. The Paris Electrical Exhibition of 1881 provided a key opportunity to demonstrate and compare these new technologies and fostered information sharing among entrepreneurs, inventors, and early adopters. The success of this exhibition spurred so much speculation in England that Parliament passed the Electric Lighting Act of 1882 to regulate these new businesses.

The Paris Exposition and its progeny (including the 1882 Crystal Palace Electrical Exhibition) had two primary goals for their lighting displays: demonstrating the light's quality and easing fears about its safety. Only recently have art historians begun to note the central role played by works of fine and decorative art as key test cases for illumination technologies.[38] The engineers' gravitation toward art objects for this purpose was logical, as these exhibit manifold gradations of color and tone upon which the effects of various illuminants could be studied and compared.[39] Additionally, as we have seen, the period was marked by a widespread and increasingly anxious awareness that works of art needed to be seen clearly and protected in domestic and institutional settings. But in reaching for art objects as proof-of-concept case studies, electricians and company promoters found themselves collaborating with or acting as curators, collectors, gallerists, and interior decorators. This is the convergence I wish to probe here, particularly as it concerns the Grosvenor Gallery and Lindsay's role as the head of its artistic and electrical ventures.

The hastily assembled group of commissioners responsible for the English display at Paris in 1881 included James Ludovic Lindsay, astronomer, bibliophile, and politician. He had just succeeded his father as the 26th Earl of Crawford and Balcarres, and was then serving as Lord Wigan in the House of Lords, where he represented a coal district that was the source of his family's wealth. Wigan was rich in cannel, the coal most popular for burning a particularly bright white coal gas flame. He was Coutts Lindsay's cousin, and would eventually encourage the gallerist to adopt the new technology by installing a small generator at the Grosvenor. The institution remained, meanwhile, a consumer of the family's coal, fusing the Lindsays' longstanding financial ventures with new ones.[40]

Much confusion surrounds the date at which the electrification of the Grosvenor actually began. Most historians place it in 1883, the date given in R. H. Parsons's influential early account of electrical power generation in England, but there is no clear evidence for this.[41] A small temporary generator in the basement may have been used to light the restaurant or library that year, but not, it seems, the pictures. Robert Monro Black's proposition that Gilbert and Sullivan's famous satirical characterization of the Grosvenor Gallery as "greenery-yallery" in their comic musical *Patience* (which premiered in April 1881) might in fact have alluded to the effects of its early electric lighting, while suggestive, cannot, therefore, be correct.[42]

But *Patience* is not, it turns out, a poorly chosen reference point for charting this artistic and technological history. When this popular satire of Aestheticism was relocated from the Opera Comique to Richard D'Oyly Carte's Savoy Theatre for that institution's grand opening in October 1881, it took center stage in the first English public building completely lit by electricity. Safety and hygiene were central matters of concern for crowded theaters as they were for art galleries and homes. At the Savoy, the sparkling new interior decorations (primrose, ivory, and red, accented with gold) had been selected and the scenery of *Patience* repainted to highlight the cleanliness and evenness of the new electric light, and critics intuited a connection between the design of the auditorium and the visual culture of the play: "Amid these agreeable surroundings – the results of modern taste and artistic advance – there was presented on Monday night the comic opera which is a good-humoured satire on this taste and this advance."[43] One commentator observed that the bright and even electric light effectively transformed the *Patience* audience into a band of stereotypical aesthetes, by which "persons of the ruddiest complexion look somewhat pale and aesthetic, and some very rubicund clergymen, in the blaze of the light, looked absolutely delicate, with a slight peach bloom colour on their rosy faces."[44]

At precisely that same moment, the Grosvenor's 1881 winter exhibition season saw the first public circulation of rumors that the gallery would also be electrically lit, but it seems likely that these mistaken early reports simply lumped the gallery in with experiments then underway at the Royal Academy.[45] In January 1882, with its annual display of Old Masters, the Academy offered the English public its first major art exhibition illuminated by incandescent electricity.[46] For two hours in the late afternoon, beginning at 4:00 p.m., gas, arc lighting, and clusters of Swan bulbs were deployed in separate galleries to encourage comparative study of the available technologies.[47]

Although the Academy would ultimately suspend its electrical experiment, returning to gas by 1884, other artistic–electrical convergences of the late 1870s and early 1880s tell us much about how art was being used to push this technology forward, and lay essential groundwork for understanding how Aesthetic art and design was well poised to underscore the qualities most desired in the new illuminant.[48] Late nineteenth-century art needed better illumination, as we have seen, but early electric lighting demonstrations also needed art.

In October 1880, when Joseph Swan began an English lecture tour announcing his successful manufacture of a completely enclosed, self-regulating incandescent electric lamp, he chose to demonstrate its effectiveness using a picture composed largely of primary colors, upon which the new light could be shown as he explained its complex inner workings.[49] At one lecture's conclusion, Newcastle engineer and armaments manufacturer William Armstrong stood up and declared that Swan's proof had convinced him to install the new lights at his Norman Shaw-designed country estate, Cragside, on a trial basis. Armstrong was a friend of Swan's and effectively the poster child for domestic electric lighting in Britain. He had already pioneered hydraulic power generation at Cragside, using turbines driven by waterfalls to illuminate his picture gallery with arc lamps in 1878.[50] Following

42

"Electric Lighting by the Swan System at Sir William Armstrong's Residence, Cragside," *Graphic* 23, no. 592 (April 2, 1881): 332.

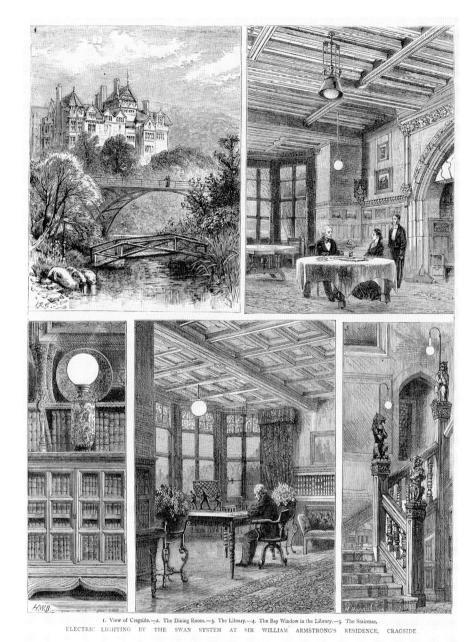

1. View of Cragside.—2. The Dining Room.—3. The Library.—4. The Bay Window in the Library.—5. The Staircase.
ELECTRIC LIGHTING BY THE SWAN SYSTEM AT SIR WILLIAM ARMSTRONG'S RESIDENCE, CRAGSIDE

Swan's 1880 demonstration, Armstrong replaced these with sixteen extra-large incandescent bulbs; he also added Swan lamps in the dining room, stairwell, hallways, and library (atop custom-wired cloisonné vases), making Cragside the first private house in Britain lit by the new technology (fig. 42).[51]

Armstrong's taste for eastern ceramics was only one facet of an interest in Aesthetic Movement art and design that ran alongside his technological enthusiasms. Cragside offered a feast of Morris & Co. patterns, and H. H. Emmerson's contemporary portrait of its owner depicts him sitting cozily in the dining room on a hand-carved bench with sunflower detail, framed by Morris-designed stained-glass windows and blue and white porcelain possibly purchased from the Rossetti collection (fig. 43).[52] It would be hard to guess that the occupant

43

Henry Hetherington Emmerson, *William George Armstrong, 1st Lord Armstrong of Cragside*, 1880. Oil on canvas, 76 × 63 cm. National Trust, Cragside, Northumberland.

of this quiet nook was one of the most innovative and ambitious engineers of his day, having earned his fortune in the design and construction of hydraulic cranes, steam warships, and breech-loading iron guns sold worldwide.[53]

Yet is it really a paradox that a consummate systems manager would also exhibit a taste for Aestheticism?[54] At Armstrong's Elswick manufactory, one of his contemporaries marveled at the "complete network of rails" by which "heavy machinery and guns in course of construction can be transported from one part of the works to another with as much ease as one might move the pieces upon a chessboard."[55] The Cragside estate, with its artificially constructed lakes and dams forcing water power down to the giant paddle wheel turbine, was a celebration of its owner's ability to generate electricity and transport it through copper wire a distance of a mile and a half, from the pump room to the house.[56] In the library, the cloisonné lamps and dangling Swan bulbs illuminated Albert Moore's prominently displayed *Follow My Leader* (ca. 1873, private collection), in which a chain of modern Grecian beauties tumble toward the object of their chase, urging each other forward in an overlapping, interlocking line of continuous, boisterous energy (figs. 44 and 45).[57]

44 (Opposite)

Looking towards the fireplace in the library at Cragside (photograph by Bedford Lemere), 1891. Historic England Archive, Swindon.

45

Albert Moore, *Follow My Leader*, from a photograph by Frederick Hollyer, *Illustrated London News* CIII, no. 2842 (October 7, 1893): 436.

When the house was opened up in the 1880s as a showcase for incandescent light, *Follow My Leader* was inevitably drafted into this demonstration and promotional program – and not merely as a test case for color. The channeling of natural forces is, after all, a key thematic and conceptual driver of Aesthetic design, as exemplified by the Morris "Bird and Trellis" and "Pomegranate" wallpapers also adorning this home (fig. 46). Here the natural order of flowering vines and fruited branches is merged with the regularized geometries coordinated by the hand of man: in the overt form of the wooden latticework, in the case of the former, or the subtle patterning that organizes the composition of the latter.

Cragside was used explicitly as a showroom for electric lighting alongside other new technologies.[58] The home was celebrated in advertisements for the newly merged Edison and Swan Company, formed after the success of the Swan bulbs in Paris in 1881.[59] Here it is worth considering another reason that electrical promoters may have favored artworks as proofs: many were themselves collectors who had an interest in making sure their holdings were protected and illuminated. Alexander Stevenson, an incorporator of the original Swan Company, owned Rossetti's watercolors *Loving Cup* (1867, unlocated) and *Lady Lilith* (1867, private collection); Moore's *Lilies* (1866, exhibited Newcastle 1878, Sterling and Francine Clark Art Institute, Williamstown, Mass.), and several works by Simeon Solomon.[60] He housed them in his Aesthetically decorated and thematically organized Tynemouth residence, and in his summer home, where his cultivation of a unified harmonious environment extended even to the complementary costuming of his wife and daughter.[61] Longtime Edison and Swan president and collector James Staats Forbes, partisan of Barbizon landscapes and uncle of Grosvenor artist Stanhope Forbes, directed investors to attend performances of *Patience* at the Savoy in 1882 in order to gauge the success of the Swan lamps for themselves.[62] Admiring business writers cited the combined evidence of Forbes's cultural interests and shrewd investments as demonstrating his capacities as a "master of many legions."[63] In the cases of these men, their status as collectors served as a tacit endorsement of the safety and quality of this emergent illuminating technology.

Unsurprisingly, then, paintings were often used by various electrical companies as test cases for demonstrating the light. At the Paris Exposition's British counterpart, the Crystal Palace Electrical Exhibition of 1882 at Sydenham, various companies were allotted spaces for showcasing their lamps, distribution systems, measuring equipment, light fixtures, installation techniques, and broader applications (in telegraphy, telephony, and railway signaling, among others).[64] The Swan Company – competing with Edison, Maxim, and Lane Fox in their display of incandescent bulbs – was given the picture gallery, in addition to the French court, the saloon dining room, and "an aesthetically fitted up office."[65] The light was lauded for producing a "beautiful effect" on the paintings, "all the colours appearing in their day light hue."[66] Swan would hereafter insist on securing art galleries as exposition competition space rather than larger, more prominent rooms devoted to other functions.

Adjacent to the picture gallery, the Domestic Electric Lighting Company created an entire display designed to demonstrate "the application of the electric light to an ordinary household" by installing it in sample interiors (fig. 47).[67]

These rooms were illuminated by Edison rather than Swan bulbs (the two companies were soon to merge their English patents), but the point is that home incandescent lighting was praised for its quality and movability and its particular suitability for modern "artistic" furnishings.[68] They included an "Early English reception room" (or Jacobean hall) adorned with an embossed leather frieze, Godwin furniture, and Royal School of Art Needlework tapestries on designs by Burne-Jones and Walter Crane.[69] Liberty & Co. constructed an "Oriental" smoking room out of their imported and manufactured textiles and bric-a-brac: soft gray Indian matting for the walls, dark blue kalmuc and Persian rugs for the floor, and Indian durrie for the ceiling, in addition to Japanese textiles hung in bamboo frames.[70] In this way,

47

"Notes at the Crystal Palace Electrical Exhibition, 3: Domestic Lighting Exhibition (the Drawing-room)," *Graphic* 25, no. 162 (March 18, 1882): 264.

1. Improved Communication between Passengers and Guard, and between Moving Train and Signal Boxes.—2. Means of Communication between Light-ships and the Shore.—3. Domestic Lighting Exhibition (the Drawing-room).—4. The Aquarium with Immersed Light.—5. In the Domestic Lighting Exhibition : A Japanese Bronze.—6. The Sewing Machine Motor.

NOTES AT THE CRYSTAL PALACE ELECTRICAL EXHIBITION

electrical promotors used aesthetic harmony, exoticism, abundance, and intimacy to sell the new technology.

Arthur Lazenby Liberty's decorating firm had long been associated with careful control of light in its public and private installations, including its own store showrooms.[71] It packed its designated Crystal Palace booth with samples of its signature dyed and printed dress and furnishing fabrics "to show that their true colours are brought out under the electric light."[72] Hiring this firm to furnish this room subjected incandescent lighting to a truly ambitious test: the public was already well acquainted with Liberty textiles, which had set a new standard in color and texture. The firm and its admirers adamantly differentiated the subdued pastel "art colors" and soft textures of Liberty fabrics from the "gaudy," "glaring," "gummed glossiness of French silks" and the "gummed and stiff" fabrics exported from the East for European consumption.[73] Consequently, Liberty's claimed its fabrics were both aesthetically and sanitarily superior to foreign products.[74] In short, the qualities Liberty was striving for and promoting in his fabrics were the same as those claimed for the new incandescent lighting technology, making each the perfect foil for the other.[75]

If Liberty's fabrics could be made to look good under the electric light, the new technology would prove to have harmonized itself to modern taste.[76] In the early 1880s, then, whether one was viewing a performance of *Patience*, touring Armstrong's Cragside, visiting an industrial fair, or shopping at Liberty's, Aesthetic Movement art and design served as a powerful exemplar for demonstrating the new possibilities of electric light. At that precise moment, Coutts Lindsay was building a new power generating plant to produce and distribute electricity underneath the Grosvenor Gallery.

The Grosvenor Gallery Network

In November 1884, the first announcements appeared in engineering trade journals seeking proposals for lighting the Grosvenor Gallery by electricity. These requested bids for supplying engines, boilers, cables, wires, and light fittings.[77] Selections were made by early December to begin installing the equipment necessary for lighting the two main picture galleries with Sun lamps, a design that combined arc and incandescent technologies, which was already under trial at the South Kensington Museum, among other locations.[78] None of these reports indicates that electricity had previously been in use at the Grosvenor; Lindsay was clearly understood at this time as lighting one location only.

On January 17, 1885, the first notice appeared announcing the incorporation of Sir Coutts Lindsay & Co., Ltd., at the gallery's address (135 New Bond Street), a new entity founded "to carry on the business of an electric company in all branches." Lindsay was listed as the sole heavily investing shareholder (4,000 shares at £1 each), with the other directors registered as nominal shareholders only: three members of the artistically and musically inclined Wade family (brothers Nugent Charles Wade, Arthur Fenwick Wade, and G. E. Wade); the engineers in charge of the installation (Reginald Brougham and J. K. D. Mackenzie); and Lindsay's lawyer (A. C. Curtis Hayward).[79] In February, it was reported that the Grosvenor Gallery had begun operating a secondary generator system "for the house to house

distribution of light in Bond-street and the neighborhood."[80] This comprised a temporary thirty-horsepower engine driving two Siemens dynamos, which sent current to sixteen secondary generators illuminating approximately three hundred lamps at the Grosvenor Gallery Library and Club (but not, apparently, in the galleries proper) as well as two nearby businesses in New Bond Street.[81] With this temporary system in place, the new company began digging a vault beneath the gallery to house the permanent Gaulard & Gibbs generators.

January 1885 also saw the opening of the Grosvenor's annual monographic winter exhibition, this time honouring Thomas Gainsborough. On the day before the gas-lit Gainsborough show closed, Lindsay distributed handwritten invitations for two weekend private views unlike any the gallery had ever staged: a test exhibition of the effects of electric lighting.[82] It was attended by Sir Frederic Leighton, Lawrence Alma-Tadema, and members of the engineering press. At 6:30 p.m., after the declining sun had cast the building into darkness, Lindsay and his assistant Arthur Wade switched on a new sun in the West Gallery: ten Sun lamps, whose light filled the cavernous space. At the same time, he illuminated the East Gallery with gas, and invited his guests to compare the results. The demonstration was apparently decisive. "The gas seemed to throw out a lurid, yellow light that imparted false shade and colour to the surrounding pictures," reported the *Telegraphic Journal and Electrical Review*. But "the white, steady glow from the 'Sun' lamps brought out the pictures in the other gallery in clear and correct definition, exactly as in ordinary daylight": "a white, yet mellow, light, free from violet or blue shade, with perfect steadiness." Eyeing the Gainsboroughs, the reporter noted that electricity, unlike gas, "throws off little heat and neither smoke nor vapour, advantages the importance of which cannot be overrated now that we have pictures in our collections costing £70,000 and £50,000."[83]

Looking back years later, the company's historians would make two essential claims about this early Grosvenor installation: that Lindsay's entry into the power generation field was motivated exclusively by a desire to light the pictures in his gallery, and that access to his new system was immediately pursued by nearby businesses: "'Put down twice the machinery, produce twice the current you require, and let me have what you can spare.' So said a neighbor. Other neighbors joined in, and the installation began to grow."[84] The wires radiating from the Grosvenor over the West End would eventually form the first large-scale house-to-house electric lighting system in England.[85] While the 1882 Electric Lighting Act had attempted to check speculative expansion by requiring special licenses and permissions for laying underground cables, there were no restrictions governing overhead wires. Taking advantage of this, Lindsay's engineers attached wrought-iron poles to adjacent rooftops in order to string the company's lines from building to building, negotiating with individual residents and proprietors rather than with London authorities. In July 1885, the *Telegraphic Journal* expressed gratitude that private enterprise had stepped in to fill the need to develop and experiment with this new technology.[86]

Yet there was another side to this: in July, Sir Coutts Lindsay & Co. was brought to Chancery Court by Smethurst & Co., lamp makers, seeking an injunction against the noise and vibration produced by the company's temporary steam engine.[87] Joseph Pyke, a neighboring silversmith and jeweler, testified in the

gallery's defense that the machinery did not disturb his premises next door at 138 New Bond Street. By the time the company's first meeting minutes were recorded three months later, Pyke had joined the board of the new Grosvenor Gallery electrical venture.[88] These same early documents track the weekly efforts of Pyke, Lindsay, Lindsay's cousin and brother-in-law the Earl of Crawford, and Arthur F. Wade, with occasional input from company lawyer Hayward, to review incoming requests for electrical service and continue expanding the company's system, sometimes by canvassing streets to drum up business.[89] By November 13, 1885, the new company defined its purview as follows:

> Customers now supplied: 742 lamps
> G. G. Buildings & 13 Sun Lamps: 300 lamps
> Customers ready: 216 lamps
> Customers soon ready: 511 lamps
> Customers agreed to take light: 216 lamps
> Applications for light under negotiations: 1039 lamps
> Total: 3024 lamps.[90]

Who were these customers? Tracing the wires that connected them over the rooftops here will help to reveal much about the physical, economic, social, and cultural landscape in which Lindsay, the Grosvenor, and Aesthetic painting were embedded. One of the company's earliest subscribers was the American expatriate photographer Henry Van der Weyde. He shared Lindsay's need to obtain the brightest, most even light in the midst of dismal English fogs for his premises at 182 Regent Street, which he opened in 1877.[91] While Lindsay was still experimenting with natural light and gas, Van der Weyde installed a dynamo and gas engine in his studio basement to power his dazzlingly bright 6,000 candle-power arc lamp. He was hired by Lindsay to photograph priceless Old Master drawings borrowed from the royal collections, among others, for the gallery's first winter exhibition.[92] He proudly promoted the innovations of the "Van der Weyde Light Studios" in an illustrated advertisement he placed in the Grosvenor's summer exhibition handbook in 1885 (fig. 48). Here he showcased the adjustable configuration of screens and reflectors that channeled and diffused the glare of the arc lamp's spark into an all-over glow, transforming his sitters into softly modeled, statuesque forms. This became the basis for a lucrative career taking society and celebrity portraits, particularly at night, as sitters costumed in elegant evening dress returned from the opera or the play – or, perhaps, given its proximity, from the Grosvenor private views.[93] Reportedly, partisans of Aesthetic painting at the Grosvenor were apt to compare the works exhibited there to the similar portraits in Van der Weyde's windows, such as the famous depiction of Mary Anderson in W. S. Gilbert's *Pygmalion and Galatea* (Lyceum Theatre, December 1883), posed in a manner that resembled an Albert Moore composition (fig. 49).[94]

The complex series of interconnections between Van der Weyde's electric light portraiture, the Grosvenor Gallery, and Aesthetic painters working in a decorative classical idiom were made even more concrete when, in December 1885, Van der Weyde became one of Sir Coutts Lindsay & Co.'s first customers, supplementing his on-site generation of power for the arc light with current drawn from the

48

"Portraits at the Van der
Weyde Light Studios, 182
Regent Street W.," in Henry
Blackburn, *Grosvenor Notes*
(summer 1885): xvii.

Grosvenor to his studio via the rooftop wires.[95] Another early adopter was
photographer Walery (Count Ostrorog), who first secured the gallery's light for his
Conduit Street studio in October 1885, and the following year constructed new
premises in Regent Street designed to make electric light photography its central
feature. He used an arrangement similar to Van der Weyde's, but also made
extensive use of incandescent lights.[96] Indeed, there was a cluster of photographers
using the Grosvenor Gallery electricity in the years 1885–7, including, in addition to

49

Henry Van der Weyde,
*Mary Anderson as Galatea in
"Pygmalion and Galatea,"*
1884. Albumen cabinet card,
14.1 × 10.4 cm. National
Portrait Gallery, London.
© National Portrait Gallery,
London.

Van der Weyde and Walery, Alexander Bassano, another prolific portraitist, who used
an arc and reflector system as well as incandescent light in his lavishly furnished Old
Bond Street studio.[97]

Many of those on the Grosvenor circuit were, like Pyke, makers and merchants
of jewelry, including Hancocks (goldsmiths and jewelers) and Thornhill & Co.
(silversmiths), both regular advertisers in the Grosvenor's summer exhibition
catalogs. Jewelers needed good light for their detailed work, but also used the
electricity as a sales tool, displaying their designs behind plate glass windows and

entwined with dazzling "fairy lights," miniature incandescent bulbs that made the silver and diamonds sparkle.[98] Meanwhile, the Café Royal, Brown's Hotel, and the Regency Club were also added to the Grosvenor circuit, and, as members of the hospitality industry, used this amenity as leverage in competing for guests and members.[99] Indeed, 1885 marked a noticeable increase in the number of London's electrically lighted clubs and restaurants, and the Grosvenor was responsible for a notable portion of this proliferation.[100]

By December 1885, it appears that the Grosvenor's permanent machinery was up and running. It comprised Siemens's largest dynamos, driven by steam engines of over 600 horse power, capable of powering 5,000 lamps.[101] This system finally enabled Lindsay to electrify a Grosvenor exhibition that winter, with the opening of the John Everett Millais retrospective on January 1, 1886. When the Sun lamps, shaded by canvas screens, were switched on during the evening private view, it took ten minutes for the "jerkiness" of the light to subside, resulting in "winking" effects, according to *Punch*.[102] By shading the light, *Truth* reported, Lindsay ensured "that the pictures benefit by the full blaze, while the gazers are shielded from it."[103] But art critics, most of whom had probably attended the daytime press view, had little to say about the effect of this new powerful illuminant upon the pictures. By the end of the year, Lindsay would replace the Sun lamps with the more easily grouped and controlled incandescent Swan bulbs Armstrong had so publicly and enthusiastically promoted.

In the Millais exhibition's third week, the gallery's hours were extended until 10:00 p.m. and the electric light advertised as a special attraction.[104] Suddenly, observers noticed that the Grosvenor had become "the centre of quite an extended area of domestic electric-lighting," from which seven miles of wires "radiate in every direction" from New Bond Street to the Café Royal in Regent Street.[105] But the house-to-house system almost immediately demonstrated its considerable risks. The weight of a heavy snowfall on January 6 caused the main Grosvenor cable affixed atop luxury silk merchants Lewis & Allenby (193–197 Regent Street) to topple a chimney stack, sending bricks crashing through their skylight and causing extensive damage to their merchandise. Later that same year, the wind blew another tower through the skylight at the Dowdeswell's Gallery (133 New Bond Street), producing a fireworks-like display. In these cases, the glassed-in roofs that provided the daytime sunlight essential for displaying fine silks and works of art became the weak points in the system, unable to withstand collisions with the cumbersome artificial lighting equipment. William Henry Preece, then consulting engineer for the Post Office, warned that "if the practice of erecting these marauding systems" of overhead wires "without any rule or regulation, were permitted, it would in a short time become an absolute nuisance. We should have our towns and our streets disfigured as they are in the [United] States," and be subjected to fire danger and interference with the telephone lines.[106]

Nor were the Grosvenor's early consumers entirely pleased with their results. The high-tension current produced by the Galuard/Gibbs dynamos was regulated by hand at the gallery, a less-than-ideal method, and one that caused the lights to flicker.[107] Worse, in the house-to-house system, the transformers were connected in series, rendering customers dependent on their neighbors.[108] For example, "if a given number of lamps, say 100, are fairly constant while all are in operation, very

bad regulation ensues amongst the remainder if some 20 or 30 are turned out."[109] The unused electrical potential surged to the remaining lamps, which often broke under the strain.[110] The company hired master engineer Sebastian Ferranti to overhaul their systems in January 1886, but remediation was a gradual process, and the lights continued to extinguish themselves frequently throughout the year.[111] In this system, then, not only were the customers visually mapped by the overhead network of wires, but each also experienced a physical attachment with the others manifested by the ebb and flow of the current.[112]

In 1885, more than the usual spate of commentators had found the summer exhibition disappointing, perhaps an indication that Lindsay's attention was diverted by the electrical venture in its first year. By the time of the summer 1886 exhibition, however, Edward Burne-Jones, "long the light of the Grosvenor," had returned, and the installation received more favorable press.[113] With the sunlight curtailed, artists had been forced to channel their energy strategically, and their stronger productions had apparently surged to the Grosvenor.[114] Most unusual for a summer show, the gallery was kept open until 10:00 p.m., lit by electricity.

From Cult to Circuit

An 1887 map of the Grosvenor system shows the network sprouting from the Bond Street gallery and crawling over the West End (fig. 50). It helps us to see for the first time the many striking ways in which the Grosvenor's publicly visible and sometimes physically dangerous transformation into an electrical power generation company, controlling ever greater swaths of the London metropolis, must have seemed like a technological manifestation of what many cultural observers had long feared: that Lindsay and the Aesthetic Movement exerted a powerful and not always admirable influence over the British art world. In 1881, when the Grosvenor's future illumination had been only a rumor, *The Times* described its "atmosphere" as "a little overcharged with art electricity."[115] The commentator used this evocative metaphor-of-the-moment to allude to a cluster of fads, fashions, and behaviors that had been associated with the gallery since its opening in 1877. One might quote endless examples, but the inaugural review by Heathcote Statham hits all the marks:

> It is impossible to overlook the presence of an element of eccentricity, the prominence given to types of painting which form the special *cultus* of small groups of worshippers who offer up a blind admiration, each to their own special high priest. There is far too much at present of this private clique spirit in connection with painting in England. An artist declines public notice, and shows his productions only as a special favor to a special circle, who kiss the hem of his garment and see nothing but perfection in his work.[116]

Statham's was not the only perspective on the matter; some critics heralded the establishment of the privately operated Grosvenor as an opportunity for artists to escape the constrictions and "cliqueism" of the Royal Academy.[117] But even some of its early sympathizers worried that Aesthetic artists were too closely associated,

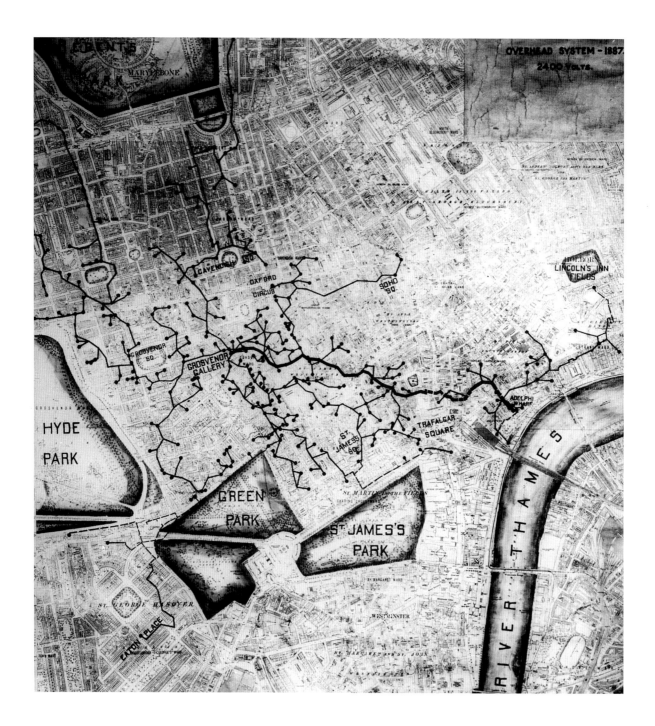

apt to turn into a "mutual admiration society" that would end up speaking only to themselves within the context of this new institution.[118]

Subsequent years brought the frequent appearance on Grosvenor Gallery walls of artists suspected of being particularly susceptible to influence – of allowing the singular style adopted by Burne-Jones, for instance, to override their individual eyes, minds, and hands. When the gallery was visited by men and women experimenting with new forms of dress (uncorseted gowns, subdued colors) and toilette, they were cited as evidence that this kind of artwork was contagious. As Linley Sambourne, George du Maurier, and Gilbert and Sullivan, among others, largely invented and gleefully lampooned an art world consumed by "cliqueomania,"

50

Grosvenor Gallery electrical distribution network, 1887. Museum of Science and Industry, Manchester.

51 (Opposite)

John Melhuish Strudwick, *A Golden Thread*, exhibited 1885. Oil on canvas, 72.4 × 42.5 cm. Tate Britain, London.

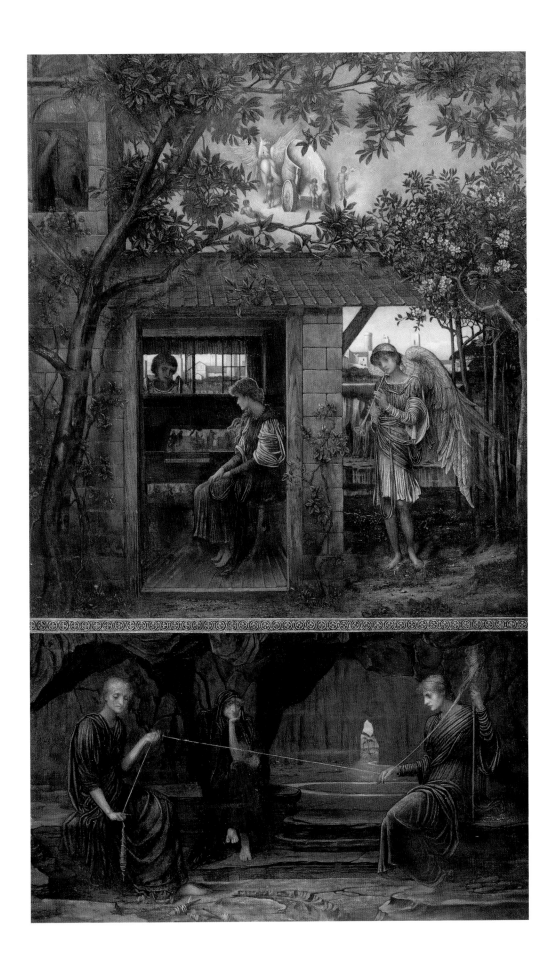

"Chinamania," and other self-inflicted "Aesthetic" compulsions, art critics seemingly could not decide which they found more troubling: on one hand, the Grosvenor's art and artists seemed to be thoroughly turned inward – in William Michael Rossetti's words, offering an "art turning forever on its own axis" – but on the other, Aestheticism was widely regarded as an uncontainable fad, possessing a dangerous potential for influencing gullible followers in art, dress, and life.[119]

Burne-Jones did not exhibit at the 1885 Grosvenor summer show, but his pupil John Melhuish Strudwick did, and *A Golden Thread* (fig. 51) received extensive critical attention, much of it negative.[120] In this tripartite composition, a young woman and soldier exchange a longing look through a window, while an allegorical figure (Fame or Love) serenades them, Father Time tolls the passing of the hours, and a chariot of love awaits them in the sky. Below, three Greek Fates spin out the titular golden thread, variously interpreted at the time as representing life or love, a shimmering strand in the "web of fate" they weave.[121] Looking at the painting's jewel-toned colors and its repetitious sequences of draped wistful figures arranged in a shallow, frieze-like non-place, the *Daily News* identified it as among the more "agreeable imitations of the methods and types of Burne-Jones"; the *Glasgow Herald* classed Strudwick with that artist's "most thorough-going disciples."[122] The *Aberdeen Weekly Journal* expressed relief that "we have got to the stage where aestheticism in this peculiar phase only lingers among the incurable."[123]

Strudwick, along with John Roddam Spencer Stanhope, Evelyn Pickering De Morgan, and Marie Spartali Stillman, were among those painters most consistently dismissed as "devotees" of the Burne-Jones "cult." What is surprising is the degree to which Aesthetic Movement scholarship today still reinforces this language of cult, worship, and temple when speaking of the Grosvenor artists and audiences, frequently collapsing Aestheticism and its caricatures.[124] Casually referring to them as a "cult" highlights one potential strand of meaning at the expense of most others, and evacuates the critical capacities of Grosvenor art viewers and Aesthetic art patrons as well as other associations the objects may have accrued. That language should be taken seriously, certainly, and examined with critical distance, but it should also be seen as part of a larger rhetorical vocabulary in which "cult" was one among many ways of gesturing toward the power and influence of a small circle of like-minded collaborators: the "mutual admiration society" some detected or feared at the Grosvenor, or, to put it in sociological terms, the institution's densely interlocking small-world network.

Within this context, we can see that when Sir Coutts Lindsay & Co. began to string its wires across the New Bond Street rooftops in 1885, the gallery's new technological system was plugged into this larger conceptual framework that already regarded the Grosvenor as a privately operated artificial generator of artistic values, extending its tentacles out to entangle the weak and the credulous. It must have been a powerful collision, this body of thoroughly ingrained assumptions and tropes, with the new electrical venture and with the gallery's further efforts to expand its reach (and improve its finances) by serving as a generator of artworks circulating throughout the country and the world.

Locally, the extension of the electrical network provided a freshly public way in which a subset of Londoners was connected with the Grosvenor in a self-

52

George Aitchison, *Design for the Interior Decoration of 15 Berkeley Square, Mayfair, London, for F. Lehmann, Esq: Elevation of a Wall in the Red Drawing Room featuring a Peacock Wall Frieze*, 1873. Drawing, 52 × 72 cm. Royal Institute of British Architects, London.

reinforcing cultural and technological circuit. Industrialist Frederick Lehmann was already linked to artists and musicians in the Grosvenor circle, including Frederic Leighton and Arthur Sullivan; he was a friend of pianist Charles Hallé, father of one of the gallery's co-directors, who played concerts at Lehmann's home in the 1870s and at the Grosvenor Gallery at various points throughout its tenure.[125] In April 1886, Lehmann was visited by Arthur Wade, the secretary of Lindsay's electrical company, who gave him an estimate for installing thirty-five to forty lights in the hall, staircase, and dining room of his famously "artistic" residence at 15 Berkeley Square.[126] The home's painted embellishments included the drawing room's stylized

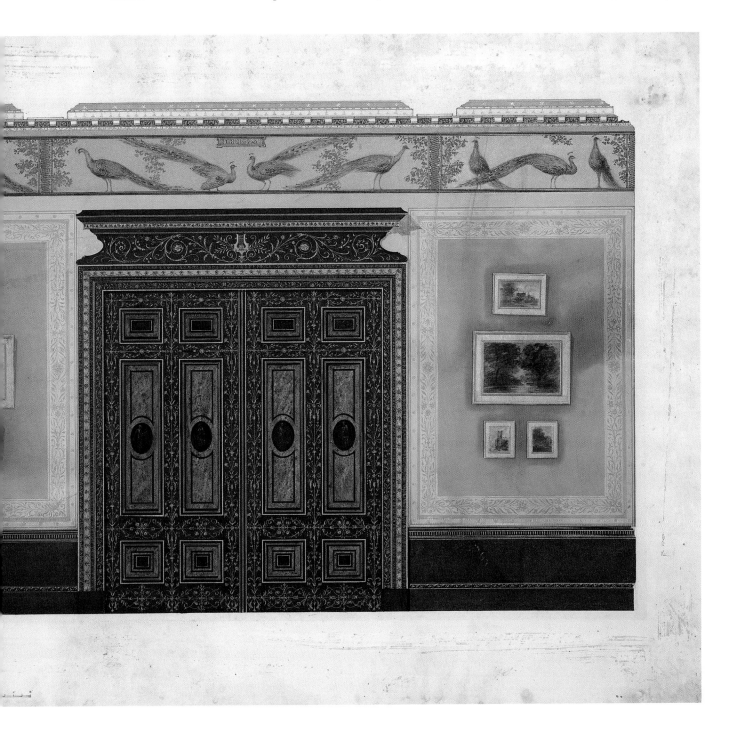

peacock frieze by Albert Moore and a dining-room sideboard adorned with Moore's decorative plaques.[127] George Aitchison's wall treatments wrapped around Lehmann's painting collection, creating a single harmonious unit, a perfect machine (fig. 52).

We have already witnessed the deployment of Liberty fabrics and décor at the Crystal Palace Electrical Exhibition of 1882; as early as September 1886, the firm took an estimate from Lindsay for lighting its Regent and Warwick Streets premises with a total of 285 incandescent lamps.[128] These properties were placed on the Grosvenor circuit in October, followed by Liberty's East India House in November.[129] That month, art critic T. Raffles Davison marveled at how thoroughly the technology had been incorporated as an artistic feature, alongside Liberty's historically costumed attendants: "The draping of the rooms and corridors and stairs in various-colored silks and embroideries under the softened electric light produced with these gaily-dressed girls a series of charming pictures," he wrote, "which are enough to make one wish for a little more brightness and beauty in our everyday life."[130] The advantages of incandescent electric light were much needed in Liberty's salesrooms at that moment. The firm was assiduously promoting its delicately tinted Indian Nagpore silk, advertising its "irregularity of weaving" that "produces a play of color rendering it unequalled for Art Drapery": subtleties that could hardly have been perceived under insufficient illumination.[131]

In 1887, a four-minute walk from the Grosvenor would have brought us to W. A. S. Benson's new showroom at 82–83 New Bond Street, located along the northern border of Lindsay's electrical network (to which he may or may not have been connected), and representing the leading edge of light fixture design.[132] Trained as an architect, Benson served as the chief metal designer and fabricator for Morris & Co., and was also a close friend and collaborator of Burne-Jones.[133] By 1883, Benson had begun specializing in lamps, among other metal brass, copper, and electroplated articles (including firescreens, tea kettles, and furniture).[134] Like Lindsay and Van der Weyde, Benson was absorbed at that moment in the mechanics of channeling light – whether produced by candles, oil, gas, or, from at least 1888, electricity – developing techniques for screening and reflecting to prevent unwanted glare and shadow.[135] In his promotional materials he discussed lamp design and placement as something that had to be carefully calibrated for each room, differentiating between general and focused lighting schemes.[136]

As he moved into the electrical field in the late 1880s and early 1890s, Benson continued to pursue designs inspired by natural forms, and he also seized the opportunity to transform electrical wires into draped or spiraling vines, incorporating them holistically into the decorative scheme of his fixtures. When surrounded by Morris & Co. textiles and wallpapers, as they often were, these motifs facilitated the organic integration of his lamps into their rooms. This was the case, for example, when Benson's fixtures were chosen as the medium for creating an artistic interior at paint manufacturer Theodore Mander's Wightwick Manor in Wolverhampton (1887–8), one of the first English country houses constructed with planned electrical illumination.[137]

Benson's electrical light fittings exemplify the modular character of Aesthetic decoration. Consider the adaptability of his bracket/table lamps, which can be seen in something close to their original installation context at Standen in East Sussex

53

W. A. S. Benson, brass
bracket / table lamp, Standen,
East Sussex, with Morris & Co.
"Willow" wallpaper. National
Trust, Standen. © National
Trust / Jane Mucklow.

(fig. 53), also adorned with Morris & Co. patterns. These adjustable lamps can be
positioned vertically or horizontally, or even hung over a bedpost; as placed at
Standen, on Morris's "Willow" wallpaper, the lamp draws its power from Benson's
electrical wiring and from the pattern's gently undulating organic vitality.[138]

Returning to the Grosvenor Gallery, then, we can now see that its
electrification not only provided an even, diffused glow suited to the shallow,
cropped, and flattened compositions of many Aesthetic paintings; it also affected a
marriage between a subdivided, modular form of artificial illumination and
pictures that could be similarly rehung and recombined for decorative effect. This is
as true, I contend, for the visually resonant paintings of the Burne-Jones circle as it
is for the works of Moore, whose 1887 Grosvenor contribution included the
explicitly self-referential canvas, *A Decorator* (private collection): in the words of
the *Standard*, "a thing of such extraordinary luminousness and gaiety of hue that
the young man seems to blink almost at his own brightness."[139]

Moving further still from the language of "cult" (and from London), we can also
consider the Grosvenor itself as a generator of works of art being distributed to
far-flung locations on an extended circuit. The gallery's history converges with
another phenomenon, the establishment of art museums in Liverpool (1877),

Manchester (1883), and Birmingham (1885), the patrons and administrators of which were in search of exhibition material that would aid in building awareness, enthusiasm, and funding for the arts in their cities.[140] In an era when many people warily noted the supply/demand ratio among a growing body of artists in relation to a limited number of art purchasers (individual and institutional), these three organizations hosted autumn exhibitions composed of the works of hometown artists as well as pictures sent from London, most of which were for sale. Organizers found themselves poised between satisfying those attendees who came to view the latest productions by local artists and those (in the words of *The Times*) "whose ruling desire is to have a good local reflection of the metropolitan achievements of the year."[141]

Many reports of these exhibitions tended to describe them as though they were outposts of the London venues; Liverpool's Walker Art Gallery had even begun to adopt a "Grosvenor hang" for part of its permanent collection in early 1884, an indication of that institution's far-reaching influence.[142] This impression became even more pronounced when the Walker's 1884 expansion enabled the organizers to offer to artists representing the Grosvenor Gallery, the Liverpool Academy of Arts, the Royal Society of Painters in Water-colors, the Royal Hibernian Academy of Arts, the Royal Institute of Painters in Water Colors, the Institute of Painters in Oil, the Dudley Gallery Art Society, and the Society of Painter Etchers – seemingly "every art corporation in the three kingdoms" – separate rooms in which to highlight each organization's works.[143] The room arranged in 1884 by Lindsay, Hallé, and Carr was thereafter referred to as the "Grosvenor Gallery," and Grosvenor artists were courted by Liverpool and Manchester as part of a heated competition between the simultaneously held autumn shows at the Walker and City Art Gallery, respectively. But dividing the artists according to their Royal Academy or Grosvenor achievements risks obscuring the significant amount of work that was done by local exhibition organizers. Far from being mere passive recipients of pictures generated elsewhere, the Walker's art committee, for instance, traveled to London each spring to visit artists' studios and place direct requests for paintings to be exhibited each autumn; they returned to London in the summer to make further selections after the Academy, Grosvenor, and other exhibitions had opened. As Edward Morris and Timothy Stevens describe it in their history of the Walker, this was a rigorously organized and ambitious program – one that made extensive use of ever-faster railway travel to transport committees and pictures back and forth between the metropolis and the "provinces."[144] While some local artists and observers registered legitimate complaints regarding proportional representation, others expressed pride in being able to command London resources to come to them.[145]

The Grosvenor circuit even extended, for a time, as far as Australia. As a result of discussions begun during the Colonial and Indian Exhibition at South Kensington in 1886, Lindsay dispatched 158 paintings, including works by Watts, Strudwick, Walter Crane, and De Morgan, to Melbourne's National Gallery in the autumn of 1887. It was the first of what Lindsay hoped might become an annual "Intercolonial Grosvenor Gallery."[146] Early reports indicated that it would, if successful, "go on to Sydney and Adelaide, and return by way of Canada."[147]

Although Lindsay had attempted to make it a "representative" show, featuring artists who were not strictly Grosvenor exhibitors, only twenty-eight of the paintings were sold, and the rest were returned directly to England.[148] This venture faced some of the same challenges as the Liverpool, Manchester, and Birmingham exhibitions, and the promotional materials for the project framed it as a similar opportunity for provincial galleries to add select works of art to their permanent collections.[149] But as Alison Inglis argues, the exhibition was both enthusiastically received and regarded as a vital cultural link binding the colonies ever closer to the empire.[150] As a commercial venture designed to meet, in Lindsay's words, the "growing need of a *more extended area* for English art," the exhibition embraced goals that precisely echoed the rhetoric of electric lighting company promotors.[151]

Taking the long view, though, it appears that circulation was a key driver of Lindsay's approach to the art business from the beginning. From its launch in 1877, the Grosvenor's gallery and satellite ventures (restaurants, libraries, clubs, and the electrical company) were conceived and often marketed as offering various admixtures of sociability, selectivity, circulation, control – and art. The Grosvenor Gallery Library was first installed in 1880. Presented as an elegantly appointed and respectable refuge for men and women engaged in various metropolitan perambulations – those wealthy enough to afford its annual membership fees, but not, perhaps, "select" enough to belong to an established London club – the library rapidly transformed into a "library club" for which the restaurant and gallery were offered as amenities. Eventually, in 1885, it was reconfigured as a club along more conventional lines, promising more exclusive access to the gallery's temporary exhibitions and abundant electric light. Finally, as the entire Grosvenor enterprise was falling apart in the 1890s, Lindsay floated the idea of a picture rental scheme.[152] This, effectively, would have transformed the gallery-as-home-of-the-gentleman-art-patron into a mobile and, above all, attainable, thing. In each of these endeavors, Lindsay found himself caught between an impulse toward expansion for maximum profit and influence, and the diminished power that resulted from diluting these financial and artistic resources, spreading them too thin, making them too select or, like an overcrowded private view, too accessible.

High Tensions

Visitors again took note of the terrible fog ("the thickest fog that ever choked a chancellor") and the "prettily shaded electric lights" at the Grosvenor winter exhibition in January 1887, a retrospective of the works of Sir Anthony van Dyck.[153] The artificial illumination enabled the galleries to open until 10:00 p.m. By this time the Grosvenor's hybrid identity of art gallery and electrical proving ground had been fully cemented. Of winter exhibitions, one reporter noted, "The pictures are sent by their titled or wealthy owners, who are naturally most anxious to see how they look amidst different surroundings, and possibly, too, in a better light."[154] At a shareholders' meeting, Swan United Company chairman (and prolific art collector) James Staats Forbes urged investors to visit the van Dyck display at the Grosvenor to study the effect of the company's own Edison-Swan lamps on the pictures – "the light is a capital one for showing such works of art" – and explained how thoroughly the two ventures had become intertwined:

The enterprising president of that gallery, Sir Coutts Lindsay, has formed a company for putting up installations of the electric light, and they are now lighting a great area round the Grosvenor Gallery, and are extending their operations in all directions … one can hardly believe that such an extension of electric lighting as that contemplated by Sir Coutts Lindsay's company can take place without greatly benefitting this Company.[155]

Swan United co-director Frederick Leyland seconded Forbes's speech. Leyland's home at 49 Prince's Gate, which contained Whistler's Peacock Room, was located well beyond the reach of the Grosvenor's electrical network, but at some point he retrofitted it to accommodate incandescent lighting (see fig. 2). Visitors would have found in his Aesthetic painting collection another opportunity to evaluate artistic applications of the new technology.

The business relationship between Leyland, Forbes, and Lindsay was reciprocal, and extended beyond providing a market for Edison-Swan bulbs. When the cables erected by Sir Coutts Lindsay & Co. began to interfere with neighboring telephone wires, Lindsay was able to settle the dispute easily, because Forbes was also (among his countless directorships) chair of the board of the United Telephone Company, with which Leyland was also actively involved. They had every incentive to solve these conflicts amicably, because at the same moment Lindsay's company was making plans to light Forbes's District Railway.[156]

Like Forbes, parliamentary representatives were pointing to the van Dyck exhibition at the Grosvenor as a demonstration of the light's capabilities, using it as grounds for advocating electrically illuminated evening opening hours at the National Gallery.[157] But for all the company's apparent success, it was during this winter display that the accident befell Richard Grove – one of the anecdotes with which this chapter began. Following this incident, the Siemens dynamo broke down on January 10, plunging nine miles of circuits into darkness.[158] Lindsay and his co-directors must have congratulated themselves upon the precautions they had taken against fire: the van Dyck pictures had been placed in special frames so they could be removed quickly in an emergency, and the gallery had a special fire brigade standing ready. Such arrangements, however, constituted a tacit admission that electricity was far from a harmless technology. As the Grosvenor network's expansion continued, these and other breakdowns brought "mishaps" and "misfortune" to the fore in public commentary about the company.[159]

Scholars in the field of "Thing Theory" remind us how malfunctions of all kinds – a broken-down car, a stubborn door – have the power to reveal the presence and impact of objects and systems that we otherwise ignore when they are operating correctly.[160] In Bruno Latour's thinking, the same holds true of organizations and other collectives; he advises us to look to conflicts and controversies (rather than, say, official mission statements) in order to understand how a group truly defines itself and its purpose.[161] Both of these points are worth keeping in mind when studying the Grosvenor's history, because the year 1887 brought both an overloaded electrical network and a famously public split between Lindsay and his gallery co-managers, Hallé and Carr, who resigned to form the New Gallery, with the vocal support of Burne-Jones, Alma-Tadema, and other artists who had been staples of Lindsay's roster. The simultaneous

breakdowns of the Grosvenor electrical web and its artistic administration revealed the inner workings (and weaknesses) of these systems as well as their previously underestimated extension into far-reaching sectors of London life.

The Sir Coutts Lindsay & Co. records for 1887 indicate that Lindsay needed money. Stretched thin, the electrical company's finances went into overdraft, and in May 1887 the board voted to borrow £5,000 from Lindsay's mother to keep it afloat. An overdraft again in June prompted a newly rigorous accounting of customers, some of whom had been allowed to coast by for several months without paying. Lindsay was scrambling to cover the cost of the company just as the Grosvenor's annual summer exhibition opened. Given the longer daylight hours, it is not surprising that contemporary reports offer no indication that electricity was used to illuminate this display. But it was a different situation altogether in the evenings, as additional electrically illuminated ventures were instituted in order to further monetize the gallery as a commercial concern.

The most conspicuous of these ventures was the founding of a new Gallery Club in May 1887, which coincided with the opening of the summer exhibition. It was organized in part by James Ludovic Lindsay, whose familial ties to Lindsay further cemented the connections between the family, the club, and the electrical company.[162] The Gallery Club, the press noted, marked a significant departure from the Grosvenor's long-term practices of hosting dinners in the restaurant or special concerts in the galleries: it offered members the opportunity to eat and drink (and smoke) in the electrically illuminated company of the pictures themselves. On its inaugural night, the Grosvenor was made as club-like as possible: a piano was placed on a platform in the West Gallery, and newspapers distributed across tables in the East.[163]

More explicitly than ever, the art of the Grosvenor was being used as an amenity to sell something else. The *Glasgow Herald* described the Gallery Club as simply "the Grosvenor Gallery lit up by electricity."[164] And as the lighting technology extended the Grosvenor's profit-generating hours well into the evenings, late visiting hours for the public were apparently curtailed. Lindsay shifted instead to a new year-round approach to exhibitions, instituting an autumn display, despite the waning daylight of that season.[165]

August 1887 saw the reincorporation of Sir Coutts Lindsay & Co. as the London Electric Supply Corporation, Ltd. This left the board of directors unchanged, but allowed the venture to recapitalize.[166] The first major project undertaken was the lighting of Edward Terry's new theater in the Strand, where electricity was promoted as an important innovation in safety, comfort, and aesthetics.[167] Press reports anticipating its opening night program, *The Churchwarden*, were eager to see what the Grosvenor Gallery system could accomplish. But the engine broke down: the electric light would not turn on, and the backup gas lighting system had to be deployed instead. Terry, humiliated, took the stage to apologize to the audience directly.[168] The incident was most unfortunate for Terry, as the apple-green and brown-pink tints in which the gallery was decorated had apparently been selected for view under electrical illumination.[169] It was also embarrassing for the electrical industry more broadly, as the *Telegraphic Journal* complained, because a significant opportunity to educate the public in the value of the new technology had instead resulted in calling attention to its failure.[170]

By the end of 1887, New Bond Street was recognized as both a center of the London art world and the center of its electric lighting industry, but both systems had become overstrained.[171] That November saw Grosvenor exhibition co-directors Carr and Hallé's public divorce from Lindsay in the form of letters-to-the-editor published and recirculated throughout the empire. The complainants stated that the "control of the Gallery" had fallen into "the hands of men utterly unconnected with art and wholly ignorant of its aims and requirements" and that "the conditions now attached to its management are no longer consistent with the dignity of the art we have tried to serve."[172] Or, to quote Burne-Jones's famous enumeration of these grievances, "Clubs, feasts, concerts, parties, advertisements placards, and refreshments – how they all vex the soul."[173] As one might have intimated from the Grosvenor's commercial exploitations described above, the ventures enumerated by Burne-Jones are collectively the departures blamed for the gallery losing its way. But Hallé provided a bit more detail in a private missive to Lindsay, lamenting, "You hardly ever come into the Gallery without Pyke on one side and Wade on the other."[174] Although not usually acknowledged as such, it seems clear that the electrical venture played a key role as a causal factor in this infamous split.[175] Perhaps the American publication *Nation* put it best when it identified the problem as Lindsay's "endeavor to set up as universal aesthetical provider."[176] The operational *use* of art (which was supposed to have been art for art's sake) had become too explicit.

Following Carr and Hallé's acrimonious departure, Coutts Lindsay carried on alone (with the help of art dealer Charles W. Deschamps), opening the *Century of British Art* exhibition in January 1888. But critics, while praising the exhibition for its educational value, lamented that it was doomed to serve as a mere accessory to the now infamous smoking club.[177] Rather than shying away from this unstable mixture of culture and commerce, Lindsay doubled down, inviting Whistler himself to lecture to members of the Gallery Club – where he apparently faced an unappreciative and restive audience.[178]

And the old clique? Burne-Jones, Alma-Tadema, and other former Grosvenor regulars made their debut at Carr and Hallé's New Gallery – illuminated by gaslight "as a set-off against the electric light of the Grosvenor."[179] The heat and heaviness of the gas seems to have been largely negated by the New Gallery's variegated marble-clad walls, living plants, and splashing fountain.[180] But gradually, as the New Gallery began to seek access to irreplaceable treasures for their winter 1889 exhibition of objects loaned by the Stuart family, it became expected, perhaps imperative, that they shift their operations from gas to electric. The *Telegraphic Journal* urged Hallé and Carr to consider using Grosvenor-generated electricity to do so.[181]

Meanwhile, still seeking new fields, Lindsay debuted the Grosvenor's first pastel exhibition in the autumn of 1888. It included William Llewellyn's *Waiting* (unlocated), described as a "life-size figure of a lady in green holding a green parasol, and standing against a green background, … seen under the electric light," and Sidney Starr's depiction of night-time socializing at the Café Royal (fig. 54), a longtime Grosvenor Gallery electrical customer.[182] But besides demonstrating that electrically illuminated spaces were considered particularly suitable subjects for this "modern" form of art, Starr's picture showcases the sparkling effects of the

54

Sidney Starr, *At the Café Royal*, 1888. Pastel on canvas, 61 × 50.8 cm. Private collection. Photo: © The Fine Art Society, London. Photo: Bridgeman Images.

"THE MOVING SPIRIT OF LONDON."

THIS POWER-HOUSE BURNS 500 TONS OF COAL
A DAY; IT CONTAINS—

8 TURBO-GENERATORS, running at
1000 REVOLUTIONS per MINUTE, developing
65,000 HORSE-POWER; to work
80 MILES OF RAILWAY
145 LIFTS and
900 CARS

For the USE and BENEFIT
of the PEOPLE OF LONDON

1000—J. 127.—15.6.10. T. WAY, Lith., Gough Sq., E.C.

advantageous amenity that had helped the Café Royal distinguish itself in a competitive London field, bringing the story of the Grosvenor Gallery as generator – as "universal aesthetical provider" – full circle.

Although the Grosvenor continued to host exhibitions through 1890, the period of its tightly intertwined art and electrical history concludes here, in 1888, the year in which a new Electric Lighting Act inaugurated significant changes in the field, among them a required shift from overhead to (comparatively invisible) underground wires. The London Electric Supply Corporation, already untethered from Lindsay's name, removed from the Grosvenor Gallery premises, and Lindsay announced the imminent relocation of the electrical plant in its basement to a new, much enlarged Ferranti-designed power station at Deptford, on the outskirts of town. With these changes, the artistic-electrical circuit in which modular, even-toned, organically extensible works of Aesthetic art and design had been used to frame and promote electricity was physically and conceptually broken. Just as incandescent lighting began to achieve wider acceptance, the popularity of Aestheticism was burning away – to be revived, one might say, in Thomas Way's nocturnal Whistlerian ode to Chelsea's Lots Road Power Station for the London Underground in 1910 (fig. 55), or Maxwell Parrish's Edison Mazda Lamp advertisements for General Electric, in the decades that followed. But in the few short years embraced by this case study, the Grosvenor Gallery provided a freshly visible exemplar of the potential gains and dangers posed by new types of cultural, technological, and corporate networked interconnection and control.

CHAPTER 3

Transatlantic Aestheticism and the Specter of Too Much Connectivity

During February 1885, multiple unattributed versions of the following anecdote circulated through American newspapers under such headlines as "One Ahead" and "Almost an Even Exchange":

> At a recent dinner party in London a dispatch arose concerning the exchange of genius between England and the United States. For every actor, singer, lecturer or person of note sent here by England, the United States made a return. There was Booth for Irving, Mary Anderson for Ellen Terry, Patti for Nilsson …; Joe Jefferson for Southern, and so on. At length, Alma Tadema, who was one of the guests, said: "England is one ahead of the United States. We sent Oscar Wilde over there but she had no fool to send back."[1]

Lawrence Alma-Tadema, the Anglo-Dutch classical painter who delivers the punchline here – alluding to Wilde's extensively publicized (and mocked) North American lecture tour of 1882, in which the poet set out to introduce Aesthetic Movement principles to the United States – was apparently deemed familiar enough to require no introduction. Engravings of Alma-Tadema's work had by that point been internationally distributed through the agency of print shops, galleries, and illustrated periodicals, and his lavishly decorated London studio-homes were among the favorite topics of foreign correspondents. But regardless of whether American readers recognized his name, the anecdote outlined a view of transatlantic contact that would have most certainly been familiar to a broad late nineteenth-century public: as made up of a series of exchanges or flows.

Contemporary observers on both sides of the Atlantic were closely attuned to flows of all kinds. This was a direct consequence of living in an increasingly networked world: a heightened awareness of international trade preferences,

Napoleon Sarony, *Oscar Wilde [No. 18]*, 1882 (detail of fig. 68).

shifting military and diplomatic alliances, immigration patterns, and large-scale political maneuvering facilitated by expedited, expanded, and consolidated transportation and communications systems. But in contrast to the neatly symmetrical returns of stage personalities sketched for comic purposes in this squib, the economic and cultural exchanges between Britain and the United States during the second half of the nineteenth century were not, in fact, understood to be evenly reciprocal. Indeed, anxieties about fundamental imbalances of trade, power, and influence consumed transatlantic discourse during this period, and artists and ideas associated with the Aesthetic Movement were caught in these tides and snares. As I will demonstrate here, Aestheticism was not merely entangled in this discourse, but rather embodied the distinctive possibilities and threats posed by various types of networks.

Throughout the late nineteenth century, British and American commentators complained that neither knew much about the art of the other. Period sources suggest that these two nations were generally more interested in watching what was happening in the French art world than they were in looking at each other. Paris, with its progressive and accessible art training centers, its important comparative international exhibitions, its treasuries of past masters, and its competitive gallery scene, was understandably a principal focus of British and American artistic attention. Likewise, in modern scholarship, France looms largest in the history of late nineteenth- and early twentieth-century art as it developed on an international stage. But perhaps this is reason enough to attend to Aestheticism as a specifically Anglo-American phenomenon: despite its cosmopolitan origins (in French art theory, English decorative principles, and Japanese compositional techniques) and its Continental parallels (most notably in Symbolism and Art Nouveau), Aestheticism offers one point of transatlantic cultural contact in which the relations and exchanges between Britain and America can be isolated and more closely examined.

It is difficult to make a precisely quantitative assessment of the American reception of British Aestheticism, but, considered most broadly, such commentary tended to be more critical, satirical, or dismissive than celebratory. (The characterization of Oscar Wilde as a "fool" in the above anecdote was certainly widespread, hence the satisfaction that Alma-Tadema might validate that view.) Certainly, there were many in the United States who took Aestheticism seriously or were patient enough to sift the good from the bad and the exaggerated, but it was often the sharpest, spiciest rebukes that traveled furthest.

This rather cool reception cannot, I believe, be separated from the particular relations between these two nations during the second half of the nineteenth century. During portions of this period, there was a very real fear that they would find themselves officially at war with each other; that American protectionism and British free trade were locked in an unsustainable conflict from which only one would emerge the victor and in which republicanism was used as a battering ram against British conservatism and social traditionalism. In this chapter we will witness Anglophobic currents coursing through American commentary on the Aesthetic Movement, helping us to understand why it never fully took root in the United States – at least not in a way that continued to recognize its British associations.

But beyond this, I argue, the transnational spread of British Aestheticism raised for American observers the disturbing specter of too much connectivity – a phrase I draw from Jan van Dijk's landmark study of *The Network Society* (1999), which explores the benefits as well as the dangers of living in a networked world.[2] Such a world is inherently unstable, he writes, and streamlined channels of transportation and communication also enable financial crises, disease, fads, and misinformation to spread potentially unchecked. Although van Dijk is writing of late twentieth- and early twenty-first-century conditions, we also see in the late nineteenth century, at the dawn of the network age explored here, an increasing awareness of the disadvantages of interconnectivity. It is my contention that Aesthetic painting and design became for some an embodiment of these dangerously contagious possibilities.

This occurred despite – in some ways, because of – the fact that Americans had few opportunities to experience British Aesthetic paintings directly on their native soil. Due to purely practical constraints, pictures that functioned as integral parts of decorative environments (such as Edward Burne-Jones's *Perseus* scenes discussed in Chapter 1) were unlikely to travel, and no U.S. art dealers specialized explicitly in British Aesthetic material during this period. And whereas Aesthetic pictures traveling to Manchester and Melbourne under the aegis of Coutts Lindsay's circulating Grosvenor Gallery brought something of their institutional context with them (see Chapter 2), they were not a major presence at world's fairs during these years, for reasons we shall examine below. This chapter demonstrates that under the networked conditions of the era, ideas traveled much further and faster than blunt, intransigent objects – with very specific consequences for how British Aestheticism was received in the United States.

These conditions help explain why the ideas Americans associated with British Aestheticism changed over time. Museum exhibitions dealing with American Aesthetic Movement material have amply demonstrated that countless late nineteenth-century American artists and designers eventually embraced variations of the modular, serial, decorative, systematic compositional principles that their British counterparts deployed.[3] The primary routes by which Americans learned about British Aestheticism have also been well established: the showrooms of Cottier & Co. in New York, the British displays at the Philadelphia Centennial Exhibition of 1876, George du Maurier's satirical *Punch* cartoons, and Oscar Wilde's North American lecture tour of 1882.[4] But upon returning to contemporary documents, what I found rather surprising was the fact that period discourse surrounding American Aestheticism so rarely acknowledged its British roots. My research indicates that during the early years of transatlantic cross-fertilization – the 1870s and early 1880s – the Englishness of Aestheticism was much discussed and debated in the United States, only to be largely dropped as a point of reference in later years. During these decades, American art critics and cultural commentators often exhibited contradictory and inconsistent attitudes toward Aesthetic material, complaining, for instance, about the impact of British architect and design reformer Charles Locke Eastlake while praising the products on offer at Cottier's: objects that were more or less a direct product of Eastlake-inspired construction. Others uncritically recirculated parodies of British Aestheticism and Grosvenor Gallery artists while simultaneously promoting the equivalent work of American decorative painters. What, exactly, was happening in these cases?

In attempting to answer these questions, this chapter returns to the familiar sites of Anglo-American Aesthetic contact listed above and retraces other, less frequently explored paths, arguing that the most pernicious assumptions that would eventually attach to British Aestheticism in the United States were established well before Wilde's arrival. Wilde, in fact, along with the British Aesthetic stage parodies that toured North America beginning in 1881, provided concrete confirmation for many American observers that their worst presumptions about British Aestheticism were true: that it was an imitative, ugly, anachronistic form of art promoted by hucksters and embraced by mindless consumers pursuing status for status's sake. As we shall see, these attitudes first began to crystallize decades earlier. British Aesthetic paintings were understood in the United States first through the lens of what Americans thought they knew of the Pre-Raphaelite Brotherhood, British design reform, and the poetry of William Morris and Dante Gabriel Rossetti; and subsequently through the institutional filters of Coutts Lindsay's Grosvenor Gallery, Henry Blackburn's illustrated exhibition catalogs and lectures, and parodies published in *Punch* and enacted on stages both public and private. These case studies are brought together here so that we might develop a clearer picture of the systems that alternately hindered and enabled the circulation of British art and artistic discourse in the United States during the second half of the nineteenth century, of what exactly Americans were laughing at when they mocked British Aestheticism and its practitioners, and of American Aesthetic anxieties provoked as much by the networked conditions of the historical moment in which the movement flourished as they were by the movement itself.

Traffic in Images

Economic concerns tended to take priority in discussions of international flows, particularly during this era of persistent financial depression. When Oscar Wilde arrived in New York in January 1882, the commercial basis for his visit was widely known in the United States, and his art "mission" (to share Aesthetic principles of home decoration and artistic appreciation) was viewed largely – and skeptically – through an economic lens.[5] Americans knew that London's Richard D'Oyly Carte had arranged Wilde's lecture tour as a promotional gambit to spur interest in the official touring production of Gilbert and Sullivan's new Aesthetic operetta, *Patience*, and many commentators exhibited an explicit determination not to be mistaken for uncritical provincials taken in by the Wilde "side show."[6] But in viewing Wilde as ground zero for the commercialization of Aestheticism in the United States, and his tour as the crucible in which a new concept of modern celebrity culture was forged, as many scholars have, we must not miss the important fact that late nineteenth-century Americans' rare encounters with contemporary British art had already been framed as commercial ventures privately organized by invested promoters and speculators for decades prior to Wilde's arrival – and had been, therefore, potentially compromised.[7] Gilded Age Americans placed him in a lineage of foreign vendors routinely suspected of attempting to unload second-rate, unsalable stuff (including but not limited to pictures) upon gullible consumers.[8]

This pattern dated back to the first exhibition of Pre-Raphaelite material shipped to the United States from England, the *American Exhibition of British Art* of 1857–8, held at New York's National Academy of Design.[9] A speculative venture spearheaded by retired British army captain Augustus Ruxton and the Pre-Raphaelite art critic William Michael Rossetti, it was intended not merely to blaze a path for British watercolors and oil paintings by Frederic Leighton, Ford Madox Brown, Elizabeth Siddal, and Walter Hughes, among others, to the walls of New York's rising class of wealthy citizens, but to establish a permanent outpost for the display and sale of British art in America.[10] Like another contemporary commercial venture, the first transatlantic telegraph cable, the possibilities of cultural outreach were hailed as simultaneously economic and diplomatic, even civilizing. In the summer of 1857, as Cyrus Field's 2,500 nautical miles of Atlantic telegraph cable were being constructed, divided, and loaded onto massive frigates to be threaded across the ocean from Ireland to Newfoundland, commentators on both sides hailed the *American Exhibition of British Art* as an effort that would similarly "open a channel of communication" between the two nations.[11]

As the cosmopolitan New York-based *Crayon* pointed out, however, "To mechanically link together two nations and two peoples is one thing, … but to unite them intellectually and morally is quite another thing."[12] After the first attempt to lay the cable failed, it took almost another decade for a successful attempt to be made (see fig. 13), and like the garbled early transatlantic messages it transmitted, English artworks sent to the United States had the potential to mark a *lack* of understanding between the two nations.[13] Many American art critics who had read and appreciated John Ruskin's appeals to the careful observation of nature found that the unusual visual language of the Pre-Raphaelite pictures did not translate. Ford Madox Brown (fig. 56) and his peers spoke, the *New York Times* complained, using "the most incomprehensible antique symbolism … Those of them who have nothing to say keep repeating the letters of the alphabet in an oracular manner, while those of them who have something to say insist upon saying that something in the Norman-French of the Plantagenets, instead of the improved English of her Most Gracious Majesty VICTORIA."[14] Expressions of baffled miscommunication cut both ways. Leighton, having sent two large, decorative canvases, found that instead of being purchased for the mansions of wealthy New Yorkers, their unclothed figures were hidden away for fear of sparking a prudish revolt.[15]

But in addition to a renewed awareness of geographic-cultural distance, there was, hanging over the entire affair, an American suspicion that no foreign commercial venture of this type could be fully trusted. Why, Americans wondered, would British picture owners, dealers, and artists have been willing to send their most treasured canvases in an era when steamships, lacking mid-ocean communication equipment, were sometimes known to vanish mid-journey and without explanation?[16] Rather than gauging the value of the pictures on their merits, skeptical critics questioned whether these works of art truly warranted the expense and risk of transporting them across the sea. "We know nothing of the parties who have attempted to palm this conglomeration of worthless things off on our American public as specimens of British art, but we suspect that there are professed picture dealers at the bottom of it, who have miscalculated the intelligence of our people," said the writer for *Frank Leslie's Illustrated Newspaper*.

"Our buyers are content to get good things from people they know."[17] Such responses demonstrate that in an era of faster steamship travel and fluctuating hopes for a transatlantic telegraphic communications channel, small-world networks were trusted in ways that nascent global networks were not.

"It is strange," Ruxton reported to Rossetti from New York, "in a city of traders, how much any enterprise gains in public estimation, if free from trade purposes."[18] He was referring to American skepticism of foreign commercial motives, but he was also writing during the onset of the first worldwide financial crisis of the modern era. While Ruxton had been en route to New York, another steamship, the *Central America*, had been caught in a hurricane off the coast of the Carolinas, sending 465 people and $1,600,000 in California gold to the bottom of the sea.[19] Soon, the loss of this specie – upon which New York banks were depending to meet their obligations – caused a brewing financial crisis to escalate into a full-blown panic, dashing the exhibition organizers' hopes for high-end picture sales. "I saw a wretched animal yesterday, who has been obliged to vacate a palace in 5th Avenue, without so much as enough to pay for a bed elsewhere," Ruxton glumly reported.[20]

This collision of incidents offers a vivid reminder of the speculative and explosive character of so much antebellum finance, and the degree to which British interests had become entangled with American markets. Thanks to dramatically

56

Ford Madox Brown, *King Lear and Cordelia*, 1849–54. Oil on canvas, 71.1 × 99.1 cm. Tate Britain, London.

shorter ocean crossing times enabled by improved steam service in the 1830s, the physical distance separating foreign capital from American investment opportunities seemed to collapse, and the period witnessed increased European and British financing of American government securities and railroads alongside continuing commitments in the sectors of mining, insurance, and land.[21] But, as Eric Hobsbawm observes in his account of this period, "global unification was not an unqualified advantage. For if it created a world economy, it was one in which all parts were so dependent on each other that a pull on one thread would inevitably set all others into movement." Hobsbawm vividly charts the outward rippling effects of New York's bank failures in 1857: "From the United States the crisis passed to Britain, thence north to Germany, thence to Scandinavia and back to Hamburg, leaving a trail of bankruptcies and unemployment, meanwhile leaping the oceans to South America."[22]

Ultimately, all of these economic and cultural obstacles worked against Ruxton and Rossetti's venture and were compounded by the fundamental dangers posed by shipping: some pictures were damaged during their return journey, and had to be repaired at great expense.[23] Their experience helps us understand why the few examples of British contemporary art that made their way to America at mid-century did so largely under the aegis of art world professionals rather than one-off coordinators. The London-based French dealer Ernest Gambart, a partner in Ruxton and Rossetti's venture, would go on to include a limited sampling of contemporary British work in the sales exhibitions he brought to the United States in 1859, 1860, 1865, and 1866, alongside current European pictures.[24] By the end of this run, however, art critics claimed to detect a fall-off in quality, and raised a louder complaint that "we are being overrun with secondhand third-rate continental works," requesting instead even a small collection "of first rate English pictures, including Turner, Holman Hunt, William Hunt, Millais, Hook, Sandys, Rossetti, Burne Jones, Madox Brown, Arthur Hughes and Brett."[25] The desire was there – these were artists whose careers Americans had followed in such journals as the *Crayon* and the *Round Table* – but no such exhibition was forthcoming, and interested viewers were forced instead to hunt for English pictures in dealers' galleries (namely those operated by Schaus and Knoedler), typically in engraved rather than painted form.[26] Notably, the handful of marquee British pictures that did find their way to the United States, such as Hunt's *Light of the World* (1849–53, Keble College, Oxford) and William Powell Frith's *Derby Day* (1856–8, Tate Britain), came in the form of painted duplicates, thereby reducing the risk posed by ocean transportation to singular works.[27]

Ten years after Gambart's last show, the Philadelphia Centennial Exhibition of 1876 offered not only the largest international display of art staged in America up to that point, but also the largest display of British painting.[28] American reviewers confessed to knowing little of current British art.[29] At the Centennial, the British section was loosely divided into an exhibition of "deceased masters" (Reynolds, Gainsborough, Turner, Constable, Mulready, Zoffany, Wilkie, Maclise, Etty, Frith, and others) and a main room featuring more contemporary work (three pictures each from Alma-Tadema, Leighton, and Poynter, in addition to examples by such artists as Watts, Hunt, Millais, Brett, Fildes, Calderon, Leslie, and Landseer). Watercolors (which included three more Alma-Tademas) were arranged along a

corridor.[30] American commentators noted approvingly that only a few of these works were offered for sale: an indication that Britain had sent a "representative collection" instead of a "commercial speculation."[31] This willingness to assume the risks of transatlantic travel without the promise of profit (this "generosity," it was called) set it apart from other foreign contributors.[32] But the non-speculative character of the British art display did not prevent American reviewers from detecting in its offerings the deleterious effects of the market. Some blamed the preponderance of sentimental story subjects upon British artists' (over)solicitation of middle-class tastes. "English artists are entirely under the domination of a class that does not comprehend art at all," complained the *New York Times*. "This is death to art."[33]

Although understood today as a watershed moment of cosmopolitan exposure and impact in the United States art and design world, the Centennial's energies were generally running in the opposite direction, attempting to establish wider foreign markets for the sale of American products.[34] Unsurprisingly, then, American commentators gave voice to a broad expectation that the benefits of the fair would accrue to home art producers. They hoped that at the very least the exhibition would spur increased American patronage of native paintings – particularly after the 1867 Paris Exposition had lured collectors toward amassing ever larger holdings of French Salon and Barbizon pictures.[35] Taking in the Centennial, Philip Quilibet in the *Galaxy* envisioned these art expenditures as an irregular series of flows, in which "a great part of the money spent by Americans on objects of art flows out to foreign pockets, while of foreign money for American art there dribbles back a very slender rill."[36] For these reasons, it seems unlikely that the Philadelphia fair could have sparked a widespread enthusiasm for English painting in America, regardless of what was sent for exhibition.

If, then, we are to understand why British art in general, and Aesthetic painting in particular, was not widely embraced in the United States during the late nineteenth century, we must understand not only the challenges involved in shipping physical objects, but also the impact of their self-designated spokesmen and mediators. Though not often considered in this transatlantic context, the London-based travel writer, artist, and editor Henry Blackburn served as a crucial, if idiosyncratic, conduit through which Americans learned about British art in the 1870s and 1880s. Blackburn tackled the obstacles faced by Ruxton, Rossetti, Gambart, and the Philadelphia Centennial art committees by proposing that British pictures be sent across the ocean in the form of illustrations: namely, photomechanically reproduced line engravings, which, he believed, promised clear, instantaneous communication between artists and viewers. But suspicions of foreign commercial profiteering still clung to Blackburn, and these, combined with his enthusiastic promotion of rapid visual transmission and his anti-tariff advocacy, evoked the promise and threat of interconnectivity and the specter of overproduction thrumming beneath early American encounters with British Aestheticism.

Blackburn's involvement with the U.S. art market began in 1873, when he first brought a collection of English watercolors and black-and-white drawings to New York for exhibition. His stated aim was to showcase and cultivate the graphic arts

– specifically, "to encourage and develop, both in England and America, the art of sketching in line as applicable to book illustration." Not only did the ever faster and wider circulation of images demand more dedicated artistic attention, he argued; photomechanical reproduction called for a new approach to engraved illustration characterized by selectivity and simplification: "What we ask for … is *better work* and *less of it* …, work which tells its story in the fewest lines."[37]

For the 1873 show Blackburn gathered exemplary contemporary works on paper from a variety of London art institutions and prepared to transport them to New York.[38] But, claiming the United States tariff rules surrounding the display and sale of foreign art remained unclear, he left England before submissions had been finalized. Assembled in only nine days, the exhibition clashed against Blackburn's inflated claims of being "on an art mission" to "influence" the United States.[39] The short-notice availability of the pictures he selected was seen by some Americans as a mark against them: they "are from the class of men who always have something nice on hand for the market, the other class, who can readily sell all they make, being hardly represented."[40] "How many years must an American wait," the *Tribune* wondered, "before we could get a drawing by … Burne-Jones, or Rossetti, or Sandys, or Madox Brown, or Whistler?"[41]

Very few of the sketches sold, but Blackburn insisted afterward that the exhibition had been so successful that the United States government had agreed to admit British drawings duty-free to all subsequent National Academy annual shows.[42] This did not happen. Instead, the project established a pattern that Blackburn would follow for years: publishing announcements that touted the achievements of his previous traveling displays; urging British artists to contribute to new ventures of ever greater scope; leaving England before American exhibition venues and tariff arrangements could be confirmed; and being forced to scale down or cancel shows when these issues could not be worked out on the fly. He often delivered radically different messages to his American and British readers, underscoring mutual benefit when speaking to the former, while dangling the incentives of sales and international fame before the latter.[43] From 1873, Blackburn, for better or worse, established himself as a nodal point facilitating artistic communication between England and America, writing and lecturing to each about the art of the other, while also promoting the art of illustration and arguing for removal of U.S. protectionist barriers to the unfettered international circulation of art.

Blackburn became a key enabler of this international circulation with the production of *Academy Notes* and *Grosvenor Notes*, two publications that he famously established in 1875 and 1877: independently operated, accessible, illustrated guides to England's annual exhibitions at the Royal Academy and Grosvenor Gallery, respectively. They were sold in England and abroad, along with titles Blackburn produced specifically for the American market, theoretically enabling works of art to circulate free of the gallery walls, and even free of the continents, on which they were displayed. Although the first illustrations were sketched by Blackburn and his team, he subsequently requested "short-hand" versions of the exhibited paintings from the artists themselves.[44] As he explained to American readers of *English Art in 1884* – a publication he had produced specifically for them – the technology of photomechanical engraving enabled

British pictures to escape the cloistered hall of the private collector, overleap the importation tariff, and bring the artist's very hand and eye into direct contact with the hand and eye of the reader (fig. 57):

> The communication between the artist and the public has thus become very rapid and direct. The artist, having completed his picture, puts down on paper, in the fewest lines, the leading features or accents of it; this memorandum or sketch is reproduced without the aid of a wood-engraver, and, by means of the printing press, multiplied over the world. There is no attempt, or should be no attempt, at making a finished picture; the object is to indicate, in the fewest lines and in the most direct way, what the artist had in his mind.[45]

"This system of expression, of communication between two minds by means of a few touches, is the great art of the illustrator," Blackburn concluded, implying that the highest success such an illustrator could achieve might be to disappear completely.[46]

Willing to trade absolute verisimilitude for immediacy, Blackburn claimed that such illustrations not only supplemented words, but might possibly surpass them in efficacy and speed.[47] Unsurprisingly, Blackburn's favorite metaphor for evoking this kind of instant, simplified, shorthand visual communication was telegraphic. Indeed, his obsession with telegraphy exceeded the realm of metaphor, because Blackburn believed, even as early as 1875, that it would soon be possible to send pictures by telegraph – at least in the form of basic outlines.[48] During the course of his career, this technology became a reality, and in 1887 we find Blackburn explaining to curious students at the Art Institute of Chicago how to chart visual information using a telegraphic matrix of the type illustrated in the *Western Electrician* three years later (fig. 58).[49]

Blackburn's American exhibitions (proposed and/or realized), essays, lectures, and illustrated publications sustained an ongoing, escalating fantasy of securing direct communication between artist and viewer regardless of distance and without the interference of a middleman.[50] And yet every one of Blackburn's ventures necessarily put *him* in the position of mediator and translator. The illustration of Burne-Jones's *King Cophetua and the Beggar Maid* (1884, Tate Britain) that Blackburn included in *English Art in 1884*, for example, did not in fact serve as a direct conduit between a British artist and American readers and viewers; Burne-Jones did not draw it, insisting (by Blackburn's account) "that no engraving should be made of a picture depending so much upon color and the artist's own handling for its expression." Blackburn overruled him, and created his own "memory-note, or map, of the principle lines" of the picture.[51]

If Blackburn's publishing ambitions and technological experimentation sometimes set him at odds with the very artists whose work he represented, his first American lecture tour both informed and alarmed his listeners. Blackburn's talks on contemporary British art, launched in November 1883, were illustrated with drawings, etchings, engravings, and photogravures, in the form of originals and stereopticon slides, and served as a key avenue for acquainting Americans with his preferred engraving techniques as well as the latest productions of

57

Edward Burne-Jones, *King Cophetua and the Beggar Maid*, in Henry Blackburn, *English Art in 1884* (New York: D. Appleton and Company, 1885), 141.

58 (Opposite)

"Sending Pictures by Telegraph," *Western Electrician* 6, no. 12 (March 22, 1890): 169.

trusts and gigantic industrial enterprises, which represent in no small degree the endeavor of capital or savings still to enjoy its wonted income, but in newer fields. Now I look upon the street railway business of the country, under the regime of electricity, as offering one of the best opportunities for local capital, and for what may be called the organization of local savings, which might otherwise lie around in napkins, like the unjust steward's talent, and be of no use to anybody. The capital in street railways in

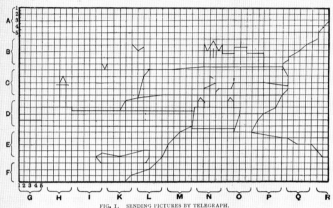

FIG. I. SENDING PICTURES BY TELEGRAPH.

America to-day reaches from $175,000,000 to $200,000,000. If the statement I have made as to the superior economy of electrical power be true, how much greater becomes the earning capacity of this investment, how much greater are the attractions held out to construct the hundreds of new roads that are still wanted and will be called for as our towns and cities grow? Of course, I am aware that it may be said that this showing might lead to a demand for lower fares. It might but the public is intelligent enough to know that other things are more necessary, such as better cars, with better heat and better light, improved tracks, faster running time and shorter headway, so that the 1,500,000,000 passengers on the street railroads every year may travel in all safety and comfort. Street railroads are peculiarly suitable as a field for local investment. Their operation can be watched all the time. They run under a man's eye when he is on the street, or past his window when he is home. He knows something of their officials; he can influence the domestic legislation they are subject to; he can assist in more ways than one to swell their earnings."

Telephone Trouble in Chicago.

The Chicago Telephone company has notified Prof. Barrett that the patrons of its service have been complaining of trouble on the line since the city began operating its North Side plant, and that the company is satisfied that the interference is due to the operation of the city plant. It was at first thought that the trouble was due to leakage, but examinations by experts of the telephone company have led to the discovery

FIG. 3. SENDING PICTURES BY TELEGRAPH.

that the trouble was caused by induction. Prof. Barrett replied that he would consider any statements the company would make, as well as any suggestions as to the best method of avoiding the difficulty. He is of the opinion that the trouble is not due to induction.

The University of Notre Dame, at South Bend, Ind., will be lighted with 12 Thomson-Houston arc lights.

Sending Pictures by Telegraph.

The accompanying cuts illustrate a method of transmitting sketches by telegraph. The advantages of such a method of communication lie in its applicability in time of war to telegraphing the position of an enemy, etc. It would also be useful in tracking a criminal, for his portrait could be transmitted rapidly from place to place. The method of working will be understood from the illustrations and the table. The original sketch is divided up into squares by means of

FIG. 2. SENDING PICTURES BY TELEGRAPH.

ordinates and abscissæ, and each square is identified by the letters which are ranged along the sides of the chart. Each of these squares is again divided into five parts, which are identified by the numbers 1, 2, 3, 4, and 5, and each such part is divided into two, and half the part is denoted by the letter j. Any point in the picture thus has two co-ordinates, as in analytical geometry, and these co-ordinates are communicated by telegraph. A broken line is, of course, identified by a number of points taken along it. When the sketch has been reproduced by joining the points constituting the lines, the details

may be filled in by the aid of the descriptive words added. The diagrams and table of the telegraphic message so fully explain the method that further comment is unnecessary. It may be of interest to add that the scene depicted in the specimen illustration is a view from Whitby Harbor. The cuts are reproduced from *Industries*. Following is the table giving the data for the construction of the diagrams, Figs. 1 and 2:

A₃R₃—A₅R₁—B₁R₁—B₂Q₄—B₄Q₁—B₄j }
Q₁—B₅P₅—B₅jP₅—C₂Q₁—C₄Q₁—C¹ }
P₅—D₂P₄—D₃P₂—E₁O₅—E₂P₅—E₂ } Foreground cliff.
Q₁—F₃Q₁—F₃O₅—E₅R₂—E₅R₃... }
D₃P₂—D₃O₃—E₁O₂—E₁O₅—D₃O₃... }
D₂O₃—D₂M₅j—D₂jM₅—D₂jO₂....... } Stone rampart (circular).
D₂N₁—D₁N₁—C₅jN₁j—D₁N₃—D₂N₃. } Watch houses (circular).
D₂O₁—D₁O₁—C₅jO₁j—D₁O₂—D₂O₂.. }
D₂N₃—C₂N₃—C₂jN₃j {...............} Flag staff.
C₄N₂—C₃N₄................ }
D₂jM₅j—D₂jH₅—D₂H₅—D₂G₅—D₅G₅ } Stone pier.
 D₅M₅...................... }
D₂H₁₃—C₃H₁—C₂H₃j—C₃H₄—D₂H₄. } Light house.
C₃j₁₂j—C₃jH₄j................... } Horizon.
D₄G₅—D₄G₁...................... } Water line.
D₅M₅—E₁M₃—E₃M₁—E₅L₅—F₂L₃— } Boat.
 F₄K₅—F₅K₄....... }
E₅K₃—E₄jL₅—E₅L₄—E₅K₃—E₄L₂— } Distant cliff.
 E₄L₃—E₅L₃—F₁L₂j—F₁L₅—E₅L₄.. }
B₅jP₅—B₅jN₂—C1M₂—C1L₃—C₂L₂— } Abbey.
 C₅jL₁—D₁K₄—D₂jK₃............ }
B₅jN₂—B₂N₂—B₃N₂j—B₁N₃j—B₃N₄j }
 —B₂N₅—B₃jN₅—B₃jO₂............ }
B₄N₃—B₃N₃..... }
B₄N₃j—B₂jN₃j {..... } Windows.
B₄N₄—B₃N₄... }
B₅jO₂—B₂jO₂—B₂jO₄—B₃jO₄—B₃jP₂ } Church.
 —B₅jP₂—B₃jO₃—B₃jO₃........... } Lower ledge.
C₅P₅—C₅L₅—D₁K₄—D₂jK₃......... } Old houses.
C₅N₄—C₄jN₄—C₄N₄j—C₄O₁j—C₃O₂ }
 C₃P₂—C₃jO₃.................... }
B₂K₅—B₃L₁—B₂jL₂.................. Seagull.

Chicago's Influence in Electric Circles.

"Chicago has been a disturbing element in electric lighting," said City Electrician Barrett of Chicago, last week, after dismissing a delegation of visiting officials, who had been inquiring about the operation of the electric system in that city.

"In the first place," continued the head of the Chicago electrical department, "the position of the city on underground wires started other communities in the same direction, and the telegraph and telephone as well as electric light companies were obliged to do something in the way of experimenting. The next movement that attracted attention was the establishment of a city electric light plant. It is now an established fact that electric lighting is the only proper means of street illumination, and I think we can safely say that we have demonstrated the fact that the city can do that kind of work a little better and at less expense than the commercial companies. Since these two features were introduced into the electrical problem in municipal service, we have had delegations galore. Chicago has been a sort of a Mecca for council committees, and they are always ready to make the pilgrimage when the Garden City is to be visited. I think that the position which we have taken here has raised the city in the estimation of the people throughout the country; they have come to respect the stand we took, which is in such striking contrast to the policy of New York. Of course, the electric companies which have been put to considerable expense through this action would be better pleased had they been let alone, but I hardly think it seriously interfered with them, for none of them has been badly crippled—they are still in business, and I guess they are not losing any money. At any rate, they maintain a prosperous appearance, and appear contented with their lot."

Grosvenor artists, many of whom were his friends.[52] But his celebration of unencumbered image circulation, his investment (artistic and financial) in photomechanical image reproduction technologies, and his vocal protestations against the art importation tariff transformed his lectures into demonstrations of an increasingly borderless international art world. Eager to attract audiences in the U.S. as in England, Blackburn was never one to resist a gossipy, crowd-pleasing anecdote, and enjoyed pointing out to his New York and Boston audiences John Everett Millais's profitable compositional repetitions. Millais "can dress up a little girl in one picture, perch her on a three-legged stool before a smoldering fire, name the picture 'Cinderella' and sell it for $15,000," he told them, "and then dress her in another costume, name the picture something else, and sell it for another $15,000."[53] But rather than serving as an interesting tidbit for his listeners (and flattering proof of Blackburn's own critical scrutinizing gaze), the widely recirculated story played into American anxieties about runaway production in foreign picture markets.[54] In the same talks he confidently hailed an imminent repeal of American importation duties: "the London artists are awaiting [it] with eagerness," warned *Harper's Weekly*, in its Blackburn lecture coverage, "and … as soon as the bill becomes a law they will empty the contents of their studios into the hold of the next steamer that leaves for New York."[55]

Taken together, these early exhibitions, illustrations, and promotional gambits painted a picture of a glutted British market bursting its borders and threatening to inundate the American art world with physical objects or, alternatively, through the lightning-fast transmission of images from artists to viewers. Americans complained about the lack of reciprocal opportunities for exhibiting native art in England, while Blackburn served as a constant reminder that markets were opening up in a way that they could not control, despite protectionist barriers. We will now enlarge this question of how these cultural transmissions were occurring to include American anxieties about what, exactly, was being transmitted.

Anxieties of Influence

In an era that preceded the establishment of permanent encyclopedic art museums in the United States, most artwork – especially contemporary foreign artwork – was necessarily encountered under commercial auspices. But there were developments specific to Aestheticism that bound it tightly to the mercantile world and led Americans to become simultaneously fascinated by and suspicious of it: namely, its close association with the field of art furniture making and selling in the 1870s. Let us consider, for example, one of the first places to see Aesthetic material with any consistency, the showrooms of Daniel Cottier & Co. on New York's Fifth Avenue, established in 1873. There, framed etchings, photographs, and ambrotypes of Aesthetic paintings were shown in juxtaposition and ensemble with wallpapers, textiles, furniture, and other ingredients for purchasing and constructing an artful home. The discourse surrounding this kind of decorative material laid the groundwork for why many Americans would come to think of British Aestheticism as a particularly contagious, uncontainable, unnatural, and troubling phenomenon.

After opening his first decorating business in Edinburgh in 1864 and founding Cottier & Company in London in 1869, the Glaswegian designer decided to pursue

a much wider field for expansion, opening outposts for sales and art dealing in Sydney, Melbourne, and New York in 1873.[56] Cottier was not alone in judging post-Civil War America to be an opportune field for British investment. The successful completion of the transatlantic cable in 1866 and the settlement of the Alabama claims via arbitration in 1872 (soothing Northern resentment of the British for supporting the Confederate Navy during the Civil War) shored up the relationship between the two nations and promised both a stabilized political sphere and ready access to information about American products and markets. After a period of wartime uncertainty and diplomatic conflict, England banked more than ever on the projected profits of American railroads, mines, and land in the form of both portfolio and direct investment.

But just five months before Cottier and his assistant James Inglis arrived in Manhattan, *Punch* published a satirical poem called "Jonathan's Lesson to John," depicting America (land of Brother Jonathan) as a place where John Bull (personifying England) could get rich quick – and get swindled even more quickly.[57] The risk, according to *Punch*, lay in a fundamentally imbalanced financial system rigged and run by political rings, "corners," wire-pulling, and other behind-the-scenes (and distinctly American) machinations. And indeed, only fifteen days after Cottier's 1873 arrival, Philadelphia- and New York-based bankers Jay Cooke and Company declared themselves insolvent, a shattering event that provoked yet another global financial crisis whose effects would linger until 1896. The international telegraph network that had so recently seemed to promise transparency and stability ultimately turned out to have been partially responsible for exacerbating the panic, abetting the rapid spread of false information.[58]

As far as Cottier was concerned, the flip side of these dangerously networked conditions was a high-speed, highly adaptable transatlantic publications landscape that had enabled a wide swath of American readers to receive some grounding in English design reform principles, thereby cultivating an appetite for the artistically chosen and manufactured decorative items in which his firm specialized. Partly due to the lack of international copyright regulation, Americans had been able for years to eavesdrop on British conversations about efforts to improve art education (with an eye toward improving the quality of manufactures) since the Great Exhibition of 1851, particularly through the efforts of the South Kensington Museum and schools and the systematic historical study they encouraged. Essays on British home decoration were published and republished in journals such as the *Eclectic Magazine of Foreign Literature, Science and Art* (New York, 1843–1907), *Littell's Living Age* (Boston, 1844–1941), and *Every Saturday* (Boston, 1866–74). Additionally, key texts synthesizing British design reform principles had also been recently circulated in the United States, including Bruce J. Talbert's *Gothic Forms Applied to Furniture, Metal Work, and Decoration for Domestic Purposes* (London, 1867; Boston, 1873); and, most influentially, Eastlake's *Hints on Household Taste* (London, 1868; Boston, 1872).

Eastlake introduced the term "art furniture" into American discourse, and, it was reported, such items could be found at Cottier's new establishment in large quantities. In *Hints on Household Taste*, Eastlake used the phrase to describe furniture purchased for the appearance and value of its craftsmanship and materials: some quantity of "art" added to mere utility.[59] At Cottier's, it formed the

decorative core of a world-in-miniature, accented by rugs from Morocco, Persia, and China; Venetian glassware and chandeliers; Greek tableware; and a replica of a stained-glass window commissioned by Queen Victoria.[60] This was the context in which reproductions (probably Frederick Hollyer photographs) of Aesthetic paintings by Albert Moore (fig. 59), Alma-Tadema, Thomas Armstrong, Simeon Solomon, and Ford Madox Brown, among others, were displayed to American viewers.[61] The result was the creation of an environment in which the boundaries between art and life and shopping were blurred. One visitor described a curtain for sale at Cottier's as "beautiful enough to make a portion of one of Alma-Tadema's or Armstrong's paintings."[62]

Here I wish to emphasize the way that American perceptions of Eastlake and British design reform framed the early reception of Aesthetic paintings in the United States as particularly, sometimes dangerously, influential. By the time Cottier's opened, Americans had been listening to and participating in the conversation begun by Eastlake for five years. What this transatlantic array of books, articles, and reviews on household decoration articulated, fundamentally, was the influential power of the material and visual culture that constituted the interior environment of the home.[63] Gilded Age American commentators continued a long national tradition of conceptualizing the home (particularly the middle-class home) as a character-, family-, and citizen-shaping crucible, and underscored, in turn, the need to steer the tastes of domestic shoppers and the professional decorators who guided them in the "right" direction. They amplified Eastlake's criticism of dwellings that had become uncomfortable, crowded, and

59

Albert Moore, *The Quartette*, photographed by Frederick Hollyer, 1895–7. New York Public Library, Wallach Division Picture Collection.

chaotic as a result of their owners blindly following fashion rather than actively exercising their common sense. Increasingly, this anxiety about passive, uncritical consumption was figured as a distinctly female susceptibility to the seductions of the marketplace.[64]

In this discursive landscape, the issue of "influence" was doubly, triply determined. If few American householders were satisfied with the home goods available for purchase in local shops or forced upon one's domicile by the dreaded "upholsterer," how were the manufacturers to be convinced (influenced) to produce better things? The public needed to demand such things, was the reply, and the market would follow – and so consumers needed to be taught to *want* improved goods.[65] Commentators insisted that art education was the solution to a full slate of challenges: artists, museums, journalists, and the authors of advice guides would raise the tastes of the broader public, while South Kensington-style collections and instruction would expose craftsmen and manufacturers to designs drawn from the full geographic reach of the historical past, thereby inducing them to develop better products.[66] Each of these influences was expected to operate upon the others, and upon the malleable human subject in their midst, with the ultimate result that Americans might live in more beautiful, more comfortable, more original, more individualized, more commonsensical houses, and become better people – better citizens – in the process.

Given the power late nineteenth-century Americans granted to interior furnishings, and the acknowledged leadership of England in the field of domestic design and decoration, it is crucial to ask what happened when these influences were perceived as flowing into the United States from abroad. The first American reviews of Eastlake's book treated it as equally applicable to American as to English life, occasionally evincing a sense of satisfaction that uninspired manufacture and unthinking consumption were as much English as American problems.[67] Certainly, Charles C. Perkins stressed Eastlake's universal applicability in his preface to the Boston edition of *Hints* in 1872.[68] Architecture and the decorative arts had national origins, Perkins acknowledged, but just as Renaissance artists adopted the styles of the ancient past in a manner appropriate to the spirit of their present moment, Eastlake and England were adopting Gothic designs, and the United States likewise might adopt these among other traditions.[69] Perkins wrote, however, that the modern age was at a distinct disadvantage, as the networked world brought nations together in a way that rendered them less distinct, making it difficult for each to evolve original and particular styles:

> Nowadays, under the pressure of universal exhibitions, telegraphs, railroads, and steamers, these nations are rapidly losing their individuality, and rubbing down each other's salient points. … Gaining nothing from each other, they look to past ages, and plunder them of obsolete shapes. The nations of Europe are much better situated than the citizens of the New World to do this effectively, for they live amidst the monuments, and in the atmosphere of the traditions which their ancestors have bequeathed to them. Nowhere, therefore, is modern sterility in the invention of form so marked as in America. We borrow at second-hand, and do not pretend to have a national taste.[70]

The solution, for Perkins, was for art schools to bring the "national mind" under "influences" which would help it to invent better, in a more informed way, so that Americans would have a comprehensive global and historical field from which to evolve and select designs best suited to them.[71]

But there were also those who eyed Eastlake's *Hints* and the Gothic style through the lens of otherness, and they tended to focus on the socio-political frameworks that differentiated England and America. Perkins himself risked republican revolt in his 1872 Editor's Preface by saying that taste, "above all other things requires to be aristocratically governed, that is, governed by the best."[72] The *American Builder* noted that the republican structure of the United States meant it lacked the social barriers that in England prevented aspiring strivers from mimicking those with more money, when in fact they should be living according to their means. For this reason, an advice guide written for a more stratified society might in fact have something to teach Americans about pursuing "a more simple and natural way of living."[73] But for Boston's *Literary World*, Eastlake's advice fell on deaf ears. "The book was written for the few thousand Englishmen who have no employment in life but the spending of their incomes, and who really need intelligent counsel and guidance in that *prima facie* simple work."[74] This perception – that the pursuit of artistic home decoration was a luxury of the (British) aristocracy, and that design reform amounted to a top-down attempt to shape the habits of ordinary Americans – would be a persistent one, as we shall see.

Making matters worse, as scholars have documented, Eastlake's paean to rational principles, honest workmanship, common sense, and critical thinking were transformed by the American marketplace into a fashion of its own.[75] Eastlake's *Hints* had located guiding principles in pre-industrial (often Gothic) craft techniques that boldly announced honest workmanship, and used them to demonstrate that modern consumers need not satisfy themselves with ugly domestic objects that often did not even fulfill their designated functions successfully. But as early as 1873, American furniture makers began churning out suites of loosely Gothicized designs in what they branded "Eastlake" style.[76] "This revolt against fashion has become the fashion," complained the *New York Times* in

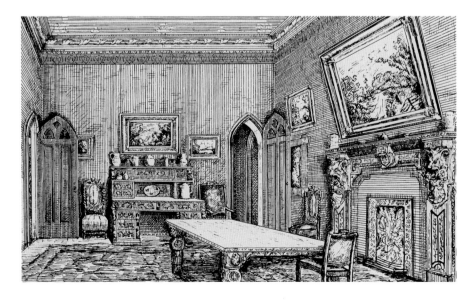

60

"The Dining-Room of Geo. O. Nichols, Esq., Cincinnati, Ohio," in Charles Wyllys Elliott, *The Book of American Interiors* (Boston: J. R. Osgood and Co., 1876), 87.

1875. "Everybody rebels in the same way."[77] Eastlake's perceived ubiquity in 1870s America, as showcased in interiors designed by Boston architect Charles Wyllys Elliott, among others (fig. 60), demonstrated the swift moving, influential current of fashion for fashion's sake.[78]

As "Eastlake" style spread, a cluster of associations attached to it, adding to suspicions that "medieval" furniture was troublingly foreign, aristocratic, and pervasive, the accusation that it was distinctly clunky and uncomfortable. "The predilection of the English authorities for heavy, straight work is well known," the *Chicago Daily Tribune* explained to its readers in 1875. And while such styles might be appropriate to a foreign physical constitution, Eastlake "did not write with a view to Western American civilization."[79] American consumers hungering after medieval furnishings came to be seen as not thinking for themselves – and, even worse, as willingly making themselves physically and financially uncomfortable.[80] When George du Maurier published a *Punch* cartoon mocking "Acute Chinamania" in certain porcelain-collecting British households in 1874 (fig. 61), it was lifted from its context and widely circulated among American newspapers without its accompanying illustration. The joke embedded in its caption – that a mother could value her china more than her children – was apparently deemed funny enough, and universal enough, without the image.[81]

61

George du Maurier, "Acute Chinamania," *Punch's Almanack for 1875*, December 17, 1874, unpaginated.

ACUTE CHINAMANIA.

May. "Mamma! Mamma! *Don't* go on like this, *pray!!*"
Mamma (who has smashed a favourite pot). "What have I got left to Live for?"
May. "Haven't you got *me*, Mamma?"
Mamma. "*You*, Child! *You're* not Unique!! There are Six of you—a Complete Set!!"

During the same years as the "Eastlake" craze, William Morris was similarly understood in America as forcing medieval English forms onto a modern world. As has been well established, Morris was known in the United States as a poet before he was revealed to be a designer of interior furnishings.[82] The American reception of his poetry in the 1860s and 1870s included much praise for his pursuit of lyrical art for its own sake, for his fresh take on old forms, and for his ability to use evocative details to transport readers into a vividly imagined world of dream. But, following his well-received American editions of *The Life and Death of Jason* (1867) and *The Earthly Paradise* (1868), the appearance of volume after volume of lengthy texts by the prolific (some said "prolix") poet gave way to some weariness; strategies that seemed original gradually revealed themselves to be somewhat repetitive.[83] Americans praised – then criticized – Morris for his remaking of language: for the forceful application of an archaic linguistic model.[84] "We must be mystical, [the modern English poets] say to themselves, we must be sorrowful, we must be 'grand, gloomy, and peculiar' – we must be anything rather than intelligible."[85]

When Morris came to be discussed in the United States as a designer, he was understood as part of a closely affiliated circle of second-wave Pre-Raphaelite artists and writers including Burne-Jones, Ford Madox Brown, Charles Augustus Swinburne, and Dante Gabriel Rossetti.[86] At first American commentators were reassured to learn that Morris was a working family man whose dye-stained hands bore the marks of honest toil.[87] But American faith in him gradually began to fade as he appeared less an independent force – the jovial paterfamilias-craftsman who feeds his babies by his decorating venture – and more a man "mixed up with a clique," a member of a "mutual admiration society."[88] The close relationship between poetry and painting among members of this group was as likely to be criticized as praised by American commentators: as though indicative of a troubling shapeshifting, an erosion of proper boundaries or principles governing the distinctive arts.

The dynamics of Morris's tight-knit circle mattered to outside observers because his firm was said to aspire "to carry the fine arts into matters of household decoration," exercising its influence "to mould the public taste."[89] Early reports of Morris, Marshall, Faulkner & Co.'s efforts – particularly their Green Dining Room at South Kensington – described their work as favoring green and blue tones and pursued on a room-sized scale, perhaps "too unique and too uniform for people to be quite certain that they will like it to the exclusion of everything else, and will never get tired of it."[90] The firm, it was reported, designed interiors as backgrounds against which dwellers moved, and was interested in extending their dictates to the costumes of the people themselves.[91]

Gradually, Americans had the opportunity to inspect work by Morris & Co. in person. As early as October 1871, Morris products could be found at the Boston boutique of J. F. Bumstead.[92] By 1873, his holdings had expanded to include Morris "wallpapers, tiles, stamped and unstamped velvets, curtain-stuffs, carpets, and the exquisite laces, fringes, tassels, etc., that go with these stuffs," and that same year Moncure Conway brokered the shipment of two dozen Morris wallpaper samples and a Burne-Jones-designed stained-glass window from London to Cincinnati for its annual Industrial Exposition.[93] But even the Morris & Co. admirer Conway had

to admit that the firm's designs "do not readily adapt themselves to a commonplace house inhabited by commonplace people" – implying that these assertive designs pushed the *self* to adapt, seeking a form suitable to its surroundings.[94]

At Cottier's in New York, Morris & Co. designs helped to create a borderless world embracing furnishing goods as well as reproductions of Aesthetic paintings. In 1875, Clarence Cook famously told *Scribner's* readers that "Cottier & Co. have serges in colors whose delightfulness we all recognize in the pictures that Alma-Tadema, and Morris, and Burne-Jones and Rossetti paint, ... the mistletoe green, the blue-green, the ducks-egg, the rose-amber, the pomegranate-flower, and so forth ... colors which we owe to the English poet-artists who are oddly lumped together as the pre-Raphaelites, and who made the new rainbow" (fig. 62).[95] Virtually no Americans would have seen any of these artists' paintings in color on their home soil aside from those of Alma-Tadema (distinctly not a "pre-

62

William Morris (designer) and Heckmondwike Manufacturing Company (manufacturer), "Tulip and Rose" furnishing fabric, 1876. Victoria and Albert Museum, London.

Raphaelite"). So although Cook asks them to call up a mental picture of the firm's line of furnishing fabrics based on the distinctive hues of Pre-Raphaelite (or Aesthetic) paintings, his readers, and visitors to Cottier's, would have actually been working in the opposite direction: using this list of characteristic hues to colorize, mentally, the black-and-white photographs and engravings they encountered on the page or in the showroom, again blurring the boundaries between objects and media.

Cook championed Cottier's holdings as the raw materials from which to build a coordinated domestic ensemble. But one man's harmony is another's contagion. Increasingly in the mid-1870s we see American publications promulgating a formula by which Pre-Raphaelite/Aesthetic paintings are linked to uncomfortable furniture and totalizing decorative schemes that run over all surfaces and remake them. They reprint and comment on British descriptions of an "art-furniture fever" afflicting London and overwriting common sense and individual taste.[96] Perhaps none was as influential as the Irish writer Justin McCarthy's 1876 account of an "aesthetic epidemic" overtaking the English metropolis, published in an American journal: "We have now in London pre-Raphaelite painters, pre-Raphaelite poets, pre-Raphaelite novelists, pre-Raphaelite young ladies; pre-Raphaelite hair, eyes, complexion, dress, decorations, window curtains, chairs, tables, knives, forks and coal-scuttles. We have pre-Raphaelite anatomy, we have pre-Raphaelite music. I have heard a melodramatic performer described as 'that clever pre-Raphaelite actress'."[97] It was, in short, an "all-pervading" "dictatorship," and, American writers warned, it was making its way to the United States.[98]

What I have tried to do here is not just revisit familiar moments in the Anglo-American Aesthetic timeline, but to draw out the ways that the early reception of Eastlake and Morris in the United States established a particular set of associations that would frame how Americans later understood Aesthetic painting: as foreign, unnatural, uncontainable, and uncomfortably close to both the influential realm of the home and the predatory realm of commercial profiteering. We will now add to this list the American anxieties that clustered around issues of imitation and decoration, which happened to coincide with the new international prominence of British Aesthetic painting in the late 1870s.

"Are we becoming imitators and not originators?" the *American Architect* asked in 1876, decrying American "merchant decorators" who had exhibited "sham" Eastlake Gothic wares at the Philadelphia Centennial.[99] Such concerns only intensified as imitation Morris papers began to spread among American vendors and Cottier's turned out American-made designs plagiarizing the British art furniture of E. W. Godwin – a widespread problem Godwin sardonically acknowledged in his slipware *Kawphyrite* (copyright) vase produced around the same time (fig. 63), asserting that the typically "Aesthetic" Anglo-Japanese/Egyptian coffee table design was in fact his intellectual property.[100] Such was the anxious nationalistic cultural tone in the United States at precisely the moment when Coutts Lindsay's Grosvenor Gallery opened in London, bringing British Aesthetic painting before the eyes of an international public in a new and hospitable manner. Unsurprisingly, the first years of American commentary on this venue found some critics castigating the

63

E. W. Godwin, slipware vase
with *Kawphyrite* [copyright]
Godwin coffee table, ca. 1877.
Height 20.7 cm, diameter
19 cm. Victoria and Albert
Museum, London.

Aesthetic artists that exhibited there as imitators and the gallery's visitors as
mindless followers of fashion.[101] American reviews of subsequent Grosvenor shows
in 1878 and 1879 slipped more frequently and vehemently into vituperations
against the "dyspeptic," "unhealthy" "imitations and echoes of Burne-Jones," among
others, featured on its walls.[102] American critics did not invent these tropes. But
the tenacity and vigor with which they used them to attack English artists who
appeared (to their eyes) to be more imitative than inventive is striking, given the
vulnerability of much new American art and design to a similar charge at precisely
that same moment.

The transatlantic conversation around the Paris 1878 exhibition is particularly
revealing in this regard. This international fair offered an arena in which American
and British artists, manufacturers, and commenters confronted and compared
each other, often triangulating their hopes, anxieties, and self-conceptions
through French examples. Divided into distinct zones by nation, the Paris
Exposition invited the same comparative analysis as all world's fairs. But as to the
question of expressions of national identity, the *New York Times* wondered, "What
can be expected when the milieu tends more and more, over the face of the globe,
to become the same? When Rome and Florence are falling into a marked
resemblance to London, and Cairo is a miniature Paris," and the goods of the
"Orient" are being designed for a Western market?[103] English critics made similar
observations. Philip Gilbert Hamerton fretted about both "the danger of too much
cosmopolitanism" and overproduction in the fine arts, and worried that the status
quo was unsustainable.[104]

As commentators set out to tackle these intersecting questions of nationality, art, and the market, they looked upon a complex field. British and American art writers both ceded the palm to France, admitting that no other nation could compete with its artists' confident and well-developed technical skills. Further, they agreed that the American pictures demonstrated significant technical improvement since the 1876 fair (which had not featured much recently produced work), and that these improvements were manifest in paintings that clearly bore the marks of the artists' Parisian teachers and residencies. Finally, American and British commentators concurred that the English display was particularly well selected and carefully organized, and featured strong contributions from many individuals that did not coalesce into any single "school."

This visual evidence, however, was interpreted in a variety of ways. Critics mounting an argument that American art was technically superior to English work framed American "Frenchness" as proof of their artists' adaptability, dexterity, and modernity, claiming that the English art looked isolated and insular by comparison.[105] From the other side, it was conceded that English art appeared untouched by Continental developments, but that its chief characteristic was substantive and thoughtful individuality, as opposed to flashy and facile Franco-American imitation.[106] England has "artistic nationality," Hamerton declared. "America scarcely has it at all ... They do not simply paint as Frenchmen paint, they think and feel as Frenchmen think and feel."[107]

Aesthetic painting was not a prominent feature of the 1878 exhibition. The English display contained only one Walter Crane oil and two watercolors, and the same small proportion of works by Burne-Jones. Frederick Sandys and Spencer Stanhope were also represented by one or two pictures each. As is shown throughout this book, Aesthetic paintings were typically conceptualized as modular and multiple, operating most effectively in coordinated settings. Distributed amongst the exhibits in 1878, they could not make the same kind of unified impression that they would have made at the Grosvenor or installed in a patron's home. But given the rhetorical position England took up at this fair – arguing that its art was not in fact insular and disconnected but rather independent and unmoved by the vagaries of foreign fashion – it could hardly afford to spotlight pictures by artists who were commonly linked to such things as "followers," "imitators," and "disciples." Even if there had been widespread agreement among British critics as to the artistic merits of Burne-Jones, for instance – and there certainly was not – his work could not be used to epitomize the singular originality of a lone clear voice. This helps us understand why Aestheticism was not embraced as a vehicle for expressions of national identity at this moment, for reasons that extend beyond its mere cosmopolitanism.

If the act of imitation involved giving up artistic selfhood in favor of another, the pursuit of decoration risked abandoning it in deference to the needs of a patron (or, at the very least, of the market). For this reason, too, Americans approached British Aesthetic painting with some grave reservations, for it was widely understood to be fundamentally decorative in nature. As early as 1870, *Every Saturday* had led American readers through the emergence of a "new school" of decorative art in England, comprised of artists such as Leighton, Watts, Moore, Burne-Jones, and Poynter, who put "realism on one side" in favor of "ideal spirit,"

and who demonstrated a particular sensitivity to the fit between image, function, and material.[108] Four years later, Moncure Conway highlighted these artists in his popular *Harper's Monthly* series on "Decorative Art and Architecture in England," followed by S. G. W. Benjamin's reports on the decorative paintings of Burne-Jones at the beginning of 1877.[109]

When the Grosvenor opened that year, providing more congenial exposure for precisely these artists, the decorative aspects of their work were much talked about in Britain and America, and this occurred at a moment when American artists moving in this direction were regarded with some skepticism. Two years earlier, in 1875, John La Farge had orchestrated a protest exhibition for American artists whose pictures had received insufficient encouragement by the National Academy of Design. Several of them were students of Boston-based painter William Morris Hunt, and La Farge opted to showcase their work by organizing a decorative installation of it at Cottier & Co. One of his own Japanesque compositions of fish and flowers (fig. 64), initially conceived as part of a multi-panel private commission for a patron's dining room, served as a keynote of the scheme.[110]

But there were those who questioned whether the efforts of the La Farge-Hunt group constituted a step forward for American art. Exhibition booster Richard Watson Gilder worked to convince his readers that La Farge's pictures were not merely decorative, and the fact that his panels were publicly linked to an abandoned commission potentially raised the specter of artistic labor spent in pursuit of an unfinished project.[111] When La Farge exhibited his *Wreath of Flowers* (1866, Smithsonian American Art Museum) at the Centennial in 1876, some commentators fretted that he was wasting his time on decorative work.[112] In 1879, his exhibits at the Water Color Society were criticized as "much labor thrown away" on still-life arrangements of Asian pottery and other *en vogue* decorative objects: "they raise the suspicion that he is trying to be popular."[113] Fears that La Farge had succumbed to a kind of decorative drain were seemingly confirmed in 1879 when he held a studio sale in Boston and announced his transition to full-time work as a decorator.[114]

That same year, the *Hartford Courant* published a dialogue set at the Grosvenor Gallery in which the American author's critical "friend" warned of the tyranny of the decorative: "no picture is considered 'beautiful' now-a-day, that is not 'decorative.' There's an angel … that will hang well beside a panel, or with one of De Morgan's plates."[115] From this perspective, the art world, driven by the impulses unleashed by Eastlake, Morris, and others, had debased itself as a producer of harmonious home accessories. The American exemplar of this trend appeared to be the Tile Club, first profiled by W. Mackay Laffan for *Scribner's Magazine* in 1879, also in dialogic form. Laffan listened in as these American artists debated whether and how they should be "decorative," whether the fashion for interior decoration was a "craze," and whether, as one "disciple of Mr. William Morris and Mr. Alma Tadema" insisted, wallpaper was the right medium for their artistic interventions; a more architecturally minded member of their group suggested that they should meet periodically to create painted tiles, drawing upon "the experience of our English neighbors" in this field.[116] One Tiler, however, openly acknowledged that the public's craving for decorative objects had definitely "interfered with the sale of our pictures."[117]

If British Aestheticism appeared to American eyes in the mid- to late 1870s as distinctly influential, imitative, and decorative, then it also seemed to be contagious: by 1879, Burne-Jones was associated with "a certain school of English painting which is having an influence on the art of our country," and expatriate New Yorker Charles Caryl Coleman was exhibiting markedly decorative work at the Grosvenor (similar if not identical to fig. 76).[118] Americans Elihu Vedder, John La Farge, and Thomas Wilmer Dewing were now being described as producing pictures reminiscent of the Pre-Raphaelite Brotherhood, for which the last was ridiculed in his debut exhibition at the Society of American Artists in 1878.[119] That organization had been founded just months after the opening of the Grosvenor Gallery as an alternative exhibiting society, and similarly aimed to provide greater exposure to artists who were pursuing non-narrative work in which the subject of the picture was less important than the means of art pursued in making it.[120] This is not to suggest that the society primarily showcased Aesthetic Movement painting, but rather that it and the Grosvenor were both understood as encouraging experiments in *l'art pour l'art*.[121] It was hung according to decorative principles.[122]

This is the network of associations that was already in place before the era of Wilde and British Aestheticism's most widely recognized caricatures in *Punch* and on the stage. Depending on one's perspective, the movement embodied a series of asymmetrical flows: potentially tainted by commerce; making its way through multiple widely distributed avenues of image and text; embraced by those with more money than taste; forcing uncomfortable English forms on the modern world; threatening to rewrite spaces, objects, and bodies; inspiring imitators; and, in its decorative aspects, potentially too beholden to patrons and purchasers. All of this was especially troubling to American observers who feared that their countrymen were inherently imitative in nature or at least in their free market practices. Small wonder, then, that they would pounce on the Aesthetic Movement as articulated by du Maurier, Gilbert and Sullivan, and Wilde, as the embodiment of all these things.

Punch, Parody, and the Proliferation of Popular Culture

If the 1870s had already proven British Aestheticism to be, to certain American eyes, disconcertingly imitative and decorative, exercising its power to remake and remodel within the influential space of the domestic interior, the 1880s supercharged these anxieties by revealing how quickly and fluidly Aesthetic signifiers could propagate. Consider a widely circulated anecdote that made its way across America in the summer of 1881: Mrs. Julian Hawthorne's account of "The Aesthetes" in *Harper's Bazaar*, which described the near simultaneous arrival of cartoonist George du Maurier and poet Oscar Wilde at the opening of Whistler's recent exhibition of his Venice pastels in London. "Mr. Whistler caught both these personages by the sleeve, and brought them face to face before one another … 'Look here, now, you fellows, I say, how was it? *Which one of you invented the other*, eh?'"[123] On its surface, the popularity of this squib reveals that Americans were familiar with Whistler's reputation as the master of sarcastic one-liners, as well as du Maurier's *Punch* cartoons satirizing the Wildean character Jellaby Postlethwaite, and enjoyed laughing at Wilde's ridiculousness – at someone who was effectively a

living caricature. Here I will probe just how nervous this laughter was, as American readers confronted the Aesthetic Movement as a phenomenon in which the boundaries between real life and its representations appeared to be dissolving, in which objects and people were seemingly self-reproducing via the uncontrollable medium of internationally distributed popular culture.

As is well known, du Maurier and *Punch* set the frame through which Wilde, Aestheticism, and its stage parodies were understood in the United States.[124] But the transatlantic dimension of this situation needs further attention. My survey of the popular American response to British Aestheticism reveals the degree to which nationalist attitudes and assumptions, combined with a heightened awareness of (and paranoia about) asymmetrical cultural and economic flows, framed how this material was understood.

Du Maurier's caricatures were evidently understood by Americans as lampooning Aesthetic London – its Pre-Raphaelite, Grosvenor Gallery world – as early as July 1878, when the *New York Times* discussed a cover illustration he had drawn for the short-lived society magazine *Piccadilly*. The American newspaper had harsh words for du Maurier's "sexless figures" whose preferences tilted toward the "thin and maudlin in art": a taste that *The Times* feared was actively "spreading." "I dwell on these things as a warning. The great American Republic is marching on to a higher civilization. Let it beware of the rottenness that comes of overcultivation, or the cant of incompetency which fools mistake for aesthetic rapture."[125] Over the next few years, du Maurier's cartoons would be scrutinized by Americans in imported copies of *Punch*, in collections like *English Society at Home* (London, 1880; Boston, 1881), and in widespread newspaper republication of the cartoons themselves, in which the captions continued to be much more widely distributed than the drawings.

This is how it came to be that long before Wilde and various satirical theatrical productions arrived to perform Aestheticism in the United States, Americans were already staging and laughing at du Maurier's *Punch* sketches in the form of drawing-room tableaux, a phenomenon that appears to have escaped scholarly attention. A strong impetus for this was *English Society at Home*, which put dozens of his cartoons and captions in the hands of party planners. Although du Maurier was only just beginning his Aesthetic satires at that time, the book did include some staples of the genre, namely "Refinements of Modern Speech" (fig. 65), in which a dour, strong-jawed and frizzy-haired "Fair Aesthetic" startles her buttoned-up dinner companion with the interrogative, "Are you *intense*?"[126] In December 1880, Mr. and Mrs. W. S. Hoyt of New Rochelle, New York, corralled their friends into staging a series of these scenes, an entertainment deemed so novel that it received both regional and national coverage. In fact, one of the organizers published a how-to guide in *Scribner's Magazine* shortly thereafter.[127]

Constructing these Aesthetic tableaux involved not only parroting the captions but following du Maurier's illustrations closely, and developing a deeper material knowledge of the Aesthetic Movement through the gathering of appropriate props, the design of telling costumes, and the painting of "Aesthetic" sets. The Hoyts' friends posed as Postlethwaite, Maudle, and the Cimabue Browns, among others; the *Scribner's* primer advised that young women wishing to play "Aesthetics" would have to be willing to "sacrifice all vanity": Aesthetic dresses were inherently

65

George du Maurier, "Refinements of Modern Speech," in *English Society at Home* (Boston: J. R. Osgood, 1881), no. 49.

Refinements of Modern Speech,

unflattering in cut and color, and "ladies of slight, girlish figures, with long, thin necks and prominent features" were best suited to such roles.[128]

Wherein lay the humor here? Some contemporaries regarded du Maurier's targets as high-society types without particular regard for national context, while others noted that there were American cliques equivalent (but not identical) to the artistic group he was skewering.[129] But on balance, his cartoons were understood as satirizing the English specifically. *Scribner's* tableaux guide advised that "actors hav[ing] the advantage of personal familiarity with English society" would have the easiest time embodying du Maurier's caricatures of "the fashionable follies in

certain London circles."[130] A Miss Lizzie Huntington of Cincinnati took up the Hoyts' playbook, and, we are told, thereby gained "insight into the weaknesses and foibles of London life and human nature."[131] Building on the ideas already associated with British design reform, Americans saw du Maurier as mocking a particularly lazy English upper class: the phenomenon of Aestheticism was understood to have originated with "certain brilliant young fellows, with more leisure than they knew what to do with" at Oxford.[132] In his caricatures, "people with money and nothing else never were more cleverly slain."[133]

What du Maurier offered – and Americans relished – was the opportunity to laugh at something distinctly English, urban, and elite.[134] We must recognize this as part of the deeper understanding that is being developed here of not just how British Aestheticism came to America, but what it signified – beyond anxieties about gender, which it provoked on both sides of the Atlantic, and which have been explored by other scholars in depth.[135] Tracking the U.S. arrival of Aesthetic stage parodies (and Wilde) at a granular level, with one eye on pre-existing assumptions about the movement, will help us place these phenomena in a more concrete and specific Anglo-American context. Namely, it demonstrates the ways that popular culture itself actualized the threat of Aesthetic contagion that so worried its satirists and critics.

On the night of April 23, 1881, immediately following the opening of Gilbert and Sullivan's new operetta *Patience* in London, a reporter from the *New York Herald* raced to scoop his journalistic competitors by telegraphing a description of the performance back to the United States via the French Atlantic cable. *Patience*, he said, was the latest blow in the "crusade against the so called 'Aesthetic', that is the crazy class, which clings to the skirts of artistic and cultivated sections of the metropolis." Without further elaboration on this point, he moved on to summarizing the two-act story:

> The opera opens in a scene representing a glade close to an ancient castle, where twenty "rapturous maidens" dressed in aesthetic draperies, playing lutes and mandolins, sing in the last stage of despair, all their love being concentrated on a male aesthete, Reginald Bunthorne ... A troop of dragoons come on the scene of their former heart conquests, but are chagrined to find their old sweethearts changed and indulging in the gushing jargon of pseudo-aestheticism, and refusing to listen to the suits of fleshly warriors ... [T]he colonel, major, and lieutenant of the regiment determine in the second act to become aesthetes with their warriors in order to win back their lost loves. By the time this is accomplished the girls themselves have seen the folly of their ways, have grown tired of the aesthetic creed and have returned to naturalness and vivacity.

"It is," the *Herald* reporter admitted, "scarcely possible in a cable dispatch to follow the details of the plot."[136]

Given the tremendous popularity of previous Gilbert and Sullivan offerings in the United States – including a number of pirated versions of *H.M.S. Pinafore* (1878)

and *Pirates of Penzance* (1879) – and the weakness of international copyright agreements, it was safe to assume that the new libretto would be crossing the Atlantic shortly. But this story concerns milkmaids, soldiers, and poets, not artists, and was set in an outdoor landscape, not within an Aesthetic interior. (Liberty & Co. did provide pastel-colored, softly draped matte fabrics for the costumes, however.) It is a satire at a second degree of removal, grounding much of its wordplay and visual humor in tropes that had already been given form not by Aesthetic writers and artists themselves, but rather by du Maurier's caricatures of them, as well as *Punch*'s sardonic reviews of London's annual art exhibitions.[137] In *Patience*, Bunthorne famously describes himself as "a pallid and thin young man, a haggard and lank young man, a greenery-yallery, Grosvenor Gallery, foot-in-the-grave young man!" The made-over dragoons striking "medieval" and "Early English" poses are embraced by one of the lovesick milkmaids as "perceptively intense and consummately utter" members of the "Inner Brotherhood." The equations drawn long before the opening of the Grosvenor Gallery still operate here: angular bodies that were of a piece with uncomfortable Eastlake furniture and Morris archaism.

The London opening of *Patience* led many correspondents to wonder which would be more accessible to American audiences: Gilbert and Sullivan's new pastoral musical comedy, or *The Colonel*, a second Aesthetic satire that had also premiered in 1881, produced by the editor of *Punch* himself in consultation with du Maurier, set not in an imagined "Gilbertia," but firmly in the present moment. *The Colonel* had actually opened in London first, debuting at the Prince's Theatre two and a half months ahead of *Patience*.[138] Although its premiere did not receive the same degree of critical attention in the United States as the highly anticipated *Patience*, a number of reviewers did attempt to explain its subject to their readers back home. Here, too, the *New York Herald* had been one of the first on the scene, this time apparently unconstrained by the limitations and expense of the telegraphic relay. Like *Patience*, *The Colonel* was a story of frauds exposed and Aesthetes transformed (fig. 66):

> Mr. Burnand's play opens with a scene representing the home of a Mr. Forester [*sic*], once a good-natured student of law, but now made desperate by the invasion of aestheticism in his once cheerful house. Lady Tompkins [his mother-in-law] … has become a convert to the "intense school" through the poems of an old art impostor, Professor Lambert Streyke, and she has succeeded in making the youthful Mrs. Forester quite as enthusiastic a worshipper at the aesthetic shrine as herself. Both ladies are dressed in the severest forms of aesthetic costume, with frowzy hair and dresses falling loosely about them. They sit in the ridiculous postures of Mr. Du Maurier's pictures, and when they talk express themselves in the most approved fashion of the "intense." They, like the "revered master," live in contemplating the beauties of the lily and in the constant endeavor to live up to the celebrated set of chinaware.

After the arrival and intervention of one Colonel Woottwell W. Woodd, of the United States cavalry,

66

Harry Furniss, "Sketches at
the Prince of Wales Theatre:
The Colonel," *Illustrated
London News* no. 2814
(March 26, 1881): 301.

Mrs. Forester is made acquainted with … the necessity of making her
home a place of welcome instead of glacial frigidity for [her husband] …
The next thing to do is to reveal the art professor as a designing charlatan,
and he is finally ignominiously kicked out of doors … Aestheticism is
banished, the ladies appear in ordinary costume and the curtain falls on a
scene of domestic happiness.

The *Herald* correspondent further noted that 1881 was "an opportune moment" for
this caricature, "long after the aesthetic craze was at its height, and when the
original founders have doubtless become as much disgusted as the public at their

brainless and sexless successors."[139] He then deferred to London's *Daily News*, which provided a capsule history of the Pre-Raphaelite Brotherhood, blaming its followers and heirs for taking a movement that did "a great deal of good" and "revived English art" and, through shallow imitation and social calculation, driving it into the realm of "absurdities."[140] The *New York Times'* reporter made a similarly careful effort to call attention to the Aesthetic Movement's legitimate roots and wide-reaching impact.[141] But most American newspapers covering the London premiere of *The Colonel* simply excerpted the *Daily News/Herald*'s plot description: "Aestheticism is banished" and "domestic happiness" restored before anyone had much sense of what it was or from whence it came.[142]

There was a brief lull in American coverage of London's *Patience* and *The Colonel* in the early summer of 1881, as D'Oyly Carte prepared to tour an American version of *Patience* with replica costumes and sets, to open at New York's Standard Theater in September. In June, however, the music and lyrics of *Patience* were published by Boston's Oliver Ditson & Co., which removed them from copyright protection. This launched a nationwide race to bring the operetta to the stage. By the first week in September, when D'Oyly Carte sent a handful of performers and the conductor P. W. Hatton to take over New York casting and rehearsals, theatrical manager Charles E. Ford (fig. 67) had already guided his opera troupe through two weeks of performances of *Patience* at Uhrig's Cave, a garden theater in St. Louis.[143] Ford's opera company, having scooped D'Oyly Carte's in making an American debut of this highly anticipated program, then relocated from St. Louis to the Grand Opera House in Baltimore. But right on Ford's heels was Emilie Melville, who premiered her *Patience* at the Bush Street Theater in San Francisco (September 1–17, 1881), and then headed east with great fanfare, forty performers plus crew in tow.[144] On the final day of her San Francisco tenure, the Boston Museum opened its *Patience* under the leadership of museum director Richard Montgomery Field.[145] These three troupes made fair bids to lock down the Western, Midwestern, and Eastern touring circuits before the cast of the official New York production had sung a single note in public.

If this wasn't enough, just one week after the September 23 opening of D'Oyly Carte's official *Patience* in New York, the Boston Museum announced that the strong attendance and enthusiasm that had greeted its performances of Gilbert and Sullivan's Aesthetic opera had led museum management to book a follow-up

67

Charles E. Ford's English Comic Opera Co., Valentine's Day Card, 1882. Chromolithograph, 6.5 × 11 cm. Library Company of Philadelphia.

entertainment: the first American staging of Burnand's *The Colonel*, opening on October 15, under the licensed supervision of London actor Eric Bayley.[146] (Indeed, it was briefly possible for Bostonians to witness *Patience* one evening and *The Colonel* the next.) Residents of Washington, D.C., who had seen Ford's troupe perform *Patience* at the Opera House in September were able to take in *The Colonel* at the same venue that December; and by the time the play reached the Philadelphia Lyceum, both the Boston Museum opera company and Philadelphia's own Gorman Church Choir company had acted *Patience* on that very stage. New York had to wait until 1882 to see *The Colonel*, as did Chicago, but neither city was short on satirical Aesthetic entertainment: *Patience* continued its residency at New York's Standard for six months, while Chicago witnessed the battle of two competing productions of the musical unveiled simultaneously three blocks apart in October 1881.[147]

And so it was that America found itself in the midst of an "aesthetic craze" of its own before Oscar Wilde had even boarded the *Arizona*, a craze born partly of an interest in seeing the latest Gilbert and Sullivan production (regardless of subject matter), and stoked by a wide range of geographically distributed theatrical and journalistic professionals seizing a clear commercial opportunity.[148] A number of American reviewers, like some of their British counterparts, clearly relished the experience of seeing through the whole thing, of pointing out that Aestheticism as caricatured did not exist: "there is really no legitimate warrant for all this satire. It is killing gnats with [Sir William] Armstrong guns."[149] But in this ongoing competition to perform the most careful skepticism and the sharpest scrutiny, other writers insisted that *Patience* and *The Colonel* did have some basis in real-life artists, designers, and poets; that these individuals were deserving of serious treatment and respect; and that it was their foolish, faddish followers that invited ridicule.[150] Between *Patience* and *The Colonel*, American commentators expressed a widespread preference for *Patience* as being the better written, more original, gentler spirited critique, attuned to the good as well as the bad in Aestheticism.

Most important for our purposes here, the arrival of *Patience* and *The Colonel* put American observers on the alert for visual signs of the movement's transatlantic transportation and transplantation. Given what we have seen were the scarce opportunities for residents of the United States – especially those living outside its urban centers – to inspect British Aesthetic objects for themselves during this period, it seems possible that many audience members may have first experienced aspects of Aestheticism firsthand as a full-color phenomenon while attending one or both of these productions. Both stories hinged on comparative demonstrations: Aesthetic dresses in Liberty fabrics changed into commonplace 1881 attire in the denouement of *Patience*, an artistic interior thrown up against a "sane" one in *The Colonel*. Both constituted an attempt to take the fight against Aestheticism to its own ground: a contest, it seems, that Aestheticism was not likely to lose. Confusingly, the advance press for the Boston and Philadelphia performances of *The Colonel* announced that this "satire on the aesthetic craze" "annihilates the blatant humbugs in art," while also inviting visitors to come enjoy the "beautiful aesthetic scenery and appointments."[151]

This conflicted and ambivalent attraction and repulsion characterized responses to these two productions in both England and America. In each play, the

visible signs of Aesthetic culture are used to mark out characters who have given up their selfhood under the powerful influence of others (the lovesick maidens longing after Bunthorne in *Patience*, the wayward Mrs. Forrester and Lady Tompkyns in *The Colonel*), or those who are wielding that influence (Bunthorne and Streyke, respectively). As both plays go to great lengths to show that Bunthorne and Streyke are, in fact, frauds, Aesthetic fabrics, furniture, painting, and poetry become the media through which those frauds are perpetrated and visually traceable. Using the word "humbug" in their press materials, *Patience* and *The Colonel* extended an invitation to audiences not simply to mock the fakery, but to experience the sublime thrill of proximity to a visual and material culture that was implicitly attempting to operate upon *them*: the pleasures of allowing oneself to be taken in while remaining simultaneously outside that net of power – the complex experiences that Michael Leja outlines in his work on turn-of-the-century skepticism and cultural engagement.[152] It is remarkable, after all, how many reviewers of these performances complain about the "aesthetic craze" afflicting modern society while also admiring the elements of *The Colonel*'s artistic interior or the first scene of *Patience*, in which twenty Aesthetic maidens in classical dresses holding antiquated instruments and singing "all worked together toward a harmonious whole."[153]

The Colonel landed stateside while the popular London production was approaching its 300th night at London's Prince of Wales Theatre. It gave American audiences the chance to experience the additional thrill of being closely connected by popular culture to something that was happening at that very moment across the ocean. What's more, it did so through a plot in which an American colonel steps forward to expose the falsities and fabrications of British poseurs; self-congratulation drips from the *New York Herald*'s characterization of the Colonel himself as "an American, polished, well versed in the ways of the social world, quick witted and refined."[154] And yet a vital component of that cultural participation involved something we have encountered before: a demonstrative unwillingness to accept uncritically a commercial cultural import of any kind. Skeptical American reviewers readily pointed out that it was not an original story at all, having been heavily adapted from Morris Barnett's comedic play *The Serious Family* (acted at London's Haymarket Theatre in 1849, but also performed in New York, where, one critic noted, it "has been a favorite for years").[155] *The Serious Family* was itself based upon Jean-François Bayard's *Le Mari à la Campagne* (Paris, 1844), with which many Americans were also familiar.[156] It was a poor situation for *The Colonel*, thematizing as it did the perpetration and exposure of artistic and cultural shams and imitations. Generally, American critics were so agitated by the possibility that Burnand might be trying to put one over on them – and so frustrated by the largely foreign constitution of the cast – that they appear to have barely noticed this otherwise flattering plot device.

By the dawn of 1882, *The Colonel* was already reported to have become a burden upon an American "public which is now sadly harassed with the wonders of what the facetious Mr. Wilde calls 'the modern renaissance.'"[157] When Wilde disembarked from the *Arizona* in New York on the morning of January 3,

announcing his intention "to diffuse beauty," the American *Critic* snapped, "we know quite as much as we need to know about aestheticism. All that is vital in the movement has long ago been absorbed into our households. Whatever is pretty in decoration or graceful in attire, or beautiful in literature and art, has found as ready a welcome in America as in England … No phase of modern society has been so thoroughly explored, conned, and appreciated by Americans."[158] The assumptions and anxieties that we have seen attached to early reports and experiences of British Aestheticism in the United States dogged Wilde as he embarked on a lecture tour that began in New York on January 9 and ended in Newport, Rhode Island, in mid-July, after extended perambulations across the continent. In response to his lectures on "The English Renaissance" and "The Art of Decoration," a number of American commentators endorsed the *Critic*'s view, citing the inescapable presence of *Patience* and *The Colonel* as only the latest evidence that Aestheticism was old news. While Wilde also found a number of appreciative listeners in the United States who were eager to advance artistic taste in their homes and communities, the general American response to his lectures was disappointment and dismissal, as the "One Ahead" anecdote that began this chapter suggests. Wilde's tour has been analyzed in depth by scholars.[159] What I want to do here is to draw out the ways in which Wilde confirmed the precise anxieties we have been examining thus far in this chapter, and reframe what, exactly, Americans were rejecting when they rejected him.

Americans who listened to Wilde's lectures heard his paeans to the passionate seeking after the study and creation of harmonious beauty in the experience of daily life as well as in new forms of artistic and poetic expression, pursued within carefully selected limitations. They heard him advocate the creation of a modern and timely art that would blend elements of Greek/classical and medieval/romantic spirit, imagining art as "a common intellectual atmosphere between all countries": what Benjamin Morgan describes as Wilde's vision of a "postnational 'empire' of art."[160] As Wilde's tour progressed, they heard him adjust from such high-flown artistic ruminations to pronouncements that more directly targeted civic leaders, manufacturers, and middle-class consumers, returning again and again to Ruskin-, Eastlake-, and Morris-inspired declarations on the importance of combining beauty and utility in all things.[161]

Crucially, in these talks directed from the first-person position of Wilde/England talking to you/Americans, Wilde lectured his audiences against imitating foreign artistic and decorative subjects and styles.[162] As he told the New Orleans *Times Picayune* in an interview, "This country affords the material for manufacturing everything the people consume … The Americans have too grand a destiny before them in manufacturing to neglect art, and they should have good schools of design everywhere, so that they may know how to make beautiful things, and to enjoy them after they are made."[163] But Wilde was widely regarded in the United States as little more than an imitator himself.[164] His debts to his intellectual predecessors were noted, and for many conjured the dreaded figure of the imitative and exploitative "sham" or "mountebank."[165] Imitation was, of course, the form taken up for ridiculing him, whether in the shape of university students who turned up at his lectures wearing burlesque exaggerations of his own costume, or of the "comical" figures of African Americans dressed like him and paraded publicly as

spectacles.[166] Meanwhile, official and unofficial images of Wilde, from du Maurier's cartoonish exaggerations to Napoleon Sarony's promotional photographs (fig. 68), appeared to (self-)generate seemingly infinite visual repetitions, reproductions, and echoes, eventually leading to a court battle over who, exactly, owned and controlled Wilde's proliferating public image.[167] Under these circumstances, Wilde's call for Americans to avoid becoming imitators was met with derisive laughter. But Wilde's discussion of manufacturing reminds us that transatlantic debates over the Aesthetic Movement occurred during a broader pitched battle for market share between England and the United States.

As we have seen, the 1878 Paris exhibition had already provoked widespread calls among native and foreign critics for American artists and manufacturers to turn to their home resources. It had opened during a period of global economic depression and attendant debate about whether England's free trade doctrine was the cause of or solution to its financial woes: whether free trade, protection, or some degree of "reciprocity" would ensure the most rapid return to prosperity and secure its long-term economic future. American producers of cheap, machine-made furniture and an array of mass-produced wooden household items (from towel racks to cradles) were already gaining a foothold in British colonial markets, eating away at much needed trade that might otherwise have benefited the mother country.[168] Meanwhile, tariff debates within the United States tended to be undertaken in terms of pro- and anti-British arguments. England – the older and more established industrial nation – was America's largest trade rival, and also offered the most persuasive case for the alternative system of free trade, a fact that was regarded by Americans with rivalry and grudging acceptance.[169]

Fundamentally, this battle was being waged over commercial goods: the very realm of *The Colonel* and *Patience* and Wilde. Exaggerated critical accounts of British Aestheticism, du Maurier's caricatures of it, and the stage parodies' exploitation of these tropes for comic effect (and economic gain) reliably featured over-the-top worship of "beautiful" things: sunflowers and lilies, blue-and-white china, bulky Eastlake or spindly Godwin furniture, Grosvenor Gallery painting – what Rebecca N. Mitchell calls a "bowdlerization of significance" in which objects take on outsize importance over the human.[170] Aestheticism, as we have seen, evoked a realm in which the commodity might have power over the person – a slippage of signifiers that would have been particularly troubling in the context of these Anglo-American battles for

68

Napoleon Sarony, *Oscar Wilde [No. 18]*, 1882. Photographic print on card mount, 33 × 19 cm. Library of Congress, Prints and Photographs Division, Washington, D.C.

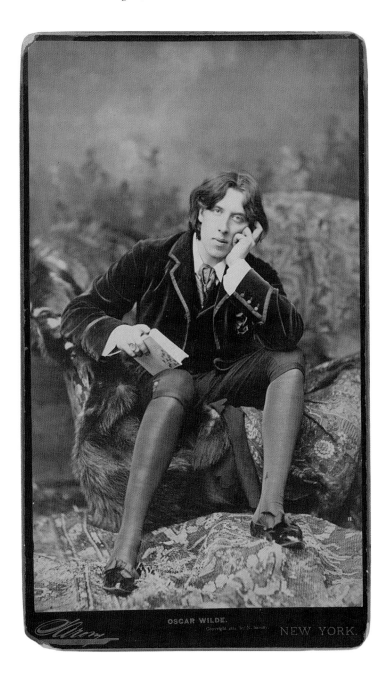

marketplace dominance. Indeed, Aesthetic markers such as Morris papers (real and imitation) were so recognizable that they effectively became market expansion personified: patterns crawling over every surface within a totalizing framework of interior coordination. Aestheticism embodied both the possibilities and the perils of networked interconnection.

Another dimension of Anglophobic reactions to British Aestheticism involved a rejection of the concept of aristocracy, with which, rightly or wrongly, it was often associated in the United States, an association that the stage parodies and the presence of Wilde further reinforced.[171] On the one hand, the late nineteenth century was marked by a broad awareness of the fact that the British aristocracy was becoming an increasingly popular social model for America's newly moneyed citizens. Aristocratic symbols, institutions, and other touchstones played a prominent role in status signaling among American elites during this period.[172] Certain American women and their families, hungering after titles themselves, publicly pursued marriage markets abroad.[173] But on the other hand, what was fundamentally at issue, as Frank Ninkovich reminds us, were general concerns about the national and international status of American republicanism. Global contact put Americans in greater dialogue with other forms of government and led many to defensively or chauvinistically shore up the benefits of their own. Given the economic conflicts outlined above, there was particular disdain in the U.S. at precisely this moment for Tory Britain, aristocrats, tradition, hierarchy: anything that distinguished England from American conceptions of republicanism.[174]

Those who fretted about the American embrace of British aristocracy were not merely concerned with what might happen. The U.S. economy hit bottom in 1877–8, the years surrounding the founding of the Grosvenor (by a titled aristocrat) and the spread of information about British Aesthetic artists. In non-coastal areas of the United States, the relationship to British absentee owners and investors was already a sensitive issue, and American farmers explicitly feared the rise of Irish-style landlordism. Extensive distrust of British ownership of American lands was bound up with larger network-based anxieties: that land was less and less likely to be owned by the person living and working on it, but rather was increasingly swept up in trusts under the control of far-flung financiers.[175]

Given the intensity of Anglophobia in the trans-Mississippi West and South, it is perhaps unsurprising that Aestheticism and Wilde were regarded – and frequently rejected – as signifiers of urban culture as it was supposedly nurtured in both England and the Northeastern states. As urban protectionist manufacturers squared off against free trade farmers, the latter grew to resent playing a colonial role in relation to both national and international centers of power and decision-making.[176] American economic nationalists and populists forged equations that linked England with the East Coast financial elite.[177] This helps explain the *intranational* Aesthetic commentary entwined with discussions of its international referents. The Louisville *Courier-Journal*, for instance, devoted several weeks to criticizing the *New York World*'s coverage of Wilde as evidence that "whatever an Englishman persists in must be imitated by his slavish admirer, the New Yorker."[178] "That which is really laughable is the slobbering snobbery of New York society, which can find nothing better to lionize."[179] Meanwhile, Atlanta observed that an "esthetic craze is very very prevalent in New York now, and the wildest vagaries of

the play writer, as indicated in *Patience*, have almost ceased to be a satire."[180] And North Carolina pointed the finger at a cluster of Northeastern imitators: "No city would have followed more promptly in the way of New York and Boston in a transplanted aesthetic craze than Pittsburgh. It always goes to extremes in such matters among a certain class."[181] These incidents reveal the further complexities of the American reception of British Aestheticism, which needs to be understood as having distinctive regional vectors and variations, and cannot be taken at face value in any kind of simplified way.

British Aestheticism arrived in the United States simultaneously with and as a result of new technologies improving transatlantic transportation and communication, enabling the creation and expansion of global markets. This networked system brought Americans into a rapid but heavily mediated contact with Aesthetic ideas and, eventually, things. The conflicted American reaction to the movement embraced everything from eager incorporation to mocking rejection, and this was, I argue, at least partly due to a broader ambivalence about the new degree and scope of international networked interconnection: a phenomenon demonstrated and exacerbated by the spread of identifiable Aesthetic markers that signaled a totalizing approach to the construction of fully coordinated, harmonious spaces and selves. Economic and social assumptions further encouraged nationalist suspicion of the movement, or motivated laughter at it. Taken together, all of these elements help us understand why, in the chapters that follow, American artists clearly practicing British Aesthetic principles were not necessarily recognized as such. Suspicion of the decorative, as we shall see, continued to stoke anxieties that artists were increasingly abdicating creative agency in favor of the desires of patrons and collectors. We will now examine those phenomena from the inside.

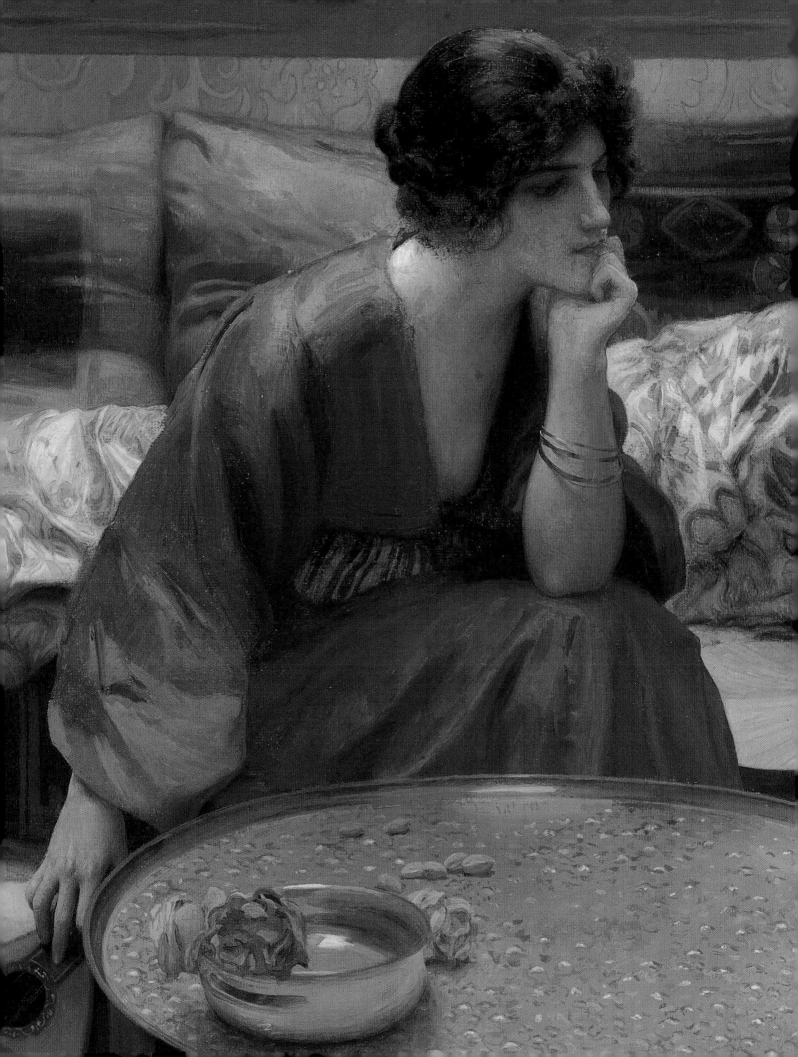

CHAPTER 4

Aesthetic New York:
Selection, Comparison, and Arrangement

For two weeks during the winter of 1883, some of the most influential art critics in the United States crowded into New York's American Art Galleries alongside roughly 3,000 other visitors to view the nation's first major exhibition of contemporary American pictures assembled by a single collector. The show offered a rare public opportunity to gauge the health of American art in a display unrestricted by internecine National Academy feuds or the sway of particular jurors at the artists' societies. And it was no random sampling of idiosyncratic collectorship: it reflected over a decade of focused acquisitions by one man, New York linen-collar entrepreneur Thomas B. Clarke, whose taste for American paintings had been profoundly shaped by a transformative encounter with a George Inness landscape, *Gray Lowery Day* (1877, Davis Museum, Wellesley, Mass.), a few years earlier.[1] This collection was not on its way to the auction block; rather, admission receipts were directed into a fund for a $300 prize to be awarded in Clarke's name to the best American figure painting exhibited at the Academy each year. As the U.S. government had just handed down a crushing 33 percent tariff restricting the importation of foreign art, the issue of home production was particularly pressing, and *New York Times* art critic Charles de Kay remarked that Clarke's exhibition would be "the straw that shows the current."[2]

What visitors saw were 140 domestically scaled landscapes and figure paintings by American artists, many still active, executed in styles that represented a wide cross-section of contemporary practice. Inness was a dominant presence, accompanied by several canvases that testified to Clarke's taste for decorative figure paintings by such Aesthetic Movement-inspired artists as Thomas Wilmer Dewing, Edwin Blashfield, Elihu Vedder, and Francis Davis Millet, among other genres and styles.[3] Art critics and commentators bombarded this array with a number of urgent questions. What would the exhibition accomplish?[4] Would it increase public interest in American art and encourage more people to become

H. Siddons Mowbray, *Idle Hours*, 1895 (detail of fig. 82).

purchasers of it?[5] What form should that art take, and how should it be fostered?[6] How broad or narrow is this collector's taste, and what does it tell us about the state of American art?[7] Is this collector acting on his own, or merely following fashion – and can we trust his selections?[8]

Clarke's taste and methods were subjected to such rigorous public trial because, in a country that lacked official infrastructure for supporting arts education or purchasing pictures for national collections, the task of fostering high culture ultimately fell to individuals ("amateurs") rather than to artists or agents of the state. In one notable recent example, New York's merchant class, in the absence of federal support, had stepped forward to establish the Metropolitan Museum of Art in 1870, and continued to remain largely responsible for its management and acquisitions, which were almost exclusively confined to art gifts.[9] Its trustees and donors, like many wealthy art collecting Americans, chased Old Masters or Salon prizewinners with an eye toward personal investment, acquiring an international range of works through dealers, auctions, Salon exhibitions, or directly from the artists themselves. They relied heavily on pictures whose value had already been validated by external criteria: the art press, exhibition awards, and a pedigree of price.

But facing the risks of a market flooded with forgeries, competition for foreign masterpieces, and appeals to cultural nationalism, several patrons and collectors in and beyond New York turned, as Clarke did, to the relatively young field of American art during the final quarter of the nineteenth century. Their purchases were hailed with expressions of patriotic gratitude, but because they were expected to exercise a powerful influence over domestic artistic production and prices, they were also held up to special scrutiny. Where internationally vetted external criteria were absent, the American holdings of amateurs like Clarke were examined for internal consistency. Wary of "reckless patronage," art critics increasingly pressured collectors to operate according to some kind of discernable system.[10]

Among the much-discussed pictures in Clarke's debut show was a canvas by Munich-trained New York artist Louis Moeller (fig. 69). In it, a woman stands in an interior – identified by some contemporaries as a studio – examining a print; a portfolio rests at her feet. The room is filled with artistic bric-a-brac: prints and drawings, eastern carpets, porcelain vessels, and a reduced bronze copy of a Greek sculpture. Moeller, in choosing this subject and this compositional format (in which he limits himself to a relatively shallow interior space paralleling the picture plane), highlights his own selective eye and controlling hand. The Clarke picture, which was almost certainly the Moeller now known as *In the Studio* or *Elegant Woman Looking at a Print*, was exhibited in the collector's 1883 display under the more active title, *The Selection*.[11]

The Selection was, like Clarke's other pictures, presented as a selection within a selection. In the words of the *New York World*, "[a] prominent painting has been made the center on each wall and around it have been grouped those works most accordant in subject and treatment," accented with draped rugs as well as potted palms and ferns.[12] Taking in the whole, Charles de Kay discerned in Clarke's collection the same careful selection embodied in Moeller's painting. He approvingly announced that Clarke was demonstrably not among "the rich men who order pictures as they do carpets, by the square yard and on the word of a dealer."[13] Moeller's *Selection* may be too detailed in its Munich-inspired realism to

69

Louis Moeller, *In the Studio*, 1883. Oil on panel, 36.2 × 28.6 cm. The Lunder Collection, accession number 037.2009.

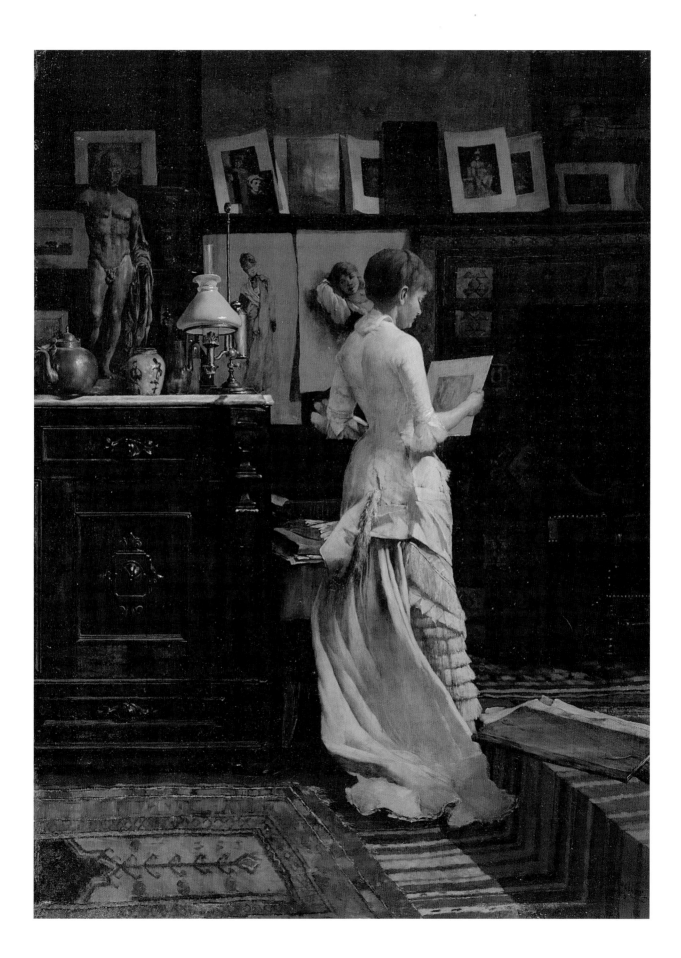

70

Louis Moeller, *Art Connoisseurs*, 1890. Oil on canvas, 20.32 × 24.9 cm. Private collection.

be classed strictly as an Aesthetic painting, but it is nevertheless a literal celebration of art for art's sake.[14] It belongs to a larger constellation of studio pictures produced on both sides of the Atlantic during these years, many of which epitomize ideas associated with the Aesthetic Movement, from Whistler's Japanesque harmonies, arrangements, and caprices of the 1860s to William Merritt Chase's Tenth Street studio interiors of the 1880s. While it is technically true that every work of art is the product of some process of selection, non-narrative pictures, as we have seen, tend to make this process explicit: take away story, specificity, and sensation of deep space, and the activity and evidence of selection are largely what remain.

Moeller's was a useful picture to have in a collection if one's capacities as a selector were constantly being thrown into question, as Clarke's were, and it serves as a suggestive platform for introducing this chapter's key themes and players. In the case studies that follow, I probe the arrival of Aestheticism (and its pictorial priorities more broadly) in the United States at the exact moment when a number of burgeoning businessmen-collectors were actively working to demonstrate their connoisseurial bona fides. Aestheticism wore its method on its sleeve, and for American amateurs who embraced its conception of the canvas, the art collection,

and the domestic interior as integrated systems, their coordinated displays – in their homes, public exhibitions, social clubs, and even in their places of business – offered conspicuous proof that their acquisitions were neither haphazard nor superficial. Pictures like Moeller's effectively thematized good collectorship, testifying to the artist's – and, by extension, the owner's – possession of a selective hand, a comparative eye, and a flair for harmonious arrangement.

But a central argument animating the following case studies is that this equation also operated in reverse: the capacities of selection, comparison, and arrangement were precisely the skills sought after and admired in the turn-of-the-century businessman. A period witness to these tendencies, Moeller mapped the overlap between these realms in other paintings, rendering the activities of *Art Connoisseurs* (fig. 70) functionally indistinguishable from those of *Three Men having a Discussion over Paperwork* (fig. 71). But if these skills were valued among American businessmen generally, they were essential for those who spent their days managing the importation, manufacturing, and sales of dry goods. The art collectors examined in this chapter – collar-maker Clarke, wholesaler William T. Evans, and retailer George A. Hearn – gravitated, whether they realized it or not, to paintings that affirmed the broader cultural value and applicability of their practical business skills, implicitly elevating their workaday practices of perception and management to the level of an art.

Analyzing this historical collision of cultural and commercial thinking and seeing is essential, because as Charles de Kay and his fellow art critics anticipated,

71

Louis Moeller, *Three Men having a Discussion over Paperwork*, undated. Oil on canvas, 47 × 62.2 cm. Private collection. Gray's Auctioneers.

the collecting habits of these Gilded Age businessmen did indeed profoundly shape the contemporary American art world. Under them, I contend, art patronage operated both directly and implicitly, blurring the line between the activities of commissioning and collecting works of art, as well-known purchasers acquired such gravitational pull that the art market seemingly bent around them. Artists competed for the attention of these businessmen-collectors as they became leaders at New York's influential social clubs, where they introduced new types of "harmonious" small-scale club art exhibitions organized according to their comparative principles, as we shall see. Several of them used their success in this private cultural arena to launch themselves as leaders of art associations that attempted to steer the networked circulation and exhibition of works of art at the local and sometimes national and international level.

In all of these cases, the tastes of a few came to carry disproportionate weight in the turn-of-the-century American art world. This chapter concludes with an examination of how and why their influence extended even beyond their active collecting lives. Some sold their holdings, flooding the market with pictures that answered to their distinctive tastes; others became the first major donors of home-grown art to American institutions, laying the foundation for what has become the national cultural patrimony. Studying the fate of these collections is a matter of continuing concern, as art museums in the United States remain no less dependent on the gifts of wealthy businesspeople today than they were a century ago. We are accustomed to asking how patrons have historically used art to their advantage; these scenarios push us to consider whether there are cases in which business skills, priorities, and thinking have been allowed to shape and determine our conceptions of artistic quality and value.

Showcasing Selectivity

Selectivity was a major theme in American art criticism of this period, and was a standard held up to evaluate both art patrons and the fledgling museums to which they made donations. The word suggested a fusion of incisive perception and decisive action, and captured the double process of building up and paring down an art collection. Selective vision was a mechanism of both protection and self-assertion; few art dealers, it was believed, acted in anything but their own self-interest, and, in league with unscrupulous counterparts across the Atlantic, were happy to unload second-rate pictures upon eager, naive American collectors.[15] One had to develop a razor-sharp eye that could size up a picture, appreciate its essential qualities, and detect fraud, or else risk being regarded as dilettante rather than skilled amateur. In 1899, dry goods wholesaler and patron of American art William T. Evans wrote a letter to the *Art Collector*, criticizing the insufficient selectivity of the Metropolitan Museum of Art, vis-à-vis paintings given by donors: "It would have been better had the Museum authorities earlier established the practice of looking gift horses in the mouth. A higher standard would have been set and much valuable wall space would have been saved if dozens, yes, hundreds, of the 'treasures' had been rejected."[16]

Evans's letter was more than just a critique: it was a public act of image construction, shoring up his identity as a selective art collector in the face of the

72

George Inness, *Georgia Pines*, 1890. Oil on canvas, 45.3 × 61 cm. Smithsonian American Art Museum, Washington, D.C. Gift of William T. Evans, 1909.

common accusation that businessmen failed to realize that "the mere accident of picture ownership may not necessarily make one a connoisseur."[17] He operated in some of the same artistic, philanthropic, and business circles as Clarke, and his development and deployment of an intentional collecting program was evidenced by his treatment of his own art collection as a holistic group. His holdings included landscapes by George Inness (fig. 72), Dwight Tryon, and Henry Ward Ranger, and non-narrative figure pieces by Thomas Wilmer Dewing, Frank Millet,

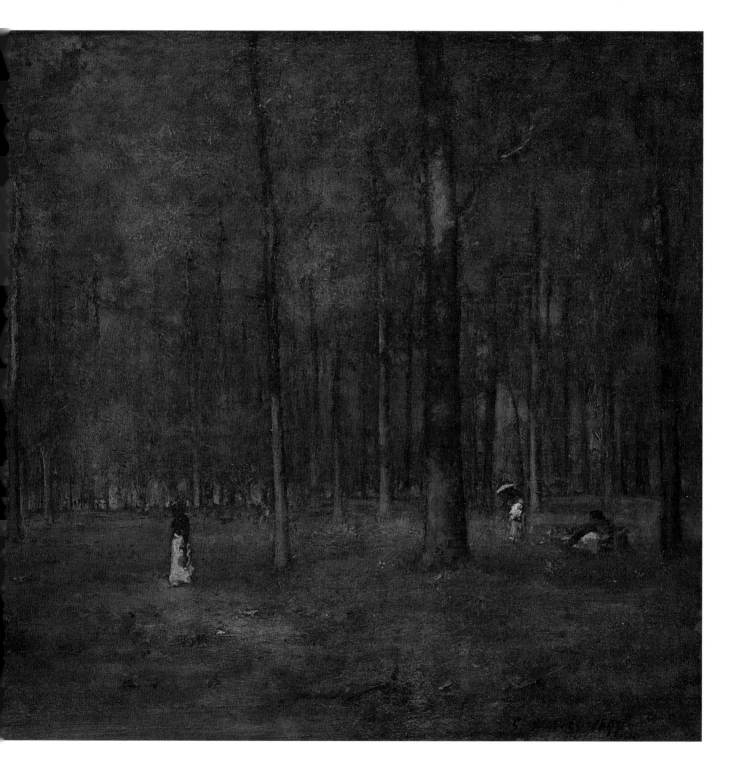

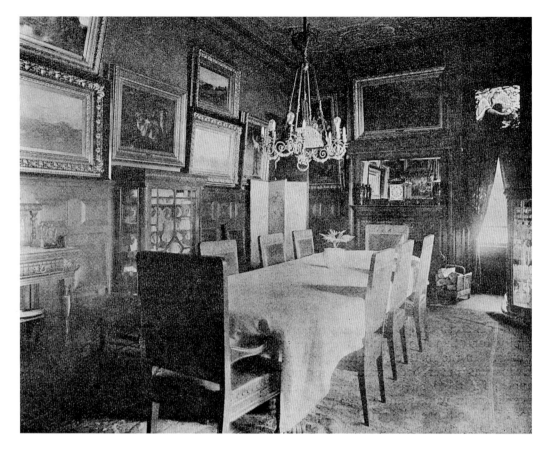

73

Dining room in the house
of William T. Evans
(photograph by Davis &
Sanford), *Art Interchange* 43,
no. 2 (August 1, 1899): 35.

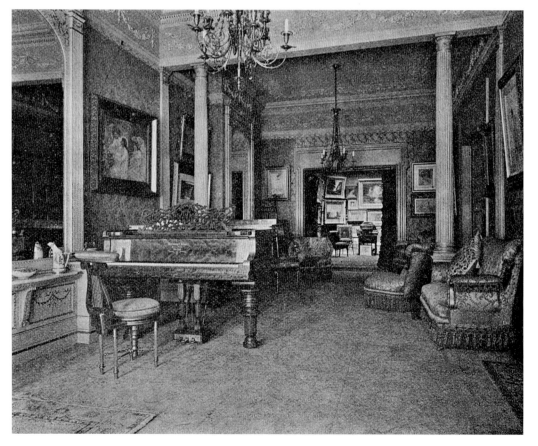

74

Music room in the house
of William T. Evans
(photograph by Davis &
Sanford), *Art Interchange* 43,
no. 2 (August 1, 1899): 35.

and Frederick Stuart Church.[18] Works by these and other artists variously associated with Aestheticism, tonalism, Symbolism, and the American Renaissance, which served only as keynotes in Clarke's collection, constituted nearly the whole of Evans's. Despite the important differences in these artists' projects, their non-narrative canvases generally shared similar tendencies toward lateral expansion of the picture plane and close coloristic harmonies over sharp contrasts.

Given what we now know about the anxious scrutiny applied to American collectors in the period, we can see that when de Kay visited Evans's New York town house in 1898 (figs. 73 and 74), he offered the highest possible praise: although the profuse collection "fills the gallery in the rear of his pretty house on West Seventy-sixth Street, lights up the walls of drawing, dining room, and vestibule, overflows into the corridors, mounts the stairs, and invades billiard room and sky parlor … a single, very distinct taste has brought it together." Throughout the home, de Kay continued, "one sees plainly enough the same controlling tendency. That tendency is toward beauty of tones rather than the story a picture tells to every eye that meets it."[19] He reported that Evans's pictures were installed in a manner that rendered it difficult to discern, in some rooms, "whether the interior has been suited to the pictures or the pictures painted for that interior."[20] The answer was, to some degree, "both." What de Kay was praising was Evans's ability to both commission work and make selections from artists' studios, dealers' galleries, annual exhibitions, temporary club shows, auctions, and other sales venues, and to combine these various purchases into a harmoniously arranged unit. The archive of Evans's correspondence is filled with letters from artists inviting him to inspect their latest productions, hoping to secure a place in what, over the course of the 1890s, rapidly became a self-generating and self-validating system.[21]

Clarke, Evans, and their peers had to work hard to counter the longstanding caricature of the unselective, unsystematic *nouveau riche* American collector. But period rhetoric reveals that in some ways the practice of assembling and arranging an art collection was in fact a natural fit for the turn-of-the-century businessman. In William O. Stoddard's *Men of Achievement: Men of Business* (1893), one of many publications that used profiles of successful entrepreneurs to define a pattern for others to live by, the author pointed out that railroad baron Cornelius Vanderbilt's "leading characteristic as a businessman" was "perceiving at a glance whatever could be done to develop any existing channel to its utmost capacity."[22] Similarly, he credited A. T. Stewart's remarkable skills of perception for his success in dry goods retail: "An incongruous article or person would at once have disappeared after his keen eye had fallen upon it."[23] Stewart takes his place among the scrutinizing gazers in the "Prominent Merchants" compilation of photographs in William C. King's *Portraits and Principles* (fig. 75), another aspirational how-to guide. "The difference between the success of this one and the failure of that one, is often simply in the use of the eyes," wrote one contributor. "One sees and seizes that at which the other but idly glances."[24] As Stewart's appearance in these lists suggests, the possession of a direct, incisive gaze was considered of special importance in the dry goods field.

This was certainly true of Alexander Millar Lindsay, a Scottish-born merchant based in Rochester, New York, during this period. As Rochester became an

75

"Prominent Merchants," in
William C. King, *Portraits and
Principles* (Springfield, Mass.:
King-Richardson Publishing
Co., 1895), plate 24Y.

important Erie Canal port in the 1870s, it functioned as an increasingly direct
pathway for importing foreign wares, expanding the range of items to which Sibley,
Lindsay, and Curr and its customers had access. Lindsay insisted on personally
inspecting the displays in each department of the store himself.[25] During the same
years that Lindsay was building up his enterprise, the Buffalo-born Aesthetic
still-life and landscape painter Charles Caryl Coleman was establishing a
transatlantic reputation as a translator of a similarly wide variety of foreign goods
into decorative panels. A painting like *Quince Blossoms* (fig. 76) showcases the
international range of objects he had gathered into his Roman studio, many of
which, as David Park Curry points out, were made specifically for export: a
Japanese paper fan and Chinese footed bowl placed in front of a Near Eastern
textile.[26] During sales visits he made to the United States in the 1890s, Coleman

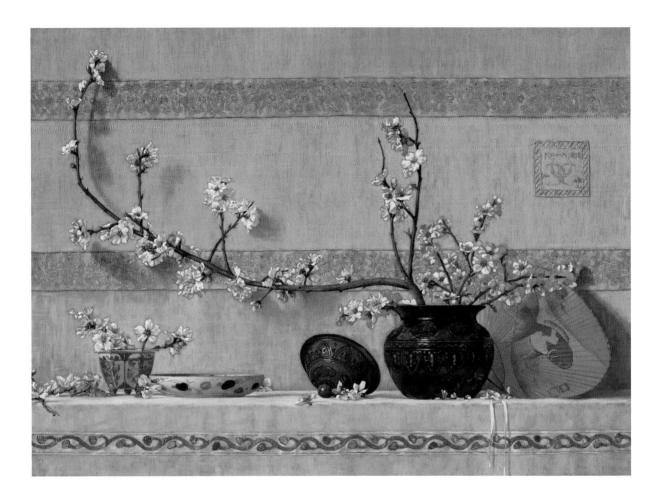

76

Charles Caryl Coleman, *Quince Blossoms*, 1878. Oil on canvas, 80.65 × 110.81 cm. Virginia Museum of Fine Arts, Richmond. J. Harwood and Louise B. Cochrane Fund for American Art. Photo: Katherine Wetzel © Virginia Museum of Fine Arts.

enticed potential buyers by extending his practice of careful selection and arrangement from his canvases to their installation environment, hosting temporary exhibitions that placed his pictures "in different corners, interspersed with draperies which give effective schemes of color and suggest dainty boudoirs and fine drawing rooms."[27] These materials included "rich old brocades, oriental draperies, and other objects," "old velvets, ancient costumes, and rare stuff that are draped about the paintings": lists that read like dry goods inventories.[28] With the profits of his own importation and sales venture, Alexander Millar Lindsay purchased *Quince Blossoms* sometime in the mid-1880s and hung it in his newly constructed Rochester home, eventually installing it as the centerpiece of his Great Room.

Without particular reference to the world of art patronage, Sarah Burns has usefully placed Aesthetic Movement paintings within the context of the Gilded Age department store world. She observes that artists were increasingly behaving like window dressers in this period, creating elaborate displays to attract consumers, and she eloquently demonstrates the surprising alignment between William Merritt Chase's opulent studio arrangements (fig. 77) and L. Frank Baum's advice (and example) for creating department store displays: "Color, light, arrangement, harmony – the elements of the merchant's stagecraft – added up to the commercial variant on the studio's art atmosphere."[29] In Burns's analysis, artists both benefited from and were criticized for their deployment of such explicit marketing strategies.

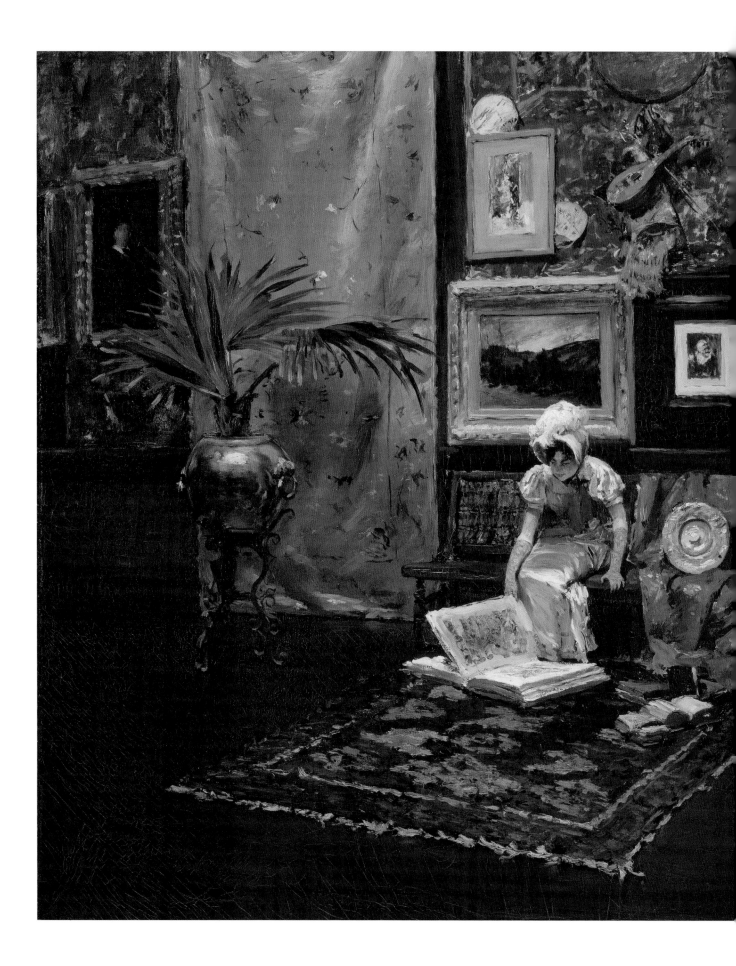

77

William Merritt Chase,
Studio Interior, ca. 1882.
Oil on canvas, 71.2 × 101.9 cm.
Brooklyn Museum, New York.
Gift of Mrs. Carl H. de Silver in
memory of her husband,
13.50.

Picture buyers are of secondary interest in Burns's story: they arrive on the scene after the fact, stepping into these sumptuous studio spaces as shoppers, potential consumers of these seductive, often escapist fantasies. But what happens after they and their purchases leave the studio? Although it is a fact that has received little attention, a remarkable number of turn-of-the-century American art collectors were, like Lindsay, not merely consumers but active executives in the dry goods field themselves. This includes not only the well-known department store magnates A. T. Stewart and John Wanamaker, but also another group of collectors, Thomas B. Clarke, William T. Evans, George A. Hearn, Benjamin Altman, John Harsen Rhoades, Charles S. Smith, Catholina Lambert, and Samuel Bancroft, Jr., the key leaders of which I examine here. All were involved in some stage of the manufacture or importation and sale of dry goods, all collected American art, and all featured Aesthetic paintings within their collections. This is not in itself surprising, as the mercantile realm, like railroads and banking, offered one of the chief avenues for amassing disposable income in late nineteenth-century America. What is surprising is the degree to which their Aesthetic paintings rewarded and reinforced the skills that were needed to succeed in this field: the ability to select, compare, and arrange fine things.

In order to understand the conceptual reciprocity between Aesthetic paintings, art collecting, and dry goods management, we need to consider the specific experiences of Clarke as a businessman. Throughout his early collecting life, Clarke served as a founding partner in the collar manufacturing firm of Clarke & King, and would remain head of its New York sales operation through the end of the 1880s. Its factory was located in the eastern central New York city of Troy, which served as the nation's leading detachable linen collar producer from the 1860s.[30] Collar-making was one of many industries radically transformed by improvements in motive power in the last quarter of the nineteenth century: steam drove the sewing machines in Troy factories where this primarily male consumable item was produced by a largely female workforce that cut, sewed, turned, folded, button-holed, and packaged 600 to 700 dozen collars per day at the time of Clarke's entry into the business in 1872.[31]

The complex calculations of collar manufacturers and salesmen involved weighing such variables as seasonal cycles, changes in the weather, and fluctuations in styles against the need to have stock ready for purchase. It was a highly competitive field, particularly in the 1880s, as firms trying to undersell each other offered their wares below cost, many going bankrupt in the process. This situation led industry journal the *Clothier and Furnisher* to call for combinations and price fixing to control these market variables. Women's collars (fig. 78), a particular specialty of Clarke & King, added another set of challenges, as they ranged in and out of fashion during this period.[32]

It took a certain kind of businessman to remain attuned to these variables in production and consumption, while simultaneously keeping a finger on the pulse and looking ahead to future vagaries of fashion – all with an eye toward profiting in a highly competitive market. Clarke's contemporaries as well as historians of American art have pointed out that he was precisely this kind of businessman.

78

"Ladies All Linen Collars and Cuffs," in B. Altman & Co., *Catalogue no. 52* (New York, 1886), 46, Winterthur Library, Del. Courtesy the Winterthur Library, Printed Book and Periodical Collection.

Just four years after the 1883 exhibition, Charles de Kay told readers of the *Magazine of Art* that Clarke, in building his art collection, "bought frankly, as he would in business, at the lowest price obtainable without haggling."[33] For art historian Robert Preato, Clarke's "strong-willed determination and shrewd business acuity … were equally important elements in the ostentatious display of [his] newly acquired wealth."[34] Sarah Burns approaches this kind of high-risk business activity as something in which Clarke's pictures participated (as objects of speculative investment) and sometimes metaphorically acknowledged (in the form of Winslow Homer's dramatic scenes of natural forces in conflict within a tumultuous, unpredictable, survival-of-the-fittest world).[35]

I wish to emphasize another set of skills and experiences, and a different kind of relationship between Clarke and his pictures – one grounded in the selective and comparative capacities cultivated within the field of collar production and sales specifically. Consider, for example, how extensive were the options for men's detachable collars at this time: "varying in height, width of opening between points, stiffness, finishing (among of gloss on the side worn outward), characteristics of points (long, short, narrow, square, or rounded), decoration (pleats or tucks), and fastenings," as historian Carole Turbin has outlined.[36] Demand for these highly varied articles in the 1880s resulted from a shifting labor market, in which increasing numbers of middle-class men moved into office work, dressing less like their counterparts in the factory or shop and more like their employers. The phrases "white collar" and "white collar stiffs" owe their origins to this moment, Turbin observes, the latter of which was derisively used to refer to aspirational clerks behaving above their station.[37] In her account, collars were rich visual signifiers: "By signaling cleanliness and taste, detachable collars marked strict

79

Thomas Wilmer Dewing, *A Garden*, 1883. Oil on canvas, 40.32 × 101.6 cm. Museum of Fine Arts, Boston. Bequest of George H. Webster, 34.131. Photo: © 2020 Museum of Fine Arts, Boston.

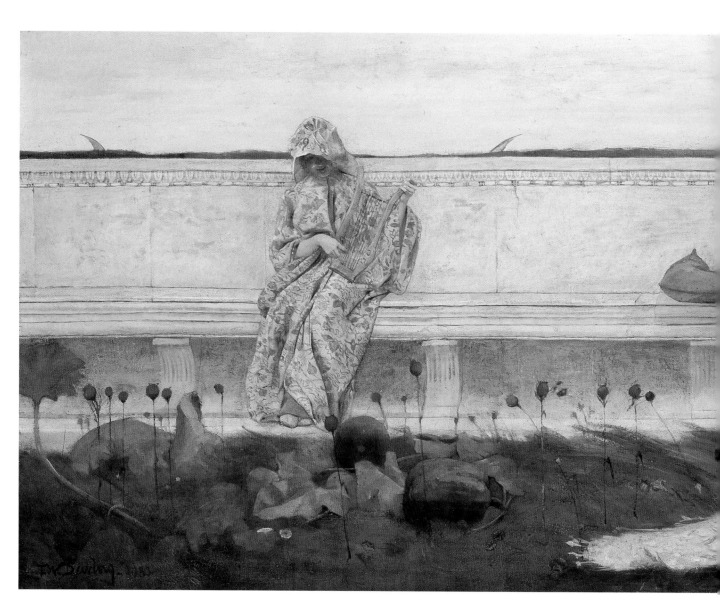

boundaries fundamental to Victorian life, delineating social position, gender, age, and situations demarcated by space and time."[38]

We could say that collars, then, involved a certain kind of connoisseurship in the arenas of manufacture, marketing, and wearing. Clarke's field required the ability to distinguish between many similar kinds of goods. And the Aesthetic paintings in his collection – pictures by Thomas Wilmer Dewing, H. Siddons Mowbray, and Francis (Frank) Davis Millet, among others – endorsed Clarke as a careful collector and so a careful selector: a capable, sharp-eyed businessman. Clarke hosted at least one annual dinner of the Motto Club, an elite social organization composed of some of New York's leading dry goods men, at his home in December 1880, where guests received personalized souvenir menus illustrated by Frederick Stuart Church and indulged in a postprandial tour of their host's American art collection.[39] Contemporaries also tell us that Clarke hung some of his pictures in the Clarke & King collar salesrooms on Church Street, and we can imagine how a canvas like Dewing's *A Garden* (fig. 79), with its strictly

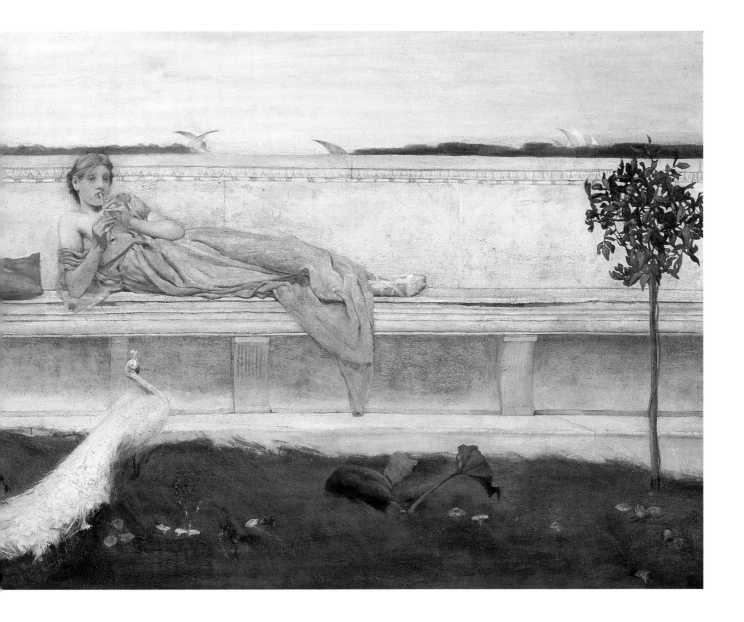

compartmentalized composition and art-as-music interplay between audible notes and vibrating floral stems, would have testified to his possession of a range of organizational and perceptual skills, regardless of where it was encountered.

As scholars have documented, during his business career Clarke also acted as an agent on behalf of some of his favorite painters, including Moeller and Inness, helping to place their works in the collections of his acquaintances.[40] When Clarke officially left the collar world and became a full-time dealer in Asian porcelain, ancient Greek Tanagra figures, and other antiquities in 1891, he used his retail skills in designing an intimately scaled, domestically furnished showroom for his offerings.[41] An account from the *New York Press* helps us imagine the experience of viewing objects under these conditions: "As Mr. Clarke shows them, he pulls curtain after curtain, and reveals one exquisite piece after another with a harmonious background of delicately tinted velvet, and with the electric light so arranged as to display each object to advantage."[42] He called his gallery "Art House," and it was, the critic Alfred Trumble gushed, "as original as its title, and in the classification and arrangement of its contents presents the aspect of a museum in which the selection and disposition of objects have been governed by the severest scrutiny and consideration of their relative interest and harmony of association."[43] Trumble, editor of connoisseurship journal the *Collector*, was especially pleased to see that these displays enabled intelligent comparison, reassuring shoppers of the authenticity of the items on view: "When standard pieces are thus grouped together the gathering of veritable things is much easier, as the collector has the advantage of contrast and comparison to guide him."[44] Commentators noted that Clarke, in launching this venture, was drawing on his many years of experience as a collector, but we might also note that he was drawing upon many years of experience as a collar man.

Celebrating Comparison

Of all the painters discussed in this chapter, Frank Millet gives us the most direct insight into what we might regard as a dry goods eye, particularly its comparative capacities.[45] Consider, for example, Millet's *Lacing the Sandal*, exhibited with the Clarke collection in 1883. In the painting that bears that title today (private collection; see 1887 illustration, fig. 80), a fair-haired young woman in a rose-tinted, semi-transparent gown belted at the breast bends over her raised foot to secure her shoe.[46] As she does so, she unselfconsciously adopts a pose reminiscent of *Nike Fastening her Sandal* from the temple of Athena Nike.[47] It is a position that showcases her garment to its best advantage, demonstrating how the textile folds and flattens, whether gathered into narrow pleats or falling and stretching over an upraised knee. Working in a style suggestive of his English contemporary Albert Moore, whose harmonious arrangements often relied upon textiles produced by Arthur Lazenby Liberty's dry goods house, Millet reduces the composition to a narrow range of accessories and tones: whites, pinks, and grays, with a touch of gold. It is a figure painting, but above all else, it is a drapery painting.

Lacing the Sandal is closely related to events that took Millet's interest in classical art and textiles beyond the canvas and out into the living world during the early 1880s. He was at that time designing costumes for stage productions, most

famously Mary Anderson's dress for her role as Galatea in *Pygmalion*. Millet's innovative use of concealed metal weights and bands to give her soft drapery the appearance of chiseled Greek marble spread his reputation internationally as Anderson wore the gown in both American and British performances, and posed for artistic photographers on both sides of the Atlantic (see fig. 49).[48] Simultaneously, Millet was elevating his public profile as a costume historian by delivering numerous lectures on ancient Greek and Roman dress in Boston and New York.[49] At these events, he illustrated the arrangement of each garment by draping it on a live model as he spoke – demonstrating, according to one observer, what "dignity and beauty" might be derived out of clothes that essentially constituted "a long sheet and a slitted meal sack."[50] The relationship of Millet's costumes to his painting practice was made explicit in 1882, when he exhibited a *Study of Costume* (unlocated) at the American Water-Color Society – a picture, as one critic described it, "in which the female figure is made secondary to the dress she wears."[51]

In this period Millet became a specialist in textiles, cultivating a knowledge of which fabric to choose, how it would drape, how it would move – how it might even express the wearer's emotions.[52] He developed, in other words, the kind of comparative expertise that lay at the heart of dry goods importing and sales as carried out by the art collecting businessmen who gravitated toward his classical Aesthetic figure paintings. William T. Evans and George Hearn, perched at the top of their wholesaling and retailing enterprises, respectively, were charged not only with acquiring a near endless variety of materials distinguished only by very fine degrees of difference, but also with making sure they were safely transported and stored and effectively arranged for buyers. Inside the New York warehouse of Evans's firm Mills & Gibb, for instance, departments from cloaks to lace formed a complex ecosystem. No period images of these two stores' interiors have yet emerged, but a contemporary photograph of the H. B. Claflin wholesale warehouse (fig. 81), packed with attentive dry goods men inspecting and comparing fabrics and prices, offers some indication of this environment and this experience.

Millet's *Lacing the Sandal* (Clarke), *After the Festival* (1888, Evans), and the unlocated watercolor *Fastening the Strophion* (Hearn) evinced the artist's – and, I would argue, implied each collector's – deep familiarity with the history, texture, and behavior of textiles.[53] And once again, Louis Moeller, though not an Aesthetic painter himself, helps us understand the physical and conceptual proximity of these businessmen to the late nineteenth-century

80

Francis Davis Millet, "Lacing the Sandal," in William M. Laffan, *Engravings on Wood* (New York: Harper & Bros., 1887).

American art world, and the lengths to which an artist might go to target that market. In *Appraisement* (by 1888, Metropolitan Museum of Art), purchased by the McKie family with Clarke's likely intervention, Moeller elevates the mercantile inspection of silks to the realm of fine art.[54] Meanwhile, in *Art Connoisseurs* (see fig. 70), he appears to have included a portrait of Hearn himself (at center), perhaps in a flattering bid to attract the dry goods retailer's attention to his work.[55]

But owning and appreciating such pictures was not only a matter of experiencing pleasure in the leisurely deployment of one's practical perceptual skills, as Michael Baxandall suggests in his definition of the "period eye" of fifteenth-century Florence; these collectors also used their paintings to support their business endeavors directly. Clarke, Evans, and Hearn exhibited their collections within their stores or those of colleagues. In 1898, for instance, Evans placed seventy pictures on loan at Loeser's department store in Brooklyn, where they were shown in a fourth-floor gallery. Millet's and H. Siddons Mowbray's studies

81

Byron Company, H. B. Claflin Dry Goods, Church and Worth Streets, 1905. Byron Company / Museum of the City of New York, 93.1.1.3204.

in fabric and form – and in judicious selection, comparison, and arrangement – were included.[56] Meanwhile, Hearn interspersed examples from his extensive artistic holdings among the items for sale at his Hearn & Son retail store. As one visitor recalled, "on their way to buy dress goods or linens the itinerant shopper could enjoy as long as she chose" pictures that, in this context, appeared to be largely the sum of their fabrics and trimmings.[57]

Millet's classical pictures were hailed as a new and productive departure for him in the early 1880s, but, as other scholars have noted, 1883 witnessed a bifurcation in his transatlantic output. Generally speaking, he continued to produce ever greater numbers of classical drapery paintings for the American market, while turning his hand to early English genre themes for exhibition and sale abroad. It is possible that as Millet's classical paintings came to be associated ever more closely with British Aestheticism, he may have elected not to enter into competition with such well-established artists as Albert Moore and Lawrence Alma-Tadema on their home ground.[58] Re-examining Millet's career through the lens of the history outlined here, however, it appears equally possible that he may have chosen to keep mining this classical vein even against critical complaints of its monotony, knowing that he had a solid base of eager American purchasers ready to acquire canvases that so artfully invited their mercantile eye. This market was cultivated in the clubs by the same collectors and according to some of the same comparative principles that drove dry goods management. It is these clubs to which we now turn.

"Freed from tedious and commonplace companions": Selective and Comparative Vision in Clubland

If Millet's career reveals the degree to which the specific tastes of a professional group might have an impact on an artist's production, the case of his fellow figure painter H. Siddons Mowbray demonstrates the crucial role that private men's social clubs played in cultivating a network of dedicated customers. In 1885, Mowbray, an English-born artist raised in the United States but living and working in Paris, had been looking to escape his profitable but restrictive relationship with the French agent who kept him busy with commissions at the expense of his personal artistic explorations. Afraid, in his words, "of becoming a hopeless employee of the dealer," he decided to return to America. As he recalled in his memoir:

> Almost immediately after settling I received a visit from T. B. Clarke, who was one of a very small group of men in New York who believed that there was some good in American art. He bought largely himself and had others in his train who followed his judgment, such as Benjamin Altman and Brayton Ives, so that a purchase by him, from an artist, meant the almost certain sale of other pictures. He was untiring in his search for men of promise and assisted many an undiscovered artist to find a purchaser for his work.[59]

In other words, in the process of his relocation, Mowbray shifted from the milieu of the dealer-based system (also a dominant form of art commerce in New York)

to one of implied patronage. Within the year, Clarke had purchased two of Mowbray's canvases, *Made Captive*, a fantastical scene of a genie entangled in gossamer nets by playful fairies, and the *Sisters – Arabian Nights*. As these examples remain unlocated, we may take as representative of the latter a slightly later Mowbray example from the Clarke (and subsequently the Evans) collection, *Idle Hours* of 1895 (fig. 82). Mowbray's debts to his French teachers Léon Bonnat and Jean-Léon Gérôme are evident in these subjects and settings, particularly as they offer an opportunity to survey an array of luxurious fabrics and furnishings.[60] But Mowbray, in his combination and recombination of elements – the same bench, pillows, and brass tray appear in several of his eastern interiors – also evinces a fascination with the processes of compositional selection and arrangement for their own sake that he shares with a number of Aesthetic painters we have considered thus far.

Clarke loaned both of his recently purchased Mowbrays to an exhibition at New York's private Union League Club, held March 11–13, 1886, of which he was a member.[61] On the walls of the club's luxuriously appointed and electrically

82

H. Siddons Mowbray, *Idle Hours*, 1895. Oil on canvas, 30.5 × 40.6 cm. Smithsonian American Art Museum, Washington, D.C. Gift of William T. Evans, 1910.

83

Francis Davis Millet,
The Connoisseur, 1885.
Watercolor on paper,
27.6 × 26.4 cm. Collection of
the Columbus Museum, Ga.
Purchase made possible by
Daniel P. and Kathleen V.
Amos at the Community
Foundation of the
Chattahoochee Valley.

illuminated art gallery, Mowbray's pictures were hung among twenty-six other canvases contributed by Clarke, whose holdings constituted approximately one-third of the ninety-three paintings shown in this important exhibition: the Union League's first devoted exclusively to American Art.[62] Department store executive Benjamin Altman, whose art collecting was carried out with Clarke's assistance, loaned ten paintings, and Evans loaned seven.[63] But perhaps the picture that revealed the most about the exhibition and the rapidly changing American art world that produced it was Millet's freshly painted *A Precious Relic* (unlocated), which depicted, one contemporary tells us, "a delightful rose tinted figure of a handsome girl in classic costume wiping 'A Precious Relic' in the shape of a small antique vase of iridescent glass" – it must have closely resembled his *Connoisseur* (fig. 83).[64] The "Precious Relic" was no mere antique vase: the *Art Amateur*'s Montague Marks described the classical figure as "looking critically at Mrs. Morgan's little $15,000 flask as if she did not believe it worth any such price."[65] "Mrs. Morgan" was Mary Jane Morgan, the recently deceased art collector and widow of shipping magnate Charles Morgan; the "little" flask was the famous eighteenth-century Chinese "peach blow" vase that had been the object of a fierce bidding war at the American Art Association auction of her collection that very month.[66] The

vase was regarded by many contemporaries as the ultimate symbol of over-expenditure, first on the part of a careless and uncritical Mrs. Morgan, and second by frantic bidders at the sale.[67] If *A Precious Relic* did in fact depict the Morgan vase, it constitutes a remarkable case in which an artist associated with classical Aesthetic subjects seemingly far removed from contemporary life created a painting that made specific reference to current artworld events – and in doing so, congratulated the painting's owner for his superior selection in sensibly choosing it over Mary Morgan's vaunted foreign vessel.[68]

The inclusion of this Millet painting in the Union League program was significant and possibly not accidental. In the March 1886 exhibition, it was shown on the same walls that had been bedecked with nearly forty of Mary Morgan's pictures, almost all of them by modern European "masters," just one year earlier.[69] The Morgan show had been a hit for the club.[70] The Union League attempted to build on its popularity by organizing subsequent exhibitions boasting ever more impressive (and expensive) examples of foreign paintings, but this taste for "masterpieces" quickly ran up against the prohibitive cost of insuring them.[71] Furthermore, the supply for such pictures was not endless, and loans drawn again and again from the same collectors and dealers resulted in the frequent reappearance of several "old friends" on the walls: a fact noted by critics with some weariness.[72] The March 1886 all-American display in which the Mowbray and Millet canvases appeared was the first exhibition organized by the club's newly elected art committee, and was understood by contemporaries as a "virtual protest" against escalating, possibly inflated values attached to foreign art as dramatized by the Morgan sale.[73] The committee's decision to mount an alternative was regarded as worthy of "national pride," but the contemporary American pictures were also more plentiful and less expensive to insure.[74]

Practical considerations aside, the March 1886 display was path-breaking. It revealed, critics claimed, the depth and variety of talent among native artists. But there was something else, too. "It is interesting to know that only one of the members of the Art Committee … is an artist," the *Magazine of Art* pointed out. This artist-member was William Sartain, who co-curated the show with a grain dealer and art critic (William H. Payne), a judge (Horace Russell), and a banker (Henry K. McHarg). "Does not this fact argue strongly in favor of the proposition that it is not good to leave the management of exhibitions wholly to artists?"[75] Crucially, the March 1886 show fueled a broader revision and transfer of cultural authority within the New York art world: from working artists to their businessmen patrons and collectors.

How did this transfer of authority occur, and what role did Aesthetic paintings play in effecting it? The answer lies in part within the history of the networking that occurred in New York's social clubs in general and the Union League in particular. In 1873, poet and literary critic Francis Gerry Fairfield evocatively described New York high society as "exhibiting the phenomenon of a kind of centripetal force balanced against a centrifugal; a tendency to fly off at a tangent and to assume closer coherence; a tendency to individuation, … and a balancing tendency to closer assimilation of elements, both of which are necessary to a healthy social

organization, the one tending to the exclusive, the other to the universal." Within this animated structure, Fairfield claimed, "are wheels within wheels, sets within sets, unities within unities" – and these subdivided, interlocking sets, concentric and constantly in motion, were men's social clubs.[76]

Clubs and associations of various forms had been a part of American life since its foundation and reached back to a long British tradition, but in the postbellum United States, private social clubs multiplied and diversified in major metropolitan areas from Boston to Philadelphia, Washington, D.C., to Chicago, Detroit to San Francisco. The largest number was concentrated in New York. In these organizations membership was secured through recommendations and votes (or rejected by blackballing), and it had to be paid for – often at a high annual price. Those who could afford to join enjoyed exclusive access to oases in the city: elaborately decorated clubhouses with bar and restaurant facilities, private dining and meeting rooms, VIP banquets with celebrity guests, among other features designed to attract and retain membership (fig. 84).[77] These buildings, it should be noted, were conceived as works of art in themselves: glittering showcases of custom decorative schemes by Cottier's, Associated Artists, and Tiffany and Co., all three of whom had provided extensive interior fittings for the Union League's most recent clubhouse.[78]

Like the private mansions springing up around them in the same Fifth Avenue neighborhoods, New York clubs played a role in the conspicuous consumption and status signaling of Gilded Age America, and their growth was predicated on the newly acquired fortunes plowed into them in exchange for the social distinction that membership conferred. But more significant than broad messages clubs may have sent outward were the functions that they performed. In the eyes of historian Sven Beckert, these functions were primarily those of consolidation, assisting in the fusion of an American bourgeoisie – the formation of a national upper class – from otherwise heterogeneous (and, independently, less powerful) social and professional sectors of the economic elite.[79] In the aftermath of the Civil War, clubs "provided institutionalized networks that … transcended the specific interests of a single economic sector," Beckert explains.[80] "The social institutions of bourgeois New York were structured like a spider web; not each point on the web was joined with every other point, but taken together they were all connected."[81] This interlinked structure "allowed them to pursue their numerous interests through a densely knit network of personal relations."[82]

Given their members' range of geographic backgrounds and professions – which increasingly included manufacturers as well as old-time merchants and bankers – club coalitions, those wheels within wheels, were always at risk of pulling themselves apart, as Fairfield recognized. So did former governor and recently retired Secretary of State Hamilton Fish, who in 1879, as the newly elected president of the Union League Club, observed in his opening address that "whatever tends to interrupt or detract from the social character and enjoyments of a club, leads toward dissolution. The social element should, therefore, be fostered and promoted by all proper means, and to all reasonable ends – your library, reading room, and works of art are valuable aesthetic agents in this direction."[83] It is the idea embedded within Fish's felicitous phrasing – that works of art served as active "aesthetic agents" operating in, around, and through club life – that concerns us here.

84

"New York City: Interior
Views of the Union League
Club," *Frank Leslie's
Illustrated Weekly* 52,
no. 1336 (May 7, 1881): 169.

Art exhibitions were key components of late nineteenth- and early twentieth-century club life in the United States, from the three-day shows arranged for the monthly meetings of New York's Union League Club, to the twice-yearly exhibitions of the Boston Art Club, and the annual presentations of American pictures at the Detroit Club. These temporary displays supplemented many clubs' permanent collections, objects acquired through member donations, committee purchases, or artist gifts in lieu of membership dues. Owned and borrowed works hung in drawing rooms, dining rooms, or dedicated art galleries. This cultivation of social clubhouses as artistic environments was a national phenomenon, but it was most

concentrated in New York, where high population density, intense competition for new club members, easy access to reporters, and the presence of artists' studios and artist-juried exhibitions (at the National Academy of Design and the Society of American Artists), as well as extensive gallery and dealer activity, rendered club exhibitions highly publicized features of the arts calendar.

Although the field of American art history still lacks a comprehensive study of art in the clubs, the crucial role these organizations played in developing and directing the market for American art in this period has been underscored by Jack Becker, Sarah Burns, Kevin Murphy, John Ott, and Linda Skalet, among others.[84] Club exhibitions granted American artists exposure, press, and potentially sales; contributed to their rising prices at auction; and laid a foundation for acquisition of their works by art museums. As *Town Topics* put it in 1906, "picture-making members appreciate the proximity of picture-buying members" – and while club exhibitions were not explicitly presented as sales, works of art could often be purchased upon inquiry, making these events a valuable pathway to private patronage for a number of American artists.[85] But it was also recognized at the time that this close entanglement of art with the clubs could have detrimental effects. As early as 1873, the *New York Times* denounced club exhibitions as potentially skewing artistic production, leading artists to "paint for a coterie instead of a country" by prioritizing work for paying collectors over work produced for the annual public artist-juried National Academy of Design exhibitions.[86] Two years later, the Academy instituted a rule excluding from its annual competition works that had already been exhibited in the clubs. This was eventually overturned, but the fact that it was deemed necessary is revealing.

Not all clubs embraced art, and not all of those who did embraced it in the same way. Aside from the Century Club, which was specifically organized to serve the interests of artists and writers, New York's Union League Club was the social institution most closely linked with art throughout this period. Within a decade of its 1863 founding, the club provided valuable support for maintaining the Union, assisted in establishing the Metropolitan Museum of Art, and embraced a chartered mission to foster the growth of American art.[87] From 1869, as Fairfield put it, "an impulse was given to aesthetic upholstery" for club meetings, in the form of temporary exhibitions and acquisitions, and the club began building a picture collection the following year.[88] Paintings were commissioned specifically for the club, purchased with club funds, or donated by members. As at a number of competing clubs, selected artists invited to join but otherwise priced out of the venture were authorized to donate works in exchange for membership.

The Union League's three-day monthly exhibitions were organized by an elected art committee of club members. In early years, these groups contained a mix of artists and laymen, with a greater proportion of the former. But by the 1880s and 1890s, its cultural leadership had been transferred almost entirely to non-practitioners (businessmen, politicians, art dealers).[89] This, too, was true of American club membership in general.[90] As early as 1881, the *New-York Tribune* pointed out that club exhibitions would only be as good (and, we should note, as selective) as the individuals organizing them: "to have a good exhibition of pictures you must have a committee, even if it be only of one man, that knows a good

picture when he sees it, and has so much confidence in the good sense and average good taste of a club like this as to believe that its members know a hawk from a handsaw."[91]

Let us now return to the March 1886 Union League display. Clarke exhibited Mowbray's *Made Captive* (unlocated) and *Sisters* (unlocated) there before they were shown publicly in the spring and fall exhibitions at the National Academy: that is to say, the paintings had already secured a purchaser. Indeed, the Union League's show was advertised as having been drawn only from private collections: pictures that had already passed the test of connoisseurship.[92] Reviewers were impressed with the quality of this collection, and recalled it as having been superior even to the year's artist-juried annual exhibition at the Society of American Artists.[93] It was superior, they argued, because of the selectivity it embodied. "It is only through picked collections like this that the public can be brought to appreciate the amount of good work which is done by American artists," wrote the *Tribune*, noting that many of these pictures had appeared before at annual artist-juried exhibitions, but that at the club they seemed "freed from tedious and commonplace companions."[94]

The exhibition was a revelation – but not only in highlighting the quality of American art. Now, on the basis of this event, the *Magazine of Art* was ready to declare the private collector's judgment superior to the artist's. Unlike the artist, "the cultivated art-lover …, who will always be glad to listen to words of advice from practitioners of undoubted standing, has no prejudices, no feeling of good-fellowship to contend against, no axes to grind, and no slights in hanging to revenge, and is therefore much more likely to be a just judge than the average artist."[95] The high standard of the collection was specifically "due to business men," the *Tribune* asserted.[96] In an era riven by a deep ideological fissure separating the interests of capital and labor – one that seemed increasingly insurmountable and irreparable – the *Tribune* tacked wildly back and forth between proposing alternative models of labor union and corporate management for resolving the disunities among artistic factions.

The social language embraced by the *Tribune* – "freed from tedious and commonplace companions" – seems to conflate the care with which the pictures were chosen and arranged with the selective membership and admission policies of the clubs themselves. Membership was limited to a set number of men of means, in whose presence male guests could also be admitted to the premises. Special daytime hours were set apart as "Ladies Days" for members' friends and family at most clubs. When the Union League's new clubhouse was constructed in 1881, it included not only a purpose-built art gallery, but (in the eyes of the club) an improved means of exhibition access: "The public and private stairways are distinct and far apart, so that the outside world, when entering or leaving the Theatre or the Art Gallery, will no longer disturb the privacy of the club."[97] *Town Topics* took up the cause of artists whose pictures were shown at the club in 1887, but who were not allowed to take dinner with the exhibition visitors.[98] Despite an occasional low rumble of discontent – a regret that "so many good things should be seen for such a short time, and by so small a portion" of those interested in the arts – most writers who visited and reviewed these exhibitions persisted in describing them as "public."[99]

These, then, were the chief qualities of club exhibitions in late nineteenth-century America: small, temporary, exclusive case studies in the activity of selection. Like all art exhibitions, they implicitly invited comparison of artworks with each other, as well as of the exhibition itself with other and earlier displays. In 1889, under Clarke's leadership, the Union League instituted a series of mixed-object exhibitions that offered an even more innovative and comparative model for viewing, evaluating, and collecting American art. The first of these used American paintings to form an aesthetic envelope for a rainbow of ancient Chinese porcelains in glass cases; subsequent installations paired American watercolors with Japanese lacquers and ivories; American landscapes with Greek and Etruscan vases and Tanagra figures; and American figure paintings with Indian and Persian metalwork.[100] Instead of approaching each artwork as a singular masterpiece, or inviting a deep dive into object histories or contexts, viewers were more or less forced to sift and savor the formal resonances generated by these juxtapositions, and to consider the exhibition itself as a carefully orchestrated composition in color, texture, and line. Borrowing a smaller number of objects and combining them (often with his own holdings) in unexpected configurations, Clarke showed how to make a virtue of necessity – and demonstrated how amenable certain contemporary American pictures could be to this kind of ensemble collecting.

A careful survey of the critical commentary responding to these 1889 Union League exhibitions reveals how dramatically these shows shifted the conversation, proposing that an exhibition itself was a work of art to be viewed and analyzed as a compositional whole, in which paintings and *objets d'art* become the raw material for the selective eye, comparative mind, and arranging hand of the clubman-collector. Such a conception rendered the skills cultivated by the dry goods man directly applicable within the cultural realm. And in one remarkable case, as I have explored elsewhere, these club exhibition practices cultivated by Clarke at the Union League and by Evans and Hearn at the Lotos were used to frame the presentation of American art for a much broader public audience. In 1904, Evans and his circle of collaborators, incorporated as the Society of Art Collectors, organized the *Comparative Exhibition of Native and Foreign Art*, an attempt to demonstrate that contemporary American painting could hold its own against the productions of nineteenth-century European masters. Pictures from the private collections of dry goods men (and club associates) Evans, Hearn, John Harsen Rhoades, Catholina Lambert, and Charles S. Smith, among others, were hung in stimulating juxtaposition in this temporary display at the American Fine Arts Building in New York. But, as at the club exhibitions that had preceded it, these pairings and groupings were designed to be comparative rather than competitive, sharing an all-pervading "tonal" harmony that made them equally collectible.[101]

The organizers even made an unsuccessful attempt to export their display to London as a confident demonstration of what American art, and American patronage, had accomplished. The artist Joseph Pennell may have had a hand in sabotaging their efforts; in any case, he and his partisans insisted in the press that "the future of American art rests with the men who are painters, and not the Art Collectors."[102] Although American museums would not, in the end, follow these patrons' recommended model for displaying American and European art

comparatively, they would be forced to grapple with the idiosyncrasies – and sometimes restrictions – of their systematically construed collections.

Selection and the (Suppositious) Museum

In considering the full implications of these patterns, let us return to the events with which this chapter began. Following the institution of the Clarke prize in 1883, Evans established a similar $300 award for the Water Color Society. Both prizes targeted young artists and frequently provided a direct pipeline for their works into the collections of the gentlemen who had initiated them: acquisitions that were much discussed and praised in the art press.[103] Critic Charles de Kay mapped this new topography of American collectorship for his readers, outlining the message he hoped artists would take from the Clarke show:

> It would be an excellent thing if artists, on finding a would-be purchaser that is a person after the fashion of Mr. Clarke, should make a serious reduction of their price for policy's sake, if for no higher reason. For, while the picture will be much more visited in the show-house of a rich man of the modern stamp, it will not receive the enthusiastic homage such as the small collector and his circle of friends would give. And should, in the course of time, that picture come to the hammer, it would have more friends ready to follow it from its modest home to the auction-room and dispute it with rival buyers there than if it had been one of a crowd in a Fifth-avenue palace.[104]

De Kay's advice was quite prescient. The "small collector and his circle of friends" is an apt description of the patrons analyzed here: highly clubbable gentlemen with extensive networks of business, social, and friendship ties, some of which they shared. Visitors to their city town houses inspected their holdings in intimate, coordinated environments; a wider circle of associates viewed them in the many club exhibitions they curated. By the time the Clarke and Evans holdings were auctioned (as de Kay had anticipated) in 1899 and 1900, respectively, their pictures had taken on their own social identities, having circulated through local, national, and international exhibitions. In 1883, an artist contemplating the accelerating trajectory of fame outlined by de Kay was advised to reduce his or her prices accordingly.

Sylvester Rosa Koehler, in his introduction to Clarke's 1883 exhibition catalog – an exhibition, we recall, that served to introduce the collector to the American public, not to close out his career with a summary of his acquisitions and accomplishments – wrote of the then thirty-five-year-old collar salesman, "It is quite legitimate to wish that the collections of American works of art now forming may be kept together …, either as family possessions or as the nuclei of future public galleries."[105] As Clarke's collection grew, it became its own standard. By 1887, the *Brooklyn Daily Eagle* could convincingly say that "he will not buy a picture unless it is worthy to grace the best representation of American art that there is in this country, and one of the best collections of pictures to be found in any country."[106] As artists gladly or reluctantly followed de Kay's advice to reduce their

prices if necessary to be included in this system, the question of what Clarke ultimately planned to do with his holdings still nagged. Were artists making sacrifices for a man who truly loved art, as he loved and was moved to tears by George Inness's *Gray Lowery Day*? Or were they pulling dollars from their own pocket for the benefit of a speculator who would eventually sell these bargains at a substantial profit? Were their works furnishing an artistic home? A dealer's storeroom? Rumors persisted throughout Clarke's collecting and art dealing career, until he announced that he would be liquidating his collection in 1899.

The collection was put up for exhibition in the weeks before the auction. This time, the job of introducing the catalog and explaining Clarke's methods fell to the artist and critic William Coffin. Facing down a torrent of criticism that Clarke was simply selling out, Coffin tried to convince visitors and potential buyers that the patron had actually been operating according to the best and noblest possible system: he was collecting as though for a "suppositious museum":

> In short, the collection gives an impression something like this: That Mr. Clarke, instead of buying for his own delectation, had been commissioned twenty-five or thirty years ago by some wealthy institution to gather together for its galleries a collection which should show to its visitors the best works of many of the men who have brought fame and reputation to the American School. It is as if this collection were about to be exhibited before its final housing in this suppositious museum, and our artists and amateurs were invited to come and give their verdict as to Mr. Clarke's breadth of judgment and acuteness in seizing opportunities. There is no such institution, and the pictures will be scattered, but we may at least hope that some of them will go to public museums, and that the rest will find owners who will value them as Mr. Clarke did, and who will share our opinion that no such comprehensive, personal, and worthy collection of American art has ever before been placed within their reach.[107]

Town Topics wasn't having it. Framing Clarke squarely as a linen-dealing businessman, it published a response titled, "The Shirt-Front of the Ex-Collector," dubbed his art auction a "white sale," and conflated his "extra white shirt front" with a flag of surrender: "the signal of distress of the picture business."[108] The anonymous author complained of the too closely focused and to his eyes insufficiently selective collection, accusing Clarke of "over-reaching a certain small section of American painters for twenty years." Responding to Coffin's lavish praise, he imagined a future in which Clarke receives a letter from Coffin representing the city of New York, informing him of his "appointment of buyer for the allied museums of this city":

> The twenty-five masterpieces of your collection have passed to the different galleries of this country. The rest of the collection is filed away in the archives at Washington, as showing the pass to which private picture collecting had come toward the end of this century … Under the present regime you are instructed to buy masterpieces in the open market, bearing in mind that pictures are divided into three classes: Pictures for public galleries, pictures for reference and pictures for the house. To the first class

belong such pictures as your large Murphy, Dewey, Davis, Martin, and some of your Innesses. To the second belong such pictures as it is necessary to have on slats for reference by students for archaeological reasons. For instance, anybody ever wanting to know how a man named Moeller or Volk or Hovenden painted can see an example by filling in a slip at a given museum; but these things are no longer to be thrust under the eyes of the public as works of art. To the third class belong such pictures as your "Mountain Road" by Wyant, your Shirlaw and some of your [Tryons].[109]

Remarkably, in the eyes of *Town Topics*, only 25 of the 375 pictures liquidated at the Clarke sale were deemed to be worth keeping, and the scenario this critic outlines bears a startling resemblance to the fate of the Clarke pictures today. Tonalist landscapes (Murphy, Dewey, Davis, and Martin) were considered by this author to be most important for public preservation and presentation, although only some of Inness's pictures make the cut. Visiting an American art museum today, you will be hard pressed to locate more than a few scattered examples of the first group, but Inness's singular interpretations of nature in its liminal, moody states have earned an unshakeable place in the canon. (*Town Topics* was not alone in this miscalculation; some contemporaries believed that Inness would eventually be forgotten.) Clarke's examples of Wyant, Shirlaw, and Tryon are regarded as "pictures for the home," recognizing their domestic scale and, at least in the case of the latter two, their decorative qualities. Figure painters of darker-toned canvases Moeller, Volk, and Hovenden come in for the worst of it here. Volks and Hovendens can still be found today, but no amount of filling in slips to request access to ("archaeological") museum pictures in storage will turn up much from Moeller, whose extensive output has been dispersed into a scattered array of private collections.

William Coffin's strategy for explaining and defending Clarke seems strange. Why evoke a "supposititious museum" – an institution that did not exist, was not, as far as we know, ever considered – and risk gesturing toward the kind of hoped-for benefaction that Clarke had *not* made? But Coffin's essay reveals a very particular way of thinking about art collecting and patronage in the Gilded Age. Henry G. Marquand, an incredibly prolific New York-based international art patron and collector of the period, serves as a useful resource here. Arguing against the United States art importation tariff in 1883, Marquand set out to correct the assumption that owning a work of art is a rich man's luxury:

> Works of art have a much wider constituency: they do not minister solely to the selfish desires of an individual; their value, if genuine, is far-reaching and permanent. It is a positive and demonstrable benefit to the community to have them in his possession. Even if for the hour they appear immersed in the inaccessible depths of private galleries, it should be remembered that from this source are fed the numerous and valuable loan-exhibitions. The force of circumstances opens doubly barred doors, and the lack of permanence in our life throws upon the market the tightly held treasures of the preceding generation.[110]

Unlike Clarke, Marquand's involvement with museums was not "suppositious" but concrete. Much of his collection was auctioned after his death. But during his lifetime, he donated funds, valuable paintings, and time to the Metropolitan Museum of Art, serving as its trustee and eventually its president, taking an active role in its management.[111] Even so, Marquand would seem to share Coffin's and Clarke's thinking: art patronage and collecting constitutes a first round of curation, pulling together objects of value for private enjoyment that, when dispersed, constitute a kind of larger virtual collection, distributed throughout the nation, forever linked not by their decorative installation or visual unity, but by their having-been-collected-ness. According to this logic, there is no fundamental distinction between private collecting and public benefaction. A collector might as well sell the collection as donate it, because the service of *selection* has already been performed.

In determining what to do with his artistic holdings, Evans had the examples of both Clarke and Charles Lang Freer (discussed in the next chapter) from which to draw. The 1899 Clarke sale had been the first major auction of a collection of American painting, and a watershed demonstration that American works could fetch prices as high as those of their European counterparts. Evans elected to sell his collection in 1900, but largely managed to avoid the accusations of profiteering that had dogged Clarke by stressing the method guiding his acquisition and deaccessioning practices. Evans publicly declared that the sale was necessary because the focus of his collecting activities was shifting, and the liquidation of his American landscapes would enable him to use his revised collection to highlight important new developments in figure painting.[112]

At the exhibition that preceded the auction, the organization of his paintings into harmonious groups upon Aesthetic principles – echoing arrangements deployed in Evans's home and in the private club shows he curated – served as an enticement for buyers. The newspaper advertisement for the sale announced that in the preview exhibition at Chickering Hall, viewers would find Evans's pictures "so admirably placed, so intelligently balanced in groups, with various masterworks as centres of panels, and disposed so that none may hurt its neighbor."[113] Such evident care in organization and display augmented the collection's commercial value and cultural aura.[114]

Finally, in 1907, shortly after Freer's gift had been accepted by the nation and publicly announced, his "old time friend" Evans determined to follow suit, and donated a first installment of fifty paintings to the Smithsonian's nascent National Gallery of Art (now the Smithsonian American Art Museum).[115] The tonal unity of Evans's second collection made it an especially attractive gift: the Washington *Evening Star* marveled that "seldom indeed is an entire collection so well related and so uniformly good."[116] This gift was shortly followed by additional donations, until the number of objects deposited reached 150. Between 1907 and 1915, Evans stayed in close contact with Smithsonian curators, constantly updating them on paintings he wished to exchange for those already given, as well as others that he wished to add to the set. He did not place any limiting conditions on his gift, but during his lifetime this wholesaler exercised tremendous control over how the pictures were hung, even extending to sending fabric swatches to the curators in what he deemed to be harmonious colors for lining the walls. The tone of the

85

Sir James Jebusa Shannon, *Magnolia*, 1899. Oil on canvas, 181.9 × 99.7 cm. Metropolitan Museum of Art, New York. George A. Hearn Fund, 1913 (13.143.2). Image copyright © The Metropolitan Museum of Art. Photo: Art Resource, N.Y.

Smithsonian administrators' letters to each other is one of somewhat resigned toleration that a patron committing to a gift this large should be indulged as fully as possible.[117]

Meanwhile, Evans's friend and fellow dry goods man George Hearn had been donating paintings to the Metropolitan Museum of Art in small batches since 1894. In 1905, he offered a further gift of twenty-seven American paintings, in addition to a $100,000 fund for future purchases. Unlike Evans, Hearn insisted that the works he donated be kept together and exhibited permanently as a group under his name. After the museum hesitated to accede to that demand, Hearn adjusted his expectations from a proviso to a "moral obligation" expected to last a minimum of twenty-five years.[118] Hearn also continued to act as the collection's chief curator after its donation, reserving the right to exchange pictures for better examples, and administering the purchasing fund he had given to the institution.[119] He used it to buy pictures that continued to serve as tightly integrated systems of color and form, many of which would have looked perfectly at home among the dry goods in Hearn & Son's stores, such as Robert Reid's *Fleur De Lis* (ca. 1895–1900), Frank Benson's *Portrait of a Lady* (1901), and James Jebusa Shannon's *Magnolia* (fig. 85), which remain in the Metropolitan Museum's collection today. He extended his practice of selection and arrangement to assisting the curators with other projects as well, as in 1906 when he escorted them through Hearn & Son's, helped them pick out case lining fabrics, and paid the bill himself.[120]

Each of these events reveals these individuals' business lives to have been intimately bound up with their art patronage and collecting in ways that have not previously been recognized. But collectors who attempted to distinguish themselves by conspicuous demonstration of their selective skills could also be destroyed by them, and those who used their business and art practices to shore up each other in an era of fluctuating economic and cultural values found themselves on unstable footing. These dangers did not exclusively impact collectors of Aesthetic painting: A. T. Stewart's skill and taste as a dry goods magnate was alternately praised and condemned based on the evidence of his art collection and memorial sculpture.[121] But the experiences of Evans drive home the risks of the networked entanglements we have been examining here. In 1910, he entered into highly publicized legal proceedings against an art forger, and was thereby forced to acknowledge that his selectivity had failed – even after he had written a letter to the Smithsonian testifying to the authenticity of the Homer Martin and George Inness pictures in question.[122] Six years later, he was revealed to have been making real estate and art purchases with Mills & Gibb funds, contributing to the debt that brought the firm into receivership. Its lawyers sought clawbacks from the artists and the Smithsonian directly, and although they were ultimately unsuccessful, the lesson was clear: tie art and business together, and one may go down with the other.[123]

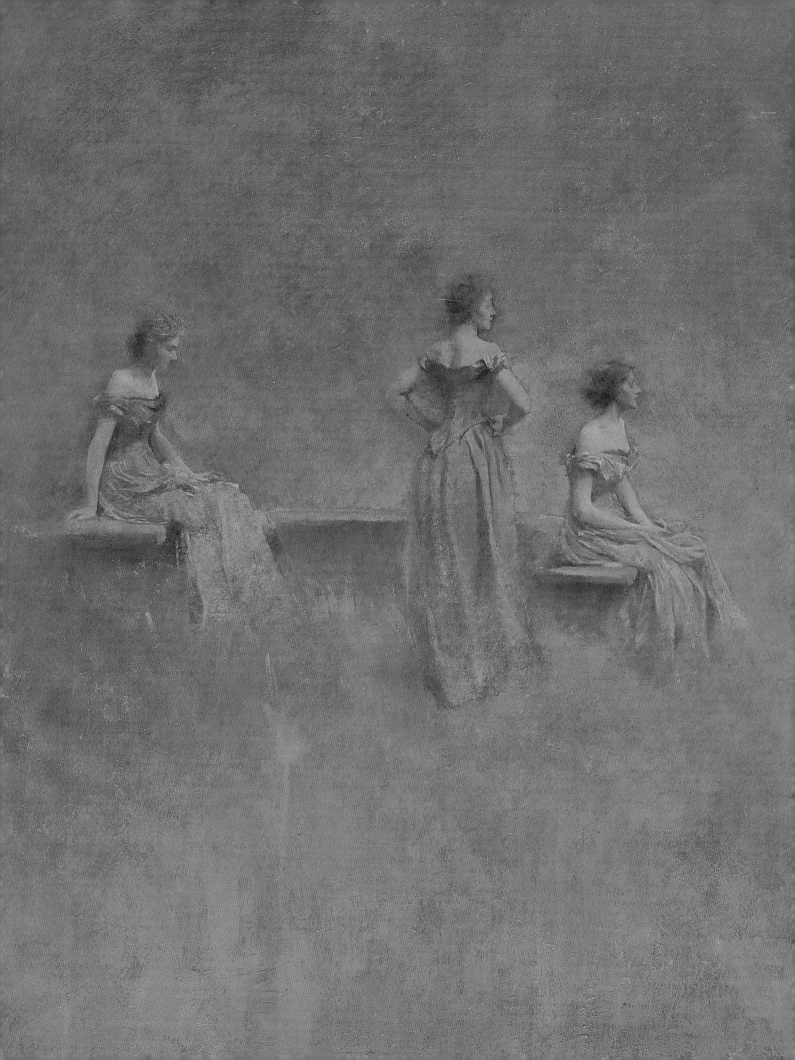

CHAPTER 5

Harmonious Systems: Expansion and Standardized Production in Detroit and Beyond

Charles Lang Freer (1854–1917) is, in many respects, the node that renders the shape of the Aesthetic patronage network in America visible.[1] He occupies this position in spite of – in fact, because of – his geographic location in Detroit, Michigan, hundreds of miles away from the late nineteenth-century beating heart of the American art world in New York City. The density of that art world, with its congested nexus of dealers, artists' studios, art schools, exhibition venues, men's social clubs, museums, auction houses, and private collections, can be easily mapped, but the specific connections between people – the plans, hopes, gambits, anxieties, and gossip voiced only in intimate conversations – are practically untraceable when these interactions occurred on a daily basis, face-to-face. Fortunately, a number of Aesthetic artists and their partisans were also writing to Freer, who traveled often to New York but was more likely to be found at home or in the offices of the Michigan-Peninsular Car Company in Detroit, attending to business matters or touring the globe in search of paintings, ceramics, and artifacts of the Near and Far East. Freer's famously scrupulous preservation of this correspondence offers a more intricate picture of the goings-on in the Aesthetic art world than we might ever have achieved otherwise, and that is one reason for his prominence in what follows.

A second reason is his marked influence on the rhetoric, behavior, and taste of that world. Although Freer began collecting American art in 1889, somewhat later than New York peers Thomas B. Clarke (1872) and William T. Evans (ca. 1879), he was the only member of his cohort to concentrate on Aesthetic pictures so exclusively, and demonstrably the first to recognize their potential as constitutive elements from which to build a fully coordinated domestic environment. His long-term patronage relationships with James McNeill Whistler (resulting in one of the two largest collections of the artist's work in the world), as well as with Dwight W. Tryon, Thomas Wilmer Dewing, and Abbott H. Thayer, exercised a strong pull

Thomas Wilmer Dewing, *The Lute*, 1904 (detail of fig. 97).

over their careers, and his Whistlerian approach to orchestrating harmonious hangings of their works transformed the way that collectors like Evans understood and interacted with their own holdings.

As the first among these patrons to announce official plans to donate a collection to an American museum, Freer's manner of conceptualizing this gift, and the limiting conditions he placed upon it, became central reference points for Evans, Hearn, and others who made similar benefactions. In this chapter, as in the previous one, it is crucially important, given the continued dependence of American museums on donations of art from individual collectors, that we ask what ideas, priorities, values, experiences – in short, what worldviews – are embodied and celebrated in the objects that are thus transformed from personal into national holdings. This is an even more pressing question in Freer's case, as his entire collection remains enshrined en bloc as its own museum, and answering it requires detailed consideration of paintings produced by his favorite American Aesthetic artists first for his home, and later with an eye toward their permanent institutional preservation.

This chapter thus begins with an extended examination of Dwight Tryon's Aesthetic landscapes, several of which were commissioned as decorations for Freer's main hall, and which, I argue, formally and conceptually reinforced experiences of "harmonious" cooperation among artists, collectors, and industrialists in Freer's orbit. We then turn to Dewing's paintings, which hung in an adjacent parlor. These, I will show, were governed by decorative rhythms of repetition and variation that linked collectors and business collaborators together while simultaneously affirming certain efficiencies of streamlined factory production. Finally, the experiences of the artist Abbott Thayer are brought into this discussion as a way to see how the particular operations and rhetoric of the Freer patronage network simultaneously benefited and constrained one of its key producers.

We have already seen how Aesthetic paintings deployed and resonated with the perceptual, managerial, and social practices of dry goods executives in New York. This chapter, however, focuses on the capacity for these works of art to

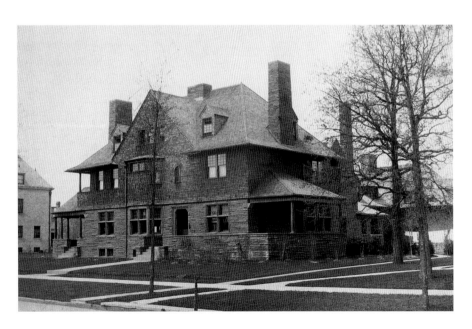

86

Wilson Eyre, Charles Lang Freer House, 1892. 71 East Ferry Street (previously 33 Ferry Avenue), Detroit, Mich. Charles Lang Freer Papers, Freer Gallery of Art and Arthur M. Sackler Gallery Archives. Smithsonian Institution, Washington, D.C. Gift of the estate of Charles Lang Freer, FSA_A.01_ 12.04.06.

function as connective agents enabling and encouraging collective action among those who owned them, lived with them, and carried out business negotiations while surrounded by them. As we shall see, these operations occurred in real, physical spaces as well as through virtual networks of paintings linked by subject and form across distances ranging from a few yards to hundreds of miles. In the time that has passed since they were first created, many of them have seemingly lost that resonance, and are exhibited today as single or separate examples of Gilded Age artistic production and conspicuous consumption. But a period viewer intuited the ability of Dewing's and Tryon's pictures to reach out beyond themselves: "both have something important to say to you, provided your mental Marconi system is tuned to receive the message."[2] What follows is an attempt to access and restore some of those lost frequencies.

The Endless Landscape: Dwight W. Tryon

Guests in Freer's Detroit home, a relatively modest two-story shingle-style dwelling built by Philadelphia architect Wilson Eyre in 1890–2, began their visit by passing through its central hub, the main hall (figs. 86 and 87). The decorative elements of this room were intimately linked: it featured seven landscape paintings that Freer had commissioned from Tryon specifically for that space, and their custom frames, the walls upon which they hung, and the ceiling above them shimmered with mottled tones of rust, copper, blue, and green: colors that had been carefully chosen to harmonize with the paintings.[3]

87

Plan of the main hall of the Charles Lang Freer House showing the position of the Tryon paintings. Based on a plan by Wilson Eyre, 1891. Detroit Institute of Arts, Mich. Gift of Louisa Eyre.

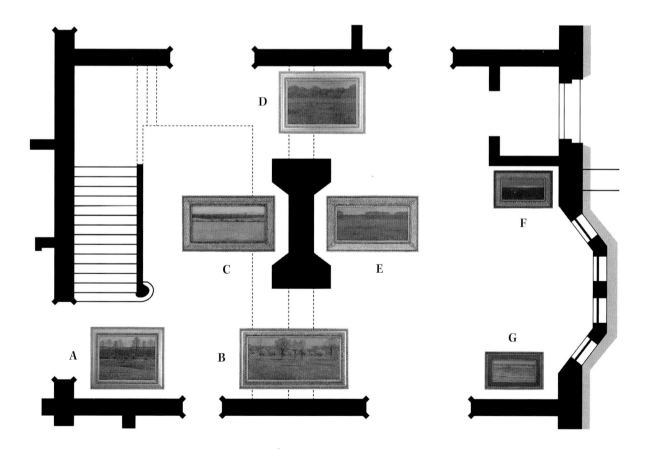

88a

Dwight Tryon, *Autumn*, 1892.
Oil on canvas, 96 × 125 cm. Freer
Gallery of Art, Smithsonian
Institution, Washington, D.C.: Gift
of Charles Lang Freer, F1893.16a-b.

88b

Dwight Tryon, *Springtime*, 1892.
Oil on canvas, 96.8 × 211.4 cm.
Freer Gallery of Art, Smithsonian
Institution, Washington, D.C.: Gift
of Charles Lang Freer, F1893.14a-b.

88c (Opposite)

Dwight Tryon, *Winter*, 1893.
Oil on canvas, 71.5 × 155.2 cm.
Freer Gallery of Art, Smithsonian
Institution, Washington, D.C.: Gift
of Charles Lang Freer, F1893.17a-b.

88d

Dwight Tryon, *Summer*, 1892.
Oil on canvas, 97 × 155.2 cm. Freer
Gallery of Art, Smithsonian
Institution, Washington, D.C.: Gift
of Charles Lang Freer, F1893.15a-b.

Walking through this space involved meandering through Tryon's cycles of the seasons (*Autumn*, *Springtime*, *Winter*, and *Summer*; figs. 88a–d) and daylight time (*Dawn*, *The Sea: Night*, and *The Sea: Morning*; figs. 88e–g). If the horizon lines of these landscapes – quiet, unmodulated expanses populated only by a handful of spindly trees – appeared to form one continuous circuit as they stretched across the room, that was because the dimensions, composition, and hanging of each painting had been precisely coordinated by artist, architect, and patron as the house was being constructed, in order to create a completely unified decorative scheme. As Tryon would later describe it,

> The room they were in was very simple, classic, severe in fact, and as Freer's taste corresponded, I tried … to make the paintings an integral part of the room and carry out, as far as possible, the classic purity of the design. For this reason I kept the flat horizon line in the four [seasons] panels of the same height. The horizontal lines of the ground, supplemented and offset by the verticals in the trees, seemed to make them a part of the architecture of the room. I think all who saw the room felt that, in a mysterious way, the pictures fitted and complemented the whole thing.[4]

Tryon had dedicated himself to Freer's project for two solid years, during which time the house and the paintings evolved together. Although the room had been designed in such a way that the paintings could be detached from the wall and exhibited independently, when Tryon submitted Freer's *Springtime* (see fig. 88b) to

88e

Dwight Tryon, *Dawn*, 1893. Oil on canvas, 71 × 154.6 cm. Freer Gallery of Art, Smithsonian Institution, Washington, D.C.: Gift of Charles Lang Freer, F1906.86a-b.

88f (Opposite)

Dwight Tryon, *The Sea: Night*, 1892. Oil on canvas, 41.8 × 87.7 cm. Freer Gallery of Art, Smithsonian Institution, Washington, D.C.: Gift of Charles Lang Freer, F1906.84a-b.

88g

Dwight Tryon, *The Sea: Morning*, 1892. Oil on canvas, 41.4 × 87.4 cm. Freer Gallery of Art, Smithsonian Institution, Washington, D.C.: Gift of Charles Lang Freer, F1906.85a-b.

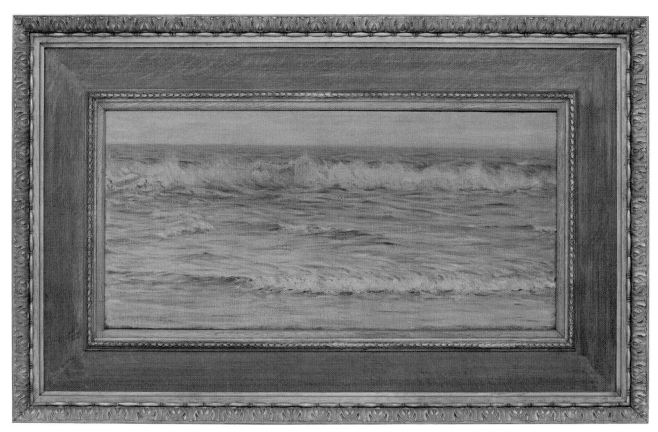

the Society of American Artists exhibition in 1896, he was shocked at the picture's appearance in a gallery context, reporting to his patron, "It is so purely a decoration that it looks strangely among the brutal realistic works around. I was much disappointed at first but I think it holds on long study of it better than most anything I could have sent. I was not aware at the time how much I subjugated myself to the room or how distinctively decorative I had made it."[5]

The letter was an indication of the impact of Freer's commission and its conditions on Tryon's artistic practice more generally. Although Tryon was surprised to see just how "decorative" his landscapes had become in the course of completing the Freer commission, his broader artistic output during the 1890s and early 1900s is in fact marked by many of the same characteristics as the pictures hung in that Detroit hall.

Consider, for example, the various compositional similarities among the independent easel pictures that Freer purchased from Tryon after the decorations for the hall were complete. These include *Early Spring in New England* (1897), *Daybreak: May* (1897–8), and *Sunrise: April* (1897–9; fig. 89), initially acquired by Freer for his private collection; and *Twilight: May* (1904), *Morning* (1906), *Autumn Morning* (1908), and *An Autumn Evening* (1908), which Freer purchased after promising his holdings to the nation.[6] These were the products of Tryon's immersion in the New England landscape and his observations of its constancy and change over the course of daylight hours and throughout the seasons. Despite the differences that make each picture individual and unique, these works are visually and conceptually linked by their flat, unbroken horizon lines; their trees function not as central points of focus or compositional organization, but as vertical notes along a horizontal staff that stretches, we might imagine, to infinity beyond the left and right boundaries of the frame. The strategy of evoking an endless landscape had been extremely useful for Tryon as he worked to unify seven separate decorative panels within Freer's domestic interior; this compositional structure appeared frequently and operated similarly throughout the remainder of Tryon's career, linking his subsequent easel paintings for Freer and others into a single, cohesive, and ever-expanding aesthetic universe.[7]

In order to appreciate fully the unbounded nature of the landscape (and the landscape painting) suggested by these compositions, it is helpful to compare them to the kind of picture that Tryon stopped painting after completing his two-year commission for Freer. In his earlier, more traditional landscapes such as *The Rising Moon: Autumn* (1889, Freer Gallery of Art), a centering motif – here the moon – may imply a certain depth of field and focus the viewer's attention on a singular swath of landscape. His post-Freer productions, however, tend to avoid bracketing devices that lead the eye into the distance or other compositional elements that would prevent the viewer from imagining these landscapes as continuing beyond their left or right edges. This compositional consistency is doubtless one of the reasons that Tryon's paintings have sometimes been characterized by art historians as "monotonous" and "mechanical."[8] But contemporary critics recognized that one of the things that made Tryon's pictures distinctive was "his power to carry you out and beyond the confining boundaries and narrow limits of the frame."[9]

Tryon, having internalized the decorative demands of the Freer commission, offers us, then, the landscape painting as a modular section of an endless space.

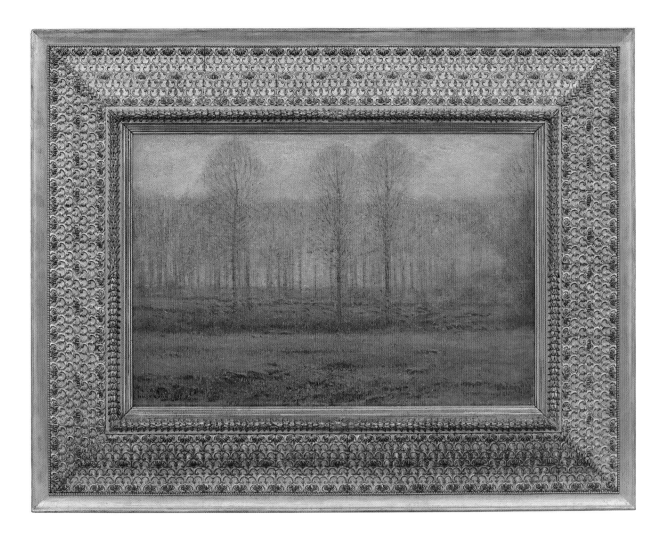

89

Dwight Tryon, *Sunrise: April*, 1897–9. Oil on panel, 50.9 × 76.3 cm. Freer Gallery of Art, Smithsonian Institution, Washington, D.C.: Gift of Charles Lang Freer, F1906.79a-b.

But these are clearly not the compositions of Albert Bierstadt or Frederic Edwin Church, pictures that call us ever westward, in the case of the former, or press us on to roam and ramble over hill and vale, volcano and ice cap, under the direction of the latter. What they offer instead is a vision of nature as an expansive and relatively undifferentiated *lateral* field. Here we seem, conceptually, to have hit the end of the frontier as envisioned in the path-breaking paper presented by historian Frederick Jackson Turner at the Columbian Exposition in 1893 – the same venue, incidentally, at which his Freer landscapes were debuted before a public audience. Once American civilization has spread to the extent that "there can no longer be said to be a frontier line," Turner explained, it takes a new form as "the steady growth of a complex nervous system for the organically simple, inert continent."[10] At the end of the century, the westward drive to envision, capture, and organize supposedly virgin territory had been largely replaced by the need to fill in the density of national transportation, communication, and mercantile networks. Tryon's landscapes picture none of these things, but it is my contention that by imposing the Aesthetic requirements of the decorative and harmonious upon the genre of landscape, they reshape the natural field into an order that corresponds with a larger cultural shift from a discourse of unidirectional penetration and discovery to one of organic linking and multidirectional growth.

That Tryon's paintings encourage us to think of these separate parcels of tree-lined landscapes (real and represented) as *linked* is a factor not only of the artist's compositional strategies, but also of the manner in which these pictures were displayed: they were most often seen "in each other's own best company" (in fellow collector William T. Evans's words) and not in isolation as single canvases or panels as we typically experience them today.[11] This was the case both in private domestic environments and in public art exhibitions, as patrons like Freer, Evans, Thomas B. Clarke, and John Gellatly insisted upon placing works by Tryon together in groups. The artist's consistent use of similar compositional structures and close tonal harmonies, together with the collective manner in which his paintings were often exhibited, made of his *oeuvre* a kind of continuous, rearrangeable series.

Furthermore, because Tryon and many of his patrons were operating according to an Aesthetic conception of interior space as three-dimensional and decorative, several of his paintings were fitted with custom frames – many designed by Stanford White – that mediated between the decorative order of the picture plane and that of its environment. White's lace-like borders (see fig. 89) eschew the large, projecting motifs of the period's popular Gothicizing and rococo-inspired frames in favor of a flattened all-over patterning that theoretically might continue endlessly into the surrounding space. A frame of this type smoothed the transition from the painted picture to the wall upon which it was hung; patrons like Freer and Evans insisted on appropriately toned and textured wall coverings, often selecting burlap fabrics in muted shades of olive, blue, or brown. In Freer's case especially, Tryon was an important collaborator in developing ideal environments for the hanging of his works.[12]

We can see that Tryon's pictures posit, then, not only an endless natural field but also an endless artistic field. They suggest, and in many ways enact, a world connected. In their multiplicity and perpetual exhibitionary rearrangement, they further propose that this world is not static but generative, proliferating without limit in a kind of infinite organic expansion.

Many other American artists were dabbling in similarly endless landscapes at this moment. American collectors of Aesthetic works by Whistler, Tryon, and Dewing were also likely to own paintings by Homer Dodge Martin, George Inness, J. Francis Murphy, or Henry Ward Ranger (all typically described as "tonalists") (see fig. 72). The unbounded landscape was also embraced as a compositional structure by contemporary artists who tended toward realism (see, for example, the sea coasts of Winslow Homer) or had taken inspiration from international currents of Impressionism (Childe Hassam and John Twachtman) or Symbolism (Albert Pinkham Ryder and Albert P. Lucas). Many different factors may account for these artists' selection of this organizational principle, with its decorative effects; they could have drawn from a range of precedents that included Whistler's nocturnes as well as certain seventeenth-century Dutch or nineteenth-century Barbizon landscapes. But despite their heterogeneous origins, all of the pictures listed in this paragraph could be easily slotted into a single collection – such as that of William T. Evans, from which the foregoing examples were drawn. A similar range of works reinforced the unified character of the holdings of Thomas B. Clarke, George Hearn, John Harsen Rhoades, Frank J. Hecker, and William K. Bixby, among others, none of whom collected Aesthetic paintings exclusively, but all of whom

showed a particular interest in the harmonious formal matrix of Aesthetic painting and the art display techniques it encouraged and enabled.

Were art patrons like Freer and Evans drawn to Aesthetic paintings (or paintings that evinced similar formal priorities) because they could be so easily and conspicuously slotted into unified systems, or did the decorative, modular tendencies of Aesthetic pictures encourage collectors to create interlinked networks of artistic holdings? Crucial as it is to this study, this is probably a chicken-and-egg question. Undoubtedly, the systemic imperatives of Aestheticism and turn-of-the-century collecting practices were mutually reinforcing. Patrons returned again and again to the same Aesthetic artists, sometimes for large decorative commissions (such as Freer's) and sometimes for independent easel pictures, which were virtually guaranteed by their decorative nature to harmonize with the patron's existing collections, as we saw in Chapter 4. Artists, meanwhile, by painting closely related canvases, could be fairly confident in securing a continued market for their works, and, eventually, could hope for permanent placement in American museums as their patrons' holdings were donated en masse. And so it is to the center of this linked and expanding universe that we must return Aesthetic patrons and their friends, who not only systematically organized these art objects and their installation environments, but also socialized and conducted business within them – as will be seen in the case of Freer and his Detroit home.

The Endless Landscape Realized: Harmony and Expansionism in Detroit

During 1896 and 1897, while Freer continued to commission additional paintings from Dwight Tryon and Thomas Wilmer Dewing to decorate his house, he was simultaneously engaged in a lengthy and intense exchange of letters with William K. Bixby of St. Louis, president of the Missouri Car and Foundry Company. They were discussing cooperative measures being taken by Bixby's company, Freer and Hecker's Michigan-Peninsular Car Company, and a handful of other railroad car building associates in New York, Michigan, and the Midwest, which laid the groundwork for their eventual consolidation as the American Car and Foundry Company in 1899 (of which Bixby would become president). At this earlier date, though, they were simply designating themselves as an informal Committee of Seven, organized, in Freer's words, to "decide upon a campaign" "for the purpose of maintaining an offensive and defensive position in the trade" and "maintaining prices, &c., between the seven companies."[13] The language of Freer's letters on the subject of this committee is urgent: "The meeting can be held at any point in the West and I will gladly attend. If the majority favor Detroit, I will gladly extend the use of my house for the purpose."[14]

No evidence survives to confirm the location of the meeting. But the Freer/Bixby letters document the intention of Freer and his associates to combine – not only for the purposes of organizing cooperative control and fixing prices across the railroad car building industry, but also for extending the reach of their business into international sectors. "An alliance of the kind indicated," explained Freer, "would certainly put us at the front of all American builders and far in advance of foreign competition."[15] This expansion included an initial plan to build railroad cars

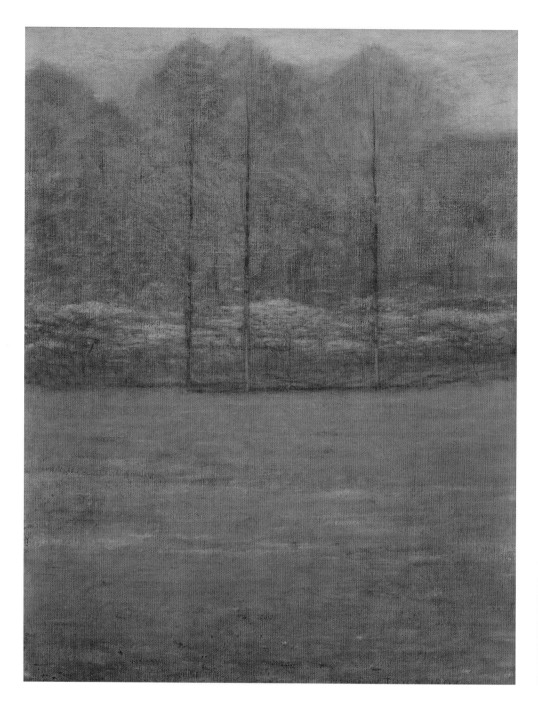

in Russia and Japan, with the possibility of near limitless international extension of the scheme.[16]

It is remarkable to imagine that Freer was willing to host these discussions in his Aesthetic Detroit home: a home often characterized by art historians as a space of isolation and retreat, and contrasted with both the noise and grime of industrial Detroit and the comparatively lavish French Renaissance mansion built by Freer's lifelong friend and business partner, Colonel Frank J. Hecker, on the neighboring lot.[17] While Hecker's home was equipped with movable partitions that transformed the sitting and dining areas into a ballroom for spectacular social events, the small windows and cozy nooks of Freer's house would seem to

90a–c

Seasons triptych, from left to right:

Dwight Tryon, *Spring*, 1893.
Oil on canvas, 102.9 × 80 cm.

Thomas Wilmer Dewing, *Summer*, 1893. Oil on canvas, 128.3 × 82.6 cm.

Dwight Tryon, *Autumn*, 1893.
Oil on canvas, 102.9 × 80 cm.

Detroit Institute of Arts, Mich. Bequest of Frank J. Hecker.

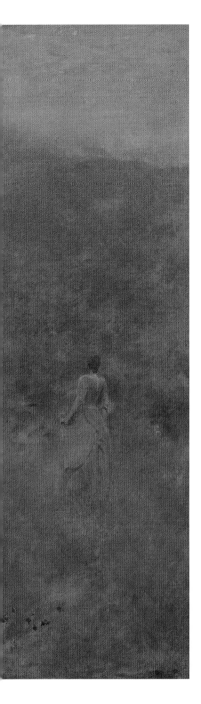

accommodate only the most intimate gatherings. Yet it is worth noting that despite the two mansions' very different architectural trappings, the Aesthetic paintings adorning their social spaces were closely related to each other in form and content. Following Freer's lead, and, in many cases, with Freer's assistance, Hecker commissioned and purchased pictures by Dewing, Tryon, and Frederick Stuart Church to fill the walls of his drawing and dining rooms. Both houses contained seasonal landscapes by Dewing and Tryon (fig. 90a–c) and decorative screens by Dewing (fig. 91). Kathleen Pyne has tracked some of the close relationships between pictures owned by Freer and Hecker, observing, among other correspondences, that Tryon's *Spring* and *Autumn* in the Hecker collection

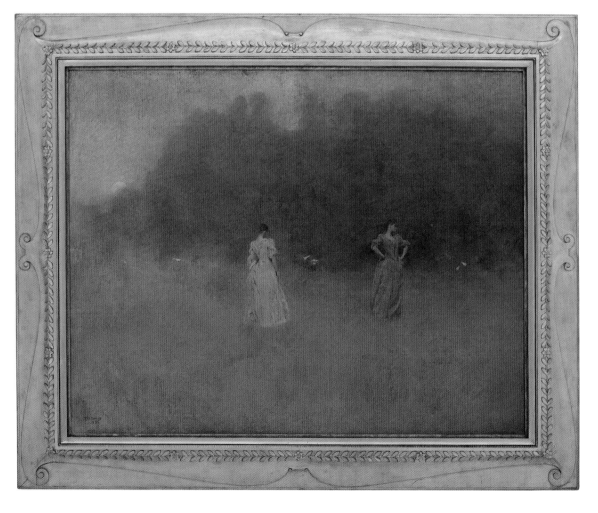

91a and b

Thomas Wilmer Dewing, *Four Sylvan Sounds*, 1896–7. Oil on panel, 175.7 × 153 cm each. Freer Gallery of Art, Smithsonian Institution, Washington, D.C.: Gift of Charles Lang Freer, F1906.72 and F1906.73.

92

Thomas Wilmer Dewing, *After Sunset*, 1892. Oil on canvas, 107 × 137.4 cm. Freer Gallery of Art, Smithsonian Institution, Washington, D.C.: Gift of Charles Lang Freer, F1906.68a.

are compositionally related to the landscapes painted by the same artist for Freer's main hall.[18]

The visual resonances between the Hecker and Freer collections are important, not only because they help establish the collaborative character of Aesthetic collecting practices among American art patrons, but also because they reveal the richly associative qualities of these apparently "repetitive" decorative works. The Aesthetic pictures belonging to Hecker's and Freer's separate art collections were intimately linked, and also functioned as nodes in a network of shared enthusiasms, acquaintances, and tokens of friendship between the two men. While a picture like Dewing's *After Sunset* (fig. 92), which hung in Freer's parlor, does indeed draw the viewer into quiet contemplation of its extended play of internal formal relationships, it also reaches *outward*, taking a measure of its meaning and identity from its close formal and conceptual ties to Dewing's *Before Sunrise* (fig. 93), its pendant image hanging in the same room, and *Summer* (see fig. 90b), housed mere yards away in the Hecker collection.[19] Hecker and Freer moved in overlapping and contiguous social and business circles, and acquaintances who visited both their homes were surely struck by the Aesthetic visual language shared by the two men.

If the Committee of Seven's meetings were in fact held at Freer's house, the representatives of the car building companies would have been surrounded by the

93

Thomas Wilmer Dewing, *Before Sunrise*, 1894–5. Oil on canvas, 106.8 × 137.6 cm. Freer Gallery of Art, Smithsonian Institution, Washington, D.C.: Gift of Charles Lang Freer, F1894.22a.

Aesthetic décor of the main hall. The collaborative measures of the committee would have been debated and outlined in the presence of paintings whose very existence testified to Freer's experience and skill as a collaborative partner – with Tryon; with a larger team of artists, decorators, and architects; and with Hecker, whose business and collecting activities were closely entwined with Freer's. By 1900, Freer would extend the same collaborative assistance to Bixby as he had to Hecker in both fields.[20]

Freer and his contemporaries described such cooperative, mutually beneficial relationships between artists and patrons, friends, business partners, or corporations as "harmonious," the same word used repeatedly by Freer and his favorite artists to capture the ideal interrelationship of formal elements within an Aesthetic painting or decorative parts within a home – especially within Freer's main hall. Tryon, for example, used the word three times in a letter of 1891, recommending for Freer's hall a square-cut portiere "more in harmony with other forms" in the room, proposing a stain for the oak paneling that would achieve "perfect harmony between wood work and side walls," and outlining his plan to commission frames that "regardless of anything shall harmonize with the pictures."[21] Harmony was a goal to be worked toward in selecting, designing, and arranging decorative elements, but harmonization was also an ongoing process: of one of the pictures designed for the hall, *The Sea: Morning* (see fig. 88g), Tryon explained that "I have at least carried it as far as I can surely without seeing it in its place – it may be later I will feel like doing something more to harmonize it with its surroundings."[22]

This vocabulary was, of course, not particular to Freer and Tryon; from the 1870s, "harmony" had been regarded as the chief goal of Aesthetic (or artistic) domestic decoration in England and America. Influential authors on interior decoration recommended "harmony" as a guiding principle. Clarence Cook insisted, "Each room ought to be considered by itself ... Its floor, its walls, its ceilings, ought to be brought into harmony by a right arrangement of color – that is the first thing."[23] Alexander Oakey defined the "decorative art craze" of the 1880s as "an organized attempt to extend and develop the achievements of art till beautiful things, and the beauty that is the result of harmony in our surroundings, became the rule and not the exception."[24]

As applied to painting in this period, "harmony" suggests a terminology deeply indebted to Whistler, who, in the 1860s, began christening his paintings with evocative and explanatory titles such as *Harmony in Green and Rose: The Music Room* (1860–1, Freer Gallery of Art), from the Hecker collection. Freer also applied it to Dewing's works, as when he wrote to the artist in 1893 to report that *The Piano* (1892, Freer Gallery of Art) had arrived, was about to be hung in a parlor decorated entirely in Dewing pictures, and was "absolutely stunning in the little room. The walls, wood work, etc., harmonize with it as perfectly as they do with *The Summer Evening*. To-night I am to have in quite a number of friends to see the painting. Wish you could be with us."[25]

This latter comment reminds us that these harmonious pictures not only were enjoyed as objects of solitary contemplation, but could become the focus of attention and discussion among like-minded friends and connoisseurs.[26] In period texts, the word "harmony" was used to describe such amicable relationships in both the social and business worlds.[27] Advice manuals such as William Ganson

Rose's *Success in Business* (1913) devoted entire chapters to the subject of harmony: "It should be the aim of a business man, not only to cultivate harmony among his co-workers, but transact business harmoniously with those from whom he buys and to whom he sells."[28] On a day-to-day basis, seeking after such harmonious relations could smooth the operations and transactions of the business world; on a larger scale, as economists were pointing out with greater frequency at the turn of the century, overly harmonious (as in cooperative and non-competitive) business relationships were concentrating the control of major branches of the commercial and industrial world into fewer and fewer hands. Pools, trusts, monopolies, and unofficial agreements between corporations facilitated price-fixing and the issue of rebates that enabled consolidated groups with overlapping boards of directors to work in "harmony," as the British economist John Hobson pointed out in his important study *The Evolution of Modern Capitalism* (see fig. 17).[29]

Such strategies, "for the purpose of maintaining an offensive and defensive position in the trade" (in Freer's words), characterized the operations not only of the Committee of Seven, but of Freer's cohort of Detroit investors and corporate managers more generally. For three decades, Freer's closest business associates included, in addition to Hecker and Bixby, Detroit businessmen James F. Joy, General Russell A. Alger, and the McMillan family. As historians have observed, these powerful Republicans formed an "interlocking financial directorate" that controlled the city's railroad car manufacturing, mining, public utilities, and street railways, among other ventures.[30] Many of them lived in the same neighborhood, attended the same church (the Fort Street Presbyterian Church, locally known as the "church of statesmen"), and belonged to the same social clubs (the Detroit and the Yondotega).[31] By 1913, University of Michigan professor of sociology Charles H. Cooley had therefore had ample opportunity to observe, "The whole business world is a network of associations, formal and informal, which aim to further the pecuniary interest of the members."[32] Interestingly, the cultivation of such harmonious business and interpersonal relationships was equated by William Ganson Rose that same year with obedience to the laws of nature itself.[33] In the context of the seasonal and temporal cycles structuring Freer's hall décor, then, any business discussions conducted by his Detroit cohort within this space would have been supported by and integrated into an organized Aesthetic system that operated as logically, predictably, and harmoniously as the changes of the seasons.

In detaching Freer's main hall from the patterns of interpretation that have treated it solely as a space of isolation and escape, I wish to complicate the notion that seasonal scenes such as Tryon's necessarily or exclusively belong to the realm of the nostalgic, the entrenched, and the backward-looking. It is equally possible in my view that nature's rhythms provided a regularized, predictable, organic counterpart to the standardized and organized systems that industrial managers and network builders (and art collectors) were cultivating at the turn of the century. It is not necessary to posit an exclusive and overriding need for escape, avoidance, and compensation to make sense of these art collections.[34] American Aesthetic paintings may just as easily have provided a comfortable and satisfying fit with (and validation of) the concepts that guided and structured these businessmen's lives – concepts such as expansionism and standardization, as

discussed in this chapter, or selectivity, arrangement, and comparison, as addressed in Chapter 4.

In the case of the Committee of Seven, their plans for corporate expansion would have been forged in a space surrounded by Tryon's endless landscapes, which, as we have seen, configured the natural world as an infinitely expanding field. While the committee worked to extend its corporate reach across the globe, Tryon's paintings foregrounded artistic expansion as a subject in itself – through their continuous horizons, their integration into a unified decorative scheme, and their presentation as intersecting cyclical series. The cohesiveness and all-over-ness of Aesthetic decoration in an interior like Freer's testified to an unchecked power of coordination and organization that extended to every surface, every object within a room. Although we are accustomed to thinking of Aesthetic space as a zone of retreat, it is also crucial to consider the ways in which Freer's hall, for example, provided an ideal environment for collaboration, cooperation, and corporate restructuring.

Within the decade, in fact, elite Detroiters (led by Freer) would look to the visual language of Aestheticism as they sought to commemorate and express corporate progress and expansionism. In 1900, Dewing completed *Commerce and Agriculture Bringing Wealth to Detroit*, his public mural for the central lunette in the new Stanford White-designed State Savings Bank (fig. 94).[35] Commerce (accompanied by a globe) and Agriculture (with a sheaf of wheat) flank a personification of Detroit, who holds a candle. Art historian Bailey Van Hook explains this arrangement as a representation of the city's famed success in

94

Thomas Wilmer Dewing, *Commerce and Agriculture Bringing Wealth to Detroit*, 1900. Oil on burlap mounted on panel, 243.8 × 435.9 cm. Detroit Institute of Arts, Mich. Museum purchase, The Eleanor and Edsel Ford Exhibition and Acquisition Fund, and partial gift of Mr. and Mrs. Silver. Photo: Bridgeman Images.

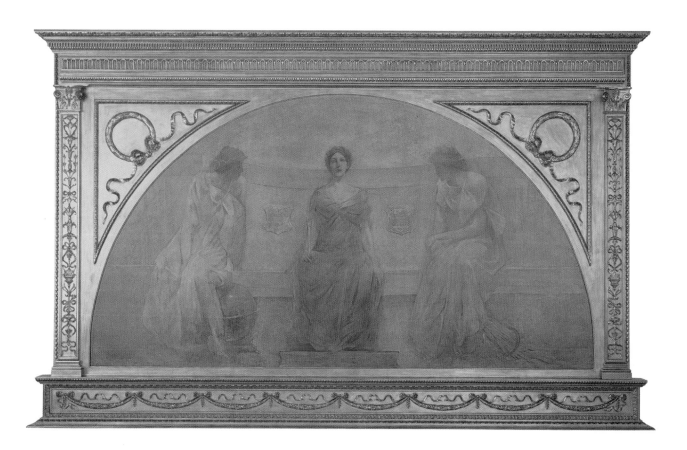

manufacturing and distributing a range of products, from railroad cars to pharmaceuticals, shoes, and seeds. She regards the mural as a "decoratively beautiful and elegant composition that still manages to express the balance and stability a financial institution intends to embody" in a manner that "could provide a vision of beauty and grace that softened the rough edges of modern commercial life" and could "quiet the businessman's soul, taking him out of the stressful world of commerce into the soothing realm of aesthetic experience."[36]

But as we have seen elsewhere in this book, Aesthetic form might just as easily be seen as conceptually aligned with, rather than opposed to, that world of commerce. The composition of *Commerce and Agriculture* suggests balance and stability, as Van Hook acknowledges, but also, I would argue, an ideal harmony – in the sense of symmetrical compositional structure and of interpersonal cooperation. As economic commentators like John Hobson pointed out at the time, harmony and expansionism together made for an especially powerful combination in the turn-of-the-century business world: it was the cooperative arrangements of tight-knit business groups like the interlocking directorate to which Freer belonged – the very group responsible for organizing and operating Detroit's State Savings Bank, in fact – that enabled corporate institutions to exercise outsize influence over markets, production, and even politics in the Gilded Age.[37]

Despite the frequent economic downturns that marked the final quarter of the nineteenth century, Detroit experienced enormous population and business growth in this period.[38] The city's geographical position facilitated its development as a nexus of water and railroad transportation, reaching eastward to New England through the Erie Canal and westward through its railroads. Even Detroit's city plan and late nineteenth-century growth patterns (fig. 95) encouraged its residents to visualize it as an ever expanding, ever denser network hub. Following the initial opportunities provided by the Civil War, during which Detroit profited from a heightened demand for railroads and railroad equipment, businessmen who specialized in the coordination of transportation and production networks harnessed the railroads to the processing and shipment of the state's natural resources (copper and lumber).[39] These financiers included men like James F. Joy and Christian H. Buhl, men who would become Freer's and Hecker's backers, business associates, and friends.

By the early years of the twentieth century, Freer's Detroit-based commercial and financial network had swelled to international proportions. One index of this expansion was the increasingly global profile of the Union Trust Company, founded in 1890 by Hecker, Buhl, Senator James McMillan, and Russell A. Alger, among others. In 1912, the Union Trust placed the following advertisement in the London *Times*: "The State of Michigan has provided British capital with many opportunities for profitable investment in the past, and the City of Detroit is its commercial heart … Our geographical position, close proximity to Canada, and financial strength give us access to data not available to others."[40]

Detroit's financial elite, then, imagined their political, economic, and cultural leadership as radiating out from the city itself. Its engines of expansion were both corporate and social. The same cohort of interlocked businessmen founded the

exclusive Yondotega social club in 1892, which Freer (its first vice-chairman) described as "a small group of sympathetic men … wishing closer personal relation and wider social development through more intimate co-operation."[41] Freer's private, unpublished notes on the club, perhaps jotted down as the basis for one of the eloquent speeches for which he was well known among his friends, evince his conviction that "this is not a limited organization. Its sphere of action is unlimited."[42] He elaborated:

> In old Rome the public roads beginning at the Forum proceeded North, South, East and West, to the centre of every province of the Empire, making each market town of Persia, Spain and Britain pervious to the soldiers of the capital. So out from this table go as it were highways to every Yondotega soul heart. Here the Yondotega soul spirit concentrates, fornicates and reproduces – here its blessings and benefits find birth, its sympathies blossom. Broader and deeper may they grow.[43]

Freer's devotion to the club grew so deep, in fact, that he had its symbols, the bird and vine, carved into the woodwork of the main hall of his home, thereby joining the expansive visual language of Tryon's Aesthetic landscapes to the Yondotega's spirit of fertile organic proliferation.[44]

The near-mystical language of Freer's Yondotega ode resonates with the rhetoric of contemporary business-oriented essays and how-to books, which urged a new orientation toward a kind of psychological expansionism. "If a thought comes into his [the successful businessman's] head," noted *Scientific American* in 1877, "it is one of breadth and compass – it does not center on self, and its narrow world. It reaches away and embraces others."[45] Active men "are always reaching out,

95

Calvert Lithograph Company, *Bird's Eye View – Showing about Three Miles Square of the Central Portion of the City of Detroit, Michigan*, ca. 1889. Library of Congress, Geography and Map Division, Washington, D.C.

reaching out for more power, for new ideas, for friends, for opportunities, for all that is worth while," exhorted William Ganson Rose. "And this reaching-out process, slowly at times, but surely, brings results."[46] Elsewhere, new studies in the burgeoning field of "business psychology" effected a fusion of the bureaucratic and the spiritual for the sake of pure profit, encouraging the businessman to "dwell mentally with the superior, the marvelous and the limitless … to place the mind in that position where it can continually draw upon that power that is limitless."[47]

A much more material and concrete component of this late nineteenth-century "reaching out" process was evident in contemporary shifts in American foreign policy, which harnessed the McKinley and Roosevelt administrations' desires for the nation to play a larger role in international affairs to the eagerness of corporate elites to expand into international markets. The attitudes and strategies of Freer and his associates were not unique, and were indicative of a broader sense that the growing (yet unstable) American economy would increasingly require international outlets and resources in order to flourish. As historian Robert H. Wiebe has observed, in the spirit of the closing of the American frontier identified by Turner, "the general fear after the mid-eighties that domestic opportunities were disappearing did encourage Americans to think more seriously about economic expansion abroad."[48] This realization occurred at the same historical moment when business influence was on the rise in the American political world, and at a time when yet another tight-knit network of highly placed, "power-minded" friends was poised to make America's political and economic expansion a reality.[49] This group included Secretaries of State John Hay and Elihu Root, Senate Foreign Relations Committee member Henry Cabot Lodge, and President Theodore Roosevelt, who "quite simply," in Wiebe's analysis, "wanted the United States to master [the] world."[50]

Two of the most visible manifestations of this turn-of-the-century expansionist orientation were the nation's involvement in the Spanish-American War and the building of the Panama Canal. Hecker and General Russell A. Alger, two of Freer's closest friends and most intimate business associates, were key players in both. The canal project was a many-sided endeavor: a complex engineering challenge, a business venture, and an international declaration of America's newly expansionist foreign policy. Hecker embodied the fusion of these various goals, serving on the government's commission while simultaneously holding a position as director in the Panama Railroad Company.[51]

To study the timeline of these and related events in Hecker's and Freer's lives is to be struck and somewhat surprised by the degree of interpenetration between their business, political, and artistic activities. In March 1892, just as they were engineering an enormous merger between the Michigan and Peninsular Car companies, they were orchestrating the cooperative, harmonious, and closely related decoration of their new houses with Aesthetic paintings. In August 1898, during the same week that Hecker was accused by the *New York Times* of facilitating the takeover of Puerto Rico and the Philippines by a "syndicate from Michigan," Freer was supervising the installation of a Dewing screen in Hecker's ballroom, embedding into the very fabric of its walls an Aesthetic visual language of harmonious tones, rhythmic forms, cyclical time, and endless expansion: a language shared and valued by the two friends and their circle of associates. And in October 1904, as Hecker was reconsidering his service on the Panama Canal

Commission, Freer was boxing up Aesthetic paintings from both of their collections to send to the *Comparative Exhibition of Native and Foreign Art*, through which their network of art-collecting friends was attempting to assert the nation's new prominence, confidence, and skill on the international artistic stage.[52]

This collocation of events is not intended to suggest that one set of capacities or interests – the ability to coordinate large railroad-building projects, say – necessarily produced another – a desire to surround oneself with Aesthetic paintings, or vice versa. I see no mere "reflection" of the corporate or political world in the artistic one. However, in recognizing that these spheres of life were not irrevocably walled off from one another, we must necessarily consider the impact of identifiable patterns of seeing, thinking about, and interfacing with the world at the points where these spheres intersect. The densely networked nature of late nineteenth-century life – in its social, political, and corporate aspects, as seen in the exemplary case of Freer, Hecker, and their interlocking circles of associates – requires us to treat the Aesthetic object as imbricated in a complex mesh of habits, attitudes, and priorities of which their makers and owners may or may not have been consciously aware. I wish to emphasize here that the organic, expansive visual language of the Aesthetic landscape, particularly as exemplified in Tryon's works as they were collected and displayed, contributed to the creation of an environment in which the cultivation of harmonious interpersonal relationships and a "reaching out" frame of mind was not a neutral, passive, or withdrawn activity. These were key strategies adopted by an American financial elite to maintain and extend the scope of their control over major sectors of American life, including corporate operations and foreign policy. The paintings potentially reinforced these patterns of thought and perception among this particular corporate, art-collecting class, whose consistent patronage of formally harmonious pictures encouraged their favorite artists to continue production in the same vein.

Rhythms of Repetition and Remembrance: Thomas Wilmer Dewing

Leaving aside for a moment the proposed gathering of the Committee of Seven in Freer's main hall, let us pass in turn to the adjoining parlor, hung throughout with the paintings of Thomas Wilmer Dewing. It was here that Freer invited "quite a number of friends" to come see how perfectly every detail of the "little room" harmonized with Dewing's *The Piano* when it was installed there in 1892, and here we observe a second strategy at work in the construction of a unified Aesthetic interior and a thematically and tonally cohesive art collection: whereas Tryon adopted the compositional structure of the endless landscape in order to secure the total coordination of the hall, Dewing populated his similarly expansive natural scenes and comparably boundless interior spaces with idealized – and generally standardized – female figures. The mottled walls and silvery green woodwork knitted the whole room together as "an opalescent, shimmering dream of color and pattern, comparable to a peacock's breast or the wings of a butterfly," as one visitor reported.[53]

Like Tryon's hall decorations, many of Dewing's parlor paintings were created specifically for the space in which they were installed. The pictures can be divided into two groups: single female figures in interior spaces (*The Piano*, *The Blue Dress*,

and *Early Portrait of the Artist's Daughter*) and pairs of female figures in landscape settings (*After Sunset*, *Before Sunrise*, see figs. 92 and 93). Yet the paintings establish an almost endless stream of correspondences that link them in continually shifting alliances with each other and with additional works – some housed in Freer's larger art collection, and others circulating through the drawing rooms, galleries, and social clubs of his tight-knit circle of fellow art patrons and business associates, as we shall see.

Just as Whistler had claimed that the Peacock Room "grew as I painted," Dewing wrote excitedly to Freer in 1892 that *After Sunset* was "growing too well to stop work on it," and subsequently brought the unfinished canvas to the parlor in order to "tone" it to its surroundings.[54] But the parlor scheme "grew" in a somewhat different manner than Tryon's hall decorations: whereas the latter had established a two-year contract with Freer to produce a set number of pictures, Dewing's plans to decorate Freer's parlor seem to have been more informal and organic.[55] Following Freer's initial purchase of *The Piano* from the Montross Gallery in 1891, Dewing was commissioned to add canvases to the ensemble over the next few years until the room seemed complete to the artist and the occupant. Each new painting therefore needed to correspond to the pictures already installed in the room as well as those gestating in the artist's mind and on his easel; each addition established and adjusted the terms to which the next canvas would need to be accommodated. Similarly, as Freer secured other Dewing pictures over the years, rotating them into and out of the gallery space he added when he enlarged his house in 1905, his collection evolved as an active, reflexive organism: it easily absorbed and incorporated a wide range of Dewing canvases and pastels, while simultaneously encouraging the artist to continue directing his artistic efforts toward certain types of pictures that could be harmonized with unified collections and interiors such as Freer's.

Like Tryon's paintings in the main hall, Dewing's parlor pictures functioned both as modular sections of a decorative scheme (and of a larger collection) and as individual easel paintings that were occasionally excised from their installation environment and shown in various club, gallery, and international exhibitions. When Dewing's works were exhibited publicly, critics often remarked upon their repetitive character, noting that the artist was "restricted by the taste he has created to a limited form of activity."[56] As such comments remind us, paintings like *After Sunset* and *The Piano*, when exhibited, lacked the unified context of Freer's parlor; their key reference points were rather to be found in Dewing's larger networks of images – his series of Cornish landscapes and interiors with female musicians, respectively.

In the case of landscapes like *Before Sunrise* and *After Sunset*, the artist was inspired by the regular summer visits he made to Cornish, New Hampshire, from 1885, where he and his wife, the flower painter and art writer Maria Oakey, anchored a colony of like-minded artists and architects, including Augustus Saint-Gaudens, Kenyon Cox, and Charles Platt.[57] Beginning around 1890, Dewing initiated a fifteen-year project of transforming the raw material of the colony's communal rituals (singing, reciting, listening) into a series of landscape paintings populated by elegant women in flowing gowns. By the time he created *After Sunset* for Freer in 1892, he had already completed many of what would become the best-known works in this series, including *Summer* (fig. 96), *Spring* (1890, Smithsonian American Art

Museum), *The Hermit Thrush* (1890, Smithsonian American Art Museum), *The Song* (1891, Colby College Museum of Art, Waterville, Maine), and *The Recitation* (1891, Detroit Institute of Arts).

Dewing sometimes referred to such landscape paintings as "decorations," by which he highlighted their fitness to serve as modules within coordinated, harmonious interior spaces. He feared – apparently with good reason – that outside the context of carefully orchestrated environments like Freer's parlor, large exhibitions would not necessarily establish favorable viewing conditions for them, famously writing to Freer that he would not submit them to the 1901 Pan-American Exposition at Buffalo because, "My pictures of this class are not understood by the great public who go to an exhibition like the Pan-American. They are above the heads of the public … My decorations belong to the poetic & imaginative world, where a few choice spirits live. Some time before long I will have an exhibition of decorations alone. Not at this time and this place."[58]

These comments have typically been interpreted as indicators of Dewing's elitism, of the distance between his Aesthetic art and the "clamor of the Gilded

96
Thomas Wilmer Dewing,
Summer, 1890. Oil on canvas,
52.1 × 90.8 cm. Yale University
Art Gallery, New Haven, Conn.

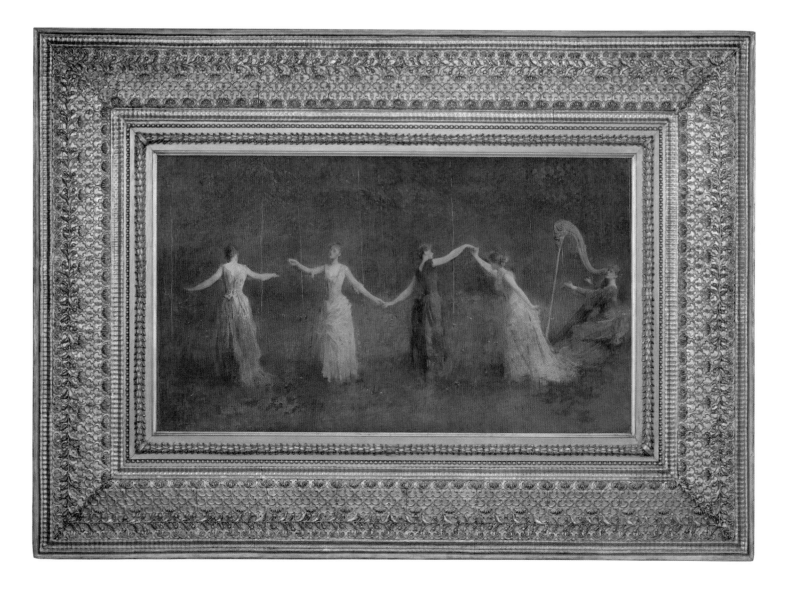

Age."[59] Insufficient emphasis has been placed on the way Dewing's remarks suggest not merely a practice of withdrawal or isolation, but, more precisely, the formation of a like-minded community of "a few choice spirits" well versed in his decorative visual language.[60] Nor has adequate attention been paid to the manner in which Dewing here testifies to the networked nature of his own artistic *oeuvre*: an "exhibition of decorations alone" could potentially accomplish what no other type of display could manage: the controlled presentation of Dewing's landscapes (to return to William T. Evans's words) "in their own best company."

If contemporary art critics had trouble understanding these paintings as individual exhibition entries, a handful of influential patrons experienced no difficulty at all in using them as anchors around which to build thematically and tonally harmonious art collections. Almost without exception, Dewing's Cornish landscapes – in which paired, linked, and doubled figures eloquently spoke to the pleasures of shared quiet moments – were scooped up by members of the small circle of art patrons to which Freer and Hecker belonged, which included their St. Louis-based business associate Bixby, as well as John Gellatly and Evans in New York, sometimes in active collaboration with each other.[61]

Evans and Freer had known each other since at least 1890, when Evans agreed to lend Aesthetic paintings by Frederick Stuart Church to an exhibition at the Detroit Club organized by Freer.[62] In 1901, Freer returned the favor by removing Dewing's *Blue Dress* from his parlor and sending it to a Lotos Club exhibition in New York at Evans's request.[63] But it seems that it was not until 1904, as part of their Society of Art Collectors collaboration in organizing the *Comparative Exhibition of Native and Foreign Art*, that Evans first visited Freer's home. The experience was a powerful and influential one: as Evans wrote to Freer upon his return, "after seeing your beautiful collection, I have resolved to rehang my drawing room with poetic works by Dewing, Tryon, Twachtman, etc."[64] Freer reciprocated by touring Evans's dry goods warehouse the next time he was in New York, eventually ordering several sets of white silk window hangings with lace trim directly through Evans himself.[65] These men, in other words, harmonized their living spaces in collaboration with (and touched with fond remembrances of) each other.

Having resolved to refocus his drawing room installation, Evans's first acquisition in this vein was Dewing's *The Lute* (fig. 97): a picture that had interested Freer, but that the more experienced collector declined to purchase, on the grounds that it would have "a splendid effect" on Evans instead.[66] *The Lute* not only stood as a signifier of the shared interests and collaborations between them; it also functioned as part of a pair, together with *La Pêche* (fig. 98), with which it was exhibited at New York's Montross Gallery with other paintings by Dewing and Tryon in 1906. The two pictures feature minor variations on the theme of four women standing and sitting in a soft green landscape, their heads marking a rhythmic procession across the canvas, in a manner not unlike Tryon's slender trees. The paintings, completed around the same time, were clearly linked in the artist's mind, but it seems that they remained conceptually connected in the minds of their owners as well. It is not clear when New York collector John Gellatly first purchased *La Pêche*, but in 1917, when he considered selling it to the Worcester Art Museum, he consulted with Freer on the subject; ultimately, Gellatly decided to keep the "thrillingly beautiful" picture for himself.[67]

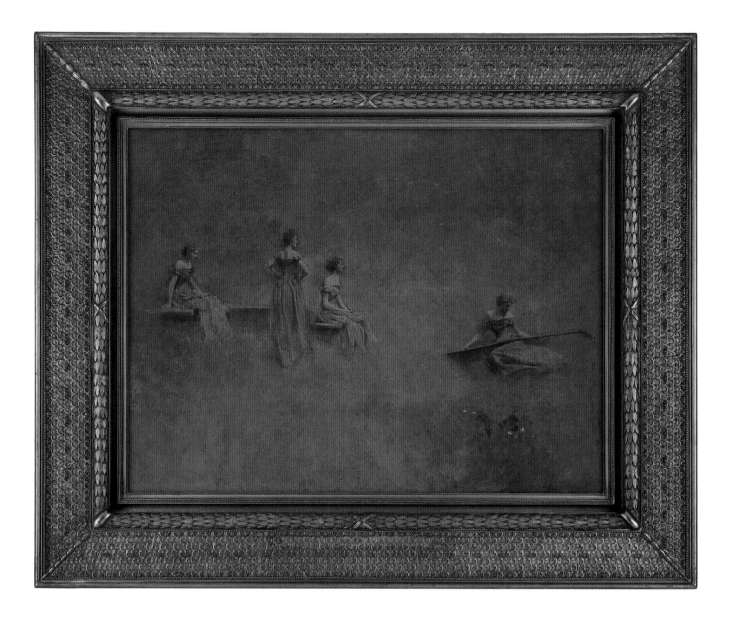

But, crucially, it was not only art collectors who were linked by Dewing's "decorations." As with Tryon's landscapes, railroad men Freer, Hecker, and Bixby shared a passion for Dewing's pictures that strengthened their business relationships as it bound them together as friends and fellow collectors. Freer secured Dewing's *Recitation* (1891, Detroit Institute of Arts) and *Summer* (see fig. 96) for Thomas Fletcher Oakes and James B. Williams respectively, who, as president and vice-president of the Northern Pacific Railroad, were his and Hecker's clients and co-investors in the car building business.[68] Dewing's frequent recourse to the motif of linked figures – such as the joining of hands in Williams's *Summer* – resulted from his own explorations of decorative compositional rhythm, but these chains also have the effect of underscoring the tight connections between the individuals who occasionally passed the paintings hand to hand within their sympathetic circle.

To look closely at the history of how Dewing's landscapes were acquired, sold, and talked about by their owners is to see these pictures enmeshed in a network of

97

Thomas Wilmer Dewing, *The Lute*, 1904. Oil on panel, 91.5 × 122.1 cm. Freer Gallery of Art, Smithsonian Institution, Washington, D.C.: Gift of Charles Lang Freer, F1913.34a.

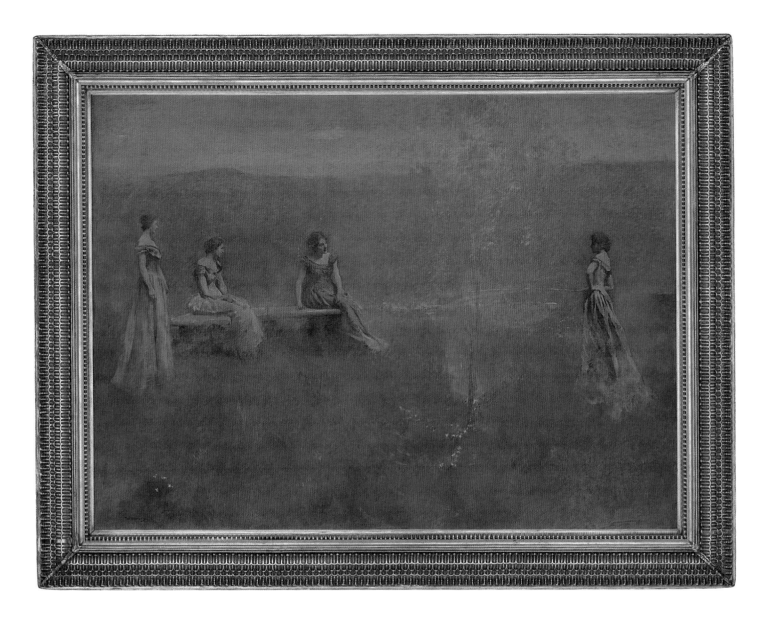

98

Thomas Wilmer Dewing,
La Pêche, 1901–4. Oil on
panel, 88.9 × 107.3 cm.
Private collection. Image
courtesy of the Metropolitan
Museum of Art, New York.

exchange and appreciation in which these visual relationships and associative meanings remained very much alive. The shape of that network often resembled the cooperative structures that organized their business affairs: the circulation of Dewing paintings bound them into what we might call an "interlocking collectorate." Just as these men served on multiple, overlapping corporate boards of directors, thereby enabling price controls and streamlined vertical and horizontal integration, they also orchestrated the art exhibitions of multiple clubs and associations, and made collaborative decisions directing the paintings of their favorite artists into the hands of those who could best appreciate them. In 1903, Freer, Gellatly, Evans, and Thomas B. Clarke, among others, even formed a secret "Twachtman Syndicate" to buy up and redistribute that recently deceased artist's works, ensuring that they did not suffer the indignity of low auction prices and found appropriate placement with respected collectors.[69] The intimately related Aesthetic paintings they owned were aids to constituting themselves as a kind of unofficial board of directors for the promotion of American art.

99

Thomas Wilmer Dewing,
The Mirror, 1907. Oil on panel,
50.8 × 40 cm. Freer Gallery of Art,
Smithsonian Institution,
Washington, D.C.: Gift of Charles
Lang Freer, F1907.168a.

100

Thomas Wilmer Dewing,
Yellow Tulips, 1908. Oil on panel,
50.8 × 40.3 cm. Freer Gallery of Art,
Smithsonian Institution,
Washington, D.C.: Gift of Charles
Lang Freer, F1908.27a.

We have seen that Dewing's landscapes were sought after by a tightly focused community of "choice spirits," whether or not they were actually "above the heads of the public" as the artist feared. And although Dewing was confident that his other specialty – pictures of women in interiors – could "stand squarely on their technical excellence," they, too, were collected in pairs, series, and groups.[70] These paintings were smaller and more numerous than the landscapes, and can be divided into several subsets: women with musical instruments, women absorbed in contemplation, and color studies, among others. Like his "decorations," their compositional echoes formed a kind of floating virtual array existing outside the boundaries of individual collections, homes, galleries, and museums. But here I would like to shift my discussion from their role in consolidating group identity to their visual rhythms of repetition, which, I will show, resonated harmoniously with certain aspects of industrial activity and rhetoric.

Dewing's subjects, in his interiors as in his landscapes, are generally presented as though they are more or less interchangeable. His single figures are reminiscent of Whistler's in that they are treated as aggregations of color and form to be arranged according to the artist's sense of harmonious tone and proportion (figs. 99 and 100). The titles of his pictures (*The Mirror*, *Yellow Tulips*) similarly direct the viewer's attention away from the personality of the sitter and toward composition as an end in itself: a strategy again characteristic of Aesthetic painting generally. In his multi-figure compositions, Dewing typically blurs or elides the distinctions between the faces or bodies of his subjects, and often seems to double or triple the same figure without differentiation.

The duplication and repetition of near-identical figures – within single canvases and across Dewing's *oeuvre* more broadly – grounds his pictures in the realm of the Aesthetic, which is to say, the decorative. These pictures may be rearranged and recombined almost endlessly, with little threat to the harmony of the collection that encompasses them or the room in which they are installed, and their consistency contributes to the establishment of the artist's brand.[71] Yet while the motivations behind Dewing's use of these repetitive techniques are not difficult to imagine, the overall effects of his treatment of female subjects have consistently remained a matter of scholarly debate. Much emphasis has been placed on the way that the pictures, by evacuating the forceful personalities, meaningful activities, and intellectual exertions of their subjects as individuals, relegate these women (and women more generally) to powerless, passive, even decorative objects of (male) manipulation.[72] Kathleen Pyne complicates this by proposing that female segregation from the active, competitive world of Gilded Age men may point instead to their superior access to the "higher life" of culture and spirit, as paragons of Anglo-Saxon evolutionary perfection.[73]

It is not difficult to imagine a late nineteenth-century American Aesthetic art patron viewing Dewing's pictures through these shifting lenses, more or less consciously cycling through a range of complex psychological responses that included experiences of both differentiation from and identification with the subjects depicted. Without diminishing the importance of asking what messages about women were encoded and decoded here, I want to enlarge our critical understanding of these paintings by redirecting this discussion to the potential

social and even economic implications of Aesthetic *form*. As we have seen, repeated figures and compositional similarities constituted a shared visual language that linked like-minded collectors and their collections together. At a deeper level, I will argue, Dewing's decorative compositional strategies invited a way of seeing that rhymed with familiar experiences of managing and interacting with standardized production in these businessmen-collectors' workaday lives. Indeed, this was an experience shared by the "few choice spirits" drawn to commissioning and purchasing Dewing's works.

In a remarkable letter dated October 18, 1906, Freer wrote to Dewing to announce that his butler/curator Stephen Waring would soon be visiting New York. "If he comes, I hope you will let him have a view of your 'factory,'" urged Freer. "It will amuse him to see how things are *made*."[74] By that date, Freer had already helped Dewing build one "factory," a Stanford White-designed studio at Cornish, partly in trade for Dewing's parlor pictures: "It has doubled my productiveness," the artist reassured Freer at the time.[75] And Freer's assistance had not been merely financial. He had also advised the artist throughout the studio's construction on the size and sheathing of roof timbers as well as insulation materials. In the case of the latter, Freer consulted with the superintendent of his newly merged Michigan-Peninsular Car Company before forwarding to Dewing samples of the waterproofing materials used in protecting the company's refrigerator cars, and sending him detailed instructions on how to install them. In the Freer–Dewing correspondence of August 1892 on the subject of the new studio, we have what would seem to be a jarring intrusion of the language and aesthetics of the industrial realm into the artist's "poetic and imaginative world."[76]

Freer's designation of Dewing's New York studio as a "factory" is highly suggestive. Some of Dewing's experiences and working methods at these studio sites do resonate with those of factory production in striking ways. In late 1893 and early 1894, for example, the financially strapped artist began a project of producing pastel drawings at an accelerated rate, focusing, by his own admission, on their commercial value, as he hoped to use them to finance an art-study trip to France and England. Dewing explained his mass production of drawings to Freer as follows: "Montross says he will sell my things for 10 per cent after I am gone. I shall leave about 30 pastels with him 250 apiece which ought to give me a little income."[77] Freer had supplied him (and Tryon) with the material he used to create these drawings: a distinctive light brown paper similar to the type favored by Whistler, upon which Dewing planned to draw Whistleresque compositions of single figures dressed in ball gowns.[78] This collaborative arrangement constituted an artistic equivalent of vertical integration, the organizational strategy favored by many Gilded Age corporations. Freer and his business associates used it in 1892 to bring separate producers of constituent railroad car parts under the aegis of one administrative corporation.[79] By similarly providing Dewing and Tryon with this raw material, Freer moved to guarantee the high quality of the final product he would eventually receive.[80]

The attempt to secure a dependable supply of high grade raw materials from which to manufacture products was only one aspect of a broader trend toward standardization in American industry during the 1880s and 1890s – a trend specially exemplified by changes in the railroad and railroad car building sectors.[81]

Companies like the Michigan-Peninsular were actively involved in and directly affected by the national standardization of railroad track gauges that occurred in 1886. The overnight switch to a universal 4 foot 8½ inch track gauge, for which all railroad cars had to be made compatible, finally and officially made the American network of railways into a fully interconnected system. Cars from all over the nation could now travel on uniform tracks, their journeys regulated by the newly instituted (1883) schedule of standardized railroad time. Universal time improved the safety of rail cargo and passengers, as did the Railroad Safety Appliance Act of 1893, which required standardized automatic couplers and air brakes on all trains – standards with which the Michigan-Peninsular, as managed by Freer and Hecker, had to comply.

Their company was well placed to adapt to these changes because standardized production had been a central feature of its factory structure for over a decade. The car building industry was in fact one of the nation's first manufacturing sectors to embrace assembly-line type production.[82] In 1885, seven years before the Michigan-Peninsular merger, a writer for the *Detroit Free Press* visited the factory of Freer and Hecker's Peninsular Car Company and described its assembly process: in order to build a railroad car, a cartload of raw materials was methodically pushed forward along tracks from one workstation to another "until it is finally put together and sent out as a perfect car." In a dramatic and highly visible feat of transformation, "every car turned out represents one carload of material used in construction."[83]

As vice-president and secretary of these two companies, respectively, Freer's various business responsibilities required him to engage with standardized corporate operations on several levels. He was doubtless familiar with the basic processes of car manufacture, as he was tasked with the responsibility of discussing working conditions, hours, and other grievances with striking laborers.[84] He was also a frequent traveler to Chicago, St. Louis, Buffalo, and New York, among other locations, where he negotiated the sale of railroad cars customized to meet the specifications of various clients.[85] But his chief expertise was in accounting, a field likewise forced to come to terms with newly standardized operating procedures, codified in the railroad industry by the Interstate Commerce Act of 1887.[86]

Freer, a famously meticulous man in his public and private record-keeping, valued uniformity and control in business practice as he did in the art objects he collected. One of his favorite artists, the Michigan potter Mary Chase Perry Stratton, recalled of Freer, "He used to insist that whatever one did should be of the finest quality. 'If you are about to make a figure five,' he would say, 'let it be the finest character it is possible for you to make.' He had no patience with sloppiness either in thinking or in workmanship."[87] Such a statement appears to collapse the distance separating the double-entry balance sheet and the railroad car assembly line from the conspicuous practices of selection and arrangement that characterize Aesthetic art; it also conflates the supervisory gaze of the corporate director with that of the art collector.[88] Viewed through this lens, Dewing's late interiors radiate the pure and clear logic of mathematical expressions, offering potentially endless permutations of models, furniture, and vases against neutral backgrounds.

The foregoing discussion of Dewing's canvases has focused on standardization of conception and composition, but taking a unique example of his work in the Freer collection also reveals the artist's interest in experimenting with standardization of construction, of touch. *Four Sylvan Sounds* (see fig. 91) is comprised of two sets of two-paneled screens inspired by the words of Ralph Waldo Emerson (in his poem "Woodnotes") and the natural harmonies that impressed the artist at Cornish (the sounds of falling water, bird calls, and wind). This screen-painting project was the first of several attempted by Dewing during the course of his career, and was inspired by both Japanese screens and those painted by Whistler. The soft, flat, all-over fields of lush greenery that characterize Dewing's landscapes here are partially built up out of something like stenciled forms, which left thin ridges of paint along the edges of several of the leaves.[89] The regularized, almost mechanized, character of this technique is clear to the naked eye, even in reproduction, but it apparently bothered neither Freer nor his partner Hecker, who admired *Four Sylvan Sounds* so much that he commissioned two sets of screens for his own home.[90] Rather than sounding a clamorous mechanical note, repetition and standardization are here elevated to the status of ideal beauty, and art is born of efficiencies similar to those practiced in the factory world.

Hard Times at Freer, Thayer & Co.

The repetitive nature of Dewing's figures and compositional formulae, which sometimes marked his pictures as less interesting or original to contemporary critics, in fact performed a useful operation as far as the artist and his relatively small pool of patrons were concerned. Their close visual relationships ensured that their owners kept each other in mind: a strategy that Dewing also exploited in his correspondence with them, sometimes to spur competition, and at other times to encourage cooperation, among them.[91] Freer's other favorite artists – Tryon, Abbott Thayer, and Frederick Stuart Church – also wrote similarly allusive and informative letters to patrons within this group, frequently using the example of one to set a higher standard for another to live up to (or, when necessary, to provide a negative counterexample). In cultivating a sympathetic community of collectors that was aware of itself as such, these artists helped to guarantee long-term support for their work, but one consequence of this was that they became "restricted by the taste [they have] created to a limited form of activity." However much they may have wanted their pictures (and their viewers) to dwell in the "poetic & imaginative world," the particular nature of this patronage system kept them partly grounded in the terrestrial one.

Significantly, Freer's artists were keenly aware of – and in some cases directly involved in – his business activities. In 1892, while Tryon was completing his landscapes for Freer's main hall, the artist asked to become an investor in the new Michigan-Peninsular Company. Freer contributed $2,500 worth of Michigan-Peninsular stock toward the total cost of the picture series.[92] Stock certificates were sent to Tryon, and the pictures were installed in Freer's home, where they became, effectively, documents of reciprocal investment between painter and patron. The New York art dealer Newman Montross and architect and frame designer Stanford White also bought stock in Freer's companies, and Dewing

received bonds from Freer in payment for a pair of pictures in 1906.[93] Such arrangements brought artists into the uncertain realm of speculative finance, and intensified the mutual commitment to future success that they shared with their patron.

Joining Dewing, Tryon, and Whistler, Abbott Thayer was the fourth major artistic contributor to Freer's contemporary American painting collection, and it is to Thayer we must turn if we are going to understand the full potential implications of this patronage system from an artist's point of view. Working for the interlocking collectorate to which Gellatly and Freer belonged was both a boon and a burden for Thayer, who found himself simultaneously sustained and constricted by the close relationships among his patrons. In this respect, Thayer's experience captures the double sense of "network" in this period as a thing that both extends and ensnares.

Thayer's artistic career was productive but notoriously unstable, and he remained financially insecure in the management of his personal accounts and in his detachment from a permanent residence throughout much of his life.[94] Though actively involved with a number of New York art institutions, he frequently rented accommodations far removed from the city, where his children and other near-to-hand members of the household served as models. Given these conditions, it is easy to imagine why Thayer may have found it useful to cultivate a stable of long-term patrons to sponsor his work, especially during a period when increasing numbers of American art enthusiasts returned again and again to the same painters for closely related, often decorative pictures. But Thayer's distressed correspondence reveals his unsuccessful attempts to meet his businessmen-patrons on their own ground, adopt their corporate language, and beat them at their own game.[95]

Like Dewing and Tryon, Thayer frequently dropped the names of competing collectors into his letters, playing one eager patron against another. At the same time, he also presented them with various models of patronage to try on, apparently hoping that at least one would flatter the wearer. In an exemplary note to Freer on May 20, 1893, for instance, Thayer constructed a historical lineage of patrons – "the Japanese dukes, Da Vinci's noble patron, and the Medicis with Raphael and Michael Angelo" – and implicitly encouraged Freer to imagine himself among these men who "recognized that an artist in the full sense was the true prince and, lacking the painter gift themselves, they painted" by supporting artists financially.[96] He was not merely asking for the purchase of individual pictures, he clarified, but rather for money that would enable him to continue producing pictures, ventriloquizing these great patrons as saying, "use my earthly comfort to soothe and calm yourselves till that calm makes you blossom and bear fruit." Admitting that he, too, had spent money on things that "soothed and calmed my long harassed life," Thayer justified those "expenditures" as "a wise investment."[97]

Shifting as he does here from the language of noblesse oblige to that of conscientious accounting, Thayer may have thought he was adeptly blurring the lines between the model of the Renaissance patron and the model of the Gilded Age businessman, but, as he learned the hard way, these two models did not blend smoothly, leaving the artist and his sponsors entangled in a vaguely defined web of perpetually unresolved, anxiety-producing personal and financial obligations. First, he tried to goad his patrons into paying ever larger amounts for his canvases

because, he insisted, their value extended into perpetuity. He encouraged Freer to believe that his pictures, when purchased, belonged not to individuals but to the nation – a full eleven years before Freer refashioned himself as an institutional collections builder.[98]

But in 1894, Thayer took this strategy one step further, asking Freer for a loan of $1,000 to $1,500, this time decoupled from any particular painting in process, of which there were many, some of which Freer had already paid for. Having no other collateral on hand, Thayer promised Freer the right of first refusal on all his subsequent work.[99] Thayer essentially proposed that Freer take up futures trading, with his pictures as the chief commodity, and it worked: Freer sent a check.[100] But with this gesture, their relationship became more muddled. If Freer was investing in Thayer, Thayer asked, shouldn't Freer want the artist's canvases and reputation to appreciate in value – even if it meant deprioritizing Freer's own commissions? During that financially difficult winter, Thayer was confident that he could sell *Clara May* (now called *Diana*, Freer Gallery of Art), a painting he had begun for Freer, to Boston's Joshua Montgomery Sears for a higher price. He sought Freer's permission to do so:

> It seems to be a simple case of Freer Thayer & Co. needing to get all they can for Thayer's productions to protect Thayer's capital. So that I ought to refuse to sell to [Freer] if I can sell … elsewhere, on the other hand I have no right to dictate to my dear partner as to his extravagancies nor prevent his buying a "Thayer" when he pleases. This is all written with a smile, but I do somehow get mixed up when I try to think out the right way.[101]

Freer did not approve, and Thayer, feeling the pressure he had put himself under, teasingly advised Freer "not go into the Thayer business any deeper."[102] But the finances of "Freer Thayer & Co." were anchored on a sinking foundation, as Thayer continued to borrow money from multiple patrons, rendering it effectively impossible to meet all promised obligations with paintings or repayment.[103]

Thayer's pseudo-corporate framing of his relationship with Freer and his own art production grew more ardent and elaborate over the course of the 1890s. He advised his "partner" not only to buy his canvases but to "sell them as fast as possible."[104] He lost track of how much money had been loaned outright, how much had been advanced on pictures not yet completed, and how much was owed for finished pictures on hand.

All of this was compounded by Thayer's experimental trial-and-error working method. As each conception and composition underwent transformations and revisions, Thayer resorted to making (and having his students make) painted copies on which he could try out new things, adding, subtracting, and adjusting as he worked toward his ideal arrangement.[105] But these studio copies generated variations upon variations that spun somewhat out of the artist's (and his patrons') control. In his letters, Thayer implied that the compositions "threaten[ed]" to keep evolving to a point where he must pursue them and eventually, if successful, sell them. And yet to his mind, these independent works were not really free for him to sell at all, because they were so closely associated with a project he had initiated for Freer.[106]

101

Abbott Handerson Thayer,
Cornish Headlands, 1898.
Oil on canvas, 76 × 101.7 cm.
Freer Gallery of Art,
Smithsonian Institution,
Washington, D.C.: Gift of
Charles Lang Freer, F1906.98a.

By all accounts, Freer did not seem to have been particularly concerned about this aspect of Thayer's work, but Gellatly, among others, continued to press the artist to separate "originals" from (lesser) variations. Thayer's generation of multiple canvases was not limited to the studio, but included landscapes supposedly painted on the spot. A case in point was a pair of Cornish seascapes painted in 1898 (figs. 101 and 102). As they passed from one member of his tight-knit collecting circle to another, Thayer was forced to clarify their relationships to each other and to the original motif. Freer purchased one of these canvases in 1899; four years later, Thayer tried to persuade him to buy the second, a "twin brother of your Cornish headlands, the same view painted another afternoon, each a portrait of that especial day, on the spot."[107] Freer declined. Thayer then shopped it around to John Harsen Rhoades and Gellatly. When writing to Gellatly, Thayer denigrated the version in Freer's collection as a "sketch," even offering to inscribe the fact that it

was "the sketch from which yours is developed" "in full view across the front" of Freer's canvas.[108] Thayer, obviously, did not do this; Freer's canvas, however, now bears an inscription on its back, applied ten years after the painting was created: "This picture of the sea from St. Ives (Cornwall) Headlands, and sold by me to Chas. L. Freer, is one of two that I did on the same spot on different days, but at the same time of day. The other I sold to Harsen Rhoades. Abbott H. Thayer / Bath, England. / Sept. 18, 1908."[109] Gellatly would eventually acquire Rhoades's *Cornish Headlands* for himself. He would refer to it thereafter as the "original."[110]

But this incident reveals something else as well. American collectors of Aesthetic painting, many of whom were intimately familiar with, if not directly involved in, the arena of mass production, demonstrably enjoyed comparing, arranging, rearranging, lending, and exchanging works of art that bore a close visual relationship to each other. And yet something about Thayer's reproductive practice apparently registered as problematic. Dewing, as we have seen, jokingly referred to his studio as a "factory"; Freer and Gellatly owned two nearly identical Dewings, which apparently caused them little concern.[111] But Thayer's methods not only raised the specter of the involvement of other "hands" in the process, they also

102

Abbott Handerson Thayer,
Cornish Headlands, 1898.
Oil on canvas, 76.5 × 101.8 cm.
Smithsonian American Art
Museum, Washington, D.C.
Gift of John Gellatly.

depended on a managerial hierarchy of worker and supervisor that operated under Thayer's control rather than that of his patrons. When the artist attempted to whet his patrons' appetites and stoke the competition between them to his advantage, suggesting that his pictures were ever on the verge of reproducing themselves, this tactic seems to have backfired, generating anxiety and doubt rather than an impulse to vie for the prize.

Monopoly or Monotony?

By 1904, the end result of Freer's fifteen years of commissions, purchases, loans, gifts, promises, plans, and negotiations was a highly focused collection of American Aesthetic paintings by Dewing, Tryon, Thayer, and Whistler (including the Peacock Room), as well as a vast cache of Chinese, Japanese, and Korean artworks. The paintings included works of art hanging in their planned location as decorations within his Detroit home, as well as those brought in and out of storage by his caretaker to produce stimulating transnational comparative arrangements on demand (fig. 103). When he proposed the whole as a gift to the nation at the end of that year, he was offering a gift of objects, but, more than that, a gift of *method*, inviting subsequent generations of viewers to attend to the harmonious formal qualities that resonated across cultures when objects were freed from the (to his mind) distracting particularities of historical context.[112]

But in trying to foreground his own systematic methods, Freer nearly derailed the donation itself. His 1904 offer letter to the Smithsonian explained the strategy behind his collecting practices: "No attempt has been made to secure specimens from unsympathetic sources ... My great desire has been to unite modern work with masterpieces of certain periods of high civilization harmonious in spiritual and physical suggestion."[113] He offered to provide funds for a separate museum building to ensure that his thousands of carefully selected and arranged American and Asian art objects would be preserved into perpetuity, where the historical, social, and contextual gaps between them would be elided by what he felt were their deeper formal and conceptual correspondences. But museum officials hesitated and expressed their desire to intermix additional objects with Freer's holdings. Afraid that such display practices "might destroy the unity and harmony of my group" and "eventually destroy the underlying purposes of my own work," Freer wrote again to the Smithsonian to clarify his methods and intentions:

> I regard my collections as constituting a harmonious whole. They are not made up of isolated objects, each object having an individual merit only, but they constitute in a sense a connected series, each having a bearing on the others that proceed or that follow it in point of time. My object in providing a building is to insure the protection of this unity and the exhibition of every object in the collections in a proper and attractive manner.[114]

Only after the personal intervention of President Theodore Roosevelt in 1906 did the Smithsonian officially accept Freer's gift and its limiting conditions, thereby transforming a patron's personal collecting system – which, as we have seen, answered not only to the demands of decorating and acquisition, but to a specific

103

Alvin Langdon Coburn,
Charles Lang Freer, 1909.
Albumen print. Charles Lang
Freer Papers, Freer Gallery of
Art and Arthur M. Sackler
Gallery Archives. Smithsonian
Institution, Washington, D.C.
Gift of the estate of Charles
Lang Freer, FSA_A.01_
12.01.2.3.

social, industrial, and economic worldview – into a storehouse of national
patrimony. Before Freer died in 1919, he selected an architect (Charles Platt) and
approved plans for his museum building, mapped out the locations in which
pictures were to be placed in galleries dedicated to individual artists, and
commissioned a few last paintings from his favorite American artists to ensure a
perfect symmetry of hanging. In doing so, he worked to ensure that Aesthetic
strategies of comparative looking, harmonious installation, and group cultivation
– the strategies that governed his private collecting – would override and replace
other museum curation methods being considered or deployed at that time or in
the future.

Approaching death in the late 1910s, Freer amended his gift to the nation to
enable the ongoing enlargement and evolution of the Asian holdings, admitting his
partial knowledge of the field.[115] But he steadfastly held that he had mastered the

104

Charles Lang Freer's handwritten plans for the Freer Gallery of Art. Freer Gallery of Art and Arthur M. Sackler Gallery Archives. Smithsonian Institution, Washington, D.C. Gift of the estate of Charles Lang Freer, FSA_A.01_01.5.2.05.20.

works of Whistler and those of Dewing, Tryon, and Thayer. These, he insisted, could never be deaccessioned, loaned, or intermixed with other collections within the building or the institution. He envisioned them filling almost half the museum, and clearly expected that they would be left on the walls where he planned and placed them (figs. 104 and 105).[116]

Freer had achieved, if not a monopoly in the works of Dewing, Tryon, and Thayer, at least a majority share. But he could never have guessed that his stockpiling would damage these artists' reputations as it has. At the Freer Gallery of Art today, the Asian holdings continue to grow and change with the arrival of new acquisitions, and are enlivened by rotating temporary exhibitions in the adjacent Arthur M. Sackler Gallery. Meanwhile, Freer's modular, highly repetitive, theme-and-variations Aesthetic paintings are left with a shrinking proportion of the wall space. Once room has been allotted for choice selections from the largest

FIRST FLOOR PLAN
BUILDING FOR THE FREER COLLECTIONS
· WASHINGTON · D · C ·

105

Charles A. Platt, plan for Freer Gallery of Art. Charles A. Platt Drawings & Blueprints. Freer Gallery of Art and Arthur M. Sackler Gallery Archives. Smithsonian Institution, Washington, D.C., FSA_A2015.26_A0397

Whistler collection in the world, there is little left over for the other three artists, and representative examples are chosen to stand for them. Some hang in corridors and stairwells; the bulk remains in storage. These scattered canvases no longer make the massed impression that so appealed to Freer. And because other museums are forbidden from borrowing them to mount any kind of complete reconsideration of them, his restrictions have obscured rather than bolstered their significance.

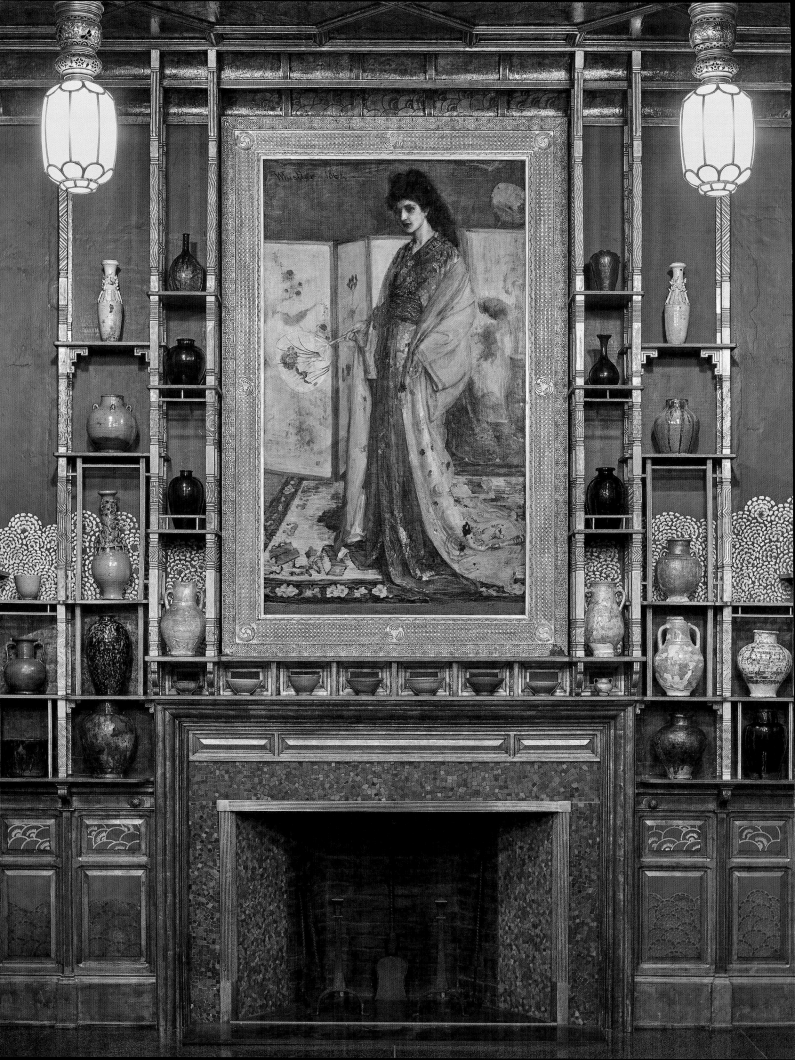

Aesthetic Painting in our Networked Age

Charles Lang Freer's gift to the Smithsonian Institution, first proposed in 1904, was inspired both in deed and in character by his friendship with James McNeill Whistler and his dedication to the principles that informed the creation and display of Whistler's art. Styling himself as the anti-Leyland, Freer spent years during and after Whistler's life working to preserve the artist's legacy, which, to Freer's mind, hinged on his mastery of universal principles that linked his pictures to the most rarified productions of Japanese and Chinese painting and to the colors and forms of Near Eastern and East Asian glazed potteries of the past and present. As Ernest F. Fenollosa famously explained in an early analysis of the Freer collection, Whistler served as the "nodule" at the center of this aesthetic network, "the interpreter of East to West and West to East."[1] Although it was a comparatively late addition to Freer's personal holdings, Whistler's Peacock Room – disassembled and transported from London to Detroit and then to Washington, D.C. – would provide a key pivot point between the American and Asian displays at the Freer Gallery of Art when it opened in 1923. It offers an apt frame for reflecting upon the ground traversed by this study and the research questions and processes that produced it.

In a transatlantic echo of Whistler altering Leyland's London dining room to accommodate the color harmonies of the *Princesse* (see fig. 3), Freer purchased the *Princesse* in 1903 and shortly thereafter considered acquiring the environment that had originally housed her. After Leyland's death in 1892, his estate had liquidated the blue-and-white porcelain that had once lined its shelves (see fig. 1), but the painted and gilded peacock interior remained at 49 Prince's Gate under new tenants until the dealers Orbach orchestrated its separate sale in 1904. As has been well documented, Freer did not find the room entirely to his taste, but was eventually convinced to purchase it as part of his broader preservation and gift campaign.[2]

James McNeill Whistler,
*Harmony in Blue and Gold:
The Peacock Room*, 1876–7
(detail of fig. 106).

Freer eventually discovered, however, that once the Peacock Room had been reassembled inside an extension to his Detroit home, he could transform it into a field for continued Aesthetic play. He used its gridded shelves as the scaffolding for creating his own compositions out of the raw materials of Chinese, Japanese, Egyptian, and Iranian potteries, arranged as color notes laid over Whistler's sparkling gold and peacock blue decoration.[3] Due to the subtle chromatic qualities of these vessels, the full effect of Freer's arrangement was dependent on natural light admitted by opening the peacock shutters, capping this room's history of illumination by candlelight, gas, and electricity with daylight.

Former Freer Gallery curator Linda Merrill saw Freer's adjustments to the room and his decision to donate rather than sell it (as Leyland had) as gestures intended to disentangle it from its associations with its former owner.[4] Although the Peacock Room was essentially empty when it was reopened in Washington, D.C., in 1923, it was eventually filled out with examples of Kangxi blue-and-white, taking visitors back, as it were, to the moment of its creation. In 2011, however, the Freer Gallery completed a full-scale reinstallation of Freer's celadon, turquoise, and buff-colored iridescent potteries, based on photographic evidence of the collector's own arrangements in 1908 (fig. 106). The Freer Gallery has presented this as returning to life and activity a display that had otherwise essentially calcified.[5]

106

James McNeill Whistler, *Harmony in Blue and Gold: The Peacock Room*, 1876–7. Photographed in 2011 with Freer's collection of ceramics installed. Freer Gallery of Art, Smithsonian Institution, Washington, D.C.: Gift of Charles Lang Freer, F1904.61.

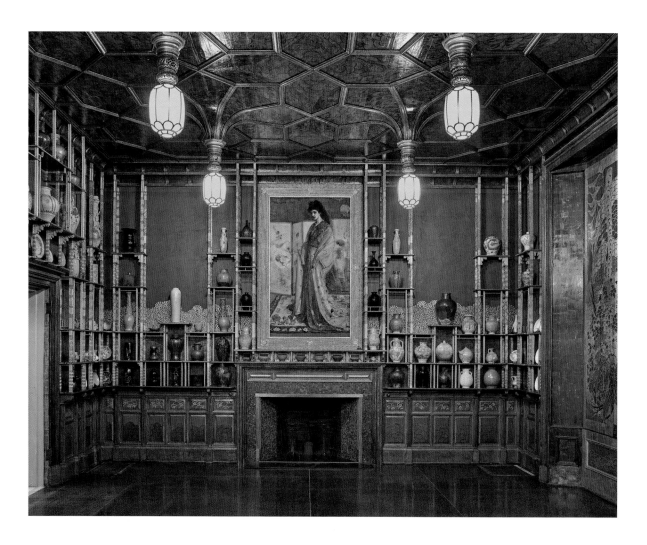

To make the new (old) version of the room "more accessible to real and virtual visitors," the gallery's curators and educators have turned to digital tools, first designing a companion website, then an app, "The Peacock Room Comes to America."[6] Scrolling through the app turns the Peacock Room into a continuous lateral circuit. Readers can access detailed photographs and additional information about each of the 250 ceramic vessels included in the display. As curator Lee Glazer has explained, this tool enables the gallery to work around the limitations of the physical space, in which posting supplemental texts and other educational materials would destroy the harmony and unity of the room.[7]

Further reaching out to virtual visitors, immersive reproductions of the Peacock Room were included in the most recent major exhibition dedicated to the Aesthetic movement, *The Cult of Beauty*, co-organized by the Victoria and Albert Museum in London and the Fine Arts Museums of San Francisco. In its London iteration, the show featured a digital projection of the Peacock Room (with Leyland-era blue-and-white china) inside a drum-shaped exhibition partition, transforming the rectilinear room into a panoramic scheme (fig. 107). The Peacock Room was only one of a series of projections created by design firm OPERA Amsterdam to animate the display. At the Legion of Honor in San Francisco, three gallery walls that more closely approximated the size and scale of the actual

107

The Cult of Beauty as installed at the Victoria and Albert Museum, London, 2011. OPERA Amsterdam.

Peacock Room served as the support for an illusionistic photomural of it. These photographs showed the room with Freer's recently reinstalled ceramics.

To my eyes, and in the eyes of some critics, these reproductions of the Peacock Room only dramatize the absence of the thing itself.[8] In this regard, Darren Waterston's 2013 MASS MoCA installation *Filthy Lucre* (fig. 108), a nearly full-scale reproduction and transformation of the Peacock Room, answers that absence with an aggressive material presence. At MASS MoCA in 2013–14 or at the Smithsonian's Arthur M. Sackler Gallery (adjacent to the Freer Gallery) in 2015–17, where I examined it, *Filthy Lucre* was heard before it was seen: recordings of discordant music and ghostly voices drifted out of the room as viewers approached it. But before it was either heard or seen, the installation could be smelled, as Waterston's dripping, layering, and smearing of oil, acrylic, and gold leaf over wood, aluminum, fiberglass, glass, and ceramic surfaces assaulted the senses with acrid freshness and excess. In creating *Filthy Lucre*, Waterston remade the Peacock Room as a claustrophobia-inducing space of disharmony and violence, breaking the wooden armatures, shattering ceramics, and blotting out the *Princesse* with apparent mold and water damage. In his translation of Whistler's fighting peacock mural, the birds are no longer squared off in a confrontation over silver coins but tear each other's innards out with their beaks and claws. In the words of MASS MoCA curator Susan Cross, Waterston brings to the fore the "ugliness" of the interpersonal dispute and conspicuous consumption that produced the original room, ensuring that fundamental disputes over art and money cannot be simply covered over or redeemed by surface beauty.[9]

108

Darren Waterston, *Filthy Lucre*, 2013–14, at MASS MoCA, North Adams, Mass. Oil, acrylic, and gold leaf on wood, aluminum, fiberglass, glass, and ceramic, with lighting and audio.

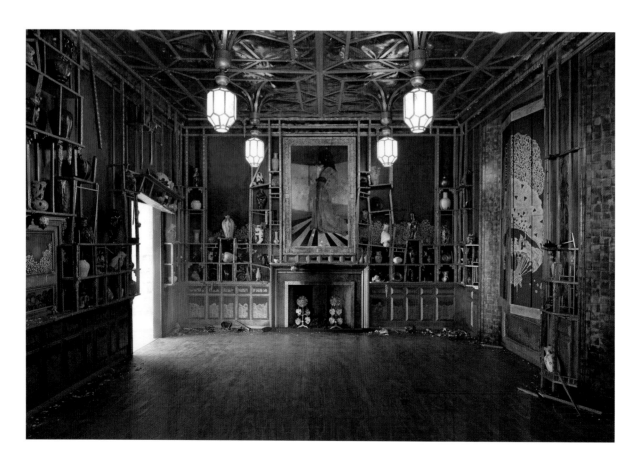

Of course, among many art historians as well as members of the general public, the scandalous narrative of the Whistler–Leyland fight has always threatened to overwhelm the room itself. In fact, John Ott begins his essay for Waterston's *Filthy Lucre* catalog by acknowledging that Whistler's Peacock Room "rarely appears in print without discussion of the dispute between the two men over the proper cost and scale of the commission."[10] It seems questionable whether there is much to be gained by entrenching and amplifying those disharmonious origins even further, particularly as they may distract us from noticing the many ways in which Aesthetic harmony could be instrumentalized in accomplishing political, corporate, technological, social, or cultural integrative ends, as I have tried to show here.

The Waterston project, though, does constitute its own complete system, and there are undoubtedly stimulating intellectual and physical pleasures to be found in immersing oneself in that environment and working out its conditions and contours. I suspect that the installation held such a strong appeal because it offered a very physical and immediate experience of a room that more people know by reputation than by actual encounter. *Filthy Lucre* could and did travel. The Peacock Room cannot. Taken together, these exhibitions and installations bring the material and the virtual into sharp juxtaposition, and invite us to reflect upon the possibilities and challenges involved in trying to access and understand the Aesthetic Movement in our networked age.

The scope, discoveries, and conclusions in this book were directly enabled by – would not have been possible without – a vast trove of digitized, keyword-searchable primary sources, one that expands dramatically each year. Whistler resources are especially bountiful, including the online full-text *Correspondence of James McNeill Whistler* and *James McNeill Whistler: The Etchings* catalogue raisonné, produced and hosted by the University of Glasgow.[11] In some crucial ways, these tools help us tap into the period experience of reading about objects and interiors rather than seeing them: much like the "habituees of Lloyds" quoted in the introduction, we stand with the "innumerable threads of the vast net-work" of information "brought together to one point" for our "use and profit," but in a much more immediate and comprehensive way than the Victorians could have imagined.[12] We can dig into the past and watch news travel; we can compare various strands of historical commentary in real time. The depth and richness of this information field can reveal connections never noticed before, but can also obscure the past we are trying to study. We may be less and less inclined to remember that we do not see what is not on the map.

At an earlier moment, when fewer digitized sources were available, it was easier to recognize which historical voices were dominating the critical conversation, and which were not being granted a place. Digital access widens the discursive field but also threatens to render it a flattened cacophony. How can we use what we know about historical reading practices, geographical and class-based circulation of publications, and other historical factors to make sure we use these new resources responsibly? In what ways might we work to prevent the emerging resource gap between the expensive databases subsidized by and available to scholars at larger institutions but not to those working elsewhere, particularly as historical material is packaged into products sold to educational institutions and embargoed behind paywalls?

What we do with the facts we gather is also at issue in this new information ecology. I have argued here that Aesthetic picture owners effectively participated in creating virtual collections that existed beyond the physical confines of their own homes: networks of objects that linked friends, business partners, and other collaborators together, sometimes across great distances. This densely reticulated bird's-eye view has been assembled by compiling auction data, digitized museum records, period exhibition and collection catalogs, and countless other resources. But the more vivid our picture of these virtual collections becomes, the more difficult it can be to figure out exactly how much of this information was accessible to picture owners at the time. The digital arrays that we create and study are not, in Arthur Balfour's sense, pictures that are "lived in" as they might have been (see Chapter 1). When considering this discrepancy, I am seized by a sensation of being both too intimately connected to the Aesthetic paintings at the heart of my study and utterly disconnected from them – the same kind of sensation that appeared to be stirring anxieties among Gilded Age Americans contemplating British Aestheticism (Chapter 3). Somehow charting these networked objects can leave us feeling in a highly dissociative state.

I have also been arguing that Aesthetic pictures must be understood in the full context of their original environments, the coordinated spaces that were constructed around and through them. The project of reassembling those collections, their spaces, and the relationships between their patrons gives rise to a longing for completeness that seems deeply akin to the desires that drove these people to acquire, install, and reinstall these objects in the first place. The researcher becomes an insatiable collector of information, diving again and again into digitized primary sources and archives in search of the stories that will complete the picture. Those stories, like the concept of network itself, can become so powerful as explanatory tools that they interfere with our understanding of information in front of us. Flush with excitement over being able to map the Grosvenor Gallery electrical network for the first time (Chapter 2), I initially mistook Benson the manufacturer of cheap tin novelties (connected to the network) for Benson the lamp designer (connection status unknown). Convinced that all business rhetoric was significant, I misunderstood the American incorporation of the Society of Art Collectors (Chapter 4) as unusual, when in fact the filing of a corporate charter was standard practice for any American art organization that wished to import paintings strictly for exhibition rather than sales. These problems are as old as storytelling itself. But the tools we now use to create maps, spreadsheets, databases, and other systems increase the likelihood that contextual minutiae will fall away as the broad patterns we think we are seeing take over.

This particular collection of stories concludes with Freer (Chapter 5) and a network anxiety his collection inspires. On the one hand, it seems, we should be grateful that Freer insisted upon the inviolability of his gift, because it ensures that a fascinating and revealing set of collecting practices is forever preserved for study within his institution. But, of course, the material completeness of the Freer Gallery comes at the expense of being able to connect its American holdings to other networks. They will be reduced to catalog reproductions and photographic images screened onto gallery walls; they will always be a physical void in other exhibition

stories we tell. The consequences of accepting gifts with such limitations attached could perhaps not have been foreseen during the early decades of the twentieth century, and should strike a cautionary note for anyone indulging the fantasy of postmortem collection management today. But one hundred years of accommodating the wishes of donors whose proffered gifts were too good to refuse has led to a patchwork of dedicated displays and regulations at many American museums, a practice that continues to generate its own momentum.[13]

Based on these and similar experiences, one hopes that it may be possible to make more informed and far-sighted acquisition decisions (and donations) in the future. As for the past, there is room, I think, and opportunity to give the artefactual record a more thorough airing in the present. If the Luce Foundation open storage centers and online collection records of American museums are any indication, a vast majority of institutions have similarly elected to show a few isolated examples drawn from seemingly redundant stockpiles of late nineteenth-century Aesthetic, tonalist, and decorative paintings, and store the remainder. Holding up one object at a time to exemplify the status-driven and escapist behaviors and proclivities of the period can only take us so far, and is essentially a *dis*connective strategy. But even – perhaps especially – a small museum with a tight budget may find itself sitting on a revealing evidentiary array produced by multiple networked intersections of historical practices and ideas, including those drawn from the most mundane realms of parlor games, office work, train travel, and idle club conversation, among other arenas. Its displays might find a way to interrogate critically and publically the rhetorics and logics of the private collections that formed institutional foundations. What if we stopped trying to work around the idiosyncrasies and disappointments and frustrations of historical collections donated en bloc, and engaged them directly instead? Would such displays begin to condition museum visitors to expect a narrative and financial accounting for how cultural authority is materially and institutionally embodied? We may only need to begin making the connections.

NOTES

INTRODUCTION

1 James McNeill Whistler to William Heinemann, ca. 9–16 September 1899, reproduced in *The Correspondence of James McNeill Whistler, 1855–1903*, ed. Margaret F. MacDonald, Patricia de Montfort, and Nigel Thorp; including *The Correspondence of Anna McNeill Whistler, 1829–1880*, ed. Georgia Toutziari, online edition, University of Glasgow, http://www.whistler.arts.gla.ac.uk/correspondence (hereafter Whistler correspondence), 2003–10 rec. no. 08523, accessed on September 29, 2011. In the broader context of the letter, Whistler was discussing investments in gold mines rather than in these networked technologies.

2 Arthur Symons, *Studies in Seven Arts* (New York: E. P. Dutton, 1906), 129–30.

3 Cosmo Monkhouse, "Albert Moore," *Magazine of Art* 8 (1885): 191.

4 Claude Phillips, "Edward Burne Jones," *Magazine of Art* 8 (1885): 287–90.

5 "Fine Arts: The Academy Exhibition – I," *Nation* 44, no. 1137 (April 14, 1887): 327.

6 In 1999, Elizabeth Prettejohn, one of the movement's chief historians, could still reasonably observe that "Aestheticism in painting remains ill-defined." See Prettejohn, "Introduction," in *After the Pre-Raphaelites: Art and Aestheticism in Victorian England*, ed. Elizabeth Prettejohn (New Brunswick, N.J.: Rutgers University Press, 1999), 2.

7 I have explored some of these ideas elsewhere in Melody Barnett Deusner, "Whistler, Aestheticism, and the Networked World," in *Palaces of Art: Whistler and the Art Worlds of Aestheticism*, ed. Lee Glazer and Linda Merrill (Washington, D.C.: Smithsonian Institution Scholarly Press, 2013), 149–64.

8 Linda Merrill's extensive research on the Peacock Room has brought its timeline of creation into focus and provides an essential foundation for what follows; see Merrill, *The Peacock Room: A Cultural Biography* (Washington, D.C.: Freer Gallery of Art, 1994). An important early source on 49 Prince's Gate and the Peacock Room is Theodore Child, "A Pre-Raphaelite Mansion," *Harper's New Monthly Magazine* 82, no. 487 (December 1890): 81–99.

9 International Exhibition, South Kensington, London, 1872; Second Annual Exhibition of Modern Pictures, Royal Pavilion Gallery, Brighton, 1875.

10 Sidney Colvin, "English Painters and Painting in 1867," *Fortnightly Review*, 2, no. 10 (October 1867): 465, quoted and discussed in Prettejohn, "Introduction," *After the Pre-Raphaelites*, 2–3; and *Art for Art's Sake: Aestheticism in Victorian Painting* (New Haven and London: Yale University Press, 2007), 7, 30–1.

11 See Prettejohn, *Art for Art's Sake*, 110–12; Robyn Asleson, "Nature and Abstraction in the Aesthetic Development of Albert Moore," in *After the Pre-Raphaelites*, 115–34; Asleson, *Albert Moore* (London: Phaidon, 2000); Marc Simpson, "Whistler, Modernism, and the Creative Afflatus," in *Like Breath on Glass: Whistler, Inness, and the Art of Painting Softly*, ed. Marc Simpson, exh. cat. (Williamstown, Mass.: Sterling and Francine Clark Art Institute, 2008), 24–51.

12 Walter Pater, "The Poetry of Michelangelo" (1871), in *Studies in the History of the Renaissance* (London: Macmillan & Co., 1873), 75–80; and Charles Augustus Swinburne, "Notes on Some Pictures of 1868," in *Essays and Studies* (London: Chatto & Windus, 1875), 377.

13 Swinburne wrote of Albert Moore's *Azaleas*, "The melody of colour, the symphony of form is complete: one more beautiful thing is achieved, one more delight is born into the world; and its meaning is beauty; and its reason for being is to be" (Swinburne, "Notes on Some Pictures," 360–1). See also Walter Pater, "The School of Giorgione," in *The Renaissance: Studies in Art and Poetry*, 3rd edn. (London: Macmillan & Co., 1888), 140.

14 James McNeill Whistler, *Mr. Whistler's "Ten O'Clock,"* lecture originally delivered in 1885 (London: Chatto & Windus, 1888), 14. See also Allen Staley, "The Condition of Music," *Art News Annual: The Academy* 33 (1967): 80–7.

15 Monkhouse, "Albert Moore," 194.

16 Mary Eliza Haweis, *The Art of Decoration* (London: Chatto & Windus, 1881), 10, 201. The following year Walter Hamilton stressed that Aesthetic artists and designers "have endeavoured to elevate taste into a scientific system"; see Hamilton, *The Aesthetic Movement in England* (London: Reeves and Turner, 1882), vii, quoted in Judith A. Neiswander, *The Cosmopolitan Interior: Liberalism and the British Home, 1870–1914* (New Haven and London: Yale University Press for the Paul Mellon Centre for Studies in British Art, 2008), 58.

17 On the provenance of the *Princesse*, see Merrill, *Peacock Room*, 74–5, 184–7.

18 See ibid., 188–233.

19 See G. C. Williamson, *Murray Marks and his Friends* (London: John Lane, 1919); and Clive Wainwright, "'A gatherer and disposer of other men's stuff': Murray Marks, Connoisseur and Curiosity Dealer," *Journal of the History of Collections* 14, no. 1 (2002): 161–76.

20 Given the tightly interlocked nature of Aesthetic picture commissioners and purchasers, it does seem that the distinctions between the outlook or mentality of the patron and the collector (both in Britain and America) in this period have been somewhat overstated; see for example Dianne Sachko Macleod, "The New Centurions: Alma-Tadema's International Patrons," in *Sir Lawrence Alma-Tadema*, ed. Edwin Becker (New York: Rizzoli, 1997), 91–8; and Saul E. Zalesch, "Introduction" and "Taste and Albert Pinkham Ryder," in "Ryder among the Writers: Friendship and Patronage in the New York Art World, 1875–1884" (PhD diss., University of Delaware, 1992), 1–9, 188–276.

21 For discussions of this phenomenon, see, for Britain, Charlotte Gere and Lesley Hoskins, "Artistic Circles," in *The House Beautiful: Oscar Wilde and the Aesthetic Interior*, exh. cat. (Aldershot: Lund Humphries in association with Geffrye Museum, 2000), 54–75; and for America, Sarah Burns, "The Price of Beauty: Art, Commerce, and the Late Nineteenth-Century Studio Interior," in *American Iconology: New Approaches to Nineteenth-Century Art and Literature*, ed. David C. Miller (New Haven and London: Yale University Press, 1993), 209–38; and Kristin L. Hoganson, *Consumers' Imperium: The Global Production of American Domesticity, 1865–1920* (Chapel Hill: University of North Carolina Press, 2010), 30–1.

22 While Helen Smith's 1980 Courtauld Institute dissertation, "Decorative Painting in the Domestic Interior in England and Wales, ca. 1850–1890," remains the most thoroughly researched and documented treatment of the decorative demands placed upon and bound up with British Aesthetic painting, Prettejohn declines even to use the word "decorative" to describe these pictures, citing its trivializing connotations; see *Art for Art's Sake*, 118.

23 Stephen Calloway and Lynn Federle Orr, eds., *The Cult of Beauty: The Aesthetic Movement 1860–1900* (London: V&A Publishing, 2011).

24 Caroline Arscott, *William Morris and Edward Burne-Jones: Interlacings* (New Haven and London: Yale University Press for the Paul Mellon Centre for Studies in British Art, 2008).

25 Merrill, *Peacock Room*, 212.

26 Whistler to Leyland, 2 and 9 September 1876, Whistler correspondence, rec. no. 08796, accessed on January 17, 2020.

27 Kathy Alexis Psomiades, *Beauty's Body: Femininity and Representation in British Aestheticism* (Stanford: Stanford University Press, 1997), 119, emphasis mine. For a more oppositional take on the Leyland/Rossetti relationship, see Francis L. Fennell, Jr., ed., *The Rossetti–Leyland Letters: The Correspondence of an Artist and his Patron* (Athens: Ohio University Press, 1978), ix–xxxiv.

28 See Sarah Burns, *Inventing the Modern Artist: Art and Culture in Gilded Age America* (New Haven and London: Yale University Press, 1996), 34. For a deeper analysis of the shift from academic to dealer-critic systems in the late nineteenth-century artworld, and the growing need for an artist to produce a recognizable (and saleable) *oeuvre*, see Harrison C. White and Cynthia A. White, *Canvases and Careers: Institutional Change in the French Painting World* (New York: Wiley, 1965).

29 Whistler to Frances Leyland (Frederick Leyland's wife), 18 or 25 July 1877?, draft, Whistler correspondence, rec. no. 02599, accessed on January 17, 2020, quoted in Merrill, *Peacock Room*, 245, note 44. In a different letter, which Whistler did send to Frederick Leyland, he lamented, "It is positively sickening to think that I should have labored to build up that exquisite Peacock Room for such a man to live in!"

Whistler to Leyland, 18 or 22 1877, Whistler correspondence, rec. no. 02589, accessed on January 17, 2020, quoted ibid., 273.

30 See, for example, Alice Carr's *Reminiscences*: "To this collector of scalps the thought that he had achieved a memorial to his quarrel which would preside over all the millionaire's fetes was sheer, unadulterated joy." Carr, *Mrs. J. Comyns Carr's Reminiscences* (London: Hutchinson, 1926), 108–9, quoted in Merrill, *Peacock Room*, 245.

31 For this type of analysis in relation to British painting, see Dianne Sachko Macleod, *Art and the Victorian Middle Class: Money and the Making of Cultural Identity* (Cambridge: Cambridge University Press, 1996), 1–19, 267–335, and "The 'Identity' of Pre-Raphaelite Patrons," in *Re-framing the Pre-Raphaelites: Historical and Theoretical Essays*, ed. Ellen Harding (Aldershot: Scholar Press, 1996), 7–26. On American Aesthetic painting as a "mind cure," see Kathleen Pyne, "Aesthetic Strategies in the 'Age of Pain': Thomas Wilmer Dewing and the Art of Life," in *Art and the Higher Life: Painting and Evolutionary Thought in Late Nineteenth-Century America* (Austin: University of Texas Press, 1996), 135–219; and Burns, "Painting as Rest Cure," in *Inventing the Modern Artist*, 120–56.

32 This summary of the "materialist" view is provided by Macleod in "The 'Identity' of Pre-Raphaelite Patrons," 22. On "distinction," see Pierre Bourdieu, *Distinction: A Social Critique of the Judgment of Taste* (Cambridge, Mass.: Harvard University Press, 1984).

33 Colleen Denney, "The Grosvenor Gallery as a Palace of Art: An Exhibition Model," in *The Grosvenor Gallery: A Palace of Art in Victorian England*, ed. Colleen Denney and Susan P. Casteras (New Haven and London: Yale University Press, 1996), 22; Macleod, *Art and the Victorian Middle Class*, 276–7.

34 Kathleen Pyne, "Whistler and the Politics of the Urban Picturesque," *Journal of American Art* 8, no. 3–4 (summer/autumn 1994): 75; and Pyne, *Art and the Higher Life*, 128. See also Deanna Marohn Bendix, *Diabolical Designs: Paintings, Interiors, and Exhibitions of James McNeill Whistler* (Washington, D.C.: Smithsonian Institution Press, 1995), 7. Nichols Clark similarly argues that Detroit-based art patron Charles Lang Freer "came to embrace [the] elitist viewpoint" embodied by the artists he collected (including Whistler); see Clark, "Charles Lang Freer: An American Aesthete in the Gilded Era," *American Art Journal* 11, no. 4 (October 1979): 63.

35 See Bourdieu, *Distinction*, 170–4. Aesthetic taste, furthermore, while it may be constituted as a process of differentiation/exclusion, is also at the same time experienced as belonging/inclusion ("elective affinity," p. 241), as discussed in Chapter 1 of this book.

36 See *The Grosvenor Gallery: A Palace of Art in Victorian England*; Colleen Denney, *At the Temple of Art: The Grosvenor Gallery 1877–1890* (Madison, N.J.: Fairleigh Dickinson University Press, 2000); and Christopher Newall, *The Grosvenor Gallery Exhibitions: Change and Continuity in the Victorian Art World* (Cambridge: Cambridge University Press, 1995), 3–37.

37 See Gere, *The House Beautiful*; Caroline Dakers, *The Holland Park Circle: Artists and Victorian Society* (New Haven and London: Yale University Press, 1999); and Dakers, *Clouds: The Biography of a Country House* (New Haven and London: Yale University Press, 1993).

38 See Linda Henefield Skalet, "The Market for American Painting in New York: 1870–1915" (PhD diss., Johns Hopkins University, 1980); *A Circle of Friends: Art Colonies of Cornish and Dublin*, exh. cat. (Durham: University Art Galleries, University of New Hampshire, 1985); Annette Blaugrund, "The Tenth Street Studio Building" (PhD diss., Columbia University, 1987); Marc Simpson, "Reconstructing the Golden Age: American Artists in Broadway, Worcestershire, 1885 to 1889" (PhD diss., Yale University, 1993); and Zalesch, "Ryder among the Writers."

39 For previous uses of "network" in this social and professional context, see, for example, Dakers, *Clouds*, 29; Macleod, *Art and the Victorian Middle Class*, 11; Burns, *Inventing the Modern Artist*, 26–30; Pyne, *Art and the Higher Life*, 139; and Dakers, *The Holland Park Circle*, 1. For its use in relation to the formal properties of designs by

Whistler, Morris, and Tiffany, see, respectively, Merrill, *Peacock Room*, 34; Linda Parry, ed., *William Morris*, exh. cat. (London: Philip Wilson in association with the Victoria & Albert Museum, 1996), 283; and Alice Cooney Frelinghuysen, "Louis Comfort Tiffany at the Metropolitan Museum," *Metropolitan Museum of Art Bulletin* 56, no. 1 (summer 1998): 33.

40 Jonathan Freedman, *Professions of Taste: Henry James, British Aestheticism, and Commodity Culture* (Stanford: Stanford University Press, 1990), 35; and Prettejohn, *Art for Art's Sake*, 38.

41 Fiona McCarthy, "The Designer," in Parry, *William Morris*, 32; Katherine C. Grier, *Culture & Comfort: Parlor Making and Middle-Class Identity, 1850–1930* (Washington, D.C.: Smithsonian Institution Press, 1997), 74.

42 See Armand Mattelart, *Mapping World Communication: War, Progress, Culture*, trans. Susan Emanuel and James A. Cohen (Minneapolis: University of Minnesota Press, 1994); Mattelart, *The Invention of Communication*, trans. Susan Emanuel (Minneapolis: University of Minnesota Press, 1996); and Mattelart, *Networking the World, 1794–2000*, trans. Liz Carey-Libbrecht and James A. Cohen (Minneapolis: University of Minnesota Press, 2000).

43 See, for example, Joel A. Tarr and Gabriel Dupuy, eds., *Technology and the Rise of the Networked City in Europe and America* (Philadelphia: Temple University Press, 1988); Stephen Graham and Simon Martin, "Constructing the Modern Networked City, 1850–1960," in *Splintering Urbanism: Networked Infrastructures, Technological Mobilities, and the Urban Condition* (London: Routledge, 2001), 39–89; and David E. Nye, *Narratives and Spaces: Technology and the Construction of American Culture* (New York: Columbia University Press, 1997) and *American Technological Sublime* (Cambridge, Mass.: MIT Press, 1994).

44 Laura Otis, *Networking: Communicating with Bodies and Machines in the Nineteenth Century* (Ann Arbor: University of Michigan Press, 2001).

45 Barbara Maria Stafford, *Voyage into Substance: Art, Science, Nature, and the Illustrated Travel Account, 1760–1840* (Cambridge, Mass.: MIT Press, 1984) and *Body Criticism: Imaging the Unseen in Enlightenment Art and Medicine* (Cambridge, Mass.: MIT Press, 1991); and Kate Flint, *Victorians and the Visual Imagination* (Cambridge: Cambridge University Press, 2000).

46 This is primarily how the word "network" was used in two conference sessions dedicated to exploring the concept as it relates to art history: "Objects," at "Networks of Design," the Design History Society Annual Conference, University of Falmouth, UK, September 2008; and "The Networked Nineteenth Century," College Art Association Annual Conference, Los Angeles, February 2009.

47 See Raymond Williams, *Keywords: A Vocabulary of Culture and Society* (New York: Oxford University Press, 1976). In 2005, "network" was added to a new edition of *Keywords*, a project that attempts to bring the vocabulary of Williams's initial study up to date and incorporate words whose resonance have acquired special significance for the early twenty-first century. Frank Webster, who writes the entry for "network," notes that its use dates back to the early sixteenth century, and that it "indicates a web of connections (often, but not exclusively, technical) which link objects, institutions, and/or people." Its significance, however, is considered only in relation to postwar experience. See Webster, "Network," in *New Keywords*, ed. Tony Bennett, Lawrence Grossberg, and Meaghan Morris (Malden, Mass.: Blackwell Publishing, 2005), 239.

48 The following analysis is based on my own keyword surveys of a number of British and American texts. Mark Wigley makes a similar observation regarding the transition from physical to conceptual networks in the nineteenth century in his essay, "Network Fever," *Grey Room* 4 (summer 2001): 94.

49 House of Commons debate regarding second reading of the railways bill, July 11, 1844, *Hansard Parliamentary Debates*, 3rd ser., vol. 76 (1844), cols. 647, 658. See also "A Railway Map of England," *Punch* 9 (October 11, 1845): 163.

50 See Peter W. Sinnema, *Dynamics of the Pictured Page: Representing the Nation in the "Illustrated London News"* (Aldershot: Ashgate, 1998); Joshua Brown, *Beyond the Lines: Pictorial Reporting, Everyday Life, and the Crisis of Gilded Age America* (Berkeley: University of California Press, 2002); and James Mussell, *Science, Time and Space in the Late Nineteenth-Century Periodical Press: Movable Types* (Aldershot: Ashgate, 2007).

51 See Alan Trachtenberg, *The Incorporation of America: Culture and Society in the Gilded Age* (New York: Hill and Wang, 1982), 130.

52 Bell quoted in Seymour J. Mandelbaum, "Cities and Communication: The Limits of Community," in Tarr and Dupuy, *Technology and the Rise of the Networked City*, 314.

53 Ray Stannard Baker, "The Movement of Wheat," *McClure's Magazine* 14, no. 2 (December 1899): 132; Edward E. Gellender, "The Economic Effects of Bankers' Advances," *Economic Journal* 11, no. 43 (September 1901): 416 (reference from *Oxford English Dictionary* definition of "network"); and Charles F. Dunbar, "The Bank-Note Question," *Quarterly Journal of Economics* 7, no. 1 (October 1892): 68.

54 Alphonse Esquiros, *British Seamen and Divers* (London: Chapman and Hall, 1868), 187–8.

55 George Smyth Baden-Powell, *Protection and Bad Times: With Special Reference to the Political Economy of English Colonisation* (London: Trubner and Co., 1879), 192, 269–70, 359–60. For the British Empire as "a net-work of dependencies and colonies and islands covering every sea," see J. R. Seeley, "The Expansion of England in the Eighteenth Century," *Macmillan's Magazine* 46, no. 276 (October 1882): 463.

56 Captain Gilbert P. Cotton, "Proximity of England to the United States Considered in Reference to Hostilities Between the Two Nations," *Journal of the Military Service Institution of the United States* 19, no. 84 (November 1896): 438.

57 For more on the increasing formalization of American business organization, see Alfred D. Chandler, Jr., *The Visible Hand: The Managerial Revolution in American Business* (Cambridge, Mass.: Harvard University Press, 1977).

58 In 1895, Julian Ralph pointed out that it was not even necessary to graph the proliferation of centralized control over California's railroads, as ordinary "railway maps which show the State gridironed with black lines all over its surface give the public an exact and true idea of the comprehensive thoroughness of the monopoly"; see "California's Great Grievance," *Harper's Weekly* 39, no. 1993 (March 2, 1895): 208.

59 See Trachtenberg, *Incorporation of America*, Chapter 3.

60 John Atkinson Hobson, *The Evolution of Modern Capitalism: A Study of Machine Production* (London: Walter Scott, 1894); rev. edn. (London: Walter Scott, 1906), 265–72.

61 Haverhill Board of Trade, *Haverhill, Massachusetts: An Industrial and Commercial Center* (Haverhill, Mass.: Chase Brothers, 1889), 124.

62 "Knowledge and Culture," *Harper's Weekly* 49, no. 2513 (February 18, 1905): 233.

63 Archibald Forbes, *Chinese Gordon: A Succinct Record of his Life* (New York: Harper and Brothers, 1884), 140 (reference from *Oxford English Dictionary* definition of "network"); "What About Ireland?" *Blackwood's Edinburgh Magazine* 840, no. 138 (October 1885): 551.

64 Janet Wolff has provided an overview of this methodological shift, from early Marxist attempts to explain cultural production through class structure, to recent decades in which "[i]t has become increasingly clear that any simple, one-to-one relationship of cultural form and uniform, static, social group is quite inadequate." She cites several mediating factors that are now regularly taken into account: the complexity of social groups, the biography of the producer, the process of translating ideas into aesthetic form (including the

mediations of the art world itself and the conventions through which an artist or author inevitably operates), and the multiplicity and mutability of reception. Wolff, "The Problem of Ideology in the Sociology of Art: A Case Study of Manchester in the Nineteenth Century," *Media, Culture, and Society* 4, no. 1 (January 1982): 64, 65–6.

65 Michael Baxandall's discussion of "cognitive style" has guided my thinking on crossover applications of workaday knowledge and experience to engagement with art; see Baxandall, *Painting and Experience in Fifteenth-Century Italy* (Oxford: Clarendon Press, 1972), 30–40.

66 On Leyland and shipping, see most recently Merrill, *Peacock Room*, 109–21; see also Duncan Haws, *Merchant Fleets in Profile*, vol. 2 (Cambridge: Stephens, 1979), 109–37; E. W. Paget-Tomlinson, *Bibby Line: 175 Years of Achievement* (Liverpool: Bibby Line, 1982), 1–12; M. Susan Duval, "F. R. Leyland: A Maecenas from Liverpool," *Apollo* 114 (August 1986): 110; and Tony Tibbles, "Speke Hall and Frederick Leyland: Antiquarian Refinements," *Apollo* 139 (May 1994): 34–7.

67 "City Notes, Reports, Meetings, &c. Edison and Swan United Electric Light Company, Limited," *Telegraphic Journal and Electrical Review* 15, no. 363 (November 15, 1884): 396–8.

68 "City Notes, Reports, Meetings, &c. United Telephone Company, Limited," *Telegraphic Journal and Electrical Review* 16, no. 396 (June 27, 1885): 578–80.

69 On Leyland's reputation as "ruthless" (with regard to the shipping industry), see Merrill, *Peacock Room*, 111–14, citing an unpublished manuscript written by H. E. Stripe, his co-worker, "Sketch of the Commercial Life of H. E. Stripe," Merseyside Maritime Museum Archives, Liverpool, ca. 1893. For Leyland's occasionally contentious relations with shareholders in his other enterprises, see accounts of meetings published in the *Telegraphic Journal and Electrical Review* and the *Electrical Engineer*, some of which are cited below.

70 George M. Beard, *American Nervousness: Its Causes and Consequences* (New York: G. P. Putnam's Sons, 1881), 117.

71 See note 31 on "mind cure" above.

72 Macleod, "The 'Identity' of Pre-Raphaelite Patrons," 23.

73 Thomas Hughes, *Networks of Power: Electrification in Western Society, 1880–1930* (Baltimore: Johns Hopkins University Press, 1983), 1.

74 Howell to Rossetti, 4 March 1873, in C. L. Cline, ed., *The Owl and the Rossettis: Letters of Charles A. Howell and Dante Gabriel, Christina, and William Michael Rossetti* (University Park: Pennsylvania State University Press, 1978), letter 207, quoted in Merrill, *Peacock Room*, 154 and 169; and Psomiades, *Beauty's Body*, 114–15.

75 See Macleod, *Art and the Victorian Middle Class*, 279; David Wayne Thomas, "Replicas and Originality: Picturing Agency in Dante Gabriel Rossetti and Victorian Manchester," *Victorian Studies* 43, no. 1 (autumn 2000): 67–102; and Julian Treuherz, "Aesthetes in Business: The Raes and D. G. Rossetti," *Burlington Magazine* 146, no. 1210 (January 2004): 13–19.

76 Treuherz, "Aesthetes in Business," 17.

77 See collections records in Susan Duval, "A Reconstruction of F. R. Leyland's Collection: An Aspect of Northern British Patronage" (MA thesis, Courtauld Institute of Art, 1982).

78 See for example the *Athenaeum*, where Leyland's collection was described as "of a character similar to Mr. Rae's." See "The Private Collections of England LXIX: Galleries Near Liverpool," *Athenaeum* 2864 (September 16, 1882): 375. The same publication noted the relationship between Leyland's *Lady Lilith*, his chalk drawing of *Venus Verticordia*, and Rae's finished oil of the latter subject when all three were exhibited in the Rossetti retrospective held at the Royal Academy in the winter of 1882–3: "The Royal Academy Exhibition," *Athenaeum* 2882 (January 20, 1883): 93. When John Bibby's collection was discussed in 1884, his William Windus pictures were connected to those owned by Leyland: "The Private Collections of England

LXXVIII: Allerton, and Croxteth Drive, Liverpool," *Athenaeum* 2970 (September 17, 1884): 409.

79 See for example William Sharp, *Dante Gabriel Rossetti: A Record and a Study* (London: Macmillan & Co., 1882), 438–9, with repeated names of Rossetti collectors Bibby, Leyland, Rae, Ionides, and others.

80 Clarence Cook, *What Shall We Do With Our Walls?* (New York: Warren, Fuller, and Lange, 1881).

81 A number of these foundational texts are cited in Linton C. Freeman's useful introductory overview, *The Development of Social Network Analysis: A Study in the Sociology of Science* (Vancouver: Empirical Press, 2004); see especially Mark Granovetter, "The Strength of Weak Ties," *American Journal of Sociology* 78, no. 6 (1973): 1360–80.

82 Even so, I have found it useful to carry into my exhumations of these art worlds an awareness of and sensitivity to the kinds of mutually reinforcing organizational structures that social network analysts have so usefully explored, particularly in the form of interlocking corporate directorates (to which John Hobson has already introduced us – see note 60).

83 Alfred Gell, *Art and Agency: An Anthropological Theory* (Oxford: Clarendon Press, 1998), 8.

84 Ibid., 62.

85 Michelle O'Malley, "Altarpieces and Agency: The Altarpiece of the Society of the Purification and its 'Invisible Skein of Relations,'" *Art History* 28, no. 4 (September 2005): 417–41.

86 O'Malley's diagram is actually much more complicated than this, and allows, like Gell's, for the possible doubling back of agency, so that the altarpiece itself also "produces" the Medici in the minds of its perceivers. Even so, this insistent language of "production" is not well adapted to the convergences between patrons and artists discussed in the following chapters.

87 Bruno Latour, *Reassembling the Social: An Introduction to Actor-Network-Theory* (Oxford: Oxford University Press, 2005), 11.

1 NETWORKS OF POWER

1 For a history of the *Earthly Paradise* project and Burne-Jones's planned designs, see Joseph R. Dunlap, *The Book That Never Was* (New York: Oriole, 1971); and *Edward Burne-Jones: The Earthly Paradise*, exh. cat. (Ostfildern, Germany: Hatje Cantz, 2009). For the evolution of the *Perseus* series, see Kurt Löcher, *Der Perseus-Zyklus von Edward Burne-Jones* (Stuttgart: Staatsgalerie Stuttgart, 1973); Fabian Fröhlich, "Frauen im Spiegel: Der Perseus-Zyklus von Edward Burne-Jones" (PhD diss., Universitat Kassel, 2002; Berlin: Dissertation. de, 2005); and Elizabeth Prettejohn, "The Series Paintings," in *Edward Burne-Jones*, ed. Alison Smith, exh. cat. (London: Tate Britain, 2018), 169–95.

2 See Annabel Zettel, "Belle et Blonde et Colorée: The Early Gouaches," in *Edward Burne-Jones: The Earthly Paradise*, 36.

3 Burne-Jones used this language in a letter to Balfour dated March 27 [1875], Balfour Papers, Add. MS 49838, fols. 14–17, British Library, London (hereafter cited as BL Balfour).

4 Liana de Girolami Cheney links Perseus to the Medici in the context of Burne-Jones's series, but does not consider the relationship of the theme to Balfour as the artist's patron; see Cheney, "Edward Burne-Jones's *Andromeda*: Transformation of Historical and Mythological Sources," *Artibus et Historiae* 25, no. 49 (2004): 208–11. On Perseus and the Medici, see John Varriano, "Leonardo's Lost *Medusa* and other Medici Medusas from the *Tazza Farnese* to Caravaggio," *Gazette des Beaux-Arts* 6, no. 130 (September 1997): 73–80.

5 Balfour's biographers have not pursued any in-depth consideration of him as an art patron. Important studies of his life include Blanche Dugdale, *Arthur James Balfour, First Earl of Balfour* (London: Hutchinson, 1936); Kenneth Young, *Arthur James Balfour:*

The Happy Life of the Politician, Prime Minister, Statesman, and Philosopher, 1848–1930 (London: Bell, 1963); Max Egremont, *Balfour: A Life of Arthur James Balfour* (London: Collins, 1980); Ruddock Mackay, *Balfour: Intellectual Statesman* (New York: Oxford University Press, 1985); and R. J. Q. Adams, *Balfour: The Last Grandee* (London: John Murray, 2007). Balfour, similarly, plays only a marginal role in art historical analyses of the *Perseus* series; see, for example, Penelope Fitzgerald, *Edward Burne-Jones: A Biography* (London: Michael Joseph, 1975), 160; and Fabian Fröhlich, "The Perseus Series," in *Edward Burne-Jones: The Earthly Paradise*, 107. Caroline Arscott, whose study of the *Perseus* series focuses on the artist rather than his patron, sees their clash of political viewpoints as a chief obstacle toward developing an account of Balfour's interest in Burne-Jones; see Arscott, *William Morris and Edward Burne-Jones: Interlacings* (New Haven and London: Yale University Press, 2008), 82.

6 The house was originally constructed in the late 1820s according to designs by John Nash. For its early history, see G. H. Gater and F. R. Hiorns, eds., *Survey of London, Vol. XX: St. Martin-in-the-Fields, Part 3: Trafalgar Square & Neighbourhood* (London: published for London County Council by Country Life, 1940), 81; and John Harris, "Lo Stile Hope e la famiglia Hope," *Arte Illustra* 6, no. 55–6 (December 1973): 326–30.

7 See Blanche Airlie to Lady Stanley, 17 March 1875, Airlie Papers, quoted in Caroline Dakers, *The Holland Park Circle: Artists and Victorian Society* (New Haven and London: Yale University Press, 1999), 87. By the time of the Balfour commission, Burne-Jones and George Howard had been friends for a decade, and the artist had also planned out and begun a *Cupid and Psyche* frieze for the latter's home at Palace Green, providing Balfour with a glimpse into what the scope of such a project might look like, according to the original plans dated 1872 (Birmingham Museums and Art Gallery). Like the *Perseus* series, however, Howard's commission would run into challenges and delays, and would ultimately require the assistance of Walter Crane and Thomas Rooke to bring it to completion in 1881. On Burne-Jones, Howard, and the *Cupid and Psyche* project, see Dakers, Chapters 6 and 7 in *The Holland Park Circle*; and Katharina Wippermann, "The Cupid and Psyche Series for 1 Palace Green," in *Edward Burne-Jones: The Earthly Paradise*, 84–95.

8 Arthur James Balfour, *Retrospect: An Unfinished Autobiography, 1848–1886* (Boston: Houghton Mifflin, 1930), 237–8.

9 Burne-Jones to Balfour, March 27 [1875], BL Balfour, Add. MS 49838, fols. 14–17. The following quotations are drawn from this letter. It was followed by a second missive in which Burne-Jones outlined the cost estimates for ten pictures and ornamentation of the ceiling (£4,000), and asked for £500 "to get started"; see Burne-Jones to Balfour, undated, BL Balfour, Add. MS 49838, fols. 18–19.

Further evidence of the *Perseus* transactions can be gleaned from the Balfour family papers now held at the National Archives of Scotland (hereafter NAS), which record, for example, Balfour's first payment to Burne-Jones (£600) on July 27, 1875; see Balfour's personal account book, NAS, GD 433/2/176/1: 1872–84. The artist's gouache on paper installation plans for the series were complete by March 1876 when they were described by a reporter for the *Academy*, see "Notes and News," *Academy* 9, no. 201 (March 11, 1876): 249. Perhaps Balfour's subsequent payment to Burne-Jones of £200 on July 5, 1876, also recorded in his personal account book for 1872–84, was meant to compensate the artist for this preparatory work. The NAS documents cited in this chapter have not previously been utilized to study the *Perseus* series or the decoration of Carlton Gardens, and I am grateful to the owner of these papers for granting me permission to make use of them.

10 In preparing the series, Burne-Jones first created full-scale bodycolor cartoons on paper (now held by the Southampton City Art Gallery), then worked these up into reliefs and oil on canvas paintings. The finished paintings, together with other incomplete pictures that were eventually added to Balfour's collection, are now held by the Staatsgalerie, Stuttgart.

11 *Perseus and the Graiae* was exhibited at the Grosvenor Gallery in May 1878; Balfour's personal account book lists payments to Burne-Jones on May 1 (£45) and August 12 (£150) of that year. NAS, GD 433/2/176/1: 1872–84.

12 "Pallas Athene with her urging spurred Perseus to action and equipped him with arms. The blind sisters of the Gorgons revealed to him the remote home of the nymphs. From there he went with wings on his feet and with his head shrouded in darkness, and with his sword struck the one Gorgon who was subject to death – the others were immortal. Her two sisters arose and pursued him. Next he turned Atlas to stone, the sea-serpent was slain and Andromeda rescued, and the comrades of Phineus became lumps of rock. Then Andromeda looked with wonder, in a mirror, at the dreadful Medusa." This translation of the Latin inscription is provided by Michael Cassin in the exhibition catalog *Edward Burne-Jones, Victorian Artist-Dreamer* (New York: Metropolitan Museum of Art, 1998), 223–4.

13 See Philip Burne-Jones, "Notes on Some Unfinished Works of Sir Edward Burne-Jones, BT," *Magazine of Art* 23 (1900), 162. At the time of the Burne-Jones studio sale, Balfour's sister Alice noted in her diary, "I am glad also that Arthur kept them to their bargain about the 2 unfinished pictures of the Perseus series, which they wished to be in the sale. He has now got them: the reduction in price in consideration of their being unfinished … A. has already suffered to the extent of some thousands by the unbusinesslike ways of the B.J. family." Alice Blanche Balfour diary, July 16, 1898, NAS, GD 433/2/224: 116–17.

14 It is unclear when these drawings were acquired, but a visitor to Carlton Gardens saw two incomplete paintings and two "chalked cartoons on brown paper" there in 1922; see Mrs. Robert E. Noble, "Lord Balfour's London House: The Historic Home of the President of the British E-S.U.," *The Landmark: The Monthly Magazine of the English-Speaking Union* 4, no. 9 (September 1922): 683. Mrs. Noble's heretofore unnoticed account contains the only detailed description of the interior of Carlton Gardens that has come to light, and will be cited throughout the following discussion.

15 A visitor to Burne-Jones's studio in 1880 reported that the artist was engaged on *Atlas Turned to Stone* at that time; see "Art and Literature," *Newcastle Courant* no. 10737 (October 15, 1880): 6.

16 Balfour received these finished oils shortly after their exhibition at the New Gallery in 1888. See "Mr. Balfour's Holiday and his House," *Pall Mall Gazette*, May 14, 1888, 7; and Balfour's account entry for August 9, 1888, citing payment of £2,856 to Burne-Jones "for two of Perseus series of pictures." NAS, GD 433/2/176/2: March 1884–February 1890.

17 See Burne-Jones to Balfour, July 26, 1887, in which the artist states that he plans to deliver and hang "the picture" (BL Balfour, Add. MS 49839, fol. 212); and Balfour's account book entry for August 2, 1887, in which he pays the artist £1,428 "for Perseus" (NAS, GD 433/2/176/2: March 1884–February 1890).

18 See Löcher, *Der Perseus-Zyklus*, 16, 38; *Edward Burne-Jones: Victorian Artist-Dreamer*, 221–2; Arscott, *Interlacings*, 56; and Fröhlich, "The Perseus Series," 104–6.

19 Burne-Jones suggested these renovations in his letter to Balfour of March 27 [1875], BL Balfour. This letter suggests that the parquet floor was installed by Balfour prior to Burne-Jones's consultation; see also Mrs. Noble, "Lord Balfour's London House," 683. As for the surrounding Morris-style ornament, the *Academy* identified the design as "decorative woodwork," while the artist's wife recalled that it was to be executed in "raised plaster." See "Notes and News," *Academy* 9, no. 201 (March 11, 1876): 249; and Georgiana Burne-Jones, *Memorials of Edward Burne-Jones*, vol. 2 (London: Macmillan & Co., 1904), 60.

20 Burne-Jones to Balfour, March 27 [1875], BL Balfour.

21 The room was large enough to accommodate at least forty

guests, and was used for a time as a rehearsal space by the Handel Society, an amateur performance group co-founded by Balfour. The Handel Society papers document rehearsals held at Balfour's home beginning in November 1882; see British Library Music Manuscript MS Mus 1215: Handel Society, book one. On concerts and performances, see Mary Gladstone Drew, "Arthur James Balfour," typewritten manuscript dated 1917, NAS, GD 433/2/80: 21–2; Frances Balfour, *Ne Obliviscaris: Dinna Forget*, vol. 2 (London: Hodder and Stoughton, 1930), 389–90; and Allan W. Atlas, "Lord Arthur's 'Infernals': Balfour and the Concertina," *Musical Times* 149, no. 1904 (autumn 2008): 35–51. On the room's capacity, see "Lord Balfour's Treasures Sold," *Daily Express*, July 16, 1929, 11.

22 Burne-Jones to Balfour, March 27 [1875], BL Balfour.

23 Drew, "Arthur James Balfour," 22.

24 This heretofore unattributed Balfour project is listed in Marianne Margaret Compton Cust Alford [Lady M. Alford], *Needlework as Art* (London: S. Low, Marston, Searle, and Rivington, 1886), 398.

25 *A Catalogue of the Contents of 4 Carlton Gardens, S.W.* (London: Knight, Frank, and Rutley, July 1929), 8. The dimensions of the floor coverings suggest that this room may have been expanded at some point to combine with the adjacent space (marked "Painting Room" on Henry Hope's original plan, see fig. 29).

26 Ibid., 10.

27 Philip Burne-Jones, "Notes on Some Unfinished Works," 162; Frances Balfour to Frank Balfour, March 2, 1906, NAS, GD 433/2/333/51.

28 The studies were in Balfour's possession by 1892. See Burne-Jones to Balfour, July [1891], BL Balfour, Add. MS 49849, fols. 69–70; and Georgiana Burne-Jones, *Memorials*, 2:215. Balfour loaned the drawings to an exhibition at the New Gallery in 1892; see *Exhibition of the Works of Edward Burne-Jones, 1892–3* (London: New Gallery, 1892).

29 Noble, "Lord Balfour's London House," 684. See for example Balfour's purchase of De Morgan tiles for his study at Whittingehame, recorded in his account book on June 2, 1881, NAS, GD 433/2/176/1: 1872–84. De Morgan's intersections with the Balfour family are discussed in greater detail below.

30 Drawn in 1878, *Angeli Laudantes* and its companion piece, *Angeli Ministrantes* (1878–81, Fitzwilliam Museum, Cambridge), were exhibited at the Grosvenor as part of a special display dedicated to decorative art in 1881; see Malcolm Bell, *Sir Edward Burne-Jones: A Record and Review* (London: George Bell & Sons, 1899), 76; A. Charles Sewter, *The Stained Glass of William Morris and his Circle* (New Haven: Yale University Press, 1974–5), vol. 1, 51 and vol. 2, illus. 533–6; Linda Parry, ed., *William Morris*, exh. cat. (London: Victoria and Albert Museum, 1996), 290; and *Edward Burne-Jones: Victorian Artist-Dreamer*, 298. Balfour's account books record a January 17, 1881 payment to Burne-Jones of £50 designated "cartoon – installments of 250 guineas." NAS, GD 433/2/176/1: 1872–84. On March 26 of that year, Balfour paid Beck, of Grosvenor Gallery, £212 10s. 0d. as "balance for E. Burne Jones picture *Angeli Laudantes*" (which, together with the £50 already paid, made up the equivalent of 250 guineas), followed by a payment to Critchfield for "glass and backing to Burne-Jones" (£12 10s. 0d.) on July 9. The drawing still belonged to Balfour in 1892, when he loaned it for display at the New Gallery; see *Exhibition of the Works of Edward Burne-Jones, 1892–3*, 36. By the time of the artist's death in 1898, however, it appears to have passed back into Burne-Jones's possession; according to Malcolm Bell, it was sold at the Burne-Jones studio sale that year, together with *Angeli Ministrantes*. Although Balfour is listed in the cartoon's provenance in the 1975 Burne-Jones catalog produced by the Arts Council of Great Britain, it has not, to my knowledge, ever been discussed in the context of the *Perseus* series, Carlton Gardens, or Balfour's art collection in general. See *Burne-Jones: The Paintings, Graphic and Decorative Work of Sir Edward Burne-Jones 1833–98* (London: Arts Council of Great Britain, 1975), 70. The cartoon is now held by the Fitzwilliam Museum, Cambridge.

31 Mrs. Noble indicated that the *Wheel of Fortune* hung in the Carlton Gardens dining room in 1922. Although Paul Harris believes it was hung at Whittingehame, Balfour's country estate at East Lothian, Scotland, it seems likely that the painting was only transferred there after the liquidation of Carlton Gardens in 1929. See Harris, *Life in a Scottish Country House: The Story of A. J. Balfour and Whittingehame House* (Whittingehame: Whittingehame House Publishing, 1989), 75 and 110, citing the sale of the painting from Whittingehame after Balfour's death in 1932, recorded in family records at NAS, GD 433/2/383.

32 *Edward Burne-Jones: Victorian Artist-Dreamer*, 154. Black-and-white studies for it had long been on view in the artist's studio, see "Art Chronicle," *Portfolio* 14 (1883): 125. On the Troy triptych, see Philip Burne-Jones, "Notes on Some Unfinished Works," 165; and *Burne-Jones: The Paintings, Graphic and Decorative Work*, 48–9.

33 Balfour's account book records a payment to Burne-Jones of £300 on April 11, 1883, for an undisclosed purpose; it is closely followed by a payment to the artist on July 4 of that year of £1,590, "making up 1800 guineas for *Wheel of Fortune*." NAS, GD 433/2/176/1: 1872–84.

34 On this painting, see John Christian, "Burne-Jones's Second Italian Journey," *Apollo* 102 (November 1975): 334–7; A. P. de Mirimonde, "Les Allégories de la destinée humaine et *La Roue de Fortune* d'Edward Burne-Jones," *Gazette des Beaux-Arts* 6, no. 99 (February 1982): 79–86; and *Edward Burne-Jones: Victorian Artist-Dreamer*, 141–55.

35 See Burne-Jones to Balfour, April 8, 1893, NAS, GD 433/2/140:28; and Philip Burne-Jones, "Notes on Some Unfinished Works," 162. This incident may have led Burne-Jones to abandon his initial plan of reliefs for the room.

36 Noble, "Lord Balfour's London House," 68.

37 *Catalogue of the Contents of 4 Carlton Gardens*, 6.

38 William Morris, *The Earthly Paradise: A Poem*, 3rd edn. (London: F. S. Ellis, 1868), 251–2.

39 On Whittingehame, see Robert Machray, "The Prime Minister at Whittingehame," *Pall Mall Magazine* 29, no. 19 (March 1903): 347; R. A. Dakers, "On the Links: Round the Home of the Premier," *The King: and his Navy and Army* XX, no. 439 (July 1, 1905): 404; Blanche Dugdale, *Family Homespun* (London: John Murray, 1940), 183–5; Frances Balfour, *Ne Obliviscaris* 2:210–14, 436; and Harris, *Life in a Scottish Country House*.

40 Harris, *Life in a Scottish Country House*, 71.

41 Ibid., 75. Balfour's account book records a £33 12s. 8d. wallpaper purchase from Morris & Co. on August 22, 1883, but does not specify the property for which the paper was intended; see NAS, GD 433/2/176/1: 1872–84. On November 10, 2000, segments of hand-printed peacock wallpaper from Whittingehame, attributed to Burne-Jones and Morris, were sold at auction by Phillips of Edinburgh, lot 290.

42 Dakers, "On the Links," 406–7; and Balfour's account book, June 2, 1881, £3 15s. 0d., NAS, GD 433/2/176/1: 1872–84.

43 See Balfour to Alice Blanche Balfour, August 5, 1899, NAS, GD 433/2/140: 46–7; and September 11, 1909, NAS, GD 433/2/74: 6; and Frances Balfour, *Ne Obliviscaris*, 2:436.

44 In some versions of the Perseus myth, the hero briefly stops in Atlas's kingdom of Hesperus and steals the golden apples on his way to rescue Andromeda. Fisher showed this large sculpture in the New Gallery's summer exhibition in 1900. It is unclear whether Balfour commissioned it or purchased it after the fact. His sister Eleanor told him she felt it would be a better fit for "the Burne-Jones room" at Carlton Gardens than for Whittingehame; see Eleanor Sidgwick to Balfour, undated, NAS, GD 433/2/479/1:20.

45 Penelope Fitzgerald states that Balfour "had to content himself with hanging the Briar Rose studies, during his premiership,

round the dining-room of 10 Downing Street" as his *Perseus* series remained incomplete. She does not cite a source for this information, however, and I have not found any indication that any version of the *Briar Rose* pictures was ever in Balfour's possession. See Fitzgerald, *Edward Burne-Jones: A Biography*, 226.

46 George A. Wade, "10 Downing Street," *Pall Mall Magazine* 23, no. 94 (February 1901): 178. This room is also known as "Pitt's Dining Room."

47 For the *Call of Perseus*, see George A. Wade, "10 Downing Street," *Pall Mall Magazine* 23, no. 94 (February 1901): 179.

48 Wade, "10 Downing Street," 178.

49 Frances Balfour to Frank Balfour, March 2, 1906, NAS.

50 See "Lord Balfour's Will," *The Times*, March 25, 1930, 19. For comments on family pictures at Whittingehame, see Balfour to Alice Blanche Balfour, July 28 and August 5, 1899, NAS, GD 433/2/140: 46–7.

51 Balfour to Alice Blanche Balfour, July 28 and August 5, 1899, NAS. In these letters he briefly explained these priorities (including the coordination of paintings, furniture, and china) with regard to the rehanging of the pictures at Whittingehame.

52 In addition to the possibly apocryphal account cited in *Outlook* ("In Passing," 3, no. 53 [February 4, 1899]: 19) and the encounters described by Humbert Wolfe below, Balfour played host to two connoisseurs named "Harris" and "Neville" in July 1911 and October 1912 respectively. See NAS, GD 433/2/342: 65–6 and GD433/2/166/9–23: 11–12.

53 Arthur James Balfour, *The Foundations of Belief* (London: Longmans, Green & Co., 1895), 57.

54 Ibid., 59. In keeping with this educational view, Balfour agreed in 1888 to take up the vice-presidency of the newly formed National Association for the Advancement of Art and its Application to Industry; see "Art in July," *Magazine of Art* 11 (1888): 37.

55 Arthur James Balfour, "The Works of G. F. Handel," *Edinburgh Review* 165, no. 337 (January 1887): 247; see also Balfour, *Foundations of Belief*, 38–9.

56 Arthur James Balfour, "Criticism and Beauty," reprinted in Balfour, *The Mind of Arthur James Balfour: Selections from his Non-Political Writings, Speeches, and Addresses, 1879–1917* (New York: George H. Doran, 1918), 216, emphasis added.

57 Balfour, *Foundations of Belief*, 48–9.

58 For "cloistral retreat," see "A Painter of Otherworldliness," *Daily News* (London), June 18, 1898, 5. This has proved a very tenacious paradigm for discussing these pictures. Fröhlich endorses Dianne Sachko Macleod's characterization of Aesthetic patronage as driven by men who, "in attempting to fill the void left by their displaced values, … turned inward, to the contemplation of well-crafted images in the privacy of their homes. Instead of mirroring the world …, Aesthetic artists offered their clients a means of escaping it." Fröhlich, "Frauen im Spiegel," 89–90, quoting Macleod, *Art and the Victorian Middle Class: Money and the Making of Cultural Identity* (Cambridge: Cambridge University Press, 1996), 272.

59 Contemporary observers drew this parallel between the Christian and mythical heroes explicitly; see, for example, "The New Gallery," *Leeds Mercury*, May 9, 1888, 3.

60 For analysis of these themes in the *Perseus* series, see Maurice Berger, "Edward Burne-Jones's Perseus-Cycle: The Vulnerable Medusa," *Arts Magazine* 54 (April 1980): 149–53; Joseph A. Kestner, *Mythology and Misogyny: The Social Discourse of Nineteenth-Century British Classical-Subject Painting* (Madison: University of Wisconsin Press, 1988), 82–106; Adrienne Munich, *Andromeda's Chains: Gender and Interpretation in Victorian Literature and Art* (New York: Columbia University Press, 1989), 123–7; Fröhlich, "Frauen im Spiegel"; and Cheney, "Edward Burne-Jones's *Andromeda*," 218–24.

61 For Burne-Jones's interest in exploring different female types, see, in addition to the above cited sources, Zettel, "Belle et Blonde et Colorée," 41–9.

62 Although Balfour would eventually become entangled in a long-term (but apparently unconsummated) romantic affair with the unattainable Lady Elcho – mirroring Burne-Jones's equally passionate attachments to women who were not his wife – he was at the time of the commission a bereft young bachelor whose close female companion and near-fiancée had just died unexpectedly. In 1875, the romantic complications that would come to define Balfour's personal life had yet to develop, so Perseus's predicament, at least as Burne-Jones imagined it – torn between the forbidden dark attractions of the Medusa and the domestic purity of Andromeda – could only have had a general, accidental relevance to the patron's own experiences and relationships.

63 See "Gleanings," *Birmingham Daily Post*, January 7, 1893, 7; and "Our Ladies' Letter," *Freeman's Journal and Daily Commercial Advertiser*, January 7, 1893, 6.

64 Nancy Waters Ellenberger conducts a very thorough analysis of the group's formation and impact on the social and political life of turn-of-the-century England in "The Souls: High Society and Politics in Late Victorian Britain" (PhD diss., University of Oregon, 1982); as well as in "The Souls and London 'Society' at the End of the Nineteenth Century," *Victorian Studies* 25, no. 2 (winter 1982): 133–60; and "Constructing George Wyndham: Narratives of Aristocratic Masculinity in Fin-de-Siècle England," *Journal of British Studies* 39, no. 4 (October 2000): 487–517. Also relevant are two publications related to a 1982 exhibition focused largely on pictures of the Souls; see Jane Abdy and Charlotte Gere, *The Souls: An Exhibition* (London: Bury Street Gallery, 1982), unpaginated; and Abdy and Gere, *The Souls* (London: Sidgwick & Jackson, 1984).

65 Fitzgerald, *Edward Burne-Jones*, 229, no citation given.

66 On Clouds and Stanway, see Caroline Dakers, *Clouds: The Biography of a Country House* (New Haven and London: Yale University Press, 1993). Other Burne-Jones works in the Wyndham collection at Clouds included *Ascension*, a cartoon for stained glass (destroyed). Stanway held a modest collection of gifts and souvenirs from Burne-Jones and his family, including a Christmas card designed for Lady Elcho, a drawing of the artist's daughter Margaret, and a gouache sketch of the Laura Lyttelton memorial design, which is discussed below; see Dakers, *Clouds*, 154; Abdy and Gere, *The Souls: An Exhibition*.

67 On the *Love* cartoon at Mells Park, see *Edward Burne-Jones: Victorian Artist-Dreamer*, 280. On the Windsors' *Paradise* cartoon, see Sewter, *Stained Glass of William Morris*, vol. 1, 41–2; and *Collection Yves Saint Laurent et Pierre Bergé* (Paris: Christie's, 2009), lot 90. It is not clear in which of the Windsors' residences it was hung. On Burne-Jones's portrait of Lady Windsor (1893–5), see *Edward Burne-Jones: Victorian Artist-Dreamer*, 324–5.

68 In December 1886, Burne-Jones invited Balfour to his studio to view the tablet. Burne-Jones to Balfour, December 13 [1886], BL Balfour, Add. MS 49839, fol. 39.

69 Dakers, *Clouds*, 154.

70 *Edward Burne-Jones: Victorian Artist-Dreamer*, 287–8.

71 I am grateful to Dr. Godfrey Evans, former Principal Curator of European Applied Art at the National Museum of Scotland, Edinburgh, for sharing his research files on Balfour's Fisher enamels; see also Dakers, *Clouds*, 147–51.

72 Noble, "Lord Balfour's London Home," 682; *Catalogue of the Contents of 4 Carlton Gardens*, 19.

73 Alford, *Needlework as Art*, 398.

74 Katie Cowper, "Realism of To-day," *Nineteenth Century* 35, no. 206 (April 1894): 626. The watercolor *Love Disguised as Reason* had entered the Pembrokes' collection sometime after the artist Edward Clifford purchased it from the William Graham sale in 1886. See *Edward Burne-Jones: Victorian Artist-Dreamer*, 135.

75 Clive Aslet, *The Last Country Houses* (New Haven and London: Yale University Press, 1982), 8.

76 Fitzgerald, *Edward Burne-Jones: A Biography*, 229; Ellenberger,

"The Souls," 105; J. Mordaunt Crook, *The Rise of the Nouveaux Riches: Style and Status in Victorian and Edwardian Architecture* (London: John Murray, 1999), 242.

77 A Souls scrapbook formerly in the collection of George Nathaniel Curzon (now held by the British Library, MS Eur F111/127), features such representative newspaper clippings as "The Souls," *Queen*, April 14, 1894: "The Souls are a set of attractive men and women of the world, very intimate, and eminently 'in touch' with one another, who have come to believe in themselves as the fine flower of culture, of a rather more delicate pate and more exquisite and subtle taste than ordinary mortals, whom they stoop to mix with when it suits them, but whom they criticize and pity."

78 Dakers, *Clouds*, 151. Elsewhere, it has been suggested that "the Souls loved Burne-Jones for his spirituality." *Edward Burne-Jones: Victorian Artist-Dreamer*, 325. Ellenberger, however, describes the broad compass of philosophical and spiritual attitudes represented by the Souls as a group; see "The Souls: High Society and Politics," Chapter 3.

79 Mark Girouard, *The Return to Camelot: Chivalry and the English Gentleman* (New Haven and London: Yale University Press, 1981), 193, 200, 208.

80 Frances Evelyn Greville, Countess of Warwick, *Afterthoughts* (London: Cassell, 1931), 46, quoted in Ruth Brandon, *The Dollar Princesses: Sagas of Upward Nobility, 1870–1914* (London: Weidenfeld and Nicolson, 1980), 26.

81 Margot Tennant Asquith, *An Autobiography*, 2 vols. (New York: George H. Doran Company, 1920), 1:208.

82 See "The New Morality," an anonymous paper about the Souls attributed to Frances Horner, D. D. Balfour, and Godfrey Webb, quoted in Ellenberger, "The Souls and London 'Society'," 134. The phrase "elective affinity" can be found in late nineteenth-century British publications related to politics, music, science, and art. See, respectively, T. W. Levin, "Elective Affinities," *Examiner* 3450 (March 14, 1874): 255–6; "Music and Action, or the Elective Affinity between Rhythm and Pitch," *Musical Times* 31, no. 564 (February 1890): 104–5; "The Development of Psychology," *Westminster Review* 45, no. 2 (April 1874): 402; and William Michael Rossetti, "English Painters of the Present Day," *Portfolio* 1 (January 1870): 114.

83 On Froude and his translation, see Susanne Stark, "A 'Monstrous Book' after All? James Anthony Froude and the Reception of Goethe's 'Die Wahlverwandtschaften' in Nineteenth Century Britain," *Modern Language Review* 98, no. 1 (January 2003): 102–16. For Froude and the Souls, see Ellenberger, "The Souls: High Society and Politics," 132.

84 Charles Darwin, *The Variation of Animals and Plants under Domestication* (London: John Murray, 1868).

85 Pierre Bourdieu, *Distinction: A Social Critique of the Judgment of Taste* (Cambridge, Mass.: Harvard University Press, 1984), 241.

86 Arscott, *Interlacings*, 34.

87 Ibid., 35.

88 "Interview with a 'Soul'," *England*, November 19, 1892, from Curzon scrapbook, BL.

89 [Lord] Thring, "Home Rule and Imperial Unity," *Contemporary Review* 51 (March 1887): 306.

90 See, on the one hand, Edward Said, *Orientalism* (New York: Vintage Books, 1979), 31–9; and Arscott, *Interlacings*, 82; and, on the other, Denis Judd, *Balfour and the British Empire: A Study in Imperial Evolution, 1874–1932* (London: Macmillan, 1968), 18–20.

91 See Ellenberger, "The Souls: High Society and Politics," 260–1.

92 Curzon to Wyndham via Lord Selborne, November 9, 1900, Selborne papers, quoted in Ellenberger, "The Souls: High Society and Politics," 279–80.

93 Lady Elcho to Balfour, October 13 and 15, 1900, Elcho papers, quoted in Ellenberger, "The Souls: High Society and Politics," 289.

94 Dugdale, *Family Homespun*, 73.

95 Dakers, *Clouds*, 93.

96 See also Burne-Jones, *Frances Campbell Balfour* (1881, Musée des Beaux-Arts, Nantes).

97 For Princess Sabra, see Burne-Jones, *Princess Sabra Drawing the Lot* (1865–6, Hanover College, Indiana); and the *Princess Tied to the Tree* (1866, Forbes Collection, New York). For Psyche, see Burne-Jones and Walter Crane, the *King and other Mourners abandon Psyche to the Monster* (1872–81, Birmingham Museums and Art Gallery).

98 Morris, *The Earthly Paradise*, 254.

99 See, for example, Martin A. Danahay, "Mirrors of Masculine Desire: Narcissus and Pygmalion in Victorian Representation," *Victorian Poetry* 32, no. 1 (spring 1994): 35–54; Kate Flint, "Edward Burne-Jones's *The Mirror of Venus*: Surface and Subjectivity in the Art Criticism of the 1870s," in Elizabeth Prettejohn, ed., *After the Pre-Raphaelites: Art and Aestheticism in Victorian England* (Manchester: Manchester University Press, 1999), 152–66; and Fröhlich, "Frauen im Spiegel."

100 On these organizations, see Alan Willard Brown, *The Metaphysical Society: Victorian Minds in Crisis, 1869–1880* (New York: Columbia University Press, 1947); and William C. Lubenow, *The Cambridge Apostles, 1820–1914: Liberalism, Imagination, and Friendship in British Intellectual and Professional Life* (Cambridge: Cambridge University Press, 1998). For the specific details of Balfour's movement in these intellectual circles, see John David Root, "The Philosophical and Religious Thought of Arthur James Balfour (1848–1930)," *Journal of British Studies* 19, no. 2 (spring 1980): 120–41.

101 On the Balfours and aluminum, see numerous references in Balfour's account books, NAS, GD 433/2/176/1–3, in addition to family correspondence also held by this institution, such as Balfour to Eleanor Balfour, November 18, 1881 (NAS, GD 433/2/195/1: 29–31) and Gerald Balfour to Balfour, October 21, 1887 (NAS, GD 433/2/166: 9:1–4). For their investments in electrical technologies, particularly the St. James and Pall Mall Electric Light Co., see, in addition to Balfour's account books, the company prospectus, "Electric Lighting in London: St. James' & Pall Mall Electric Light Co.," *Engineer*, September 5 and 12, 1890. Balfour's uncle, Lord Salisbury, was one of the earliest adopters of domestic electric lighting in London at Hatfield House; see *The Passion of the Lamp: The Story of the Electric Lamp* (London: Edison Swan Company, Ltd., 1948), 22–3. On Benson, metalwork, and electricity, see Ian Hamerton, ed., *W. A. S. Benson: Arts and Crafts Luminary and Pioneer of Modern Design*, exh. cat. (Woodbridge: Antique Collectors' Club, 2005). In its current (presumably repaired) state, the golden *Graiae* can best be described as gilt plaster on wood, but reviews of it at the Grosvenor Gallery in 1878 indicate that in a previous state it featured metal plates or sheets applied to the surface of the composition; see, for example, "Grosvenor Gallery," *Era* 2067 (May 5, 1878): 7; and "The Grosvenor Gallery," *British Architect* 9, no. 21 (May 1878): 239.

102 Balfour to Mary Gladstone Drew, December 29, 1885, Mary Gladstone Papers, BL, Add. MS 46238, fol. 9; Curzon, quoted in Margot Tennant Asquith, *Autobiography*, 1:176. "Interwoven" was the title of an unpublished memoir written by D. D. Lyttelton chronicling the relationships between some of the Souls, now kept in the Chandos Papers, Churchill College, Cambridge, and cited in Ellenberger, "The Souls: High Society and Politics," 243, note 88.

103 See note 64 above.

104 "The New Gallery," *The Times*, May 9, 1888, 10.

105 Cosmo Monkhouse, "The New Gallery," *Academy* 33, no. 842 (June 2, 1888): 383–4.

106 See, for example, "Current Art," *Magazine of Art* 10 (1887): 292–3; "The Grosvenor Gallery," *Daily News* (London), May 2, 1887, 2; and F. G. Stephens, "The New Gallery," *Athenaeum* 3160 (May 19, 1888): 653.

107 Arscott, *Interlacings*, 53. This was a point frequently made by critics at the time. See, for example, "Exhibitions," *Art Journal* (July 1888): 221.

108 Cynthia Asquith in a letter to her mother, Lady Elcho, recalling what her mother had told her about the Souls, quoted in Abdy and Gere, *The Souls*, 13. For a more detailed discussion of Souls' conversations, see Ellenberger, "The Souls: High Society and Politics," 106–9 and Chapter 3.

109 Mrs. Humphry Ward, *A Writer's Recollections* (London: W. Collins Sons & Co., 1918), 29.

110 Cynthia Asquith, *Remember and Be Glad* (London: James Barrie, 1952), 108, quoted in Ellenberger, "The Souls: High Society and Politics," 136.

111 Margot Tennant Asquith seems to be the fountainhead of information for most scholars who mention the Souls' games; see *Autobiography*, 1:73–6 and 2:12. Ellenberger draws on a range of primary sources to derive her list of games; see "The Souls: High Society and Politics," Chapter 2. Several games are listed in Abdy and Gere, *The Souls*, 12.

112 Ellenberger, "The Souls: High Society and Politics," 86–94, 98.

113 Emily Bryan, "Nineteenth-Century Charade Dramas: Syllables of Gentility and Sociability," *Nineteenth Century Theatre and Film* 29, no. 1 (summer 2002): 45.

114 W. H. Mallock, in his poem, "The Souls," ridiculed the group for intellectual immaturity and escapism, "talking of faith, and devotion, and purity" that are only "the illusions of youth." *Fortnightly Review* 312 (December 1, 1892): 701–3. See also the clipping from the *World*, July 16, 1890, preserved in Curzon scrapbook, BL.

115 "Lord Haldane's Memories," *The Times*, January 17, 1929, 13–14.

116 See Burne-Jones's report of a Souls dinner in an 1875 letter to George Howard, Castle Howard Archives, quoted in Dakers, *Holland Park Circle*, 87.

117 *New York Times*, March 20, 1930, 18.

118 Sydney Brooks, "Some English Statesmen," *McClure's Magazine* 37, no. 2 (June 1911): 128.

119 Alfred Kinnear, "The Gentle Life of Mr. Balfour," in *Our House of Commons: Its Realities and Romance*, 2nd edn. (Edinburgh: Blackwood and Sons, 1901), 263.

120 See *The Times*, June 22, 1878, 1; and "Recent Concerts," *Pall Mall Gazette*, April 12, 1879, 4.

121 The newspapers barely register Balfour's presence in the House in the 1870s. By the 1890s, it was commonly reported that when Balfour arrived in Parliament fresh from the university debating hall in 1874, he had already acquired the sobriquets "Miss Nancy" and "Aunt Fanny," due to his aforementioned love of blue-and-white, his delicate health, and the "various little effeminate habits" that distinguished him from "the robust graduates of Cambridge"; see Sydney Brooks, "Balfour as a Leader," *St. John Daily Sun (New Brunswick)*, April 17, 1901, 10. Such retrospective accounts were common in the years after 1887, when Balfour ascended to Irish secretaryship, but I have as yet encountered no sources that cite specific evidence dating this reputation to his pre-parliamentary days.

122 On "goats," see Ward, *Recollections*, 40. For the Fourth Party, see Harold Gorst, *The Fourth Party* (London: Smith, 1906). In 1882, Linley Sambourne adapted the program design for Gilbert and Sullivan's hugely popular Aesthetic satire, *Patience*, to depict three members of the Fourth Party as peacock feather-worshiping, sunflower-gazing Aesthetes – "The Troublesome Trio, Appearing Nightly during the Performance of 'Impatience' at St. Stephen's," *Punch* 83 (November 11, 1882): 218.

123 The Fourth Party made themselves into caricatures before the fact, even going so far as to pose for a group portrait drawn for *Vanity Fair* 24 (December 1, 1880); see "The Fourth Party," *Primrose League Gazette*, November 1, 1908, 5; and Young, *Arthur James Balfour*, 71.

124 See, for example, Randolph Churchill, quoting Gladstone, in a letter to Salisbury, January 3, 1886, excerpted in Lewis Perry Curtis, *Coercion and Conciliation in Ireland, 1880–1892* (London: Oxford University Press, 1963), 73.

125 See "London Correspondence," *Freeman's Journal and Daily Commercial Advertiser* (Dublin), March 7, 1887, 5.

126 Balfour to Lady Elcho, August 12, 1890, typewritten copy, NAS, GD 433/2/67:4, also reprinted in Jane Ridley and Clayre Percy, eds., *The Letters of Arthur Balfour and Lady Elcho, 1885–1917* (London: Hamish Hamilton, 1992), 72; "The Royal Academy of Arts," *Aberdeen Weekly Journal*, May 2, 1891, 5.

127 "Mr. Balfour: A Study," *Pall Mall Gazette*, October 21, 1891, 1.

128 "Hibernia," *Punch* 94 (March 10, 1888): 118.

129 "The Future of Irish Politics," *Fortnightly Review* 57, no. 341 (May 1895): 686.

130 "Politicians on the Wane," *Speaker* 1 (April 26, 1890): 445.

131 See "Down to the Depths, with Apologies to Sir Edward Burne-Jones," *Westminster Budget* V, no. 109 (March 1, 1895): 1.

132 Burne-Jones's *Baleful Head* was described as "caviare to the general" in "The Grosvenor Gallery," *Liverpool Mercury*, May 2, 1887, 5. Balfour's esoteric philosophical language was similarly characterized by Archdeacon Farrar in "Mr. Balfour on 'The Foundations of Belief,'" *English Illustrated Magazine* 139 (April 1895): 19.

133 [Henry W. Lucy], "Studies in Character," *New Review* 1, no. 6 (November 1889): 574–5.

134 Humbert Wolfe, "The White Trousers of Mr. Balfour," *English Review* 58 (June 1934): 664–5.

135 For the later caricatures of Balfour, see "Rickety," *Punch* 125 (October 7, 1903): 237; and Max Beerbohm, *Mr. Balfour – A Frieze*, from *Fifty Caricatures* (London: William Heinemann, 1913), no. 36.

136 For a nineteenth-century example of the usage of "political androgyny," see "Theory of Political Representation," book review of *The Rationale of Political Representation* (London: R. Hunter, 1835), in *American Quarterly Review* 39 (September 1836): 212. For twentieth-century scholarly and theoretical deployments of this concept, see Constance Jordon, "Representing Political Androgyny: More on the Siena Portrait of Queen Elizabeth I," in *The Renaissance Englishwoman in Print: Counterbalancing the Canon*, ed. Anne M. Haselkorn and Betty S. Travitsky (Amherst: University of Massachusetts Press, 1990), 157–76; and Jean Baudrillard, "Transpolitics, Transsexuality, Transaesthetics," in *Jean Baudrillard: The Disappearance of Art and Politics*, ed. William Chaloupka and William Stearns, trans. Michel Vanentin (New York: St. Martin's, 1992), 21.

137 Balfour was consistently characterized by his contemporaries as indecisive; for further exploration of this topic, see E. H. H. Green, "'No Settled Convictions'? Arthur Balfour, Political Economy, and Tariff Reform: A Reconsideration," in *Ideologies of Conservatism: Conservative Political Ideas in the Twentieth Century* (Oxford: Oxford University Press, 2002), 18–41.

2 SWEETNESS AND ELECTRIC LIGHT

1 W. H. Preece, F.R.S., "The Application of Electricity in Lighting and Working," a lecture delivered January 4, 1888, before the Royal Society of Arts, as part of its Juvenile Lecture Series, reprinted in the *Journal of the Society of Arts* 36 (January 13, 1888): 177.

2 "Inquests," *Standard*, January 8, 1887, 2.

3 "The Dangers of Electric Lighting," *Telegraphic Journal and Electrical Review* 20, no. 477 (January 14, 1887): 21. The *Electrician*, however, blamed the coal gas and gas fittings for the explosion; see "A Sad Fatality," *Electrician* 18 (January 14, 1887): 209.

4 Cursory attempts to draw together the gallery's artistic and electrical ventures under the same heading can be found in Anthony Clayton, "'Greenery-yallery, Grosvenor Gallery': Avant Garde Outpost and Power Supply Pioneer," *Westminster History Review* (2000): 14–22; and Gavin Weightman, *Children of Light: How Electricity Changed Britain Forever* (London: Atlantic Books, 2011), Chapter 6.

5 Although this plan is dated 1889, after other alterations on the site had been made, its depiction of the art galleries generally matches

descriptions published around the time of Grosvenor's opening. See for example "Notes and News," *Academy* 9, no. 211 (May 13, 1876): 469; and "The Grosvenor Gallery," *The Times*, March 12, 1877, 4. On the construction history of the gallery, see Colleen Denney, "The Grosvenor Gallery as Palace of Art: An Exhibition Model," in *The Grosvenor Gallery: A Palace of Art in Victorian England*, ed. Colleen Denney and Susan P. Casteras (New Haven and London: Yale University Press, 1996), 9–36; Denney, *At the Temple of Art: The Grosvenor Gallery, 1877–1890* (Madison, N.J.: Fairleigh Dickinson University Press, 2000), 15–34; and "Bourdon Street and Grosvenor Hill Area," in *Survey of London*, vol. 40, ed. F. H. W. Sheppard (London: London County Council, 1980), 57–63. *British History Online*, www.british-history.ac.uk/survey-london/vol40/pt2/pp57-63, accessed November 19, 2019.

6 "The Chat of the Fair," *London Mayfair*, March 20, 1877, 15–16. C. E. Halle discusses these conflicts and Lindsay's subsequent purchase of neighboring properties; see Halle, *Notes from a Painter's Life* (London: J. Murray, 1909), 102. For lawsuits of this type in urban London, see Chris Otter, *The Victorian Eye: A Political History of Light and Vision in Victorian Britain* (Chicago: University of Chicago Press, 2008), 70.

7 "High Court of Justice, April 3, Chancery Division, Barker v. Lindsay," *The Times*, April 4, 1878, 11. Even so, Lindsay was prevented from making the Water Color Room and Sculpture Room as tall as he wanted them to be; see "Fine Arts: The Grosvenor Gallery," *Observer*, April 15, 1877, 3.

8 Agnes D. Atkinson, "The Grosvenor Gallery," *Portfolio* 8 (1877), 98.

9 "The Grosvenor Gallery," *The Times*, March 12, 1877, 4. For the velarium and its prototypes, see Denney, "The Grosvenor Gallery as Palace of Art," 21.

10 See "The Grosvenor Gallery," *Daily News* (London), January 12, 1877, 2; and "The Grosvenor Gallery," *The Times*, March 12, 1877, 4.

11 On foggy days during the summer, conditions were almost as bad as in the winter; see "The Man About Town," *County Gentleman* XXII, no. 1147 (May 3, 1884): 551. On fog, the Grosvenor Gallery, and Whistler's nocturnes, see Caroline Arscott, "Subject and Object in Whistler: The Context of Physiological Aesthetics," in *Palaces of Art: Whistler and the Art Worlds of Aestheticism*, ed. Lee Glazer and Linda Merrill (Washington, D.C.: Smithsonian Institution Scholarly Press, 2013), 55–65.

12 See "Olla Podrida," *St. James's Magazine* 4, no. 31 (1877): 715; "The Grosvenor Gallery," *Morning Post*, May 1, 1877, 6; "The Grosvenor Gallery," *Standard*, May 3, 1877, 6; and Sidney Colvin, "The Grosvenor Gallery," *Fortnightly Review* 21, no. 126 (June 1877): 833.

13 "English Art," *New York Herald*, May 13, 1877, 8. Not all praise was unqualified; see complaints about raking light in "The Grosvenor Gallery Exhibition," *Athenaeum*, 2584 (May 5, 1877): 583.

14 Just over ten years later, the *Art Journal* identified "the precise effect of a studio top-light" upon Greek drapery as "the most characteristic thing in his work"; see "Midsummer," *Art Journal* (October 1887): 317. On Moore's studio, E. W. Godwin, "Studios and Mouldings," *Building News* 36 (March 7, 1879): 261, cited in Robyn Asleson, *Albert Moore* (London: Phaidon, 2000), 149.

15 Asleson, *Albert Moore*, 137.

16 See ibid.

17 "Book Review," *Quarterly Review* 134, no. 268 (April 1873): 291.

18 On decorative art appealing to the eye, while "mystery and chiaroscuro" appeal to the mind, see "English and American Painting at Paris in 1878, II," *International Review* 6 (May 1879): 558–9.

19 "The Grosvenor Gallery," *The Times*, March 12, 1877, 4; "London Notes," *Ipswich Journal* no. 7522 (May 1, 1877): 2.

20 "Our Van," *Baily's Monthly Magazine of Sports and Pastimes* XXX, no. 208 (June 1, 1877): 297.

21 On "harmonious decorations," see "The Grosvenor Gallery," *The Times*, March 12, 1877, 4; and "Our Illustrations," *Graphic* (London) 15, no. 390 (May 19, 1877): 463. See also "London Notes," *Ipswich Journal* no. 7522 (May 1, 1877): 2. Other commentators, it should be noted, did

not find Lindsay's crimson and sage wall treatments to be a fitting complement to the pictures; see, among others, "The Grosvenor Gallery Exhibition," 583; "The Grosvenor Gallery," *Morning Post*, May 1, 1877, 6; "The New Show," *Judy* 21 (May 9, 1877): 37; and "English Art: The Grosvenor Exhibition – the Painter's Paradise," *New York Herald*, May 13, 1877, 8.

22 From the beginning it was understood that the gallery would be approached as though it was itself a picture, working toward a harmonized whole; see "Notes and News," *Academy* 9, no. 211 (May 13, 1876): 468. See also Atkinson, "The Grosvenor Gallery," 98.

23 "The Grosvenor Gallery," *The Times*, March 12, 1877, 4. The Grosvenor was distinguished by its domestic styling; see "London Notes," *Ipswich Journal* no. 7522 (May 1, 1877): 2; Atkinson, "The Grosvenor Gallery," 98; "The Grosvenor Gallery," *Morning Post*, May 1, 1877, 6; "The Grosvenor Gallery," *Pall Mall Gazette*, May 2, 1877, 11; H. Heathcote Statham, "The Grosvenor Gallery," *Macmillan's Magazine* 36, no. 212 (June 1877): 112.

24 This becomes most evident in a series of interviews conducted by the electric trade journal *Lightning* in 1892; see, for instance, "Artificial Light in Studios," *Lightning: The Popular and Business Review of Electricity* 1, no. 12 (January 7, 1892): 268.

25 "Art and Literature," *Newcastle Courant* no. 10568 (July 13, 1877): 6. Contemporary artists appear to have shown under the gas during Grosvenor winter exhibitions only.

26 In December 1882, the lack of artificial lighting at the old Water Color Society caused an exodus to the Grosvenor; see "London Letter," *Art Interchange* 10, no. 1 (January 4, 1883): 11. But *Vanity Fair* wrote of a banquet held in the Grosvenor restaurant beneath "an almost garish display of gas": "Had a sudden catastrophe engulphed these rooms in flames, English art, literature, and beauty would have lost their best and brightest"; see Firefly, "The Social Week," *Vanity Fair* 17 (May 12, 1877): 298.

27 On pre-electrical concerns about gas damage to pictures, see Geoffrey N. Swinney, "The Evil of Vitiating and Heating the Air: Artificial Lighting and Public Access to the National Gallery, London, with particular reference to the Turner and Vernon Collections," *Journal of the History of Collections* 15, no. 1 (2003): 83–112.

28 For the gallery's steam-powered ventilation system, fire hydrant system, and elevator, see "The Grosvenor Gallery," *The Times*, March 12, 1877, 4.

29 On furs, see "The Man About Town," *County Gentleman* xxv, no. 1287 (January 8, 1887): 39; on offensive cooking smells, see "The Man About Town," *County Gentleman* xix, no. 993 (May 21, 1881): 546; and "Notes on Current Events," *British Architect* 21, no. 2 (January 11, 1884): 13.

30 Of the first exhibition of Old Master drawings, the *Daily News* observed, "Nothing but sunlight, the lack of which cannot be supplied by the most ingenious arrangement of gas, is wanted to make the Winter Exhibition at the Grosvenor Gallery a perfect success"; see "Old Masters' Drawings at the Grosvenor Gallery," *Daily News* (London), December 22, 1877, 3. See also "English Water-Colours at the Grosvenor Gallery," *Architect* (London) 18 (December 8, 1877): 306.

31 "Joshua Reynolds at the Grosvenor Gallery," *London Evening News*, January 2, 1884, 4. See also "The Grosvenor Gallery," *Glasgow Herald*, January 9, 1884, 4; and Henry B. Wheatley, "Decorative Art in London," *Decorator and Furnisher* 3, no. 6 (March 1884): 206.

32 Editorial, *The Times*, June 9, 1881, 9.

33 See "Smoke Abatement," *The Times*, January 10, 1881, 4.

34 "The Grosvenor Gallery," *Morning Post*, May 1, 1877, 6. See also "The Grosvenor Gallery Exhibition," 583; and "The Pictures of the Year," *Blackwood's Edinburgh Magazine* 143, no. 872 (June 1888): 822. *Funny Folks* retitled Whistler's *Arrangement in White and Black* (ca. 1876, Freer Gallery of Art) "A Reflection": "For Mr. Whistler. Do have your pictures covered with glass. Something might then be seen in them"; see Grosvenor Gallery Gaieties," *Funny Folks* IV, no. 181 (May 18, 1878): 157.

35 "The Grosvenor Gallery," *Daily News* (London), May 1, 1884, 3.

36 See, among others, "Our London Letter," *Northern Echo*, November 2, 1881, 4; "Music, Science, and Literature," *Bath Chronicle* 126, no. 6416 (November 3, 1881): 6; "London Correspondence," *Western Times*, November 16, 1881, 7; "Municipal Matters," *Hampshire Telegraph and Sussex Chronicle*, November 19, 1881, 2; and "Topics in Town," *Northampton Mercury* CLXII, no. 8398 (November 19, 1881): 5.

37 Hollis Clayson, *Illuminated Paris: Essays on Art and Lighting in the Belle Epoque* (Chicago: University of Chicago Press, 2019), 3.

38 See ibid., Introduction and Chapter 3. See also Alice Barnaby, *Light Touches: Cultural Practices of Illumination, 1800–1900* (London: Routledge, 2017); and Hélène Valance, *Nocturne: Night in American Art* (New Haven and London: Yale University Press, 2018).

39 "Pictures were to be seen lighted by the electric lamp, demonstrating successfully that the colors are not changed by it, but remain as they were during daylight"; see "Electric Progress," *Blackwood's Edinburgh Magazine* 131, no. 796 (February 1882): 255.

40 Thomas Hughes, *Networks of Power: Electrification in Western Society, 1880–1930* (Baltimore: Johns Hopkins University Press, 1983), 97. The Grosvenor Gallery's records indicate that the company was regularly buying coal from the Wigan Coal Company for unspecified uses; see, for example, the entry for January 13, 1886, in the Sir Coutts Lindsay Company Limited Minute Book, 1885–1888, LMA/4278/01/018/001, held at the London Metropolitan Archives and discussed in greater detail below.

41 Robert Hodson Parsons, *The Early Days of the Power Station Industry* (Cambridge: Cambridge University Press, 1939), 21–41. The company's own historical outline, issued in October 1888, placed the first electrical installations at the plant "about four years ago," which aligns with my contention that November 1884 marks the beginning of the use of this technology at the Grosvenor (see below).

42 Robert Monro Black, *The History of Electric Wires and Cables* (London: Peter Peregrinus Ltd., 1983), 36.

43 "The Stage," *Academy* 20, no. 491 (October 15, 1881): 302; "Savoy Theatre," *Daily News* (London), October 11, 1881, in Swan's electric light book, no. 1, 1880–1893, Swan Papers, Tyne and Wear Archives, 1101/598, p. 139 (hereafter Swan's electric light book, no. 1). On the other hand, Savoy proprietor Richard D'Oyly Carte described the new plaster moldings as more in keeping with the Italian Renaissance than with "the so-called 'aesthetic' manner"; see D'Oyly Carte quoted in Walter Hamilton, *The Aesthetic Movement in England* (London: Reeves and Turner, 1882), 38. As for the suitability of the decoration to electrical illumination, consider that Robert Hammond, in his 1884 book on electricity, found white paints to be especially vulnerable to gas "smuts"; see Hammond, *The Electric Light in our Homes* (London: Frederick Warne, 1884), 10. It was not until late December 1881 that electric lights for the Savoy stage were perfected.

44 "Electric Lighting in London," *Newcastle Daily Chronicle*, January 24, 1882, in Swan's Electric Light Book, no. 1, p. 217. For D'Oyly Carte's public address given before the opening night on October 10, 1881, in which he enumerates the "improvements" "in the lighting and decoration" of architect C. J. Phipps's new Savoy building, see Hamilton, *The Aesthetic Movement in England*, 37–9.

45 See n. 36, above. No exhibition visitors indicated that electric light was in use at this time.

46 This was preceded by the Glasgow Institution of Fine Arts, which had a permanent Maxim incandescent lighting system installed in 1881; see "1881," *Electrician* 8 (January 14, 1882) 137; and *Telegraphic Journal and Electrical Review* 9, no. 213 (December 1, 1881): 487.

47 "Electric Lighting in London," *Newcastle Daily Chronicle*, January 24, 1882, in Swan's electric light book, no. 1, p. 217. See also Stanley C. Hutchison, *The History of the Royal Academy* (London: Chapman & Hall, 1968), 141–2. Arc lighting for picture galleries had recently been tested at the Paris Salon in 1877 with mixed results. In the spring of 1880, it was announced that the French government had

signed a contract with the Jablochkoff company to continue the arc installation – without consulting the dissatisfied artists and Salon jurors. The effects were so bad, one commentator asserted, that the whole idea of electric light in picture galleries had been ruined. See "The Electric Light," *Once a Week* 10, no. 235 (April 1, 1879): 280; and "The Salon, Paris," *Athenaeum* 2741 (May 8, 1880): 607. These complaints stemmed from the challenges that the bright arc lamp posed to regulation: its operation required manually or mechanically maintaining a fixed distance between a pair of consumable carbon rods across which the bluish-white illuminating arc leapt. For a recommendation in favor of the arc lamp, see Gordon Wigan, "Electric Lighting for Picture Galleries," *Magazine of Art* 6 (1883): 358–9.

48 For the Royal Academy's return to gas, see "The Royal Academy," *The Times*, June 26, 1884, 6. Electricity was reinstated in the late 1880s and included in building renovations of the early 1890s, resulting in complete application at the Academy by 1894; see Hutchison, *History of the Royal Academy*, 142.

49 Joseph Swan, "Electric Lighting," a lecture given at the Literary and Philosophical Society, Newcastle upon Tyne, October 20, 1880, official transcript in Swan's electric light book, no. 1; see also multiple newspaper reports of this event.

50 "The Electric Light," *British Trade Journal and Export World* 16 (December 2, 1878): 621. Swan cited the arc light's success in the Cragside picture gallery as proof of the possibilities of electric lighting just two months later at the Literary and Philosophical Society of Newcastle, at a meeting presided over by William Armstrong himself; see *Northern Daily Express*, February 3, 1879, handwritten copy in Swan's electric light book, no. 1, pp. 179–89.

51 "Scientific News," *English Mechanic and World of Science*, no. 820 (December 10, 1880): 322; K. G. Beauchamp, *Exhibiting Electricity*, IEE History of Technologies Series, 21 (London: Institution of Electrical Engineers, 1997), 56.

52 Mark Girouard, *The Victorian Country House*, revised and enlarged edn. (New Haven and London: Yale University Press, 1979), 312–14 and notes.

53 For Armstrong's contemporary reputation as a businessman, see "Fortunes Made in Business," *London Society* 48 (September 1885): 209–40.

54 For the quaint art and architecture of Cragside as a "paradox," given Armstrong's career, see A. N. Wilson, *The Victorians* (London: Hutchinson, 2002), 384.

55 "Fortunes Made in Business," 230.

56 "The Electric Light," *British Trade Journal and Export World* 16 (December 2, 1878): 621. During this period, water was often used as an analog for understanding or explaining electrical flows.

57 *Follow My Leader*, Armstrong's first important artistic acquisition, was painted on-site by Moore, who was recuperating at Cragside after an illness. It marks, as Oliver Garnett and Robyn Asleson have pointed out, a brief but notable turn toward motion as a subject in this artist's *oeuvre*. See Oliver Garnett, "Sold Christie's, Bought Agnew's: The Art Collection of Lord Armstrong at Cragside," *Apollo* 137 (April 1993): 254; and Asleson, *Albert Moore*, 124–5.

58 See, among others, Kenneth Warren, *Armstrong: The Life and Mind of an Armaments Maker* (self-published, 2010), 158–72.

59 The Swan Company won the highest award for incandescent lamps at this exposition. In England, the Swan and Edison companies were consolidated to secure patent rights and prevent legal conflicts; see Adam Gowans Whyte, *The Electrical Industry: Lighting, Traction, and Power* (London: Methuen & Co., 1904), 15.

60 The *Loving Cup* connected Stevenson to other versions owned by Leyland and Bibby, and was connected by critics to Leathart examples. *Lady Lilith* was related to versions owned by Leyland, Bancroft, and Coltart.

61 Dianne Sachko Macleod, *Art and the Victorian Middle Class:*

Money and the Making of Cultural Identity (Cambridge: Cambridge University Press, 1996), 291, 476; and Macleod, "Private and Public Patronage in Victorian Newcastle," *Journal of the Warburg and Courtauld Institutes* 52 (1989): 205. His brother J. C. Stevenson remained involved in the company's affairs.

62 "Swan Electric Light Company," *Telegraphic Journal and Electrical Review* 11, no. 252 (September 23, 1882): 250.

63 "Illustrated Interviews: No. 12: Mr. John Morgan, Secretary, London, Chatham and Dover Railway," *Railway Magazine* 2 (June 1898): 482; "In Passing," *Outlook* 1, no. 23 (July 9, 1898): 723; obituary, *Economist*, April 9, 1904, 613; E. G. Halton, "The Staats Forbes Collection – 1: The Barbizon Pictures," *Studio* 36, no. 151 (October 1905): 30, 33.

64 On this exhibition, see Beauchamp, *Exhibiting Electricity*, 165–6; and Graeme Gooday, *Domesticating Electricity: Technology, Uncertainty, and Gender, 1880–1914* (London: Pickering & Chatto, 2008), 93–7; on the Crystal Palace art gallery, see "Art Notes," *Magazine of Art*, 4 (1881): xviii; and Jan Piggott, *Palace of the People: The Crystal Palace at Sydenham, 1854–1936* (Madison: University of Wisconsin Press, 2004), 133–4. The relocated and reconfigured Great Exhibition building was lauded as an ideal place to host a comparative electrical exhibition, specifically as it housed a commercial gallery space inside; see "The Crystal Palace Electrical Exhibition," *Telegraphic Journal and Electrical Review* 10, no. 217 (January 21, 1882): 40. See also "The Electrical Exhibition at the Crystal Palace," *Saturday Review* (London) 53, no. 1372 (February 11, 1882): 172–3; in Swan's electric light book, no. 1, p. 221; and "International Electric Exhibition at the Crystal Palace," *Illustrated London News* LXXX, no. 2235 (March 4, 1882): 218, 221.

65 "Our Illustrations: The Crystal Palace Electrical Exhibition," *Graphic* (London) 25, no. 642 (March 18, 1882): 259. See also Gooday, *Domesticating Electricity*, 96; and "The International Exhibition," *The Times*, February 27, 1882, 12. Records do not indicate which works of art were exhibited here; it seems likely that electric light was simply applied to the existing Crystal Palace picture gallery. The directors of the Swan Company chose not to contribute to the technological display, preferring instead to show the application of their lighting to domestic and decorative purposes; see notes in Swan minute book, Swan Papers, Tyne and Wear Archives, 1101/585, November 1881 and after.

66 "The Prince of Wales at the Electrical Exhibition," *Daily News* (London), March 26, 1882, in Swan's electric light book, no. 1, p. 233.

67 See "Our Illustrations: The Crystal Palace Electrical Exhibition," *Graphic* (London) 25, no. 642 (March 18, 1882): 259, which indicates that the display was "sumptuously fitted up to reproduce the rooms of a modern home."

68 On movability, see "Our Illustrations: The Crystal Palace Electrical Exhibition," *Graphic* (London) 25, no. 642 (March 18, 1882): 259. For "artistic" decoration, see "The Electric Exhibition at the Crystal Palace," *Saturday Review* (London) 53, no. 1377 (March 18, 1882): 329.

69 Organized by Messrs. Watts and Co.; see "The Prince of Wales at the Electrical Exhibition." For Burne-Jones and Crane, see "Furniture Viewed by Electricity," *Art Amateur* 6, no. 6 (May 1882): 128.

70 "Metropolitan Gossip," *Belfast News-Letter*, March 13, 1882, 3. For more on the smoking room, see "Vanities," *Vanity Fair* 27 (March 11, 1882): 136; and "The Crystal Palace Electrical Exhibition," *Morning Post*, March 9, 1882, 3.

71 Liberty's sold "lanterns from China and Japan" for garden parties and other uses as well as oil lamps in 1881; see *Eastern Art Manufactures and Decorative Objects from Persia, India, China, and Japan* (London: Liberty & Co., 1881), 78. This catalog included an evocative description of Liberty's East Indian Art Warehouse, where lighting was key to creating an exotic atmosphere (p. 17). See also "Girls' Gossip," *Truth* XVIII, no. 464 (November 19, 1885): 805; "Music:

Covent Garden Concerts," *Illustrated Sporting and Dramatic News*, August 13, 1881, 514; and "Floats and Flies," *Fun* 34, no. 849 (August 17, 1881): 66.

72 "Domestic Electric Lighting: Furniture and Decoration," *Furniture Gazette* 17, new series (April 1, 1882): 201–3. Liberty's designed the Indian cotton durrie on the ceiling and had it manufactured "to their order." The Liberty fabrics here were discussed further in "The Crystal Palace Electrical Exhibition," *Morning Post*, March 9, 1882, 3; "Pen and Ink Notes," *Cabinet Maker and Art Furnisher* 1 (April 1, 1882): 182–3; and "Recent Additions to the Crystal Palace Electrical Exhibition," *Journal of Gas Lighting* 39, no. 985 (March 28, 1882): 558–9.

73 "Notes on Current Events," *British Architect* 11, no. 5 (January 31, 1879): 43. Naturally, this praise was reproduced in Liberty's own catalog; see *Eastern Art Manufactures and Decorative Objects*, 115; *Messrs. Liberty & Co., London* (1887), 65.

74 Alison Adburgham, *Liberty's: A Biography of a Shop* (London: George Allen and Unwin, 1975), 33.

75 In 1883, the year after the Crystal Palace Electrical Exhibition, Liberty acquired Chesham House, Regent Street, to use as a carpet and furniture display room, and illuminated it with electric light; see ibid., 42–3. Liberty became a staple of the London exhibitions of the 1880s; Adburgham lists its involvement with the Fisheries, Health, Inventions, and Colonial and Indian exhibitions; see p. 59.

76 Not all agreed that such fabrics passed the test. Around this time, Mary Eliza Haweis wrote that she felt that new colors might need to be devised for the new lighting: "Blues and peacock-greens become painfully vivid; while yellow, which nearly disappears under gas, keeps its natural colour"; see Haweis, *The Art of Decoration* (London: Chatto & Windus, 1881), 355.

77 "The Grosvenor Gallery," *Electrician* 14, no. 2 (November 22, 1884): 21; "Tenders for Electric Lighting Wanted," *Telegraphic Journal and Electrical Review* 15, no. 364 (November 22, 1884): 417. This aligns with the company history provided by Lord Crawford in "The Electric 'Lights o' London,'" *Pall Mall Gazette*, October 16, 1889, 3.

78 On Sun lamps supplied by the Electric Sun Lamp and Power Company at the South Kensington Museum, see, among others, "South Kensington Museum," *The Times*, July 9, 1883, 9; and "Notes," *Telegraphic Journal and Electrical Review* 13, no. 294 (July 14, 1883): 29.

79 "New Company Registered: Sir Coutts Lindsay and Company, Limited," *Telegraphic Journal and Electrical Review* 16, no. 373 (January 17, 1885): 61.

80 "The National Company for Electrical Distribution," *Engineering* XXXIX, no. 998 (February 13, 1885): 162. February appears to mark the first date at which temporary generators were running, if subsequent legal complaints filed against the gallery for noise and vibrations produced by its equipment can be taken as evidence; see, for example, "Law Intelligence: High Court of Justice, Chancery Division," *Morning Post*, July 18, 1885, 3.

81 J. Dixon Gibbs, "The Distribution of Electrical Energy by Secondary Generators," paper given April 13, 1885, published in the *Society of Engineers Transactions for 1885* (London: Spon, 1886), 59. There is no indication that the gallery itself was lit before late March 1885.

82 One of these invitations survives in a letter from Lindsay to a Mr. Lewis, March 27, 1885, Nottinghamshire Archives, Nottingham, DD/1251/20/210.

83 "Electric Light at the Grosvenor Gallery," *Telegraphic Journal and Electrical Review* 16, no. 386 (April 18, 1885): 358.

84 W. J. Gordon, "The Lighting of London," *Leisure Hour* (November 1889): 28; "Notes," *Electrician* 21, no. 545 (October 26, 1888): 779.

85 J. Kenneth D. Mackenzie, responding to Gibbs, "The Distribution of Electrical Energy by Secondary Generators," quoted in *Society of Engineers Transactions for 1885*, 60.

86 "The Grosvenor District Electric Supply," *Telegraphic Journal and Electrical Review* 17, no. 397 (July 4, 1885): 12. For Lindsay's similarly entrepreneurial intervention in the London art world, see "Art," *Examiner* 3602 (February 10, 1877): 180–1; "The Grosvenor Gallery," *Pall Mall Gazette*, May 2, 1877, 11.

87 "Law Intelligence: High Court of Justice, Chancery Division," 3.

88 "Charge of Perjury," *Morning Post*, August 20, 1885, 6. It also seems likely that Pyke was one of the earliest people connected to the network. Key Sir Coutts Lindsay & Co. documents are held by the London Metropolitan Archives and will be used throughout the remainder of this essay. They are Sir Coutts Lindsay Company Limited Minute Book, 1885–8, LMA/4278/01/018/001 (hereafter SCLC 1885–8); and Sir Coutts Lindsay Company Limited Minute Book, 1886–8, LMA/4278/01/018/002 (hereafter SCLC 1886–8).

89 See, for example, company meeting notes from November 20, 1885 (SCLC 1885–8), when the secretary Arthur Wade reports having made several calls along St. James's Street to negotiate the supply of light.

90 See company meeting notes from November 13, 1885 (SCLC 1885–8).

91 For an overview of Van der Weyde's natural and artificial lighting experiments, see Rogier Van der Weyden, "Henry Van der Weyde (1839–1924)," *History of Photography* 23, no. 1 (1999): 68–72.

92 The photographs were used in the process of reproducing drawings in the substantial exhibition catalog produced for the winter show; see J. Comyns Carr, introduction to *The Grosvenor Gallery Illustrated Catalogue: Winter Exhibition (1877–78)* (London: Librarie de l'art, 1877), iv; and "The Grosvenor Gallery," *British Architect* 9, no. 20 (May 17, 1878): 227.

93 H. Baden Pritchard, "The Van der Weyde Electric Studio in Regent Street," in *Photographic Studios of Europe* (London: Piper & Carter, 1882), 72–6.

94 See Olive Weston, "A Prince of Photographers," *Daily Inter Ocean* (Chicago), July 14, 1889, 18. The decorative and dramatic potential of Ovid's *Pygmalion* legend (as recently retold by William Morris in his *Earthly Paradise* of 1868), in which the titular Cypriot artist's longing brings his perfect statue to life, had already been exploited by Grosvenor artists to much acclaim in 1878 (Burne-Jones) and 1881 (G. F. Watts), sustaining an interest in the theme that fueled the 1883–4 revivals of Gilbert's 1871 play in New York and London. Anderson's much publicized stage costume was designed by the American painter Francis Davis (Frank) Millet, as discussed in Chapter 4.

95 See company board meeting notes for November 27 and December 18, 1885, "for lighting his studio," and October 22, 1886, for powering the arc light (SCLC 1885–8). Van der Weyde was still an account holder in 1887; see company board meeting notes for July 15, 1887 (SCLC 1886–8). By 1892, he had switched to a supply provided by the Pall Mall Electric Light Co.; see Henry Van der Weyde, "Electric Lighting in Photography," *British Journal of Photography* XXXIX, no. 1666 (April 8, 1892): 233.

96 "Walery's New Studio," *British Journal of Photography* XXXIII, no. 1388 (December 10, 1886): 775–6; Edward L. Wilson, "The Application of the Electric Light to Photography by Means of Double Reflection," *Photographic Mosaics* (1888): 144–5.

97 Photographers J. Robinson & Sons and Franz Baum also considered taking the light; see company board meeting notes for October 27, 1885, and September 16, 1886 (SCLC 1885–8).

98 See, for example, "Notes," editorial, *Electrician* 28, no. 703 (November 6, 1891): 1.

99 Company board meeting notes for October 20, 1885, record that Thornhill, Café Royal, Regency Club, and Brown's Hotel were tested together (SCLC 1885–8).

100 Company board meeting notes record other early adopters, including St. George's Hanover Square Church (October 6, 1885);

Putney's Hotel and the Bristol Hotel (November 13, 1885); the Hanover Square Club (October 2, 1885), the Isthmian Club (November 13, 1885), and the Royal Yacht Club (June 1, 1886).

101 Mackenzie responding to Gibbs, quoted in *Society of Engineers Transactions for 1885*, 60.

102 "The Millais Exhibition at the Grosvenor Gallery," *Pall Mall Gazette*, January 1, 1886, 11; "Our Ladies' Column," *Bristol Mercury and Daily Post*, January 9, 1886, 6; "Grist to the Millais at the Grosvenor," *Punch* 90 (January 9, 1886): 13. See also J. Munro, "Correspondences Speciales de l'étranger: Angleterre," *La Lumière Électrique* XXI, no. 38 (September 18, 1886): 570–1.

103 "Girls' Gossip," *Truth* XIX, no. 471 (January 7, 1886): 26.

104 Advertisements noted that the gallery directors were keeping the Grosvenor open late "in compliance with a widely expressed desire"; see, for example, *The Times*, January 26, 1886, 1.

105 "Notes on Current Events," *British Architect* 25, no. 3 (January 15, 1886): 30; "Electric Lighting," *Daily News* (London), January 11, 1886, 3; Professor George Forbes, "Some Points in Electrical Distribution," paper read before the Society of Arts, February 19, 1886, reprinted in *Electrician* 16 (February 26, 1886): 316.

106 Preece, May 19, 1886, testimony before the Select Committee of the House of Lords on the Electric Lighting Act (1882) Amendment Bills, *Sessional Papers* (1886), vol. VII, 218–19.

107 "Echoes from the West-End," *Electrician* 16 (March 5, 1886): 335; Forbes, "Some Points in Electrical Distribution," 316. Forbes insisted, however, that most of the gallery's customers were satisfied.

108 R. E. B. Crompton argued, in promoting his own battery system, "that with the alternating transformer system, as at present arranged, they [Grosvenor customers] were very greatly dependent on what their neighbour did, and that accidents to their neighbour's transformer affected an innocent person several blocks off in a way that could not happen with the direct system by distribution carried on from a series of accumulating or storage centers"; see "The Society of Telegraph-Engineers and Electricians: Alternate Current Transformers," *Electrician* 20, no. 511 (March 2, 1888): 443.

109 "Secondary Generators or Transformers," editorial, *Telegraphic Journal and Electrical Review* 18, no. 439 (April 23, 1886): 367.

110 "Transformers," editorial, *The Telegraphic Journal and Electrical Review* 22, no. 535 (February 24, 1888): 185, recalling the faults in the Gaulard/Gibbs system.

111 Ferranti's innovations would lead to patent disputes with the National Co. and their Gaulard/Gibbs system (and Ferranti's alterations to it) by June 1886. New adjustments by Ferranti seem to have solved some but not all of the problems by year's end, when an anonymous employee of a lighted hotel complained that the lights go out frequently; see "The Grosvenor Gallery Installation," *Telegraphic Journal and Electrical Review* 19, no. 475 (December 31, 1886): 646.

112 Sir Coutts Lindsay & Co. engineer Mackenzie later recalled that in his time with the company, "he [had] known as many as eight houses plunged into darkness owing to the short circuits occurring between the gas fittings and the electric wires in the first and last of these houses;" see "The Society of Telegraph Engineers and Electricians Discuss the Alternating System," *Electrician and Electrical Engineer* 7, no. 76 (April 1888): 177.

113 G.W.S., "Art in London," *New-York Tribune*, June 6, 1886, 11.

114 See reports of Frederic Leighton's address to the Academy such as the one given in the *Standard*, May 8, 1886, 5.

115 "Grosvenor Gallery," *The Times*, May 2, 1881, 10.

116 Statham, "The Grosvenor Gallery," 118.

117 See "Art: New Art Gallery," *Examiner* 5363 (May 13, 1876): 550; "From Our London Correspondent," *Manchester Guardian*, March 29, 1877, 5; "The Grosvenor Gallery Exhibition," 583; and Atkinson, "The Grosvenor Gallery," 99.

118 "Olla Podrida," *St. James's Magazine* 4, no. 31 (1877): 715; "The

Royal Academy," *Saturday Review* (London) 43, no. 1130 (June 23, 1877): 767.

119 William Michael Rossetti, "The Grosvenor Gallery," *Academy* 11, no. 264 (May 5, 1877): 396.

120 See, for example, "The Grosvenor Exhibition," *Athenaeum* 3000 (April 25, 1885), 541; "The Grosvenor Gallery," *British Architect* 23, no. 19 (May 8, 1885): 219–20. For more positive responses, see "The Grosvenor Gallery," *Leeds Mercury*, April 28, 1885, 8; "The Picture Exhibitions," *Bell's Life in London*, April 28, 1885, 4; and George Bernard Shaw, "Art," *Our Corner* 5 (June 1885): 375.

121 "The Grosvenor Gallery," *Daily News* (London), April 27, 1885, 3.

122 Ibid.; "The Grosvenor Gallery," *Glasgow Herald*, April 27, 1885, 9.

123 "The Grosvenor Gallery," *Aberdeen Weekly Journal*, April 27, 1885, 6.

124 The real danger of influence may be found in allowing this discourse to migrate uncritically into our own. Titling a major recent traveling exhibition of Aesthetic material, *The Cult of Beauty* (Victoria and Albert Museum, London/Fine Arts Museums of San Francisco, 2011–12), marked only the latest prominent example of this tendency.

125 For an announcement of one of Hallé's concerts, see *The Times*, April 20, 1882, 1.

126 See company board meeting entry for April 2, 1886 (SCLC 1885–8); and "Concerts," *Orchestra* 22, no. 549 (April 2, 1874): 4.

127 See Charlotte Gere, *Artistic Circles: Design & Decoration in the Aesthetic Movement* (London: V&A Publishing, 2010), 119; Caroline Dakers, *The Holland Park Circle: Artists and Victorian Society* (New Haven and London: Yale University Press, 1999), 137; Asleson, *Albert Moore*, 125–6; Barbara Bryant, "The Grosvenor Gallery, Patronage, and the Aesthetic Portrait," in *The Cult of Beauty: The Aesthetic Movement 1860–1900*, ed. Stephen Calloway and Lynn Federle Orr, exh. cat. (London: V&A Publishing, 2011), 164; and Esme Whittaker, "Leighton and Aitchison," in *The Cult of Beauty*, 118–19.

128 See company board meeting entry for September 16, 1886 (SCLC 1885–8), which records estimate "for installing 42 10 cp and 2 20 cp lamps in their basements at Nos. 222 and 218 Regent St" and "136 10 cp and 105 20 cp lamps at their premises in Regent St. and Warwick St."

129 See company board meeting entries for October 14, 1886, and November 20, 1886 (SCLC 1885–8).

130 T. Raffles Davison, "Artistic Dress at Liberty's," *British Architect* 26, no. 22 (November 26, 1886): 482.

131 *"Liberty" Art (Dress) Fabrics & Personal Specialities, East India House, 218–222, Regent Street, W.* (London: Liberty & Co. [1886]), 3. A similar range is given in their Liberty Velveteen, as discussed by the *Gentlewoman*, September 24, 1892, reprinted in *"Liberty" Yule-Tide Gifts* (London: Liberty & Co., 1892), 31. Both catalogs consulted on microfilm at the National Art Library, Victoria and Albert Museum, London.

132 In a previous essay touching on some of these topics in 2011, I mistakenly stated that W. A. S. Benson was definitively connected to the Grosvenor Gallery network. I have since discovered that while this may have been possible, the "Benson" referred to in the Sir Coutts Lindsay & Co. board meeting entries for October 30 and November 20, 1886, was actually J. B. Benson, of Benson's Bond Street Novelties, at 25 Old Bond-Street W. (SCLC 1885–8). My original statement appears in "Whistler, Aestheticism, and the Networked World," in *Palaces of Art*, 155.

133 Benson constructed metal models from which Burne-Jones painted armor and other accessories in such Grosvenor compositions as *King Cophetua and the Beggar Maid* (with Benson himself modeling for the king) and several panels in the *Perseus* series. Burne-Jones first saw Benson's sister Margaret at a Wagner performance in 1877, and pursued her as the model for his Medusa in the *Perseus* series; see Martin Harrison and Bill Waters, *Burne-Jones* (London: Barrie and

Jenkins, 1973), 113; and Avril Denton, "W. A. S. Benson: A Biography," in *W. A. S. Benson: Arts and Crafts Luminary and Pioneer of Modern Design*, ed. Ian Hamerton, exh. cat. (Woodbridge: Antique Collectors' Club, 2005), 48–9. Denton provides an overview of Burne-Jones and Benson's early collaborations, including an 1878 piano case and expansion of Burne-Jones's home at Rottingdean. Peter Rose goes further, arguing that Benson's work for Burne-Jones may have inspired his commercial metalwork in new directions; see Rose, "W. A. S. Benson: A Pioneer Designer of Light Fittings," *Journal of the Decorative Arts Society 1850–the Present*, no. 9: "Aspects of British Design 1870–1930" (1985): 51.

134 Rose, "W. A. S. Benson"; A. H. Church, "Benson's Lamps," *Portfolio* 21 (1890): 19; "Lamp-Making as a Learned Profession," *Pall Mall Budget* XXXV, no. 1004 (December 22, 1887): 19–20.

135 "Lamp-Making as a Learned Profession," 19–20. Rose quotes an advertisement first published in W. Shaw, ed., *The British Home of Today* (London: Hodder & Stoughton, 1904), in which Benson's shop is described as lighted "with that modulation and gradation which is indispensable to an artistic effect"; see Rose, "W. A. S. Benson," 55.

136 W. A. S. Benson, *Notes on Some of the Minor Arts* (London: self-published, 1883), 6–7. This 1883 handbook featured designs for oil and gas, and said nothing explicitly about electric lighting. A full-scale discussion of the challenges of electric lighting is featured his *Notes on Electric Wiring and Fittings* (London: self-published, 1897).

137 Stephen Ponder, *Wightwick Manor and Gardens* (London: National Trust, 1993), 35.

138 For more on Standen, a country house designed by Philip Webb for the Beale family 1891–4, see Mark Girouard, "Standen, Sussex – I," *Country Life* 147, no. 3808 (February 26, 1970): 494–7, and "Standen, Sussex – II," *Country Life* 147, no. 3809 (March 5, 1970): 554–7; and Arthur Grogan, *Standen, Sussex* (London: National Trust, 1977). On electric lighting at Standen, see Maureen Dillon, *Artificial Sunshine: A Social History of Domestic Lighting* (London: National Trust, 2002), Chapter 6; and Abigail Harrison Moore and Graeme Gooday, "Decorative Electricity: Standen and the Aesthetics of New Lighting Technologies in the Nineteenth Century Home," *Nineteenth-Century Contexts* 35, no. 4 (2013): 363 83.

139 "The Grosvenor Gallery, First Notice," *Standard*, May 2, 1887, 2.

140 Amy Woodson-Boulton notes the clustering of these openings, though she does not connect that history to that of the Grosvenor; see Woodson-Boulton, *Transformative Beauty: Art Museums in Industrial Britain* (Stanford: Stanford University Press, 2012), 12.

141 "Art in Manchester," *The Times*, September 26, 1878, 4.

142 "Art Notes," *Liverpool Mercury*, January 21, 1884, 5; "The Permanent Collection at the Walker Art Gallery," *Liverpool Mercury*, January 17, 1885, 6.

143 "Art Notes," *Liverpool Mercury*, July 16, 1884, 5; "Art in September," *Magazine of Art* 7 (1884): xlvii.

144 Edward Morris and Timothy Stevens, *History of the Walker Art Gallery, Liverpool, 1873–2000* (Bristol: Sansom & Co., 2013), Chapter 1.

145 See "Art Notes," *Liverpool Mercury*, July 16, 1884, 5. For complaints see, for example, "Art Chronicle," *Portfolio* 15 (January 1884): 204; and "Notes on Current Events," *British Architect* 18, no. 13 (September 29, 1882): 459.

146 For the hope that it would become an annual feature, see Lindsay's unsigned letter soliciting support for the project dated July 1886 and held in the Coutts Lindsay papers, National Library of Scotland, Edinburgh, 87/1. For "Intercolonial Grosvenor Gallery," see *Times of India*, January 25, 1887, 5.

147 "Art at the Antipodes," *Artist*, May 1, 1887, 156–7; *Newcastle Courant* no. 11088 (July 22, 1887): 2.

148 Alison Inglis, "Empire of Art: The Grosvenor Gallery Intercolonial Exhibition, Melbourne, 27 October 1887–7 January 1888,"

in *The Victorian World*, ed. Martin Hewitt (London: Routledge, 2012), 598.

149 Lindsay, July 1886 letter, as cited in note 146.

150 Inglis, "Empire of Art," 598–9.

151 Lindsay, July 1886 letter (emphasis added).

152 "Literature and Art," *Nottingham Post*, October 30, 1890, 4. The *Pall Mall Gazette* was quick to point out that his idea had been suggested before, a "Circulating Picture Loan Society" "on the principle of Mudie's library"; see "Art Notes," *Pall Mall Gazette*, November 12, 1890, 1.

153 "The Man About Town," *County Gentleman* XXV, no. 1287 (January 8, 1887): 39; F.F.-M. [Florence Fenwick-Miller], "The Ladies' Column," *Illustrated London News* XC, no. 2490 (January 8, 1887): 37.

154 "Our Ladies' Column," *Leicester Chronicle* 77, no. 3960 (January 8, 1887), supplement 1.

155 "The Swan United Electric Light Company, Limited," *Electrician* 18 (February 25, 1887): 361.

156 See company board meeting notes, February–March 1887 (SCLC 1886–8).

157 See House of Commons testimony in *Hansard Parliamentary Debates*, 3rd ser., vol. 319 (1887), col. 1587.

158 By late 1886 or early 1887, the company was controlling nine miles of circuits; see Killingsworth W. Hedges, "Central-Station Electric Lighting," *Institution of Civil Engineers Minutes of Proceedings* 88 (1887), 397.

159 "The Dangers of Electric Lighting," *Telegraphic Journal and Electrical Review* 20, no. 477 (January 14, 1887): 21; "Fatal Accident at Grosvenor Gallery," *Telegraphic Journal and Electrical Review* 20, no. 478 (January 21, 1887): 57.

160 Bruno Latour writes of "accidents, breakdowns, and strikes" as situations in which, "all of a sudden, completely silent intermediaries become full-blown mediators"; see Latour, *Reassembling the Social: An Introduction to Actor-Network-Theory* (Oxford: Oxford University Press, 2005), 81. See also Bill Brown, "Thing Theory," *Critical Inquiry* 28, no. 1 (autumn 2001): 3–4; Bjornar Olsen, "Material Culture after Text: Re-Membering Things," *Norwegian Archaeological Review* 36, no. 2 (2003): 96; and Jorg Kreienbrock, *Malicious Objects, Anger Management, and the Question of Modern Literature* (New York: Fordham University Press, 2012).

161 See Latour, *Reassembling the Social*, part I, especially p. 31.

162 G.W.S., "A Three-Cornered Fight," *Chicago Daily Tribune*, May 5, 1887, 1.

163 "The Man About Town," *County Gentleman* XXV, no. 1305 (May 14, 1887) 655.

164 "Our London Correspondence," *Glasgow Herald*, March 21, 1888, 7.

165 Infamously, Lindsay's first autumn show was dedicated entirely to Vassili Verestchagin, Russian painter of bombastic and bloody war and religious scenes. The gallery was redecorated with electrically illuminated Orientalist bric-a-brac; see *London and Brighton*, November 2, 1887, 5; "The Man About Town," *County Gentleman* XXV, no. 1329 (October 29, 1887): 1447. The *Artist* joked that people were likely to mistake the Grosvenor display for an exhibition of carpets (perhaps Liberty's?); see *Artist and Journal of Home Culture* VIII, no. 95 (November 1, 1887): 356.

166 The first mention of the new concern appears in the company board meeting notes for August 19, 1887 (SCLC 1886–8); Sir Coutts Lindsay & Co. resolves to wind up on December 19, 1887 (SCLC 1886–8).

167 See program for *The Churchwarden* at Terry's Theatre, October 17, 1887, Bodleian Library, University of Oxford, John Johnson Collection: London Playbills Surrey-Tivoli (55).

168 See, for example, "Terry's Theatre," *Morning Post*, October 18, 1887, 5.

169 Mrs. Humphry, "Social Echoes," *London Society* 52, no. 311 (November 1887): 622.

170 *Telegraphic Journal and Electrical Review* 21, no. 517 (October 21, 1887): 406.

171 Ibid., December 2, 1887, 566.

172 See their letter to the editor, published in *The Times* and elsewhere, November 2, 1887, 9.

173 Burne-Jones to Hallé, October 3, 1887, reprinted in *The Times*, January 27, 1888, 9 (and elsewhere).

174 Hallé to Coutts Lindsay, reprinted in "The Grosvenor Gallery Quarrel," *Daily News* (London), January 26, 1888, 6.

175 "The Truth about the Grosvenor 'Split': An Interview with Sir Coutts Lindsay," *Pall Mall Gazette*, November 3, 1887, 1.

176 "Two Grave Controversies," *Nation* 45, no. 1173 (December 22, 1887): 502.

177 "British Art at the Grosvenor Gallery," *The Times*, second notice, January 14, 1888, 15; "The Man About Town," *County Gentleman* XXVI, no. 1341 (January 21, 1888): 103.

178 "The Man About Town," *County Gentleman* XXVI, no. 1344 (February 11, 1888): 171.

179 Ibid., no. 1346 (February 25, 1888): 244.

180 "The New Gallery," *Royal Cornwall Gazette* no. 4425 (May 17, 1888): 6.

181 "Electric Light and the Stuart Exhibition," *Telegraphic Journal and Electrical Review* 24, no. 580 (January 4, 1889): 13.

182 "The Grosvenor Exhibition of Pastel Pictures," *Athenaeum* 3183 (October 27, 1888): 560; "Pastels," *Sporting Times* 1310 (October 27, 1888): 2.

3 TRANSATLANTIC AESTHETICISM

1 "Current Notes," *Boston Journal*, February 27, 1885, 2; see also "One Ahead," *Detroit Free Press*, February 22, 1885, 17; and "Almost an Even Exchange," *Star Tribune* (Minneapolis), March 8, 1885, 6, which attributes the anecdote to the Toronto *Globe*.

2 Jan van Dijk, *The Network Society*, 2nd edn. (London: Sage, 2006), 187.

3 See especially the exhibition catalogs *In Pursuit of Beauty: Americans and the Aesthetic Movement* (New York: Rizzoli for the Metropolitan Museum of Art, 1986); *Candace Wheeler: The Art and Enterprise of American Design 1875–1900* (New York: Metropolitan Museum of Art, 2001); and Stephen Calloway and Lynn Federle Orr, eds., *The Cult of Beauty: The Aesthetic Movement 1860–1900* (London: V&A Publishing, 2011), which highlighted some American objects not included in the catalog.

4 See, in addition to the exhibition catalogs cited above, Mark Girouard, "Queen Anne in America," in *Sweetness and Light: The Queen Anne Movement, 1860–1900* (Oxford: Clarendon Press, 1977); David Scobey, "What Shall We Do with Our Walls? The Philadelphia Centennial and the Meaning of Household Design," *European Contributions to American Studies* 27 (January 1, 1994), 87–120; Sylvia Yount, "'Give the People What They Want': The American Aesthetic Movement, Art Worlds, and Consumer Culture" (PhD diss., University of Pennsylvania, 1995).

5 For the "mission," see (among others) "The Commercial Value of an Aesthete," *New York Herald*, January 4, 1882, 6.

6 "The Charlatan's Welcome," *Springfield Republican*, February 9, 1882, 4; see also "An Aesthetic Pretender," *Art Amateur* 6, no. 3 (February 1882): 48.

7 See (among others) Jonathan Freedman, *Professions of Taste: Henry James, British Aestheticism, and Commodity Culture* (Stanford: Stanford University Press, 1990); and David M. Friedman, *Wilde in America: Oscar Wilde and the Invention of Modern Celebrity* (New York: W. W. Norton & Co., 2014).

8 See "The Commercial Value of an Aesthete," *New York Herald*, January 4, 1882, 6; "Oscar Wilde's Visit," *Detroit Free Press*, February 14, 1882, 4; and *Boston Daily Advertiser*, January 4, 1882, 4.

9 Detailed accounts of this American exhibition venture can be found in William Michael Rossetti, *Ruskin, Rossetti, Preraphaelitism: Papers 1854–1862* (New York: Dodd, Mead, and Company, 1899), 178–96; Rossetti, *Some Reminiscences of William Michael Rossetti*, 2 vols. (London: Brown, Langham & Co. Ltd., 1906), 1:264–8; David Howard Dickason, *The Daring Young Men* (Bloomington: Indiana University Press, 1953), Chapter 6; Roger W. Peattie, *Selected Letters of William Michael Rossetti* (University Park: Pennsylvania State University Press, 1990), 82–100; and Susan P. Casteras, *English Pre-Raphaelitism and its Reception in America in the Nineteenth Century* (London: Associated University Presses, 1990), Chapter 3. After the New York exhibition closed in December 1857, it was augmented with additional pictures forwarded by Rossetti and sent to Philadelphia's Pennsylvania Academy of Fine Arts (February 3–March 20, 1858), before traveling to the Boston Athenaeum (April 5–June 1858); see Casteras, *English Pre-Raphaelitism*, 51.

10 See Rossetti to William Bell Scott, April 8, 1857, reprinted in Peattie, *Selected Letters*, 82, as well as the exhibition prospectus issued by Rossetti, which was republished in various abridged and unabridged versions in British newspapers and periodicals, and was enclosed with a letter to Charles Eliot Norton, July 15, 1857, reprinted in Peattie, *Selected Letters*, 86–9.

11 For opening a channel of communication, see "Proposed Exhibition of British Art in New York," *Critic* (London) 16, no. 390 (July 1, 1857): 301; and "Foreign Art: The Exhibitions of the British and French Paintings in New York," *New York Times*, November 7, 1857, 2. See also "Our Window," *Putnam's Monthly Magazine* 10, no. 57 (September 1857): 420. Even Rossetti's promotional materials framed the exhibition not as a joining of wires or hands, but as a joining of blood; see prospectus reprinted in Peattie, *Selected Letters*, 87.

12 P., "Sketchings," *Crayon* 5, no. 9 (September 1858): 266.

13 As one British author complained, "The isolated scraps in which the main items of intelligence reach the Old World … are very apt to puzzle all but the well-informed, and … discourage efforts necessary to obtain a comprehensive view of American affairs"; see "America," *Illustrated London News* 1445 (September 14, 1867): 277.

14 "Foreign Art," 2.

15 On this incident, see Rossetti, *Some Reminiscences*, 1:266; Mrs. Russell Barrington, *Life, Letters and Work of Frederic Leighton*, 2 vols. (London: G. Allen, 1906), 2:46, cited in Casteras, *English Pre-Raphaelitism*, 54 and 195, note 59. For the creation and exhibition of these canvases, see *Frederic, Lord Leighton: Eminent Victorian Artist*, exh. cat. (New York: Harry N. Abrams, 1996), 109.

16 Attempting to mitigate this risk, Ruskin and Rossetti insured the pictures with a £50,000 fund against "contingencies"; see "Talk of the Studios," *Critic* (London) 16, no. 390 (July 1, 1857): 302, quoting the *Builder*.

17 "Fine Arts: Professed Exhibition of British Art, Academy of Design," *Frank Leslie's Illustrated Newspaper* 4, no. 101 (November 7, 1857): 358. For further suspicions of the salesroom, see "British and French Art in New York," *Knickerbocker* 51, no. 1 (January 1858): 52.

18 Ruxton to Rossetti, September 29, 1857, quoted in Peattie, *Selected Letters*, 88, note 3.

19 See (among others) "Loss of the Central America," *New-York Tribune*, September 18, 1857, 5.

20 Ruxton to Rossetti, September 29, 1857, reprinted in Rossetti, *Ruskin, Rossetti, Preraphaelitism*, 180.

21 See Mira Wilkins, *The History of Foreign Investment in the United States to 1914* (Cambridge, Mass.: 1989), 49–53, 94–101.

22 E. J. Hobsbawm, *The Age of Capital, 1848–1875* (London: Weidenfeld and Nicolson, 1975), 85–6.

23 See Ruxton to Rossetti, August 1858–November 1861, excerpted in Peattie, *Selected Letters*, 99, note 2.

24 These were *The Second Exhibition in New York of Paintings, the Contributions of the Artists of the French and English Schools*, National Academy of Design, New York (1859); *The Third Annual Exhibition of French and Flemish Pictures*, Goupil's, New York (1860); *The Fourth Exhibition of French, Flemish, and English Pictures*, Tenth Street Studio Building, New York, 1865; and *English and Continental Art*, Tenth Street Studio Building, New York, 1866. For more on Gambart, see Pamela M. Fletcher, "Creating the French Gallery: Ernest Gambart and the Rise of the Commercial Art Gallery in Mid-Victorian London," *Nineteenth-Century Art Worldwide* 6, no. 1 (spring 2007), unpaginated.

25 "Fine Arts," *New-York Tribune*, December 22, 1866, 11. See also "Art in London," *New-York Tribune*, August 12, 1869, 2.

26 For English engravings available in America, see "Fine Emporiums this Winter," *Round Table* 1, no. 3 (January 2, 1864): 44. On gallerists William Schaus and Michael Knoedler, see Malcolm Goldstein, *Landscape with Figures: A History of Art Dealing in the United States* (Oxford: Oxford University Press, 2000), Chapters 3 and 4.

27 A version of Hunt's sketch for the *Light of the World* was included in the *American Exhibition of British Art* of 1857–8 and was sold to John Wolfe; see Rossetti to Hunt, February 23 [1858], reprinted in Peattie, *Selected Letters*, 95–6. On the New York exhibition of a duplicate of Frith's *Derby Day*, see "Fine Arts," *Albion* 41, no. 29 (July 18, 1863): 345.

28 "The New World's Fair," *New-York Tribune*, May 10, 1876, 5.

29 See S.N.C., "Art at the Exhibition," *Appletons' Journal* XV, no. 376 (June 3, 1876): 724–5; and "The Century – Its Fruits and Its Festival: X – Art," *Lippincott's* 18 (October 1876): 393–403.

30 "The New World's Fair," *New-York Tribune*, May 10, 1876, 5.

31 "The Exhibition: English Contributions to the Fine Art Department," *Boston Daily Advertiser*, May 25, 1876, 1.

32 Watrous, "Art at the Centennial," *San Francisco Bulletin*, October 26, 1876, 1. See also C.C., "Features of the Fair," *New-York Tribune*, October 21, 1876, 3. The French, having deprived themselves of their Luxembourg Museum pictures for the Vienna Exposition of 1873, had been unwilling to part with them again; others feared destruction at sea; see William M. F. Round, "Art at the Exposition," *Independent* 28, no. 1436 (June 8, 1876): 12.

33 "Gar," "The English Art Display," *New York Times*, May 25, 1876, 1.

34 See Robert W. Rydell, *All the World's a Fair: Visions of Empire at American International Expositions, 1876 1916* (Chicago: University of Chicago Press, 1984), Chapter 1.

35 Philip Quilibet [George Edward Pond], "Art and the Centenary," *Galaxy* 19 (May 1875), reprinted in Sarah Burns and John Davis, eds., *American Art to 1900: A Documentary History* (Berkeley: University of California Press, 2009), 740.

36 Ibid., 741.

37 Henry Blackburn, "Black and White," *Athenaeum* 2346 (October 12, 1872): 473 (original emphasis). For more on Blackburn and the history of illustration, see Gerry Beegan, *The Mass Image: A Social History of Photomechanical Reproduction in Victorian London* (Basingstoke: Palgrave Macmillan, 2008), 111. For the evolution of photomechanical reproduction techniques, see Beegan, *The Mass Image*, Chapters 3 and 4; and James Mussell, *The Nineteenth-Century Press in the Digital Age* (Basingstoke: Palgrave Macmillan 2012), Chapter 2.

38 "Exhibition of Sketches of All Nations," *New-York Times*, November 29, 1872, 5.

39 See Henry Blackburn, letter to the editor of the *Standard*, November 4, 1872, 5; Blackburn, "The Coming Water-Color Exhibitions," letter to the editor of the *New-York Tribune*, February 3, 1873, 5; *Boston Daily Globe*, March 4, 1873, 1; and "Exhibition of Sketches of All Nations," *New York Times*, November 29, 1872, 5.

40 "Fine Arts," *Nation* 16, no. 399 (February 20, 1873): 137; see also "Glances at the Water-Color Exhibition," *New-York Tribune*, February 21, 1873, 2.

41 "The Coming Water-Color Exhibition," *New-York Tribune*, February 1, 1873, 12.

42 "Scraps," *Graphic* (London) 7, no. 178 (April 26, 1873): 9.

43 Compare Blackburn, "The Coming Water-Color Exhibitions," 5, and Henry Blackburn, "American Exhibitions of English Water Colors and Sketches," *Athenaeum* 2383 (June 28, 1873): 829–30.

44 For "short-hand," see Henry Blackburn, "The Art of Popular Illustration," lecture delivered at Thirteenth Ordinary Meeting of the Royal Society, London, March 10, 1875, reprinted in *RSA Journal* 23 (March 12, 1875): 371. For this shift in his illustration practice, see his introduction to *Academy Notes* (London: Chatto & Windus, 1876), 3.

45 Henry Blackburn, *English Art in 1884* (New York: D. Appleton and Company, 1885), viii.

46 Ibid., x.

47 It is clear that Blackburn's fascination with rapid visual notation aligns with the contemporary interest in shorthand transcription, as explored in relation to Whistler's etchings by Caroline Arscott, "Stenographic Notation: Whistler's Etchings of Venice," *Oxford Art Journal* 29, no. 3 (2006): 371–93.

48 See "Personal," *New-York Tribune*, December 7, 1875, 4.

49 See "An Author, Artist, and Critic," *Chicago Tribune*, February 10, 1887, 8. A version of this process was demonstrated at the Paris Electrical Exhibition of 1881; see K. G. Beauchamp, *Exhibiting Electricity*, IEE History of Technologies Series 21 (London: Institution of Electrical Engineers, 1997), 165.

50 On Blackburn and middlemen, see also G.W.S. [George W. Smalley], "Notes from London," *New-York Tribune*, January 31, 1874, 3. Here I am also thinking about the fantasy of lossless transmission entertained by colonial North American residents as discussed by Jennifer Roberts in *Transporting Visions: The Movement of Images in Early America* (Berkeley: University of California Press, 2014), Chapter 2. The hopes and anxieties with which Blackburn is struggling here regarding what and how the visual can communicate should also be understood in relation to Aestheticism's aspirations toward "unmediation" as discussed by David Peters Corbett in *The World in Paint: Modern Art and Visuality in England, 1848–1914* (University Park: Pennsylvania State University Press, 2004), Chapter 2.

51 Blackburn, paraphrasing Burne-Jones's wishes, in *English Art in 1884*, 141.

52 Blackburn delivered four stereopticon lectures in 1883 on "Modern Art and Artists" at the Boston Art Club, moving on to Boston's Chickering Hall in December, followed by the Art Society of Worcester, Massachusetts, and New York's National Academy of Design in January. On Blackburn's social network in the vicinity of London's Fitzroy Square, see Robyn Asleson, *Albert Moore* (London: Phaidon, 2000), 88.

53 "Pictures of the Year," *Boston Daily Advertiser*, December 4, 1883, 8. Blackburn had already included versions of these remarks in British publications and lectures; see "English Art in 1883," *National Review* 2, no. 7 (September 1883): 50, and "Local and District News: Pictures of the Year," *Gloucester Citizen*, October 24, 1883, 3. In America, his Millais anecdote was reprinted in "Mr. Blackburn's Ideas About Art," *New York Times*, January 27, 1884, 2; "The Studio: Notes and News," *Art Interchange* 12, no. 3 (January 31, 1884): 29; "Art and Letters," *Brooklyn Union*, February 7, 1884, 2.

54 On the changing American art tariff in the late nineteenth century, see Kimberly Orcutt, "Buy American? The Debate over the Art Tariff," *American Art* 16 (autumn 2002): 82–91; and Robert E. May, "Culture Wars: The U.S. Art Lobby and Congressional Tariff Legislation during the Gilded Age and Progressive Era," *Journal of the Gilded Age and Progressive Era* 9, no. 1 (January 2010): 37–91.

55 "Personal," *Harper's Weekly* 28, no. 1419 (March 1, 1884) 135.

56 On Cottier, see *In Pursuit of Beauty*, especially Catherine Hoover Voorsanger's biographical entry for Daniel Cottier, pp. 414–16; Max Donnelly, "Daniel Cottier, Pioneer of Aestheticism," *Journal of the Decorative Arts Society* 23 (1999): 32–51; and Donnelly, "Cottier and Company, Art Furniture Makers," *Magazine Antiques* 159, no. 6 (June 2001): 916–25.

57 "Jonathan's Lesson to John," *Punch* 64 (April 5, 1873): 139.

58 See Dwayne Winseck, "Submarine Telegraphs, Telegraph News, and the Global Financial Crisis of 1873," *Journal of Cultural Economy* 5, no. 2 (2012), 197–212.

59 Charles Locke Eastlake, *Hints on Household Taste* (London: Longmans & Co., 1868), 82. Eastlake's influence in the United States has been examined by Mary Jean Smith Madigan, "The Influence of Charles Locke Eastlake on American Furniture Manufacture, 1870–90," *Winterthur Portfolio* 10 (1975): 1–22; and Marilynn Johnson, "Art Furniture: Wedding the Beautiful to the Useful," in *In Pursuit of Beauty*, 142–75.

60 "Art Matters," *New York Herald*, January 13, 1874, 5; and "Art Matters," *New York Herald*, January 28, 1874, 4.

61 A list of photographs is given in "Art Matters," *New York Herald*, January 13, 1874, 5, and includes Albert Moore's *The Quartette* (the example that appears in figure 59 dates from a later moment). Although the *Herald* does not identify the photographer, the bulk if not the whole of this inventory was likely produced by Frederick Hollyer, whose later catalogs contain most of these titles; see, for example, *Catalogue of Platinotype Reproductions of Pictures &c. Photographed and Sold by Mr. Hollyer No. 9 Pembroke Sqr. London W.* (London: Frederick Hollyer and Frederick T. Hollyer, 1902). On Hollyer, see Martin Barnes, "Frederick Hollyer," in *Encyclopedia of Nineteenth-Century Photography*, ed. John Hannavy, 2 vols. (New York: Taylor and Francis, 2008), 1:710–12; and Alicia Craig Faxon, "Rossetti's Reputation: A Study of the Dissemination of his Art through Photographs," *Visual Resources* 8 (1992): 219–45.

62 "The Arts," *Appletons' Journal* 14, no. 343 (October 16, 1875): 506.

63 See Kathy Alexis Psomiades, *Beauty's Body: Femininity and Representation in British Aestheticism* (Stanford: Stanford University Press, 1997); and Katherine C. Grier, *Culture & Comfort: Parlor Making and Middle-Class Identity, 1850–1930* (Washington, D.C.: Smithsonian Institution Press, 1997).

64 American reviewers believed Eastlake's book would prevent people (frequently, but not only, women) from blindly following fashion. See (among others) the review of *Hints on Household Taste* published in the *New York Evangelist* 43, no. 46 (November 14, 1872): 1.

65 See, for example, "Art in Our Homes and Schools," *Scribner's Magazine* 5, no. 4 (February 1873): 513; and "An Exhibition of Decorative Art," *Scribner's Magazine* 10, no. 4 (August 1875): 518. An alternative view held that American taste could not be raised until its residents had already been surrounded by improved household goods; see "Art, Music, and the Drama," *Appletons' Journal* 10, no. 227 (July 26, 1873): 123.

66 See (among others) "Eastlake's Hints on Household Taste," *Every Saturday* (Boston), 3, no. 13 (March 29, 1873): 339–40; and W.H.W., "Fine Art," *Old and New* 8, no. 2 (August 1873): 243.

67 "New Books," *Detroit Free Press*, December 8, 1872, 5; "Cheap Work," *New York Commercial Advertiser*, January 7, 1869, 1.

68 Charles C. Perkins, "Editor's Preface," in Charles Locke Eastlake, *Hints on Household Taste* (Boston: J. R. Osgood & Co., 1872), vii.

69 Ibid., xi–xii.

70 Ibid., xiii.

71 Ibid., xiv.

72 Ibid., viii.

73 "Eastlake's 'Hints on Household Taste'," *American Builder and Journal of Art* 8/9 (January 1, 1873): 6–7.

74 "Current Literature," *Literary World* 3, no. 7 (December 1, 1872): 97.

75 See Madigan, "The Influence of Charles Locke Eastlake"; and Freedman, *Professions of Taste*, 105.

76 "8. Hints on Household Taste," *North American Review* 116, no. 238 (January 1873): 206; W.H.W., "Fine Art," 240; book review of Talbert, *Gothic Forms Applied to Furniture …*, *North American Review* 118, no.

242 (January 1874): 206. By 1874–5, furniture in the "Eastlake style, now so fashionable" was advertised for perusal and purchase at the rooms of C. J. Soyard, Boston (*Boston Post*, June 30, 1874, 3); as well as at Weber Furniture Co., Detroit (*Detroit Free Press*, March 4, 1875, 2); Mitchell & Rammelsburg Furniture Co., Cincinnati (*Cincinnati Daily Star*, March 9, 1875, 4); Warren Ward & Co., New York (*New York Evangelist* 46, no. 15 (April 15, 1875, 8); A. S. Herenden Furniture Co., Cleveland (*Ohio Farmer*, April 24, 1875, 265); Lang & Nau, Brooklyn (*Brooklyn Daily Eagle*, May 8, 1875, 4); and the Mitchell Furniture Co., St. Louis (*St. Louis Post-Dispatch*, October 16, 1875, 1).

77 "Household Art," *New York Times*, October 17, 1875, 10.

78 Predating Cottier's, Charles Wyllys Elliott's Household Art Company of Boston featured an international range of decorative items for the home, as well as items designed and constructed by him. Elliott's *Book of American Interiors* (Boston: J. R. Osgood & Co., 1876), which touts his achievements and importations in Boston, suggests the widespread interest in Eastlake in the United States. On Elliott, see "Art, Music, and the Drama," *Appletons' Journal* 10, no. 227 (July 26, 1873): 123; and Madigan, "The Influence of Charles Locke Eastlake," 7–8.

79 "Domestic Furniture: The Foundations of Good Taste," *Chicago Daily Tribune*, September 5, 1875, 7; see also W.H.W., "Fine Art," 241.

80 "Eastlake and his Ideas, I," *Art Amateur* 1, no. 6 (May 1880): 127.

81 *Punch's Almanack for 1875* (December 17, 1874), 7. For American circulation of the caption, see (among others) *Evening Telegram* (New York), April 19, 1875, 2.

82 On William Morris and the United States, see (among others) Roger B. Stein, *John Ruskin and Aesthetic Thought in America, 1840–1900* (Cambridge, Mass.: Harvard University Press, 1967); Elisabeth Aslin, *The Aesthetic Movement: Prelude to Art Nouveau* (New York: Praeger, 1969); and Eileen Boris, *Art and Labor: Ruskin, Morris, and the Craftsman Ideal in America* (Philadelphia: Temple University Press, 1986). The first reference to Morris's design business in America that I have seen occurred in 1867, when he was misleadingly identified as "a pattern drawer for manufacturers"; see "Personal," *Cincinnati Daily Gazette*, August 26, 1867, 4. This was corrected the following year; see "Foreign Literary Intelligence," *Book Buyer* 1, no. 4 (January 15, 1868): 2–3.

83 See, for example, "Current English Literature," *Galaxy* 11, no. 4 (April 1871): 606–9; "Recent Literature," *Atlantic Monthly* 3, no. 1 (March 1873), 359–60. For "prolix," see (among others) "The Poetry of William Morris," *Catholic World* 12, no. 67 (October 1870): 100.

84 Compare, for example, E. C. Stedman, "Latter-Day British Poets," *Scribner's Magazine* 9, no. 4 (February 1875): 435, and "New Publications," *New-York Tribune*, March 24, 1876, 6; also *Independent* 28, no. 1434 (May 25, 1876): 8.

85 "Literature," *Aldine* 6, no. 5 (May 1873): 108.

86 The first major American account of the Morris & Co. decorating firm –"connected with the so-called Pre-Raphaelite movement" – appears to have been published in "An English Art Enterprise," *Nation* 12, no. 296 (March 2, 1871): 139–40.

87 See "Personal," 4; Mary Clemmer Ames, "William Morris's 'Earthly Paradise,'" *Independent* 22, no. 1114 (April 7, 1870): 3; *Chicago Tribune*, August 6, 1871, 5; "William Morris," *Every Saturday* 2, no. 16 (October 19, 1872): 429; and "William Morris's New Poem," *San Francisco Bulletin*, January 25, 1873, 1. For dye-stained hands, see "Personal," *Detroit Free Press*, April 1, 1879, 5.

88 "The Poetry of William Morris," *Catholic World* 12, no. 67 (October 1870); 101; see also "Gossipy Paragraphs," *Detroit Free Press*, June 30, 1870, 3; and "Dante Gabriel Rossetti," *Christian Register* XLIX, no. 33 (August 13, 1870): 4.

89 R. H. Stoddard, "William Morris," *Appletons' Journal* 7, no. 169 (June 22, 1872): 675; "Literary Notes and Gleanings," *Fort Wayne Daily Gazette*, August 6, 1870, 2. On "influence," see also "William Morris," *Harper's Bazaar*, 6, no. 32 (August 9, 1873): 50; and "The 'William Morris Window,'" *Scribner's Magazine* 6, no. 2 (June 1873): 245.

90 See Moncure D. Conway, "Decorative Art and Architecture in England," *Harper's Monthly* 49, no. 293 (October 1874): 625–6; "A 'Designing' Poet," *Detroit Free Press*, October 26, 1873, 2; and "Letter from Boston," *Massachusetts Spy* 102, no. 18 (May 2, 1873): 3.

91 "A 'Designing' Poet," 2; "Dress," *Hartford Courant*, January 15, 1875, 1.

92 "Music, Art, and Business," *Christian Watchman* (Boston) 52, no. 41 (October 12, 1871): 5.

93 "The 'William Morris Window,'" 245. 1873; Moncure Conway, "Correspondence: London Letter," *Cincinnati Commercial*, August 11, 1873, 1; "Fine Arts: Catalogue of the Art Collection of the Cincinnati Exposition," *New-York Tribune*, October 31, 1873, 7.

94 Moncure D. Conway, "Decorative Art and Architecture in England," *Harper's Monthly* 50, no. 295 (December 1874): 45.

95 Clarence Cook, "Beds and Tables, Stools and Candlesticks: Some Chapters on House-Furnishing," *Scribner's Magazine* 10, no. 2 (June 1875): 179.

96 See "The Art-Furniture Fever," *Tinsley's Magazine* (London), 12 (July 1873): 648–52; reprinted in *Every Saturday* (Boston) 4, no. 9 (August 30, 1873): 249–51. See also "Art at Home," *Saturday Review* (London) 36, no. 947 (December 20, 1873): 777–8; excerpted and discussed in "Art," *Appletons' Journal* 11, no. 255 (February 7, 1874): 188; and "Thoughts of a Country Critic," *Cornhill Magazine* (London) 30, no. 180 (December 1874): 717–27; excerpted in *Littell's Living Age* 124, no. 1595 (January 2, 1875): 30, and elsewhere.

97 Justin McCarthy, "The Pre-Raphaelites in England," *Galaxy* 21, no. 6 (June 1876): 725.

98 Ibid. See also Bowman Blake, "The Medieval Mania," letter to the editor of the *New York Daily Graphic* (New York), May 4, 1876, 523.

99 "Sham Medieval Furniture," *American Architect and Building News* 1, no. 48 (November 25, 1876): 383. See also "Furniture at the Centennial," *Aldine* 8, no. 9 (May 1, 1877): 297.

100 On the Godwin vase, see Susan Weber Soros, "Plagiarism of Godwin's Designs," in *The Secular Furniture of E. W. Godwin* (New Haven and London: Yale University Press, 1999), 76–7.

101 See, for example, "The Drama in London," *Spirit of the Times* (New York) 98, no. 15 (May 19, 1877): 412.

102 Julian Hawthorne, "Artists of the Future," *New-York Tribune*, June 4, 1878, 2; Reay, "London," *Hartford Courant*, June 4, 1879, 1, "Sentimental Art," *Philadelphia Times*, July 3, 1878, 2.

103 "Can America Produce an Original Art?" *New York Times*, January 27, 1878, 6.

104 Philip Gilbert Hamerton, "English and American Painting at Paris in 1878, II," *International Review* 6 (May 1879): 558–9.

105 R.S., "The Paris Exposition – XV," *Nation* 27, no. 700 (November 28, 1878): 331–2.

106 E. F. S. Pattison, "The International Exhibition, Paris, 1878," *Academy* 14, no. 322 (July 6, 1878): 20–1.

107 Philip Gilbert Hamerton, "English and American Painting at Paris in 1878," *International Review* 6 (February 1879): 113.

108 "Decorative Painting – 'Poetry,' by Mr. Poynter," *Every Saturday* 1, no. 28 (July 9, 1870): 434.

109 Moncure D. Conway, "Decorative Art and Architecture in England," three-part series in *Harper's Monthly* (October–December 1874); S. G. W. Benjamin, "Contemporary Art in England," excerpt from *Contemporary Art in Europe* (New York: Harper, 1877), in *Harper's Monthly* 320, no. 54 (January 1877): 167–8.

110 Henry Adams identifies this as the dining room of Charles Freeland at 117 Beacon Street, Boston, in a home designed by Henry Van Brunt. The commission was abandoned due to illness in 1865, and taken up by Albion Bicknell. See Adams, "A Fish by John La Farge," *Art Bulletin* 62, no. 2 (June 1980): 270. On the exhibition at Cottier's, which would turn out to be foundational for the creation of the Society of American Artists two years later, see Jennifer A. Bienenstock, "The Formation and Early Years of the Society of

American Artists: 1877–1884" (PhD diss., City University of New York, 1983), 18–22.

111 Richard Watson Gilder, "Some Other Pictures," *Scribner's Magazine* 10, no. 2 (June 1875), 253.

112 E.S., "The International Exhibition," *Nation* 23, no. 579 (August 3, 1876): 72.

113 Mariana Griswold van Renssalaer, "Recent Pictures in New York," *American Architect and Building News* 5, no. 169 (March 22, 1879): 93; "Studies of the Artists," *New York Times*, February 5, 1879, 5. See also William M. F. Round, "Fine Arts: The Water Color Society," *Independent*, 31, no. 1579 (March 6, 1879): 9.

114 For announcement, see "The La Farge Paintings," *Boston Post*, December 17, 1879, 3; and "The La Farge Art Sale," *New York Times*, December 17, 1879, 5. For recent work on La Farge and the Aesthetic Movement, see Katie Kresser, *The Art and Thought of John La Farge: Picturing Authenticity in Gilded Age America* (Farnham: Ashgate, 2013).

115 Reay, "London," 1.

116 W. Mackay Laffan, "The Tile Club at Work," *Scribner's Magazine* 17, no. 3 (January 1879): 401–2. Laffan places this debate in early autumn 1877.

117 Ibid., 401. On the Tile Club, see Doreen Bolger Burke, "Painters and Sculptors in a Decorative Age," in *In Pursuit of Beauty*, 296–7; and Ronald G. Pisano, *The Tile Club and the Aesthetic Movement in America*, exh. cat. (New York: Harry N. Abrams, 1999).

118 "Correspondence: The Grosvenor Gallery, II," *American Art and Building News* 6, no. 195 (September 20, 1879): 93; "The Fine Arts," *Boston Daily Advertiser*, March 8, 1880, 2.

119 W.J.S., "The Paris Exposition – IX: American Painting," *Nation* 27, no. 692 (October 3, 1878): 210–11; S. G. W. Benjamin, "Present Tendencies of American Art," *Harper's Monthly* 58 (December 1, 1878): 491; H. C. Brunner, "The Society of American Artists," *Puck* 3 (March 27, 1878), 3.

120 On the founding of the Society of American Artists, see Bienenstock, "The Formation and Early Years of the Society," Chapter 1.

121 See "Scraps," *Graphic* (London) 21, no. 547 (May 22, 1880): 515; and William Sharp, "The Royal Academy and the Salon," *National Review* 9, no. 52 (June 1887): 520.

122 See Bienenstock, "The Formation and Early Years of the Society," 46–7; and de Kay, "Society of American Artists," *New York Times*, March 7, 1878, 4.

123 Mrs. Julian Hawthorne, "The Aesthetes," *Harper's Bazaar*, 14, no. 25 (June 18, 1881): 387 (original emphasis).

124 See (among others) Walter Hamilton, *The Aesthetic Movement in England* (London: Reeves and Turner, 1882), Introduction and 75–82; Roger Stein, "Artifact as Ideology: The Aesthetic Movement in its American Cultural Context," in *In Pursuit of Beauty*, 26; Sarah Burns, *Inventing the Modern Artist: Art and Culture in Gilded Age America* (New Haven and London: Yale University Press, 1996), 89.

125 "Whistler and Vanity Fair: Society and Art in London," *New York Times*, July 26, 1878, 1.

126 George du Maurier, *English Society at Home* (Boston: J. R. Osgood & Co., 1881), no. 49. See also "New Publications," *New-York Tribune*, December 20, 1880, 6.

127 "A Unique Entertainment," *New York Times*, December 30, 1880, 2; "A Novel Entertainment from 'Punch,'" *Scribner's Magazine* 21, no. 6 (April 1881): 952, 953.

128 "A Novel Entertainment from 'Punch,'" 953.

129 For the former, see "New Publications," 6. For the latter, see Greta, "Boston Correspondence," *Art Amateur* (August 1880): 54–5.

130 "A Novel Entertainment from 'Punch,'" 952.

131 "At Dexter Hall," *Cincinnati Enquirer*, February 19, 1881, 4; "A Novel Entertainment from 'Punch,'" 953. See also Echo, "Un Pot Pourri," *Buffalo Commercial*, April 16, 1881, 1; and "The Art Entertainment Last Night," *Buffalo Commercial*, June 15, 1881, 3.

132 "Current Miscellany," *Democrat and Chronicle* (Rochester, N.Y.), July 3, 1881, 2.

133 "Holiday Books," *Philadelphia Times*, December 2, 1880, 3.

134 See N.N., "London in the Season," *Daily American* (Nashville, Tenn.), July 25, 1880, 3; "London's Aesthetic Lunatics," *Daily American* (Nashville, Tenn.), March 3, 1881, 3; "Miscellaneous Notes," *New York Times*, February 27, 1881, 4.

135 See (among others) Burns, *Inventing the Modern Artist*, Chapter 3; Anne Anderson, "The Mutual Admiration Society, or Mr. Punch Against the Aesthetes," *Popular Narrative Media* 2, no. 1 (2009): 69–88; and Rebecca N. Mitchell, "Acute Chinamania: Pathologizing Aesthetic Dress," *Fashion Theory* 14, no. 1 (2010): 45–64.

136 "Patience," *New York Herald*, April 24, 1881, 12.

137 See particularly du Maurier's "The Rise and Fall of the Jack Spratts: A Tale of Modern Art and Fashion," part III, *Punch* 75 (September 21, 1878): 122. *Punch* was at that time widely available and read in the United States, and du Maurier's cartoons were reprinted in American publications, sometimes within the month; see Burns, *Inventing the Modern Artist*, 89.

138 Gilbert and Sullivan (and D'Oyly Carte) were at pains to point out, however, that *Patience* had been written first, and in no way took its inspiration from *The Colonel*. This information was printed in the London opening night programme. See, for example, "Patience," *New York Herald*, April 24, 1881, 12.

139 "An Aesthetic Comedy," *New York Herald*, February 14, 1881, 4.

140 Ibid.

141 "England Before Europe," *New York Times*, March 21, 1881, 1.

142 See, for example, "The Drama," *Boston Daily Globe*, February 20, 1881, 10; "An Aesthetic Comedy," *Detroit Free Press*, February 20, 1881, 11.

143 M.H.F., "Third Discourse on Happenings in the American Metropolis," *Chicago Tribune*, September 4, 1881, 9; "General Mention," *New York Times*, September 6, 1881, 5.

144 See advertisements in *Daily Alta California*, August 28, 1881, 4; and *Salt Lake City Herald*, September 15, 1881, 1. See also "The Melville Troupe," *Salt Lake City Herald*, September 15, 1881, 5.

145 "The Theatres," *Boston Daily Advertiser*, September 19, 1881, 8.

146 See advertisements in *Boston Post*, September 30, 1881, 2, and October 1, 1881, 4.

147 "Music," *Chicago Tribune*, October 16, 1881, 17.

148 The phrase "aesthetic craze" was attached to *Patience* from its early announcements and later in its advertisements; see (among many others) "Current Foreign Topics," *New York Times*, April 13, 1881, 1.

149 "England Before Europe," 1. See also "Art Studies in England," *New York Times*, May 19, 1881, 2; "The Spirit of the Stage: New York," *Spirit of the Times* (New York) 102, no. 25 (January 21, 1882): 2; "London Gossip," *New-York Tribune*, April 24, 1882, 2. This was not exclusively a factor of American geographical distance, as similarly skeptical reviews appeared in "At the Play," *Observer* (London), February 6, 1881, supplement, 1; and G.A.S. [George Augustus Sala], "The Playhouses," *Illustrated London News* LXXVIII, no. 2178 (February 12, 1881): 151, among others.

150 See, for example, "Patience," *New York Herald*, April 24, 1881, 12; "The Colonel," *Boston Daily Globe*, October 16, 1881, 9, reprinting much of "Sketches at the Prince of Wales's Theatre," *Illustrated London News* LXXVIII, no. 2184 (March 26, 1881): 302.

151 "'The Colonel' Tonight," *Boston Daily Globe*, October 15, 1881, 5.

152 For "humbug" in press materials, see, for *Patience*, "Amusements," *Washington Post*, September 28, 1881, 4; and for *The Colonel*, "Amusements," *Philadelphia Inquirer*, 7. On the complex nature of the American "humbug," see Michael Leja, *Looking Askance: Skepticism and American Art from Eakins to Duchamp* (Berkeley: University of California Press, 2004).

153 "The Perfection of 'Patience,'" *New Haven Register*, May 25, 1881, 2.

154 "Amusements," *New York Herald*, January 17, 1882, 7.

155 "The Spirit of the Stage: New York," 682.

156 Anne Anderson, "'The Colonel': Shams, Charlatans, and Oscar Wilde," *The Wildean: Journal of the Oscar Wilde Society* 24 (July 2004): 39. Complaints about *The Colonel*'s lack of originality were voiced in "Amusements," *New York Times*, January 17, 1881, 5; "City Summary," *New York Clipper*, January 21, 1882, 726; "New York," *Chicago Daily Tribune*, January 22, 1882, 9; and "Amusements," *Puck* 10, no. 255 (January 25, 1882): 331.

157 "Amusements," *New York Times*, 5. A similar complaint was voiced in "Amusements," *New York Herald*, January 17, 1882, 7.

158 "The Drama," *Critic* 30 (January 28, 1882): 29.

159 In addition to sources already cited, see Mary Warner Blanchard, *Oscar Wilde's America: Counterculture in the Gilded Age* (New Haven and London: Yale University Press, 1998), Prologue and Chapter 1; Roy Morris, Jr., *Declaring his Genius: Oscar Wilde in North America* (Cambridge, Mass.: Harvard University Press, 2004); Michele Mendelssohn, *Henry James, Oscar Wilde, and Aesthetic Culture* (Edinburgh: Edinburgh University Press, 2007); and Benjamin Morgan, "Oscar Wilde's Un-American Tour: Aestheticism, Mormonism, and Transnational Resonance," *American Literary History* 26, no. 4 (winter 2014): 664–92.

160 Morgan, "Oscar Wilde's Un-American Tour," 667.

161 These summaries of content are drawn from a variety of contemporary reports as well as from published versions of his lectures, which underwent a fair amount of evolution as he progressed across the United States. See Oscar Wilde, "The English Renaissance" and "House Decoration," in *Miscellanies* (London: Methuen, 1908), 241–77, 279–90.

162 See, for example, Wilde, "The English Renaissance," 267.

163 "Oscar Wilde," *Times Picayune*, June 18, 1882, 11.

164 See, for example, "Oscar Wilde," *Nation* 34, no. 863 (January 12, 1882): 28.

165 "The Charlatan's Welcome," *Springfield Republican*, February 9, 1882, 4; "An Aesthetic Pretender," *Art Amateur* 6, no. 3 (February 1882): 48.

166 For Harvard students who attended his lecture in costume, see "Oscar Wilde in Boston," *Boston Journal*, February 1, 1882, 3; something similar happened at Fort Wayne, Indiana: *Daily Inter Ocean* (Chicago), February 18, 1882, 12. In Washington, D.C., "a negro dressed exactly like Oscar Wilde, with an enormous sunflower in his button-hole" was paraded down Pennsylvania Avenue as a liquor advertisement; see Miss Grundy, "Washington Gossip," original correspondence of the *Courier-Journal* (Louisville, Ky.), January 29, 1882, 4.

167 On Sarony's copyright case, see (among others) Jane Gaines, "Photography Surprises the Law: The Portrait of Oscar Wilde," in *Contested Culture: The Image, the Voice, and the Law* (Chapel Hill: University of North Carolina Press, 1991), 42–83; David A. Novak, "Sexuality in the Age of Technological Reproducibility: Oscar Wilde, Photography, and Identity," in *Oscar Wilde and Modern Culture*, ed. Joseph Bristow (Athens: Ohio University Press, 2008), 63–95; and Erin Pauwels, "Napoleon Sarony's Living Pictures: Photography, Performance & American Art, 1865–1900" (PhD diss., Indiana University, 2015), Chapter 2.

168 "American Export Trade in Furniture," *Furniture Gazette* 8, no. 232 (September 27, 1879): 212.

169 Edward P. Crapol, *America for Americans: Economic Nationalism and Anglophobia in the Late Nineteenth Century* (Westport, Conn.: Greenwood Press, 1973).

170 Mitchell, "Acute Chinamania," 48.

171 See "Oscar Wilde," *Nation* 34, no. 863 (January 12, 1882): 29; "What About this Wilde?" *Times Picayune*, January 22, 1882, 6; and Abbott Foster, "Aesthete – Or Philistine," *International Review* 12 (March 1882): 241.

172 Sven Beckert, *The Monied Metropolis: New York City and the Consolidation of the American Bourgeoisie, 1850–1896* (Cambridge: Cambridge University Press, 2001): 255–6, 260.

173 Ruth Brandon, *The Dollar Princesses: Sagas of Upward Nobility, 1870–1914* (London: Weidenfeld and Nicolson, 1980); Marian Fowler, *In a Gilded Cage: From Heiress to Duchess* (New York: St. Martin's Press, 1994).

174 Frank A. Ninkovich, *Global Dawn: The Cultural Foundations of American Internationalism, 1865–1890* (Cambridge, Mass.: Harvard University Press, 2009).

175 Crapol, *America for Americans*, 92.

176 Ibid., 14.

177 Stephen Tuffnell, "'Uncle Sam is to be Sacrificed': Anglophobia in Late Nineteenth-Century Politics and Culture," *American Nineteenth Century History* 12, no. 1 (March 2011): 77–99.

178 "The World and Oscar Wilde, O!" *Courier-Journal* (Louisville, Ky.), January 9, 1882, 4; "New York Notes," original correspondence of the *Courier-Journal* (Louisville, Ky.), January 15, 1882, 9.

179 H.W., "New York in Mid-Winter," original correspondence of the *Courier-Journal* (Louisville, Ky.), January 18, 1882, 5.

180 "New York Notes," special correspondence, *Atlanta Constitution*, November 20, 1881, 6, citing as evidence ladies' fashions on the street, the cover of the *Century*, and the face of Augustus Saint-Gaudens's *Farragut* sculpture.

181 "Library Hall – 'Patience,'" *People's Press* (Winston Salem, N.C.), November 17, 1881, 3.

4 AESTHETIC NEW YORK

1 On Clarke and his art collection, see Linda Henefield Skalet, "Thomas B. Clarke, American Collector," *Archives of American Art Journal* 15, no. 3 (1975): 2–7; H. Barbara Weinberg, "Thomas B. Clarke: Foremost Patron of American Art from 1872 to 1899," *American Art Journal* 8, no. 1 (May 1976): 52–83; and Sarah Burns, *Inventing the Modern Artist: Art and Culture in Gilded Age America* (New Haven and London: Yale University Press, 1996), 204–5, 211–12.

2 [Charles de Kay], "Mr. Clarke's Exhibition," *New York Times*, December 28, 1883, 5. For reports of the exhibition, see (among others) "Notes and News," *Art Interchange* 11, no. 2 (July 19, 1883): 20; "Mr. T. B. Clarke's Collection of American Pictures," *New-York Tribune*, December 28, 1883, 5; "The Clarke Exhibition: First Notice," *Studio* 2, no. 52 (December 29, 1883): 297; "Monthly Record of American Art: January," *Magazine of Art* 7 (1884): ix. For attendance figures, see "Results of Mr. Clarke's Exhibition," *New-York Tribune*, January 15, 1884, 3.

3 "The Thomas B. Clarke Collection," *New York Daily Graphic*, December 28, 1883, 430.

4 Clarence Cook, "Thomas B. Clarke's Pictures," *Art Amateur* 10, no. 3 (February 1884): 61.

5 "Notes and News," *Art Interchange* 11, no. 2 (July 19, 1883): 20; "Thomas B. Clarke's Exhibition," *Art Union* 1, no. 1 (January 1884): 13.

6 This is the explicit question with which Sylvester Rosa Koehler begins his essay "Concerning Collections" in the Clarke sale catalog; see *The Private Collection of Thomas B. Clarke, of New York: Exhibited at American Art Gallery, New York, December 28, 1883 to January 12, 1884* (New York: Studio Press, 1883), 5. See also "Old Masters," *Boston Daily Advertiser*, November 16, 1883, 5; "Mr. T. B. Clarke's Collection of American Pictures," 5; "Notes from New York: Mr. Clark's [sic] Typical Collection of American Art," *Boston Journal*, December 31, 1883, 2.

7 "For American Art," *New York Herald*, December 28, 1883, 6; "Thomas B. Clarke's Exhibition," 13; "The Fine Arts: The Thomas B. Clarke Collection," *Critic* 1 (January 5, 1884): 11; M. G. Van Rensselaer, "Pictures of the Season in New York," *American Architect and Building News* 15, no. 430 (March 22, 1884): 136; *Art Interchange* 11, no. 9 (October 25, 1883): 97.

8 *Art Interchange*, 11, no. 9 (October 25, 1883): 97.

9 On the institution's history, see Winifred E. Howe, *A History of the Metropolitan Museum of Art*, vol. 2 (New York: Columbia University Press, 1946); and Calvin Tompkins, *Merchants and Masterpieces: The Story of the Metropolitan Museum of Art* (New York: E. P. Dutton, 1970).

10 [de Kay], "Mr. Clarke's Exhibition," 5.

11 Although no definitive sales records have emerged that document this part of its history, the Louis Moeller painting currently called *In the Studio* and held by the Colby College Museum of Art, Waterville, Maine (Lunder collection, 037.2009) precisely matches contemporary descriptions of Clarke's Moeller, called *The Selection* (no. 88 in the 1883–4 Clarke exhibition catalog), rendering the date of 1885 currently assigned to *In the Studio* incorrect. See "Studio Notes," *Studio* 1, no. 16 (April 21, 1883): 154; "Mr. T. B. Clarke's Collection of American Pictures," 5; "The Fine Arts," *Boston Daily Advertiser*, December 29, 1883, 5; and "Art in New York," *Boston Daily Globe*, January 6, 1884, 2.

12 "American Artists' Work," *New York World*, December 28, 1883, 5.

13 [de Kay], "Mr. Clarke's Exhibition," 5.

14 Note that Koehler, in his introduction to the Clarke catalog, says that the now "misunderstood," "dangerous phrase, 'art for art's sake,'" once, in the Renaissance, simply signaled "the pleasure in workmanship as workmanship" – and that an appreciation of an art object for what it is, and not what it should be doing, is something with which he wishes to associate Clarke and his collection; see Koehler, "Concerning Collections," 6–7.

15 It is interesting to compare this complaint as expressed on the side of the art collector and on the side of the dealer around the time of the Clarke exhibition. "Few people buy pictures on their own judgment and every collector is suspicious of being inveigled into purchasing worthless canvases," wrote the *Art Interchange* 11, no. 9 (October 25, 1883): 97. But from the dealer's side, "It is hard to see how the standard of art in this city is likely to be raised by sweeping charges or covert insinuations that many of the works imported by our leading dealers are forgeries"; see "Art News and Comments," *New-York Tribune*, January 20, 1884, 4.

16 William T. Evans, "Letter to the Editor," *Art Collector* 9, no. 6 (January 15, 1899): 85. For Evans as an art patron and collector, see William H. Truettner, "William T. Evans, Collector of American Paintings," *American Art Journal* 3, no. 2 (fall 1971): 50–79; Stephanie Koziski, "William T. Evans" (unpublished manuscript, Smithsonian American Art Museum/National Portrait Gallery Library, 1979); Linda Henefield Skalet, "The Market for American Painting in New York: 1870–1915" (PhD diss., Johns Hopkins University, 1980); and Jack Becker, "A Taste for Landscape: Studies in American Tonalism" (PhD diss., University of Delaware, 2002).

17 Montezuma [Montague Marks], "My Note-Book," *Art Amateur* 32, no. 4 (March 1895): 104.

18 "Evans Loan Collection," *New York Times*, November 11, 1906, second magazine section, 4.

19 Charles de Kay, "The Private Collection of W. T. Evans," *New York Times*, August 21, 1898, illustrated magazine supplement, 12.

20 Ibid.

21 William T. Evans letters, 1842–1869, Archives of American Art, Smithsonian Institution.

22 William O. Stoddard, *Men of Achievement: Men of Business* (New York: Charles Scribner's Sons, 1893), 51.

23 Ibid., 187.

24 Rev. Willard E. Waterbury, "Eyes that See," in *Portraits and Principles of the World's Great Men and Women with Practical Lessons on Successful Life by over Fifty Leading Thinkers*, ed. William C. King (Springfield, Mass.: King, Richardson & Co., 1895), 298.

25 David C. Sargent, *Alexander Millar Lindsay* (Canton, Conn.: Lithographics, Inc., 1984), 26 and 62, quoting Andrew D. Wolfe, *Bold Century, 1868–1968: 100 Adventurous and Happy Years of*

Merchandising: The Story of Sibley, Lindsay and Curr Company of Rochester, Monroe County, New York (Rochester: Sibley, Lindsay and Curr Co., 1968), 34.

26 David Park Curry, "The Painting Over the Table," *Source: Notes in the History of Art* 24, no. 2 (winter 2005): 63–4, which places *Quince Blossoms* in the Lindsay collection. On this painting, see also "Charles C. Coleman," *Art Amateur* 2, no. 3 (February 1880): 45–6; and Doreen Bolger Burke, "Painters and Sculptors in a Decorative Age," in *In Pursuit of Beauty: Americans and the Aesthetic Movement*, exh. cat. (New York: Metropolitan Museum of Art, 1986), 333.

27 "Gossip About Art," *New York Press*, May 4, 1890, 11.

28 "Notes in Current Art," *Chicago Tribune*, June 22, 1890, 36; "New Exhibit of Paintings: Charles Caryl Coleman's Choice Collection at the Art Institute," *Chicago Herald*, June 20, 1890, 5. In Buffalo, it was reported, "much taste has been displayed by Mr. Coleman, both in placing his pictures, and in the dainty, artistic adjuncts which he has interspersed here and there in the way of ancient illuminated manuscripts, antique coffers, a carved wooden Virgin from some Italian shrine, and other quaint and interesting objects"; see "Mr. Coleman's Pictures," *Buffalo Morning Express*, July 20, 1890; see also Scio, "Sub Rosa," *Buffalo Courier*, August 31, 1890, 1.

29 Burns, *Inventing the Modern Artist*, 55; see also Sarah Burns, "The Price of Beauty: Art, Commerce, and the Late Nineteenth-Century Studio Interior," in *American Iconology: New Approaches to Nineteenth Century Art and Literature*, ed. David C. Miller (New Haven and London: Yale University Press, 1993), 209–38.

30 No detailed history of Clarke & King has been written. My knowledge of the firm has been largely derived from period trade journals, especially the *Clothier and Furnisher*. On collar-making in Troy, see Carole Turbin, *Working Women of Collar City: Gender, Class, and Community in Troy, New York, 1864–86* (Urbana: University of Illinois Press, 1992), here p. 509.

31 "Our State Institutions XXVIII: The Collar and Cuff Factories of Troy," *New York Times*, March 16, 1872, 5.

32 Compare, for example, "Troy's Collar and Cuff Trade During 1881," *Clothier and Furnisher* 11, no. 5 (December 1881): 9; and "The Collar and Cuff Trade of Troy," *Clothier and Furnisher* 11, no. 10 (May 1882): 16.

33 Charles de Kay, "Movements in American Painting: The Clarke Collection in New York," *Magazine of Art* 10 (1887): 38. (The artist Thomas Wilmer Dewing would beg to differ. His handwritten list of sales includes this notation for *The Garden*: "sold to T. B. Clarke for $250.00 one half the price I asked." Dewing to Charles Lang Freer, undated, in Charles Lang Freer Papers, Freer Gallery of Art Archives, Box 7.)

34 Robert R. Preato, "Collectors of American Tonal Painters: Charles Lang Freer, Thomas B. Clarke, William T. Evans and George A. Hearn," in William H. Gerdts et al., *Tonalism, An American Experience*, exh. cat. (New York: Grand Central Art Galleries, 1982), 39.

35 Burns, *Inventing the Modern Artist*, 212.

36 Turbin, *Working Women of Collar City*, 510.

37 Ibid., 515.

38 Ibid., 510.

39 "A Unique Dinner," *Brooklyn Daily Eagle*, December 19, 1880, 4. For more on the club's dry goods affiliations, see "Dinner of the Motto Club," *New-York Tribune*, January 23, 1881, 2.

40 See Skalet, "The Market for American Painting in New York," 136–41; and Weinberg, "Thomas B. Clarke," 65. Further information on Clarke's arrangements with Moeller and Inness can be found in William H. Gerdts, *Louis Moeller, N.A. (1855–1930): A Victorian Man's World*, exh. cat. (New York: Grand Central Art Galleries, 1984), 6–18; and multiple entries in Michael Quick, *George Inness: A Catalogue Raisonné* (New Brunswick, N.J.: Rutgers University Press, 2007).

41 Susan Hayes Ward, "Fine Arts," *Independent* 43, no. 2241 (November 12, 1891): 7.

42 "Rents a House for his Chinese Collection," *New York Press*, reprinted in *Cleveland Plain Dealer*, July 26, 1896, 20.

43 [Alfred Trumble], "The Passing Show," *Collector* 3, no. 1 (November 1, 1891): 2.

44 [Alfred Trumble], "As the Wind Blows," *Collector* 3, no. 13 (May 1, 1892): 195.

45 On Millet's career more generally, see H. Barbara Weinberg, "The Career of Francis Davis Millet," *Archives of American Art Journal* 17, no. 1 (1977), 2–18; Marc Simpson, "Windows on the Past: Edwin Austin Abbey and Francis Davis Millet in England," *American Art Journal* 22, no. 3 (autumn 1990): 65–89; and Mary Beth Kreiner, "Francis Davis Millet's 'Reading the Story of Oenone,'" *Bulletin of the Detroit Institute of Arts* (1995): 14–25.

46 Clarke's Millet, *Lacing the Sandal*, was acquired by July 1883 (according to the checklist published in Weinberg, "Thomas B. Clarke"), and subsequently listed as no. 134 in Clarke's 1891 collection catalog, where the description matches this painting: "Seen in profile, at full length, and turned towards the right, a charming young Greek girl stands, with her right foot elevated upon a stool covered with a leopard skin, repairing the loosened lacings of her sandal. Signed at the right." Contemporary descriptions of Clarke's painting can also be found in "The Thomas B. Clarke Collection," *New York Daily Graphic*, December 28, 1883, 430; "Paintings at the American Art Galleries," *Critic* 13, no. 328 (April 12, 1890): 187; and "Gossip About Art," *New York Press*, April 13, 1890, 16.

47 Kreiner, "Francis Davis Millet's 'Reading the Story of Oenone,'" 20. Millet's fascination with the Parthenon sculptures in this period links him to Albert Moore, James McNeill Whistler, and Frederic Leighton, among others.

48 "Mary Anderson as a Statue," *People and New Hampshire Patriot*, March 8, 1883, 3; Kreiner, "Francis Davis Millet's 'Reading the Story of Oenone,'" 17.

49 Kreiner, "Francis Davis Millet's 'Reading the Story of Oenone,'" 16–18. Kreiner notes that Millet's own illustrated account of designing the costumes for this play appeared in 1881; see [F. D. Millet], "Costumes in the Greek Play at Harvard," *Century* 23, no. 1 (November 1881): 55–79.

50 "Mr. Millet on Roman Costumes," *Critic* 1, no. 7 (April 9, 1881): 95. This author regarded Millet's suggestions as offering a direct counter to caricatures of Pre-Raphaelite and Aesthetic fashion that were reaching the United States: "It would be well if our countrywomen, before the new gospel of ugliness reaches them from mediaeval London, could have an opportunity to see out of what simple forms … the dignity and beauty of Roman dress were mainly composed."

51 "The American Water-Color Society," *Independent* 34, no. 1733 (February 16, 1882): 8.

52 See Emily Nolan, "Greek Dress II: Another Aspect," *Harper's Bazaar* 24, no. 4 (January 24, 1891): 63; and Kreiner, "Francis Davis Millet's 'Reading the Story of Oenone,'" 16–17.

53 For Clarke's *Lacing the Sandal* (private collection), see note 46 above. For Evans's *After the Festival* (1888, private collection), see checklist published in Truettner, "William T. Evans, Collector of American Paintings"; and *An American Perspective: Nineteenth-Century Art from the Collection of Jo Ann & Julian Ganz, Jr.*, exh. cat. (Washington, D.C.: National Gallery of Art, 1981), 77–8. Millet's *Fastening the Strophion* was in the Hearn collection at the time of its exhibition at the New York Athletic Club in 1891; see *New York Herald*, August 30, 1891, 15. A painting by this title was listed as lot 33 in the sale at Sotheby's, New York (June 3, 1971).

54 For identification of the men in Moeller's *Appraisement* as merchants, see "Glass and Shadow Box," *New York Herald*, March 27, 1888, 6; and "The Spring Academy," *New York Times*, March 31, 1888, 4; for customs inspectors, see Charles M. Kurtz, "National Academy Notes: 1888 – Eighth Year," *National Academy Notes, including the Complete Catalogue of the Spring Exhibition, National Academy of Design*, no. 8 (1888): 37; and "The Academy Exhibition," *Harper's Weekly* 32, no. 1633 (April 7, 1888): 250. For Clarke and the McKie family, see Weinberg, "Thomas B. Clarke," 56.

55 My identification of Hearn in *Art Connoisseurs* (see fig. 70) is based on comparison of it with photographs included in Hearn's December 1913 obituaries; see, for example, "George A. Hearn, One of Rarest Types of Collectors," *New York Times*, December 7, 1913, Sunday magazine, 9. For Moeller's decision to include a portrait of Clarke in one of his pictures, see discussion of *Chess Game* (unlocated) in Weinberg, "Thomas B. Clarke," 60.

56 See "The Evans Art Collection," *Brooklyn Daily Eagle*, May 17, 1898, 7; "A Brooklyn Art Display," *New York Times*, May 19, 1898, 9; and "Exhibit of American Paintings," *New-York Tribune*, May 20, 1898, 5.

57 "George A. Hearn, One of Rarest Types of Collectors."

58 Kreiner, "Francis Davis Millet's 'Reading the Story of Oenone,'" 20–1.

59 "Thomas B. Clarke," editorial, *New-York Tribune*, January 20, 1931, 22, quoting Herbert F. Sherwood, ed., *H. Siddons Mowbray, Mural Painter, 1858–1928* (Stamford, Conn.: privately printed, 1928), 44.

60 On Mowbray's training, see H. St. G. [Homer Saint-Gaudens], "Henry Siddons Mowbray," *Critic* 46, no. 6 (June 1905): 522; and Doreen Bolger Burke, *American Paintings in the Metropolitan Museum of Art*, vol. 3 (New York: Metropolitan Museum of Art, 1980), 326.

61 *Exhibition of Paintings, March 11, 1886*, Union League Club, New York, 1886.

62 "Native Painters at the Union League," *New York Times*, March 12, 1886, 4.

63 Ibid. Exhibition information from Skalet, "The Market for American Painting in New York," 90, note 29.

64 "The Artists' Fund," *New York Herald*, February 7, 1886, 15. *A Precious Relic* had been debuted at the Artists' Fund Society Exhibition the previous month; see also "Artists' Fund Society," *New York Times*, February 13, 1886, 5; and "The Artists' Fund Sale," *New York Times*, February 17, 1886, 2. Millet exhibited *The Connoisseur* in March 1885; see "The American Water-Color Society Exhibition," *Art Amateur* 12, no. 4 (March 1885): 79.

65 Montezuma, "My Note Book," *Art Amateur* 14, no. 4 (March 1886): 76.

66 John Ott, "How New York Stole the Luxury Art Market: Blockbuster Auctions and Bourgeois Identity in Gilded Age America," *Winterthur Portfolio* 42, no. 2/3 (summer/autumn 2008): 141. This essay provides essential background and analysis on the impact of the American Art Association.

67 See C. Griffith Mann, "Exporting China: The Collecting Tastes of William and Henry Walters," in Vimalin Rujivacharakul, ed., *Collecting China: The World, China, and a History of Collecting* (Newark: University of Delaware Press, 2011), 99–106; and Laura Meixner, "'Gambling with Bread': Monet, Speculation, and the Marketplace," *Modernism/modernity* 17, no. 1 (January 2010): 171–99.

68 Until the painting is located, we cannot know whether Millet actually depicted the Morgan vase in *A Precious Relic* or whether Montague Marks was simply taking the opportunity offered by the painting to comment on the recent Morgan sale. In either case, however, Marks's commentary indicates that it was possible for period viewers to draw public and specific connections between works of Aesthetic painting and contemporary objects and events.

69 *Exhibitions of Oil Paintings … at the Reception in Honor of William M. Evarts*, Union League Club, New York, 1885. For "masters," see "Paintings at the Union League Club," *New-York Tribune*, February 13, 1885, 4.

70 See, for example, Montezuma, "My Note Book," *Art Amateur* 12, no. 4 (March 1885): 76.

71 On prohibitively high insurance costs, see "New York's Littleness," *Washington Post*, October 4, 1885, 5; and Montezuma, "My Note Book," *Art Amateur* 13, no. 5 (October 1885): 88.

72 "American Art at the Lotos," *New-York Tribune*, December 17, 1898, 6.

73 "The Fine Arts," *Critic* 116 (March 20, 1886): 146.

74 "An American Exhibition," *New York Herald*, March 12, 1886, 5; "Native Painters at the Union League," *New York Times*, March 12, 1886, 4.

75 "Monthly Record of American Art: March," *Magazine of Art* 9 (1886): xxii. For the year's art committee, see *Union League Club of New York* (annual report) (1886), 4.

76 Francis Gerry Fairfield, *The Clubs of New York: With an Account of the Origin, Progress, Present Condition and Membership of the Leading Clubs* (New York: Henry L. Hinton, 1873), 231–2.

77 Although a major factor in the organization of late nineteenth-century American social life, men's clubs have yet to receive the fully comprehensive study they deserve. Key sources that illuminate the operations, structures, and significance of club life (aside from volumes documenting the histories of individual clubs) include Fairfield, *The Clubs of New York*; Frederic Cople Jaher, *The Urban Establishment: Upper Strata in Boston, New York, Charleston, Chicago, and Los Angeles* (Urbana: University of Illinois Press, 1982); Paul DiMaggio, "Cultural Entrepreneurship in Nineteenth-Century Boston, Part I: The Creation of an Organizational Base of High Culture in America," *Media, Culture and Society* 4, no. 1 (1982): 33–50; DiMaggio, "Cultural Entrepreneurship in Nineteenth-Century Boston, Part II: The Classification and Framing of American Art," *Media, Culture and Society* 4, no. 4 (1982): 303–22; Mark C. Carnes, *Secret Ritual and Manhood in Victorian America* (New Haven and London: Yale University Press, 1989); Carnes and Clyde Griffen, eds., *Meanings for Manhood: Constructions of Masculinity in Victorian America* (Chicago: University of Chicago Press, 1990); E. Anthony Rotundo, *American Manhood: Transformations in Masculinity from the Revolution to the Modern Era* (New York: Basic Books, 1993); and Sven Beckert, *The Monied Metropolis: New York City and the Consolidation of the American Bourgeoisie, 1850–1896* (Cambridge: Cambridge University Press, 2001).

78 See especially "Union League's New Home," *New-York Tribune*, February 16, 1881, 2; "The Union League Club House," *Harper's Weekly* 25, no. 1260 (February 19, 1881): 118–19; "A New Palace for a Club," *New York Times*, March 4, 1881, 8; and "New Quarters of the Union League Club," *Frank Leslie's Illustrated Weekly* 52, no. 1336 (May 7, 1881): 169.

79 Beckert, *The Monied Metropolis*, 238–40; see also Neil Harris, *The Land of Contrasts: 1880–1901* (New York: G. Braziller, 1970), 17.

80 Beckert, *The Monied Metropolis*, 263.

81 Ibid., 264.

82 Ibid., 309.

83 This address is partially reprinted in Henry Bellows, *Historical Sketch of the Union League Club of New York: Its Origin, Organization, and Work, 1863–1879* (New York: Club House, 1879), 153.

84 In addition to the work of Jack Becker, Sarah Burns, John Ott, and Linda Skalet, which has already been cited here, see Kevin Murphy, "Economics of Style: The Business Practices of American Artists and the Structure of the Market, 1850–1910," PhD diss., University of California, Santa Barbara, 2005.

85 "Palette and Brush: The Artist Members of the Lotos Club," *Town Topics* 55, no. 9 (March 1, 1906): 16; Skalet, "The Market for American Painting in New York," 95.

86 "Hints on Art," *New York Times*, April 26, 1873, 3; see also "Picture Shows at Clubs: Their Value to Artists and Purchasers," *New York Times*, January 30, 1887, 8.

87 Skalet, "The Market for American Painting in New York," 88, citing William Henry Irwin, Earl Chapin May, and Joseph Hotchkiss, *A History of the Union League Club* (New York: Dodd, Mead, and Co., 1952), 13.

88 Fairfield, *Clubs of New York*, 125, 112.

89 These changes can be tracked through committee listings in the Union League's self-published annual reports.

90 On the growing presence of businessmen among club membership, see, for example, Stylus, "Our New York Letter," *Literary World* 17, no. 4 (February 20, 1886): 64–5; "Similar in Many Ways," *New York Times*, February 22, 1886, 2; and "The Professional Clubs," *New York Times*, January 10, 1887, 2.

91 "Last Meeting in its Old Home," *New-York Tribune*, February 11, 1881, 5.

92 "Paintings at the Union League Club," *New-York Tribune*, March 12, 1886, 5.

93 "Art News and Comments," *New-York Tribune*, May 9, 1886, 14.

94 "Paintings at the Union League Club," 5.

95 "Monthly Record of American Art: March," *Magazine of Art* 9 (1886): xxii.

96 "Art News and Comments," *New-York Tribune*, May 9, 1886, 14.

97 "The Union League Club House," *Harper's Weekly* 25, no. 1260 (February 19, 1881): 118.

98 "Noblesse oblige, gentlemen. When you borrow a man's property and invite him to your house, it is your business not to leave the servants to entertain him. If his pictures are worth hanging, he is worth saying 'how d'ye do' to when he comes, at your printed invitation, to see the use you have made of them"; see "Saunterings," *Town Topics* 17, no. 2 (January 13, 1887): 4.

99 "Art Notes and News," *Art Interchange* 18, no. 3 (January 29, 1887): 34.

100 *A Collection of Oil Paintings and Antique Chinese Porcelains Exhibited Feb. 14–16, 1889* (Union League Club, 1889); *Catalogue of Antique Japanese Art Objects and of the Annual Exhibition of Water-Colors, April 11–13, 1889* (Union League Club, 1889); *Descriptive Catalogue of Oil Paintings and Oriental Carved Stones Embracing Noted Specimens of Jade, Jadeite, Crystal, Agate, Etc.* (Union League Club, 1889); and *Catalogue of Pictures by American Figure Painters and Persian and Indian Works of Art, the Union League Club, New York, February 13, 14, and 15, 1890* (Union League Club, 1890).

101 Melody Barnett Deusner, "Constructing the 'Deadly Parallel': Paintings, Politics, and the Comparative Eye in Turn-of-the-Century Clubland," *American Art* 31, no. 2 (summer 2017): 96–103. The history of American tonalism has typically been told as the story of an artistic movement, with practitioners striving toward shared modes of expression, rather than (as I argue is the case) as a story of collectors and dealers actively and profitably shaping this category from the outside; see Wanda M. Corn, *The Color of Mood: American Tonalism 1880–1910*, exh. cat. (San Francisco: M. H. de Young Memorial Museum, 1972); Gerdts et al., *Tonalism: An American Experience*; Ralph Sessions, *The Poetic Vision: American Tonalism*, exh. cat. (New York: Spanierman Gallery, 2005); and David A. Cleveland, *A History of American Tonalism: 1880–1920* (Manchester, Vt.: Hudson Hills Press, 2010). Becker, "A Taste for Landscape," provides a somewhat more balanced view, and includes additional discussion of the *Comparative Exhibition*.

102 "One Who Delivers the Goods," letter to the editor of the *American Art News* 8, no. 24 (March 26, 1910): 4.

103 "Art's Princely Patrons," *New York World*, May 24, 1885, 2. In 1893, Evans increased the amount of the Water Color Society prize from $300 to $500, with the understanding that the award-winning picture would automatically enter his collection; see [Trumble], "Something for Everybody," *Collector* 4, no. 7 (February 1, 1893), 101.

104 [de Kay], "Mr. Clarke's Exhibition," *New York Times*, 5.

105 *The Private Collection of Thomas B. Clarke*, 15.

106 "Thomas B. Clarke's Collection of American Pictures," *Brooklyn Daily Eagle*, December 18, 1887, 2.

107 William Coffin, "Introduction," in *Catalogue of the Private Art Collection of Thomas B. Clarke, New York* (New York: American Art Galleries, 1899), 12.

108 "The Shirt-Front of the Ex-Collector," *Town Topics* 41, no. 8 (February 23, 1899): 17; "American Art Stuck on Itself: A Summer

Tooting for a few Vested Interests," *Town Topics* 41, no. 23 (June 8, 1899): 14–15.

109 "The Shirt-Front of the Ex-Collector," 17.

110 Henry G. Marquand, "The Tariff on Works of Art," *Princeton Review* (January–June 1884): 148–9.

111 On Marquand, see Daniëlle O. Kisluk-Grosheide, "The Marquand Mansion," *Metropolitan Museum of Art Journal* 29 (1994): 151–81; Cynthia Saltzman, *Old Masters, New World: America's Raid on Europe's Great Pictures, 1880–World War I* (New York: Viking, 2008), Chapter 1; Melody Deusner, "'In seen and unseen places': The Henry G. Marquand House and Collections in England and America," *Art History* 34, no. 4 (September 2011): 754–73, and Melody Barnett Deusner, "Building a Reputation: Henry Gurdon Marquand's New York Mansion," in *Orchestrating Elegance: Alma-Tadema and the Marquand Music Room*, ed. Kathleen M. Morris and Alexis Goodin, Sterling and Francine Clark Art Institute exh. cat. (New Haven and London: Yale University Press, 2017), 37–61.

112 In the catalog accompanying the 1900 sale of Evans's collection, Charles de Kay outlined the various collecting parameters that Evans had adopted over the years; see *Catalogue of American Paintings Belonging to William T. Evans* (New York: American Art Association, 1900), 5–6. The *New York Times* (also possibly de Kay) repeated this assertion that American figure painting "has so fascinated [Evans] that he has resolved to devote himself more completely to figures than to landscapes, and hence the present sale"; see "The W. T. Evans Pictures," *New York Times*, January 25, 1900, 4.

113 "Last Days of Exhibition ... the Notable Collection of American Paintings Belonging to Mr. William T. Evans, of this city," advertisement for American Art Galleries exhibition of the Evans collection to be sold at Chickering Hall, *New York Times*, January 28, 1900, 10.

114 On the close relationship between the experience of visual pleasure encouraged by the Aesthetic object and the "aura" of the sale commodity, see Lee Glazer, "'A Modern Instance: Thomas Dewing and Aesthetic Vision at the Turn of the Century" (PhD diss., University of Pennsylvania, 1996), 54–65, and Chapter 4.

115 Freer refers to Evans as "my old time friend" in a letter to Richard Canfield, September 28, 1904, Charles Lang Freer Papers, Freer Gallery of Art, letterpress book vol. 15. On the Evans gift to the Smithsonian, see Truettner, "William T. Evans, Collector of American Paintings"; and Lois Marie Fink, *A History of the Smithsonian American Art Museum: The Intersection of Art, Science, and Bureaucracy* (Amherst: University of Massachusetts Press, 2007), 61–2.

116 Leila Mechlin, "American Paintings: Most of the Evans Collection Now on Exhibition," *Evening Star* (Washington, D.C.), April 6, 1907, 8.

117 For Evans's correspondence with curators at the Smithsonian and his ongoing revisions of his collections (including discussion of the samples of "Dundee drapery" he sent for the walls), see the William T. Evans files, Registrar, Smithsonian American Art Museum, particularly folders 8–16.

118 For the conditions of Hearn's donations, see *Metropolitan Museum of Art Bulletin* 1, no. 3 (February 1906): 33–4; 1, no. 7 (June 1906): 102–3; and Tomkins, *Merchants and Masterpieces*, 100–1.

119 Carrie Rebora Barratt, "George A. Hearn: 'Good American Pictures Can Hold Their Own,'" *Antiques* 157, no. 1 (January 2000): 221.

120 Ibid., 219–20, citing Howe, *A History of the Metropolitan Museum of Art*, vol. 2, 137.

121 Compare "The A. T. Stewart Collection," third notice, *Art Amateur* 16, no. 5 (April 1887): 101; and Montezuma, "My Note Book," *Art Amateur* 2, no. 3 (February 1880): 47.

122 "Says Clausen Sells Spurious Paintings," *New York Times*, March 15, 1910, 5; see also "The Trade in Bogus Pictures," *Current Literature* 45, no. 1 (July 1908): 45.

123 See, among others, "Saunterings," *Town Topics* 76, no. 22 (November 30, 1916): 5; "Artists Sued on Sales to W. T. Evans," *Evening Post* (New York), January 24, 1917, 1; "Seek to Recover Money W. T. Evans Paid for Paintings," *New York Herald*, January 25, 1917, 7; and Truettner, "William T. Evans, Collector of American Paintings," 61–2.

5 HARMONIOUS SYSTEMS

1 On Charles Lang Freer and his collection, see, among others, Nichols Clark, "Charles Lang Freer: An American Aesthete in the Gilded Era," *American Art Journal* 2, no. 4 (October 1979): 54–68; Helen Nebeker Tomlinson, "Charles Lang Freer: Pioneer Collector of Oriental Art" (PhD diss., Case Western Reserve University, 1979); Keith N. Morgan, "The Patronage Matrix: Charles A. Platt, Architect, Charles L. Freer, Client," *Winterthur Portfolio* 17, no. 2/3 (summer/ autumn 1982): 121–34; *Apollo* (special issue on Charles Lang Freer), 118, no. 258 (August 1983); Thomas Lawton and Linda Merrill, *Freer: A Legacy of Art* (Washington, D.C.: Freer Gallery of Art, 1993); Kathleen Pyne, *Art and the Higher Life: Painting and Evolutionary Thought in Late Nineteenth-Century America* (Austin: University of Texas Press, 1996), Chapter 4; Kathleen Pyne, "Portrait of a Collector as an Agnostic: Charles Lang Freer and Connoisseurship," *Art Bulletin* 78, no. 1 (March 1996): 75–97; Lee Glazer, "'A Modern Instance': Thomas Dewing and Aesthetic Vision at the Turn of the Century" (PhD diss., University of Pennsylvania, 1996); Linda Merrill, *The Peacock Room: A Cultural Biography* (Washington, D.C.: Freer Gallery of Art, 1998); Ann C. Gunter, *A Collector's Journey: Charles Lang Freer and Egypt* (Washington, D.C.: Smithsonian Institution, 2002); and Lee Glazer, *Charles Lang Freer: A Cosmopolitan Life* (Washington, D.C.: Smithsonian Institution, 2017).

2 "The Gilder," "Palette and Brush: New Paintings by Dewing and Tryon," *Town Topics* 55, no. 2 (January 11, 1906): 14. "Marconi system" refers to the wireless radio-wave telegraphy recently pioneered by Guglielmo Marconi.

3 For the most thorough account of Freer's house and its decoration, see Thomas W. Brunk, "The Charles L. Freer Residence: The Original Freer Gallery of Art," *Dichotomy* 12 (fall 1999): 6–150.

4 Tryon to George Alfred Williams, quoted in Henry C. White, *The Life and Art of Dwight William Tryon* (Boston: Houghton Mifflin, 1930), 82–4.

5 Tryon to Freer, March 21, 1896, Charles Lang Freer Papers, Freer Gallery of Art (hereafter CLFP FGA), Box 23.

6 It should be noted that art objects acquired by Freer after 1904 had a double function, as works that were expected to bring pleasure to their patron during his lifetime and as specially selected examples of the artist's *oeuvre* intended to represent him for posterity in the museum then being organized under that patron's name.

7 Tryon paintings in William T. Evans's collection included *Twilight at Auvergne* (1878, Montclair Art Museum, N.J.), *On the Seine* (1880), *Daybreak* (1885), *A May Morning* (1890), *The River: Evening* (1892), *Springtime* (1897–9), *November* (1904–5), and *An Autumn Evening* (1908); see William H. Truettner, "William T. Evans, Collector of American Paintings," *American Art Journal* 3, no. 2 (fall 1971): 78. William K. Bixby owned at least ten paintings by Tryon that he purchased in 1904; see Linda Merrill, *An Ideal Country: Paintings by Dwight William Tryon in the Freer Gallery of Art* (Washington, D.C.: Freer Gallery of Art, Smithsonian Institution, 1990), 76–7. For a detailed study of Tryon's life and work in New York, Massachusetts, and Maine, see Merrill, *An Ideal Country.*

8 Tomlinson describes Tryon's paintings as "stark, familiar scenes, all similar in construction, each finished with technical accuracy" and, like the artist's own personality, "austere, reliable, polished and perhaps a bit monotonous"; see Tomlinson, "Charles Lang Freer," 119. Similarly, William Gerdts has observed that contemporary critics saw tonalist painting generally as "attractive and poetic, but also somewhat monotonous"; see William H. Gerdts

et al., *Tonalism: An American Experience* (New York: Grand Central Art Galleries, 1982), 27. For "mechanical," see Merrill, *An Ideal Country*, 76.

9 *Detroit Free Press*, July 17 [1918?], from typescript copy in Frank J. Hecker curatorial file at the Freer Gallery of Art.

10 Frederick Jackson Turner, "The Significance of the Frontier in American History," a paper read at the meeting of the American Historical Association at the Columbian Exposition in Chicago, July 12, 1893, reprinted in Turner, *The Frontier in American History* (New York: Henry Holt and Company, 1920), 15.

11 This phrase was used by Evans to describe how American pictures should ideally be exhibited at the Metropolitan Museum of Art. It is indicative of these Aesthetic collectors' exhibitionary tendencies more broadly. See Evans's letter to the editor of the *Art Collector* 9, no. 6 (1899): 85.

12 On Stanford White's frames, which also appear on many of Dewing's pictures, see Nina Gray and Suzanne Smeaton, "Within Gilded Borders: The Frames of Stanford White," *American Art* 7, no. 2 (spring 1993): 32–45; and Susan Hobbs, *Thomas Wilmer Dewing: Beauty into Art; A Catalogue Raisonné* (New Haven and London: Yale University Press, 2018), 1:73–7. Tryon collaborated with Freer on both the decoration of the patron's home and, with the additional input of Dewing, an exhibition of pastels by Tryon, Dewing, and Whistler at the Louisiana Purchase Exhibition at St. Louis in 1904. For Freer's domestic projects, see the frequent correspondence between Freer and Tryon, 1890–2, CLFP FGA, Box 23, much of which receives additional commentary in Brunk, "The Charles L. Freer Residence," 27–44. On the St. Louis exhibition, see Glazer, "A Modern Instance,'" Chapter 3.

13 Freer to William K. Bixby, September 29, 1897, CLFP FGA, Box 3. As early as 1896, Freer, as co-founder, director, and vice president of the Michigan-Peninsular, proposed establishing a protective association among railroad car manufacturers. The Committee of Seven apparently also included Jacob L. Smyser (president of the Ohio Falls Car Manufacturing Company and the committee's chairman), F. E. Canda (of the Canda Car Manufacturing Company), and William McMillan (Freer's close friend and business associate in Detroit). In addition to the letter cited above, see letters from Freer to Bixby, May 23, 1896; July 8, 1897; September 6, 1897; October 6, 1897; and October 13, 1897, CLFP FGA, Box 3. Bixby, Smyser, Canda, and McMillan would continue to serve together on the board of directors of the American Car and Foundry Company after its consolidation in 1899. On Freer's business affairs, see most recently Glazer, *Charles Lang Freer*, Chapter 1.

14 Freer to Bixby, September 6, 1897, CLFP FGA, Box 3.

15 Freer to Bixby, October 6, 1897, ibid.

16 Freer to Bixby, October 13, 1897, ibid. We know at least some of these plans eventually came to fruition; on construction of cars for the Russian government, see Freer to Joseph Breck, December 22, 1915, ibid., Box 4.

17 The business relationship and friendship between Freer and Hecker extended back to 1873, when Hecker, originally from St. Louis, recruited Freer, a New York native, to fill the position of paymaster for Hecker's New York, Kingston, and Syracuse Railroad. They continued to engage in a number of railroad ventures, most importantly the Eel River Rail Road, which first brought them into the orbit of financiers James F. Joy and Christian H. Buhl, and whose integration with Wabash led Freer and Hecker to divert their attention to the manufacture of railroad cars and relocate to Detroit. There they founded and managed the Peninsular Car Company (established 1879) and operated the Michigan-Peninsular Car Company, formed out of a merger with the McMillan family interests in 1892. The extensive correspondence between Freer and Hecker held by the Freer Gallery of Art has provided an essential foundation for my research. On Freer and Hecker's business operations, see, in addition to biographical sources for Freer listed above, Charles Moore, *History of*

Michigan, vol. 3 (Chicago: Lewis Publishing Company, 1915), 1484–5; Frank J. Hecker, *Activities of a Lifetime: 1861–1923* (Detroit: privately printed, 1923); John Douglas Peters and Vincent G. Robinson, *Detroit: Freight Cars before Automobiles* (Belleville, Mich.: Treasure Press, 2005); and Graydon M. Meints, "Detroit's First Big Industry: Railroad Cars," *Historical Society of Michigan Chronicle* 29, no. 4 (winter 2007): 9–11.

On Hecker's home, see Kathleen Pyne, "Classical Figures: A Folding Screen by Thomas Dewing," *Bulletin of the Detroit Institute of Arts* 59 (spring 1981): 4–14. The Freer and Hecker homes are contrasted by Susan Hobbs, *The Art of Thomas Wilmer Dewing: Beauty Reconfigured* (Washington, D.C.: Smithsonian Institution Press, 1996), 19; Aline B. Saarinen, *The Proud Possessors: The Lives, Times, and Tastes of Some Adventurous American Art Collectors* (New York: Random House, 1958), 121–2; and Merrill, *An Ideal Country*, 54.

18 Pyne, "Classical Figures," 12–13. The Dewing screens, commissioned by Hecker after he saw and admired Freer's decorative partitions, were installed by Freer in Hecker's drawing room as a surprise for the latter, who was out of town when they were delivered. In another anecdote relayed by Freer, Hecker stood by while Freer unpacked Dewing's pastel drawing now known as *Lady in Yellow* (1894), and liked it so much he begged Freer to let him buy it. Freer could not refuse his friend, and Hecker "carried the picture home with him under his arm"; see Freer to Howard Mansfield, September 10, 1894, CLFP FGA, letterpress book vol. 2.

19 For the compositional relationships between these Dewing works, see Pyne, "Classical Figures," 12–13; and Susan Hobbs, "Thomas Dewing in Cornish, 1885–1905," *American Art Journal* 17, no. 2 (spring 1985): 15–16. Hobbs points out that Dewing used the same two models for both pictures.

20 Freer and Bixby's joint ventures encompassed not only the field of railroad car building (in the Committee of Seven and as co-founders of the American Car and Foundry Company), but also that of art collecting. In addition to correspondence documented here, see Betsy Fahlman, "Wilson Eyre in Detroit: Charles Lang Freer House," *Winterthur Portfolio* 15, no. 3 (autumn 1980): 269; and Merrill, *An Ideal Country*, 76–7.

21 Tryon to Freer, April 5, 1891, CLFP FGA, Box 23.

22 Tryon to Freer, April 6, 1893, ibid.

23 Clarence Cook, *The House Beautiful* (New York: Scribner, Armstrong and Company, 1878), 333.

24 Alexander Oakey, "A Trial Balance of Decoration," *Harper's New Monthly Magazine* 64 (April 1882): 734.

25 Freer to Dewing, March 13, 1893, CLFP FGA, letterpress book vol. 1. In this letter, Dewing's *The Piano* is referred to by its alternate title, *A Musician*.

26 For another instance of Freer debuting his pictures in a social setting, see Freer to Newman Montross, April 7, 1893, CLFP FGA, letterpress book vol. 1 (regarding Tryon's *Springtime*). Freer's conception of his new home as a social space is made evident by his decision to host two dinners there in 1894 that were considered important enough to be reported by the local press. See the *Evening News Telegraph* (Detroit), February 18, 1894 and the *Sunday News Tribune* (Detroit), April 15, 1894. He also hosted a "violet luncheon" at his home in February 1897, according to the *Sunday News-Tribune* (Detroit), February 28, 1897. Photocopies in Charles Lang Freer curatorial files, Freer Gallery of Art.

27 Consider, for example, this 1894 meditation on the nature of human relationships: "The pleasure which love affords is due to a certain harmony between the constitutions of the one loving and the one loved. *Vice versa*, a want of harmony, or *discord*, in two natures produces dislike, or hate"; see Lester Frank Ward, *Dynamic Sociology, or, Applied Social Science* (New York: D. Appleton and Company, 1894), 675, emphasis in original.

28 William Ganson Rose, *Success in Business* (New York: Duffield and Company, 1913), 189.

29 John Hobson's 1894 study (discussed in greater detail in the introduction), though British, drew many of its examples from the contemporary American economy. In its revised edition, published in 1906, Hobson speaks of trusts – groups including Standard Oil, Gould Harriman, Morgan, Vanderbilt, and the Pennsylvania Railroad – as working together in "harmony." He uses this word to highlight the potentially pernicious effects of industrial combinations, lamenting the failure of the competitive market to "strike out harmony" between large corporate entities who instead find ways to cooperate behind the scenes and "secure for themselves advantages arising from improved methods of production without regard for the vested interests of other individuals or of society as a whole." See Hobson, *The Evolution of Modern Capitalism: A Study of Machine Production*, rev. edn. (London: Walter Scott, 1906), 261, 315–16.

30 Robert Conot, *American Odyssey: A History of a Great City* (Detroit: Wayne State University Press, 1986), 95. Tomlinson, in discussing Freer's biography, also notes the tightly interlocked nature of Detroit's business and social worlds; see Tomlinson, "Charles Lang Freer," 27–48. What has not been previously examined, however, is the role that art objects played in cementing some of these communal bonds.

31 See "Church of Statesmen: Chandler, Alger, Joy and Others in their Church Work," *Evening News* (Detroit), November 25, 1888, 7. The Fort Street Presbyterian Church included among its regular attendees, in addition to Freer and Hecker, General Russell A. Alger, James F. Joy, and the Buhl family: all important investors (and, in the cases of Joy and the Buhls, mentors) in Freer's and Hecker's business operations. All of these men also belonged to the St. Clair Fishing and Shooting Club; see "The Clubs of the St. Clair Flats," *Forest and Stream* 25, no. 8 (September 11, 1890): 151. Freer and Hecker both belonged to the Detroit and Yondotega clubs, together with several members of the McMillan family, their close business associates.

32 Charles H. Cooley, "The Institutional Character of Pecuniary Valuation," *American Journal of Sociology* 18, no. 4 (January 1913): 553.

33 In a near-mystical passage, Rose asserts: "The laws of nature will all work for man's advancement, if he will work with the laws … Working against any of these laws will mean opposition from them; working with them will mean harmony"; see Rose, *Success in Business*, 185.

34 Sarah Burns conversely contends that strenuous hunting and fishing scenes like those painted by Winslow Homer may have appealed to Gilded Age business men precisely because they proved a strenuous, masculine antidote to "drawing room" art (like Tryon's); in her view, "Instead of affording the aesthetic escape proffered by many of his contemporaries, Homer's paintings functioned to displace the experience of precariousness and uncertainty, of unpredictable and often disastrous fluctuation, onto the natural world, source of the 'natural law' that regulated economic life"; see Burns, *Inventing the Modern Artist: Art and Culture in Gilded Age America* (New Haven and London: Yale University Press, 1996), 194.

35 On the commissioning of the State Bank building and its mural – both projects guided by Freer, a director of the bank since 1890 – see Bailey Van Hook, *A Mural by Thomas Wilmer Dewing: Commerce and Agriculture Bringing Wealth to Detroit* (New York: Spanierman Gallery, 1998).

36 Ibid., 15, 19.

37 During that same year, Freer and his friends (including Hecker and Russell A. Alger) announced a second commission, this time for a monument designed by Stanford White, with assistance from Dewing, Tryon, Augustus Saint-Gaudens, and Frederick MacMonnies, to commemorate the bicentennial anniversary of Detroit. White's design incorporated a peristyle, fountain, 220-foot Doric column, sculptural groups, and a gas torch on a sacrificial tripod, to stand, in White's words, as "a gateway and beacon to the commerce of the West"; see "Detroit Bicentennial Memorial," *American Architect and Building*

News 68, no. 1277 (June 16, 1900): 88. One of its promotors hoped it would serve as "an advance guard of our later civilization," to "elevate and refine not alone our own city, but all the distant cities and lands which are woven together with the strong network of mutual interests"; see "Detroit's Great Opportunity To Add to its World-Wide Fame," *Detroit Free Press*, March 14, 1900, 5. This classicizing structure was expected to cost approximately one million dollars, but its backers never succeeded in raising adequate funds for its construction.

38 On this period in Detroit history and the central place of Freer's commercial cohort within it, see, for example, Conot, *American Odyssey*; Melvin G. Holli, *Reform in Detroit: Hazen S. Pingree and Urban Politics* (New York: Oxford University Press, 1969); Holli, "Before the Car: Nineteenth-Century Detroit's Transformation from a Commercial into an Industrial City," *Michigan History* 64 (March–April 1980): 33–9; Donald F. Davis, *Conspicuous Production: Automobiles and Elites in Detroit, 1800–1933* (Philadelphia: Temple University Press, 1988); and Graydon M. Meints, *Michigan Railroads and Railroad Companies* (East Lansing: Michigan State University Press, 1992).

39 Tomlinson, "Charles Lang Freer," 28–9. Tomlinson observes that through a New England takeover of Michigan railroads in 1870s, "Men like James Joy and Christian Buhl used Detroit as a homebase for far reaching empires."

40 "Union Trust Company, Detroit, Michigan, USA," *The Times* (London), January 22, 1912, 36.

41 Freer to Emory W. Clark, November 5, 1916, CLFP FGA, Box 13, folder 4.

42 From Freer's undated notes on the Yondotega Club, ibid., Box 52, folder 4.

43 Ibid.

44 Tomlinson interprets the bird and vine motif as related to Freer's membership in the Yondotega Club; see "Charles Lang Freer," 97, 106–7.

45 "The Man of Business and the Business Man," *Scientific American* 36, no. 4 (January 27, 1877): 56.

46 Rose, *Success in Business*, 90.

47 Christian D. Larson, *Business Psychology* (New York: Thomas Y. Crowell and Company, 1912), 109.

48 Robert H. Wiebe, *The Search for Order, 1877–1920* (New York: Hill and Wang, 1967), 230.

49 Among others, see most recently Sven Beckert, *The Monied Metropolis: New York City and the Consolidation of the American Bourgeoisie, 1850–1896* (Cambridge: Cambridge University Press, 2001), 298.

50 Wiebe, *The Search for Order*, 232–4.

51 Hecker resigned from the commission, citing his health, in November 1904; he remained on the board of directors of the Panama Railroad Company until 1905. See "Canal Zone Climate Puts Commissioner Out," *New York Times*, November 18, 1904, 5; and "Farnham a Director of Panama Railroad," *New York Times*, April 18, 1905, 7.

52 Hecker and Freer continued to be involved in expansive enterprises long after the period in which they are typically assumed to have been engaged in active business. Their correspondence on these matters was conducted while Freer was ostensibly vacationing and seeking out art treasures abroad. Their later investments included the International Banking Company and the Los Reyes Gold Mining and Milling Company, as well as a short-lived takeover of the *Detroit Free Press*. Furthermore, it should be noted that even after Freer resigned his directorship of the State Savings Bank, he continued to attempt to influence its management from behind the scenes; see, for example, Freer to Hecker, January 11, 1907, CLFP FGA.

53 Quoted in White, *The Art and Life of Dwight William Tryon*, 81.

54 For Whistler's comment on the Peacock Room, see Elizabeth Robins Pennell and Joseph Pennell, *The Life of James McNeill Whistler*,

vol. 1 (London and Philadelphia: W. Heinemann and J. B. Lippincott, 1908), 204. For Dewing's description of his work for Freer's parlor, see Dewing to Freer, November 18 and 22, 1892, CLFP FGA, Box 14.

55 Although the arrangements between Freer and Dewing may have been less specific than those between Freer and Tryon, the parlor pictures formed part of a long pattern of reciprocal exchange between the artist and his patron, which included not only payment for pictures but also a monetary loan from Freer to Dewing and the patron's sponsorship of a second studio for the artist at Cornish, New Hampshire. See Hobbs, "Thomas Dewing in Cornish," 18 and 31, note 42.

56 Francis Raymond, "The Comparative Exhibition," *Outlook*, December 10, 1904, 932. Sadakichi Hartmann stated that Dewing and Tryon "are like song composers who excel in a simple little melody and never tire of repeating it"; see Hartmann, *A History of American Art* (Boston: L. C. Page, 1901), 135. Hartmann here claims to be repeating a general criticism of Dewing and Tryon and suggests that this description does not reflect his personal opinion of their work.

57 On the Cornish art colony, see Hobbs, "Thomas Dewing in Cornish"; Pyne, *Art and the Higher Life*, 135–49; and *A Circle of Friends: Art Colonies of Cornish and Dublin*, exh. cat. (Durham: University Art Galleries, University of New Hampshire, 1985).

58 Dewing to Freer, February 16, 1901, CLFP FGA, Box 14.

59 On the "elitism" of Freer and his artists, see Clark, "Charles Lang Freer," 63; Pyne, *Art and the Higher Life*, 202; and Glazer, "'A Modern Instance,'" vi.

60 Only Glazer has remarked on this communal thrust of Dewing's statement: "If Dewing's decoration rhetorically placed his work in the inaccessible realm of visionary poetry, it also paid tribute to a more worldly community of sympathetic collectors and like-minded artists that had found its social and aesthetic center at 33 East Ferry Avenue"; see Glazer, "'A Modern Instance,'" 32. Even so, art historians have failed to consider that the constitution of such "like-minded" communities through a shared appreciation of the visual language of Aestheticism might have relevance beyond the art world, in business, politics, and the general operations of elite power groups at the turn of the century.

61 In addition to Dewing interiors like the *Fortune Teller* (1904) and *Brocart de Venise* (ca. 1904–5), Bixby owned the artist's landscape *Silver Birches*; see Pyne, *Art and the Higher Life*, 202, note 180. Gellatly purchased several of the Cornish paintings, most of them apparently shortly after Dewing completed them in the 1890s, including *Spring* (1890), *Hermit Thrush* (1890), and *In the Garden* (1892–4); he later added *La Pêche* (1901–4) to his collection in 1917. Evans began purchasing Dewing landscapes slightly later than Gellatly and apparently with the encouragement of Freer (as will be discussed below), first acquiring *The Lute* (1904) in 1904 and *Summer* (1890, from the collection of Stanford White) in 1907. For provenance, see Hobbs, *Thomas Wilmer Dewing*.

62 Evans to Freer, March 26, 1890, CLFP FGA, Box 15, folder 23.

63 Freer to Evans, November 11, 1901, ibid., letterpress book vol. 15.

64 Evans to Freer, quoted in a letter from Freer to Dewing, November 2, 1904, ibid.

65 Freer to Evans, October 28, 1904, ibid.

66 Freer to Dewing, November 4, 1904, ibid., Box 14. Apparently Freer never lost interest in the painting, and when it came up for sale at Evans's partial liquidation of his collection in 1913, Freer finally acquired it for himself.

67 Gellatly to Freer, November 17, 1917, ibid., Box 16, folder 14. Gellatly had purchased the painting by 1904; see Hobbs, *Thomas Wilmer Dewing: Beauty into Art*, 1:305.

68 For the provenance of *Summer* and *The Recitation*, see Hobbs, *Thomas Wilmer Dewing*, 1:242–3; and 255–8. For the relationship of

Williams and Oakes to Freer (and their investments in his Peninsular Car Company), see ibid., 1:46–7.

69 The exhibition was publicly known to be organized by Twachtman's "friends," but the discussion of the "syndicate" occurred only in private documents. See Dewing to Freer, March 29, [1903] and April 7, 1903, CLFP FGA, Box 14. The existence of the syndicate is also discussed briefly in Tomlinson, "Charles Lang Freer," 44; and in Linda Merrill's research notes in the Freer Gallery of Art files on Twachtman's *Drying Sails*, ca. 1900.

70 Dewing to Freer, February 16, 1901, CLFP FGA Box 14.

71 On the issue of branding and Aestheticism, see Charles de Kay, "Lessons of the Comparative Art Exhibition," *New York Times*, November 20, 1904, Sunday Magazine section; 1; Burns, *Inventing the Modern Artist*, 34; and Glazer, "'A Modern Instance,'" Chapter 1.

72 For the best known and most often cited interpretation of this type, see the scholarship of Bailey Van Hook, particularly *Angels of Art: Women and Art in American Society, 1876–1914* (University Park: Pennsylvania State University Press, 1996) and "Decorative Images of American Women: The Aristocratic Aesthetic of the Late Nineteenth Century," *Smithsonian Studies in American Art* 4, no. 1 (winter 1990): 44–69. See also Roger Stein, "Artifact as Ideology: The Aesthetic Movement in its American Cultural Context," in *In Pursuit of Beauty: Americans and the Aesthetic Movement*, ed. Doreen Bolger Burke (New York: Rizzoli for the Metropolitan Museum of Art, 1986), 41.

73 Pyne, *Art and the Higher Life*, 183, citing the scholarship of Carol Crist and Barbara Gelpi. On evolutionary perfection, see ibid., 198–219, and Pyne, "Evolutionary Typology and the American Woman in the Work of Thomas Dewing," *American Art* 7, no. 4 (autumn 1993): 12–29. Martha Banta reads Dewing's pictures through the writings of John Dewey, who "values any kind of contemplation that leads toward experience, purpose, and inner power"; see Banta, *Imaging American Women: Idea and Ideals in Cultural History* (New York: Columbia University Press, 1987), 355.

74 Freer to Dewing, October 18, 1906, CLFP FGA, letterpress book vol. 19, emphasis in original.

75 Dewing to Freer, August 18, 1893, ibid., Box 14.

76 Freer to Dewing, August 4 and 13, 1892, ibid., letterpress book vol. 1; and Dewing to Freer, August 22, 1893, ibid., Box 14.

77 Dewing to Freer, March 19, 1894, ibid., Box 14. Hobbs discusses these pastels in greater detail in *The Art of Thomas Wilmer Dewing*, 202–18.

78 See Dewing to Freer, December 20 and 26, 1893, and April 9, 1894, CLFP FGA, Box 14. Susan Hobbs clarifies that Dewing, after consideration, chose a similar but smoother paper for these pastels; see Hobbs, *Thomas Wilmer Dewing*, 2:656.

79 On the merger of the Detroit Car Wheel Company, the Michigan Forge & Iron Company, and the Detroit Pipe & Foundry Company under the management of Freer and Hecker's Michigan-Peninsular Car Company, see the Michigan-Peninsular's prospectus published in the *New York Times*, July 13, 1892, 6; Peters and Robinson, *Detroit: Freight Cars before Automobiles*, 7–12; and Meints, "Detroit's First Big Industry," 6–11.

80 Merrill identifies two of Tryon's pastels on brown paper, *Central Park: Moonlight* and *Winter: Connecticut Valley* (both 1894, Freer Gallery of Art), as belonging to the Whistler paper set; see *An Ideal Country*, 120. When Tryon wrote to thank Freer for sending the material, he underscored the associational value of the medium: "Your letter and also the Whistler paper are at hand and I have again to thank you for your kind thought of me. I will take double pleasure in using this paper from its various associations"; see Tryon to Freer, April 5, 1894, CLFP FGA, Box 23. Among the Whistleresque Dewing pastels that resulted from this collaboration are *Sappho* and the *Pink Dress* (both 1893–4, Freer Gallery of Art), despite the fact that Dewing eventually chose a smoother brown paper upon which to work. See Hobbs, *Thomas Wilmer Dewing*, 2:656, 660–1, and 662–3.

81 See Alan Trachtenberg, *The Incorporation of America: Culture and Society in the Gilded Age* (New York: Hill and Wang, 1982), 57; and Alfred D. Chandler, Jr., *The Visible Hand: The Managerial Revolution in American Business* (Cambridge, Mass.: Harvard University Press, 1977), 130. My discussion of how these changes related to railroad car building is heavily indebted to Chandler.

82 Meints points out that the American Car and Foundry Company – an entity created out of an 1899 merger between the Michigan-Peninsular Car Company and several other corporations – introduced an "'assembly-line' technique a half dozen years before Henry Ford refined it at his Highland Park factory to build the Model T"; see "Detroit's First Big Industry," 10.

83 "A Thriving Industry: Description of the New Works of the Peninsular Car Company," *Detroit Free Press*, March 29, 1885, 11.

84 On April 27, 1891, the *Evening News* (Detroit) reported that Freer had spoken to striking workers who insisted that the Peninsular Car Company should pay its employees for nine-hour workdays. Freer had apparently laughed and replied that men who were not his employees had no right to make that request; see photocopy in Freer curatorial files at the Freer Gallery of Art. For an earlier account of Freer speaking directly with striking workers, see "Crossing the City: The Strike Spreads a Distance of Five Miles," *Detroit Free Press*, May 6, 1886, 5, 8.

85 See, for example, Freer to Hecker, April 11 and 26, 1883, Frank J. Hecker Papers, Burton Collection, Detroit Public Library; and Freer to Hecker, September 21, 1894, CLFP FGA, Box 17.

86 Chandler, *The Visible Hand*, 130.

87 Mary Chase Perry Stratton, unpublished memoirs, CLFP FGA.

88 For further ruminations on Aestheticism and accounting, see Melody Barnett Deusner, "Constructing the 'Deadly Parallel': Paintings, Politics, and the Comparative Eye in Turn-of-the-Century Clubland," *American Art* 31, no. 2 (summer 2017), 96–103.

89 This quality is also observed by Hobbs, "Thomas Dewing in Cornish," 21, and *Thomas Wilmer Dewing*, 1:280–2. Hobbs notes that Dewing's wife, specialist in flower painting Maria Oakey Dewing, may have assisted in painting this greenery.

90 On Hecker's screens, see Pyne, "Classical Figures"; and Hobbs, *Thomas Wilmer Dewing*, 1:289–91, 299–301.

91 John Gellatly, William T. Evans, and Thomas B. Clarke were each at one point or another cast by Dewing in a negative light for the sake of shoring up his relationship with Freer; see, for example, Dewing to Freer, April 10, 1894, and December 21, 1893, CLFP FGA, Box 14. On other occasions, Dewing begged Freer to purchase pictures that Gellatly had already rejected, apparently hoping that Gellatly's lack of interest in a picture would augment, rather than detract from, its value in Freer's eyes; see Dewing to Freer, June 22, 1915, ibid.

92 For documentation regarding Tryon's previously unreported investment in Michigan-Peninsular, see Tryon to Freer, July 22, 1892, and August 7 and 27, 1892, CLFP FGA, Box 23; and Freer to Tryon, August 3, 1892, CLFP FGA, letterpress book vol. 1. Tryon was so pleased with the profits that he asked to buy another $2,000 worth of the company's stock the following year, but Freer advised him rather to buy debt endorsed by Michigan-Peninsular in the Central Car Co. Tryon took $3,000 worth, and reinvested in 1894. See Tryon to Freer, May 11 and 20, 1893, and June 12, 1893, CLFP FGA, Box 23; and Freer to Tryon, May 18, 1893, and June 9 and 12, 1893, CLFP FGA, letterpress book vol. 1.

93 Freer sent Newman Montross ten shares ($1,000) in Michigan-Peninsular Preferred Stock in February 1893, but did not indicate whether this constituted payment for a picture or an independent investment from Montross; see Freer to Henry S. Ives, February 14, 1893, CLFP FGA, letterpress book vol. 1. Stanford White invested $50,000 in the newly founded American Car and Foundry Company in 1899, on behalf of a "beautiful lady"; see White to John Scoville, February 11, 1899, Stanford White Papers, Avery Library, Columbia

University, New York, letterpress book vol. 24, p. 440 (transcribed by Kenneth Myers and held in American Car & Foundry Co. curatorial files at Freer Gallery of Art). Freer purchased Dewing's *La Comedienne* and *Mandolin* in June 1906 for a total of $3,000, paid in bonds for an unspecified company; see Freer to Dewing, June 30, 1906, CLFP FGA, letterpress book vol. 20, cited in Freer Gallery of Art electronic collection records by Merrill for *La Comedienne*, dated June 29, 1993.

94 Richard Murray, "Abbott Thayer's Stevenson Memorial," *American Art* 13, no. 2 (summer 1999): 4–5.

95 For analyses of Thayer's art and writings with an eye toward his grief, anxiety, and nervous exhaustion, see Alexander Nemerov, "Vanishing Americans: Abbott Thayer, Theodore Roosevelt, and the Attraction of Camouflage," *American Art* 11, no. 2 (summer 1997): 50–81; and Elizabeth Lee, "Therapeutic Beauty: Abbott Thayer, Antimodernism, and the Fear of Disease," *American Art* 18, no. 3 (fall 2004): 32–51.

96 Thayer to Freer, May 20, 1893, CLFP FGA, Box 29.

97 Ibid.

98 "I … trust to teaching the American to invest in them as a form of public spirit, recognizing them as … of an inestimable value to the nation." After finishing a picture, he hopes that "some noble gentleman … will pay the price the nation owes for it!"; see ibid.

99 "If you lend me, could it not be protected by my written promise to let you have first choice of every subsequent canvas[?]"; see Thayer to Freer, January 18, 1894, CLFP FGA, Box 29.

100 Thayer to Freer, January 23, 1894, ibid.

101 Thayer to Freer, January 18, 1894, ibid.

102 Thayer to Freer, August 20, 1894, ibid.

103 Thayer to Freer, December 1, 1895, ibid.

104 Thayer to Freer, May 1, 1896, ibid.

105 On Thayer's experimental studio practices, see Murray, "Abbott Thayer's Stevenson Memorial."

106 Thayer to Freer, October 19, 1908, CLFP FGA, Box 29.

107 Thayer to Freer, September 10, 1903, ibid.

108 Thayer to Gellatly, March 5, [1908], John Gellatly Papers, Archives of American Art, Smithsonian Institution.

109 Electronic curatorial records for Thayer, *Cornish Headlands*, Freer Gallery of Art.

110 Gellatly to Emma Thayer, May 12, 1918, Thayer Papers, Archives of American Art, Smithsonian Institution.

111 Freer owned Dewing's *A Portrait* (Freer Gallery of Art) and Gellatly his *The Spinet* (Smithsonian American Art Museum), both 1902.

112 On the Freer gift, see Linda Merrill, "Composing the Collection," in Lawton and Merrill, *Freer: A Legacy of Art*, 182–201.

113 Freer to Samuel P. Langley, December 27, 1904, CLFP FGA, Box 20.

114 Freer to Hecker, January 17, 1905, and February 7, 1905, ibid.; Freer to Langley, January 18, 1905, ibid., Box 20.

115 Merrill, "Composing the Collection," 198–201.

116 For an example of Freer's coordination with his chosen artists to plan the hanging and lighting of their works in the museum, see Freer to Thayer, August 12, 1912, CLFP FGA, Box 29.

CONCLUSION

1 Ernest F. Fenollosa, "The Collection of Mr. Charles L. Freer," *Pacific Era* 1, no. 2 (November 1907), 61.

2 For the most complete history of the room, see Linda Merrill, *The Peacock Room: A Cultural Biography* (Washington, D.C.: Freer Gallery of Art, 1998).

3 Ibid., 343, note 236. See also Lee Glazer and Margaret R. Laster, "Introduction," in *Palaces of Art: Whistler and the Art Worlds of Aestheticism*, ed. Lee Glazer and Linda Merrill (Washington, D.C.: Smithsonian Institution Scholarly Press, 2013), 3.

4 Merrill, *The Peacock Room*, 23, 344.

5 Julian Roby, "Director's Statement," in *Darren Waterston: Filthy Lucre*, exh. cat. (New York: Skira Rizzoli, 2014), 119.

6 Lee Glazer and Maya Foo, "The Peacock Room Comes to America," Freer Gallery of Art, https://www.youtube.com/watch?v=sWbbYT2x12M.

7 Ibid.

8 See, for example, Paul Stirton, exhibition review, *West 86th: A Journal of Decorative Arts, Design History, and Material Culture* 19, no. 1 (spring–summer 2012), 135–6; and Waldemar Januszczak, "Beautiful to Behold," *Sunday Times*, April 3, 2011.

9 Susan Cross, "Beauty and Bile: Darren Waterston's *Filthy Lucre*," in *Darren Waterston: Filthy Lucre*, 13.

10 John Ott, "Eruptions in Art and Money," in *Darren Waterston: Filthy Lucre*, 107.

11 *The Correspondence of James McNeill Whistler, 1855–1903*, ed. by Margaret F. MacDonald, Patricia de Montfort, and Nigel Thorp; including *The Correspondence of Anna McNeill Whistler, 1829–1880*, ed. Georgia Toutziari, online edition, University of Glasgow, 2003–10, http://www.whistler.arts.gla.ac.uk/correspondence; and Margaret F. MacDonald, Grischka Petri, Meg Hausberg, and Joanna Meacock, *James McNeill Whistler: The Etchings, a Catalogue Raisonné*, online edition, University of Glasgow, 2012, http://www.etchings.arts.gla.ac.uk.

12 Alphonse Esquiros, *British Seamen and Divers* (London: Chapman and Hall, 1868), 187–8, quoted in introduction.

13 In 1991, for instance, the Metropolitan Museum of Art landed the Walter H. Annenberg collection of Impressionist pictures, outbidding the Philadelphia Museum of Art, the National Gallery of Art in Washington, D.C., and the Los Angeles County Museum of Art. All four institutions had hosted a traveling exhibition of the collection as they competed to secure the favor of Annenberg, who announced that the pictures could not be loaned, deaccessioned, or broken up. Each museum pitched Annenberg its own vision for the future, and some went so far as to invent unasked-for concessions. The Metropolitan won the billion-dollar prize with an eight-foot-square model of the proposed permanent installation and a documentary in which the Annenbergs could introduce their pictures to the public personally and perpetually. Today, the Annenberg paintings can be found lodged inside separate galleries nested within the museum's late nineteenth-century French holdings. See, among others, Grace Glueck, "Portrait of a Collector: Walter Annenberg," *New York Times*, April 25, 1990, C13; and William H. Honan, "A Diplomatic Dance to Win the Annenberg," *New York Times*, April 1, 1991, C11.

BIBLIOGRAPHY

This book draws upon an extensive range of primary sources. For the reader's convenience, most newspaper and magazine articles are cited in chapter notes but omitted from the bibliography.

Abdy, Jane, and Charlotte Gere. *The Souls*. London: Sidgwick & Jackson, 1984.

— *The Souls: An Exhibition*. London: Bury Street Gallery, 1982. Exhibition catalog.

Abelson, Elaine. *When Ladies go a-Thieving: Middle-Class Shoplifters in the Victorian Department Store*. New York: Oxford University Press, 1989.

Adams, Amanda. *Performing Authorship in the Nineteenth-Century Transatlantic Lecture Tour*. Farnham: Ashgate, 2014.

Adams, R. J. Q. *Balfour: The Last Grandee*. London: John Murray, 2007.

Adburgham, Alison. *Liberty's: A Biography of a Shop*. London: George Allen and Unwin, 1975.

After Whistler: The Artist and his Influence on American Painting. Atlanta: High Museum of Art, 2003. Exhibition catalog.

The Age of Rossetti, Burne-Jones & Watts: Symbolism in Britain, 1860–1910. London: Tate Gallery Publishing, 1997. Exhibition catalog.

Alford, Marianne Margaret Compton Cust [Lady M. Alford]. *Needlework as Art*. London: S. Low, Marston, Searle, and Rivington, 1886.

Alger, Russell A. *The Spanish-American War*. New York and London: Harper & Brothers Publishers, 1901.

Alloway, Lawrence. *Network: Art and the Complex Present*. Ann Arbor: UMI Research Press, 1984.

An American Perspective: Nineteenth-Century Art from the Collection of Jo Ann & Julian Ganz, Jr. Washington, D.C.: National Gallery of Art, 1981. Exhibition catalog.

The American Renaissance, 1876–1917. Brooklyn: Brooklyn Museum, 1979. Exhibition catalog.

American Tonalism: Selections from the Metropolitan Museum of Art and the Montclair Art Museum. Montclair, N.J.: Montclair Art Museum, 1999. Exhibition catalog.

Anderson, Anne. "'The Colonel': Shams, Charlatans, and Oscar Wilde." *The Wildean: Journal of the Oscar Wilde Society* 24 (July 2004): 34–53.

— "The Mutual Admiration Society, or Mr. Punch against the Aesthetes." *Popular Narrative Media* 2, no. 1 (2009): 69–88.

—. "Wilde, Whistler, and Staging 'Art for Art's Sake.'" *Theatre Notebook* 70, no. 1 (2016): 32–65.

Anderson, Benedict. *Imagined Communities: Reflection on the Origin and Spread of Nationalism*. London: Verso, 1983.

Arnold, Horace Lucian. *The Factory Manager and Accountant: Some Examples of the Latest American Factory Practice*. New York: Engineering Magazine, 1903.

Arscott, Caroline. "Stenographic Notation: Whistler's Etchings of Venice." *Oxford Art Journal* 29, no. 3 (2006): 371–93.

— "Subject and Object in Whistler: The Context of Physiological Aesthetics," in *Palaces of Art: Whistler and the Art Worlds of Aestheticism*, ed. Lee Glazer and Linda Merrill, 55–65. Washington, D.C.: Smithsonian Institution Scholarly Press, 2013.

—. *William Morris and Edward Burne-Jones: Interlacings*. New Haven and London: Yale University Press for the Paul Mellon Centre for Studies in British Art, 2008.

Artistic Houses: Being a Series of Interior Views of a Number of the Most Beautiful and Celebrated Homes in the United States, with a Description of the Art Treasures Contained therein. New York: D. Appleton and Company, 1883–4.

Asleson, Robyn. *Albert Moore*. London: Phaidon, 2000.

Aslet, Clive. *The Last Country Houses*. New Haven and London: Yale University Press, 1982.

Aslin, Elizabeth. *The Aesthetic Movement: Prelude to Art Nouveau*. New York: Praeger, 1969.

—. *Nineteenth Century English Furniture*. New York: T. Yoseloff, 1962.

Asquith, Margot Tennant. *An Autobiography*, 2 vols. New York: George H. Doran Company, 1920.

—. *Off the Record*. London: Frederick Muller, 1943.

—. *Remember and Be Glad*. London: James Barrie, 1952.

Atlas, Allan W. "Lord Arthur's 'Infernals': Balfour and the Concertina." *Musical Times* 149, no. 1904 (autumn 2008): 35–51.

Baekeland, Frederick. "Collectors of American Painting 1813–1913." *American Art Review* 3, no. 6 (November–December 1976): 120–66.

Balfour, Arthur James. *Criticism and Beauty: A Lecture Rewritten*. Oxford: Clarendon Press, 1910.

—. *A Defence of Philosophic Doubt: Being an Essay on the Foundations of Belief*. London: Macmillan and Co., 1879.

—. *The Foundations of Belief*. London: Longmans, Green & Co., 1895.

—. *The Mind of Arthur James Balfour: Selections from his Non-Political Writings, Speeches, and Addresses, 1879–1917*. New York: George H. Doran, 1918.

—. *Retrospect: An Unfinished Autobiography, 1848–1886*. Boston: Houghton Mifflin, 1930.

—. "The Works of G. F. Handel." *Edinburgh Review* 165, no. 337 (January 1887): 214–47.

Balfour, Frances. *Ne Obliviscaris: Dinna Forget*, 2 vols. London: Hodder and Stoughton, 1930.

Banta, Martha. *Imaging American Women: Idea and Ideals in Cultural History*. New York: Columbia University Press, 1987.

Barnaby, Alice. *Light Touches: Cultural Practices of Illumination, 1800–1900*. London: Routledge, 2017.

Barratt, Carrie Rebora. "George A. Hearn: 'Good American Pictures Can Hold Their Own.'" *Antiques* 157, no. 1 (January 2000): 218–23.

Barringer, Tim, and Elizabeth Prettejohn, eds. *Frederic Leighton: Antiquity, Renaissance, Modernity*. New Haven and London: Yale University Press for the Paul Mellon Centre for Studies in British Art and the Yale Center for British Art, 1999. Exhibition catalog.

Barringer, Tim, Jason Rosenfeld, and Alison Smith. *Pre-Raphaelites: Victorian Avant-Garde*. London: Tate, 2012. Exhibition catalog.

Barrow, R. J. *Lawrence Alma-Tadema*. London: Phaidon, 2003.

Baxandall, Michael. *Painting and Experience in Fifteenth-Century Italy*. Oxford: Clarendon Press, 1972.

Beard, George M. *American Nervousness: Its Causes and Consequences*. New York: G. P. Putnam's Sons, 1881.

Beauchamp, K. G. *Exhibiting Electricity*. IEE History of Technologies Series, 21. London: Institution of Electrical Engineers, 1997.

Beaufort, Madeline Fidell, and Jeanne K. Welcher. "Some Views of Art Buying in New York in the 1870s and 1880s." *Oxford Art Journal* 5, no. 1 (1982): 48–55.

Becker, Edwin, ed. *Sir Lawrence Alma-Tadema*. New York: Rizzoli, 1997. Exhibition catalog.

Becker, Howard Saul. *Art Worlds*. Berkeley: University of California Press, 1982.

Becker, Jack. "A Taste for Landscape: Studies in American Tonalism." PhD diss., University of Delaware, 2002.

Beckert, Sven. *The Monied Metropolis: New York City and the Consolidation of the American Bourgeoisie, 1850–1896*. Cambridge: Cambridge University Press, 2001.

— and Julia B. Rosenbaum, eds. *The American Bourgeoisie: Distinction and Identity in the Nineteenth Century*. New York: Palgrave Macmillan, 2010.

Beegan, Gerry. *The Mass Image: A Social History of Photomechanical Reproduction in Victorian London*. Basingstoke: Palgrave Macmillan, 2008.

Beer, Janet, and Bridget Bennett, eds. *Special Relationships: Anglo-American Antagonisms and Affinities, 1854–1936*. New York: Manchester University Press, 2002.

Bell, Malcolm. *Sir Edward Burne-Jones: A Record and Review*. London: George Bell & Sons, 1899.

Bender, John, and Michael Marrinan. *The Culture of Diagram*. Stanford: Stanford University Press, 2010.

Bendix, Deanna Marohn. *Diabolical Designs: Paintings, Interiors, and Exhibitions of James McNeill Whistler*. Washington, D.C.: Smithsonian Institution Press, 1995.

Bennett, Tony, Lawrence Grossberg, and Meaghan Morris, eds. *New Keywords*. Malden, Mass.: Blackwell Publishing, 2005.

Bently, Lionel, Jennifer Davis, and Jane C. Ginsburg, eds. *Copyright and Piracy: An Interdisciplinary Critique*. Cambridge: Cambridge University Press, 2010.

Berger, Maurice. "Edward Burne-Jones's Perseus-Cycle: The Vulnerable Medusa." *Arts Magazine* 54 (April 1980): 149–53.

Best, Antony, and John Fisher, eds. *On the Fringes of Diplomacy: Influences on British Foreign Policy*. Farnham: Ashgate, 2011.

Bienenstock, Jennifer A. "The Formation and Early Years of the Society of American Artists: 1877–1884." PhD diss., City University of New York, 1983.

Black, Robert Monro. *The History of Electric Wires and Cables*. London: Peter Peregrinus Ltd., 1983.

Blackburn, Henry. *English Art in 1884*. New York: D. Appleton and Company, 1885.

Blanchard, Mary Warner. *Oscar Wilde's America: Counterculture in the Gilded Age*. New Haven and London: Yale University Press, 1998.

Blaugrund, Annette. *Paris 1889: American Artists at the Universal Exposition*. Philadelphia and New York: Pennsylvania Academy of the Fine Arts and H. N. Abrams, 1989.

—. "The Tenth Street Studio Building." PhD diss., Columbia University, 1987.

Blondheim, Menahem. *News Over the Wires: The Telegraph and the Flow of Public Information in America, 1844–1897*. Cambridge, Mass.: Harvard University Press, 1994.

Boime, Albert. "America's Purchasing Power and the Evolution of European Art in the Late Nineteenth-Century," in *Saloni, gallerie, musei e loro influenza sullo sviluppo dell'arte dei secoli XIX e XX*, ed. Francis Haskell, 123–39. Bologna: CLUEB, 1981.

—. "Entrepreneurial Patronage in Nineteenth-Century France," in *Enterprise and Entrepreneurs in Nineteenth- and Twentieth-Century France*, ed. Edward C. Carter II, Robert Forster, and Joseph N. Moody, 137–207. Baltimore: Johns Hopkins University Press, 1979.

—. "Ryder on a Gilded Horse." *Zeitschrift für Kunstgeschichte* 56, no. 4 (1993): 564–75.

Bolger, Doreen. "William Macbeth and George A. Hearn: Collecting American Art, 1905–1910." *Archives of American Art Journal* 15, no. 2 (1975): 9–15.

Boos, Florence Saunders. *The Design of William Morris' "The Earthly Paradise."* Lewiston, N.Y.: E. Mellen Press, 1990.

Boris, Eileen. *Art and Labor: Ruskin, Morris, and the Craftsman Ideal in America*. Philadelphia: Temple University Press, 1986.

Bourdieu, Pierre. *Distinction: A Social Critique of the Judgment of Taste*. Cambridge, Mass.: Harvard University Press, 1984.

Bourne, Kenneth. *Britain and the Balance of Power in North America, 1815–1908*. Berkeley: University of California Press, 1967.

Boyer, M. Christine. *Manhattan Manners: Architecture and Style, 1850–1900*. New York: Rizzoli, 1985.

Brake, Laurel, and Marysa Demoor, eds. *The Lure of Illustration in the Nineteenth Century: Picture and Press*. New York: Palgrave Macmillan, 2009.

Brandon, Ruth. *The Dollar Princess: Sagas of Upward Nobility, 1870–1914*. London: Weidenfeld and Nicolson, 1980.

Brown, Alan Willard. *The Metaphysical Society: Victorian Minds in Crisis, 1869–1880*. New York: Columbia University Press, 1947.

Brown, Bill. "Thing Theory." *Critical Inquiry* 28, no. 1. (autumn 2001): 1–22.

Brown, Jocelyn Marie. "An American Collector: John Gellatly." MA thesis, George Washington University, September 1971.

Brown, Joshua. *Beyond the Lines: Pictorial Reporting, Everyday Life, and the Crisis of Gilded Age America*. Berkeley: University of California Press, 2002.

Brumbaugh, Thomas. "The American 19th Century, Part 3: The Gellatly Legacy." *Art News* 67 (September 1968): 48–51, 58–60.

Brunk, Thomas W. "The Charles L. Freer Residence: The Original Freer Gallery of Art." *Dichotomy* 12 (fall 1999): 6–150.

Bryan, Emily. "Nineteenth-Century Charade Dramas: Syllables of Gentility and Sociability." *Nineteenth Century Theatre and Film* 29, no. 1 (summer 2002): 32–48.

Bullen, J. B. *The Pre-Raphaelite Body: Fear and Desire in Painting, Poetry, and Criticism*. Oxford: Clarendon Press, 1998.

Burk, Kathleen. *Old World, New World: Great Britain and America from the Beginning.* New York: Atlantic Monthly Press, 2008.

Burke, Doreen Bolger. *American Paintings in the Metropolitan Museum of Art,* vol. 3. New York: Metropolitan Museum of Art, 1980.

—, ed. *In Pursuit of Beauty: Americans and the Aesthetic Movement.* New York: Rizzoli for the Metropolitan Museum of Art, 1986. Exhibition catalog.

Burne-Jones, Edward. *Burne-Jones Talking: His Conversations, 1895–1898, Preserved by his Studio Assistant, Thomas Rooke,* ed. Mary Lago. Columbia: University of Missouri Press, 1981.

Burne-Jones, Georgiana. *Memorials of Edward Burne-Jones,* 2 vols. London: Macmillan & Co., 1904.

Burne-Jones, Philip. "Notes on Some Unfinished Works of Sir Edward Burne-Jones, BT." *Magazine of Art* (1900): 159–67.

Burne-Jones: The Paintings, Graphic and Decorative Work of Sir Edward Burne-Jones 1833–98. London: Arts Council of Great Britain, 1975. Exhibition catalog.

Burns, Sarah. *Inventing the Modern Artist: Art and Culture in Gilded Age America.* New Haven and London: Yale University Press, 1996.

—. "The Poetic Mood in American Painting: George Fuller and Thomas Wilmer Dewing." PhD diss., University of Illinois at Urbana-Champaign, 1979.

—. "The Price of Beauty: Art, Commerce, and the Late Nineteenth-Century Studio Interior," in *American Iconology: New Approaches to Nineteenth Century Art and Literature,* ed. David C. Miller, 209–38. New Haven and London: Yale University Press, 1993.

—, and John Davis, eds. *American Art to 1900: A Documentary History.* Berkeley: University of California Press, 2009.

Bury, Shirley. *Jewellery, 1789–1910.* Woodbridge: Antique Collectors' Club, 1991.

Calloway, Stephen, and Lynn Federle Orr, eds. *The Cult of Beauty: The Aesthetic Movement 1860–1900.* London: V&A Publishing, 2011. Exhibition catalog.

Candace Wheeler: The Art and Enterprise of American Design 1875–1900. New York: Metropolitan Museum of Art, 2001. Exhibition catalog.

Cannadine, David. *The Decline and Fall of the British Aristocracy.* New Haven and London: Yale University Press, 1990.

Carey, James W. *Communication as Culture: Essays on Media and Society.* Boston: Unwin Hyman, 1989.

Carnes, Mark C. *Secret Ritual and Manhood in Victorian America.* New Haven and London: Yale University Press, 1989.

—, and Clyde Griffen, eds. *Meanings for Manhood: Constructions of Masculinity in Victorian America.* Chicago: University of Chicago Press, 1990.

Carruthers, Annette. "Symbolism and Politics in Morris & Co. Tapestries from Melsetter House, Orkney." *Burlington Magazine* 147 (June 2005): 383–9.

Casteras, Susan P. *English Pre-Raphaelitism and its Reception in America in the Nineteenth Century.* London: Associated University Presses, 1990.

—, and Alicia Craig Faxon, eds. *Pre-Raphaelite Art in its European Context.* London: Associated University Presses, 1995.

A Catalogue of the Contents of 4 Carlton Gardens, S.W. London: Knight, Frank, and Rutley, 1929.

Chaloupka, William, and William Stearns, eds. *Jean Baudrillard: The Disappearance of Art and Politics,* trans. Michel Vanentin. New York: St. Martin's, 1992.

Chambers, Emma. "From Chemical Process to the Aesthetics of Omission." *Art History* 20, no. 4 (December 1997): 556–74.

Chandler, Jr., Alfred D. *The Visible Hand: The Managerial Revolution in American Business.* Cambridge, Mass.: Harvard University Press, 1977.

Chandler, George. *Liverpool Shipping: A Short History.* London: Phoenix House, 1960.

Cheney, Liana de Girolami. "Edward Burne-Jones's *Andromeda*: Transformation of Historical and Mythological Sources." *Artibus et Historiae* 25, no. 49 (2004): 197–227.

Child, Theodore. "A Pre-Raphaelite Mansion." *Harper's New Monthly Magazine* 82, no. 487 (December 1890): 81–99.

Christian, John. "Burne-Jones's Second Italian Journey." *Apollo* 102 (November 1975): 334–7.

A Circle of Friends: Art Colonies of Cornish and Dublin. Durham: University Art Galleries, University of New Hampshire, 1985. Exhibition catalog.

Clapper, Michael. "'I Was Once a Barefoot Boy!' Cultural Tensions in a Popular Chromo." *American Art* 16, no. 2 (July 2002): 17–39.

Clark, Jennifer. "John Bull's American Connection: The Allegorical Interpretation of England and the Anglo-American Relationship." *Huntington Library Quarterly* 53, no. 1 (winter 1990): 15–39.

Clark, Nichols. "Charles Lang Freer: An American Aesthete in the Gilded Era." *American Art Journal* 11, no. 4 (October 1979): 54–68.

Clayson, Hollis. *Illuminated Paris: Essays on Art and Lighting in the Belle Epoque.* Chicago: University of Chicago Press, 2019.

Clayton, Anthony. "'Greenery-yallery, Grosvenor Gallery': Avant Garde Outpost and Power Supply Pioneer." *Westminster History Review* (2000): 14–22.

Cleveland, David A. *A History of American Tonalism: 1880–1920.* Manchester, Vt.: Hudson Hills Press, 2010.

Cline, C. L., ed. *The Owl and the Rossettis: Letters of Charles A. Howell and Dante Gabriel, Christina, and William Michael Rossetti.* University Park: Pennsylvania State University Press, 1978.

Colvin, Sidney. "English Painters and Painting in 1867." *Fortnightly Review* 2, no. 10 (October 1867): 464–76.

Conn, Steven. *Museums and American Intellectual Life, 1876–1926.* Chicago: University of Chicago Press, 1998.

Conot, Robert. *American Odyssey: A History of a Great City.* Detroit: Wayne State University Press, 1986.

Constable, W. G. *Art Collecting in the United States of America: An Outline of a History.* London: Nelson, 1964.

Cook, Clarence. *The House Beautiful.* New York: Scribner, Armstrong and Company, 1878.

—. *What Shall We Do With Our Walls?* New York: Warren, Fuller, and Lange, 1881.

Cooley, Charles H. "The Institutional Character of Pecuniary Valuation." *American Journal of Sociology* 18, no. 4 (January 1913): 543–55.

Cooney, Gabriel. "Building the Future on the Past: Archaeology and the Construction of National Identity in Ireland," in *Nationalism and Archaeology in Europe,* ed. Margarita Díaz-Andreu and Timothy Champion, 146–63. Boulder, CO: Westview Press, 1996.

Cooper, Nicholas, and H. Bedford Lemere. *The Opulent Eye: Late Victorian and Edwardian Taste in Interior Design.* London: Architectural Press, 1976.

Corbett, David Peters. *The World in Paint: Modern Art and Visuality in England, 1848–1914.* University Park: Pennsylvania State University Press, 2004.

—, and Lara Perry, eds. *English Art, 1860–1914.* New Brunswick, N.J.: Rutgers University Press, 2001.

—, and Sarah Monks, eds. *Anglo-American: Artistic Exchange between Britain and the USA.* Oxford: Wiley-Blackwell, 2012.

Corn, Wanda M. *The Color of Mood: American Tonalism: 1880–1910.* San Francisco: M. H. De Young Memorial Museum, 1972. Exhibition catalog.

The Correspondence of James McNeill Whistler, 1855–1903, ed. Margaret F. MacDonald, Patricia de Montfort, and Nigel Thorp; including *The Correspondence of Anna McNeill Whistler, 1829–1880,* ed. Georgia Toutziari. Online edition, University of Glasgow, 2003–10, http://www.whistler.arts.gla.ac.uk/correspondence.

Crapol, Edward P. *America for Americans: Economic Nationalism and Anglophobia in the Late Nineteenth Century.* Westport, Conn.: Greenwood Press, 1973.

Craven, Wayne. *Gilded Mansions: Grand Architecture and High Society.* New York: W. W. Norton & Co., 2009.

—. *Stanford White: Decorator in Opulence and Dealer in Antiquities.* New York: Columbia University Press, 2005.

Crook, J. Mordaunt. *The Rise of the Nouveaux Riches: Style and Status in Victorian and Edwardian Architecture.* London: John Murray, 1999.

Curry, David Park. *James McNeill Whistler: Uneasy Pieces.* Richmond: Virginia Museum of Fine Arts, 2004.

—. "The Painting Over the Table." *Source: Notes in the History of Art* 24, no. 2 (winter 2005): 60–9.

Dakers, Caroline. *Clouds: The Biography of a Country House.* New Haven and London: Yale University Press, 1993.

—. *The Holland Park Circle: Artists and Victorian Society.* New Haven and London: Yale University Press, 1999.

Danahay, Martin A. "Mirrors of Masculine Desire: Narcissus and Pygmalion in Victorian Representation." *Victorian Poetry* 32, no. 1 (spring 1994): 35–54.

Darren Waterston: Filthy Lucre (New York: Skira Rizzoli, 2014). Exhibition catalog.

Davidoff, Leonore. *The Best Circles: Society, Etiquette, and the Season.* London: Croom Helm, 1973.

Davis, Donald F. *Conspicuous Production: Automobiles and Elites in Detroit, 1800–1933.* Philadelphia: Temple University Press, 1988.

Davis, Elliot Bostwick, et al. *American Painting.* Boston: MFA Publications, 2003.

De la Peña, Carolin, and Siva Vaidhyanathan, eds. "Rewiring the 'Nation': The Place of Technology in American Studies." Special issue, *American Quarterly* 58, no. 3 (September 2006).

Dearinger, David B., et al. *Rave Reviews: American Art and its Critics, 1826–1925.* New York: National Academy of Design, 2000.

Denney, Colleen. *At the Temple of Art: The Grosvenor Gallery 1877–1890.* Madison, N.J.: Fairleigh Dickinson University Press, 2000.

—, and Susan P. Casteras, eds. *The Grosvenor Gallery: A Palace of Art in Victorian England.* New Haven and London: Yale University Press, 1996.

Desmond, Harry W., and Herbert Croly. *Stately Homes of America: From Colonial Times to the Present Day.* New York: D. Appleton and Company, 1903.

Deusner, Melody Barnett. "Constructing the 'Deadly Parallel': Paintings, Politics, and the Comparative Eye in Turn-of-the-Century Clubland." *American Art* 31, no. 2 (summer 2017): 96–103.

—. "'In seen and unseen places': The Henry G. Marquand House and Collections in England and America." *Art History* 34, no. 4 (September 2011): 754–73.

—. "Whistler, Aestheticism, and the Networked World," in *Palaces of Art: Whistler and the Art Worlds of Aestheticism,* ed. Lee Glazer and Linda Merrill, 149–64. Washington, D.C.: Smithsonian Institution Scholarly Press, 2013.

Dickason, David Howard. *The Daring Young Men.* Bloomington: Indiana University Press, 1953.

Dillon, Maureen. *Artificial Sunshine: A Social History of Domestic Lighting.* London: National Trust, 2002.

DiMaggio, Paul. "Cultural Entrepreneurship in Nineteenth-Century Boston, Part I: The Creation of an Organizational Base of High Culture in America." *Media, Culture and Society* 4, no. 1 (1982): 33–50.

—. "Cultural Entrepreneurship in Nineteenth-Century Boston, Part II: The Classification and Framing of American Art." *Media, Culture and Society* 4, no. 4 (1982): 303–22.

—, and Michael Useem. "Social Class and Arts Consumption: The Origins and Consequences of Class Difference in Exposure to the Arts in America." *Theory and Society* 5, no. 2 (March 1978): 141–61.

Dimbleby, David, and David Reynolds. *An Ocean Apart: The Relationship between Britain and America in the Twentieth Century.* New York: Random House, 1988.

Donnelly, Max. "British Furniture at the Philadelphia Centennial." *Furniture History* 37 (January 2001): 91–120.

—. "Cottier and Company, Art Furniture Makers." *Magazine Antiques* 159, no. 6. (June 2001): 916–25.

—. "Daniel Cottier, Pioneer of Aestheticism." *Journal of the Decorative Arts Society 1850–the Present,* no. 23 (1999): 32–51.

Dorment, Richard, and Margaret F. MacDonald. *James McNeill Whistler.* New York: H. N. Abrams, 1995.

Dougan, David. *The Great Gun-Maker: The Story of Lord Armstrong.* Newcastle upon Tyne: Northern Heritage, 1971.

Dowling, Linda C. *The Vulgarization of Art: The Victorians and Aesthetic Democracy.* Charlottesville: University Press of Virginia, 1996.

Drew, Mary Gladstone. *Some Hawarden Letters, 1878–1913,* ed. Lisle March-Phillipps and Bertram Christian. New York: Dodd, Mead & Co., 1918.

Du Boff, Richard B. "The Telegraph in Nineteenth-Century America: Technology and Monopoly." *Comparative Studies in Society and History* 26, no. 4 (October 1984): 571–86.

Du Maurier, George. *English Society at Home.* Boston: J. R. Osgood & Co., 1881.

Dugdale, Blanche. *Arthur James Balfour, First Earl of Balfour.* London: Hutchinson, 1936.

—. *Family Homespun.* London: John Murray, 1940.

Dunlap, Joseph R. *The Book That Never Was.* New York: Oriole, 1971.

Duval, M. Susan. "F. R. Leyland, A Maecenas from Liverpool." *Apollo* 114 (August 1986): 110–15.

—. "A Reconstruction of F. R. Leyland's Collection: An Aspect of Northern British Patronage." MA thesis, Courtauld Institute of Art, 1982.

Eastlake, Charles L. *Hints on Household Taste in Furniture, Upholstery, and Other Details.* London: Longmans, & Co., 1868. Boston: J. R. Osgood & Co., 1872.

Edward Burne-Jones: The Earthly Paradise. Ostfildern: Hatje Cantz Verlag, 2009. Exhibition catalog.

Edward Burne-Jones, Victorian Artist-Dreamer. New York: Metropolitan Museum of Art, 1998. Exhibition catalog.

Egremont, Max. *Balfour: A Life of Arthur James Balfour.* London: Collins, 1980.

Eisenman, Stephen. *Design in the Age of Darwin: From William Morris to Frank Lloyd Wright.* Evanston, Ill. Northwestern University Press, 2008. Exhibition catalog.

Eldredge, Charles C. *American Imagination and Symbolist Painting.* New York: Grey Art Gallery and Study Center, New York University, 1979. Exhibition catalog.

Ellenberger, Nancy Waters. "Constructing George Wyndham: Narratives of Aristocratic Masculinity in Fin-de-Siècle England." *Journal of British Studies* 39, no. 4 (October 2000): 487–517.

—. "The Souls and London 'Society' at the End of the Nineteenth Century." *Victorian Studies* 25, no. 2 (winter 1982): 133–60.

—. "The Souls: High Society and Politics in Late Victorian Britain." PhD diss., University of Oregon, 1982.

Emirbayer, Mustafa, and Jeff Goodwin. "Network Analysis, Culture, and the Problem of Agency." *American Journal of Sociology* 99, no. 6 (May 1994): 1411–54.

Empires Restored, Elysium Revisited: The Art of Sir Lawrence Alma-Tadema. Williamstown, Mass.: Sterling and Francine Clark Art Institute, 1991. Exhibition catalog.

Erickson, Bonnie H. Review of *Social Network Analysis: Methods and Applications,* by Stanley Wasserman and Katherine Faust. *Historical Methods* 30, no. 3 (summer 1997): 149–58.

E. W. Godwin: Aesthetic Movement Architect and Designer. New Haven and London: Yale University Press, 1999. Exhibition catalog.

Exhibition of the Works of Edward Burne-Jones, 1892–3. London: New Gallery, 1892. Exhibition catalog.

Fahlman, Betsy. "Wilson Eyre in Detroit: Charles Lang Freer House." *Winterthur Portfolio* 15, no. 3 (autumn 1980): 257–70.

Fairfield, Francis Gerry. *The Clubs of New York: With an Account of the Origin, Progress, Present Condition and Membership of the Leading Clubs*. New York: Henry L. Hinton, 1873.

Farmer, Silas. *The History of Detroit and Michigan: Or, the Metropolis Illustrated*. Detroit: Silas Farmer & Co., 1884.

Faude, Wilson H. "Associated Artists and the American Renaissance in the Decorative Arts." *Winterthur Portfolio* 10 (1975): 101–30.

Faxon, Alicia Craig. "Rossetti's Reputation: A Study of the Dissemination of his Art through Photographs." *Visual Resources* 8 (1992): 219–45.

Fennell, Jr., Francis L., ed. *The Rossetti–Leyland Letters: The Correspondence of an Artist and his Patron*. Athens: Ohio University Press, 1978.

Fennema, Meindert, and Huibert Schijf. "Analysing Interlocking Directorates: Theory and Methods." *Social Networks* 1 (1978–9): 297–332.

Fields, Tim, Elan Zingman-Leith, and Susan Zingman-Leith. *The Secret Life of Victorian Houses*. Washington, D.C.: Elliott & Clark, 1993.

Fink, Lois Marie. *A History of the Smithsonian American Art Museum: The Intersection of Art, Science, and Bureaucracy*. Amherst: University of Massachusetts Press, 2007.

Fitzgerald, Penelope. *Edward Burne-Jones: A Biography*. London: Michael Joseph, 1975.

Flanders, Judith. *Inside the Victorian Home*. W. W. Norton & Co., 2004.

Fletcher, Pamela M. "Creating the French Gallery: Ernest Gambart and the Rise of the Commercial Art Gallery in Mid-Victorian London." *Nineteenth-Century Art Worldwide* 6, no. 1 (spring 2007), http://www.19thc-artworldwide.org/spring07/143-creating-the-french-gallery-ernest-gambart-and-the-rise-of-the-commercial-art-gallery-in-mid-victorian-london (accessed January 10, 2020).

Flint, Kate. *Victorians and the Visual Imagination*. Cambridge: Cambridge University Press, 2000.

Forty, Adrian. *Objects of Desire: Design and Society since 1750*. London: Thames and Hudson, 1986.

Fowler, Marian. *In a Gilded Cage: From Heiress to Duchess*. New York: St. Martin's Press, 1994.

Franklin, J. Jeffrey. *Serious Play: The Cultural Form of the Nineteenth-Century Realist Novel*. Philadelphia: University of Pennsylvania Press, 1999.

Frederic, Lord Leighton: Eminent Victorian Artist. New York: Harry N. Abrams, 1996. Exhibition catalog.

Freedman, Jonathan. *Professions of Taste: Henry James, British Aestheticism, and Commodity Culture*. Stanford: Stanford University Press, 1990.

Freeman, Linton C. *The Development of Social Network Analysis: A Study in the Sociology of Science*. Vancouver: Empirical Press, 2004.

Frelinghuysen, Alice Cooney. "Louis Comfort Tiffany at the Metropolitan Museum." *Metropolitan Museum of Art Bulletin* 56, no. 1 (summer 1998): 8–100.

Friedman, David M. *Wilde in America: Oscar Wilde and the Invention of Modern Celebrity*. New York: W. W. Norton & Co., 2014.

Fröhlich, Fabian. "Frauen im Spiegel: Der Perseus-Zyklus von Edward Burne-Jones." PhD diss., Universitat Kassel, 2002; Berlin: Dissertation. de, 2005.

Frost, David, and Michael Shea. *The Rich Tide: Men, Women, Ideas and their Transatlantic Impact*. London: Collins, 1986.

Fyfe, Gordon. *Art, Power and Modernity: English Art Institutions, 1750–1950*. London and New York: Leicester University Press, 2000.

Gagnier, Regenia. *Idylls of the Marketplace: Oscar Wilde and the Victorian Public*. Stanford: Stanford University Press, 1986.

Gaines, Jane. "Photography Surprises the Law: The Portrait of Oscar Wilde," in *Contested Culture: The Image, the Voice and the Law*, 42–83. Chapel Hill: University of North Carolina Press, 1991.

Garnett, Oliver. "The Letters and Collection of William Graham – Pre-Raphaelite Patron and Pre-Raphael Collector." *Walpole Society* 67 (2000): 145–342.

—. "Sold Christie's, Bought Agnew's: The Art Collection of Lord Armstrong at Cragside." *Apollo* 37 (April 1993): 253–8.

Garnham, Nicholas, and Raymond Williams. "Pierre Bourdieu and the Sociology of Culture: An Introduction." *Media, Culture, and Society* 2, no. 3 (1980): 209–23.

Gater, G. H., and F. R. Hiorns, eds. *Survey of London, Vol. XX: St. Martin-in-the-Fields, Part 3: Trafalgar Square & Neighbourhood*. London: published for London County Council by Country Life, 1940.

Gell, Alfred. *Art and Agency: An Anthropological Theory*. Oxford, Clarendon Press, 1998.

Gerdts, William H. *Louis Moeller, N.A. (1855–1930): A Victorian Man's World*. New York: Grand Central Art Galleries, 1984. Exhibition catalog.

—, et al. *Tonalism: An American Experience*. New York: Grand Central Art Galleries, 1982. Exhibition catalog.

Gere, Charlotte. *Artistic Circles: Design & Decoration in the Aesthetic Movement*. London: V&A Publishing, 2010.

—, and Lesley Hoskins. *The House Beautiful: Oscar Wilde and the Aesthetic Interior*. Aldershot: Lund Humphries in association with Geffrye Museum, 2000. Exhibition catalog.

Gillett, Paula. *Worlds of Art: Painters in Victorian Society*. New Brunswick, N.J.: Rutgers University Press, 1990.

Girouard, Mark. *Life in the English Country House: A Social and Architectural History*. New Haven and London: Yale University Press, 1978.

—. *The Return to Camelot: Chivalry and the English Gentleman*. New Haven and London: Yale University Press, 1981.

—. "Standen, Sussex – I." *Country Life* 147, no. 3808 (February 26, 1970): 494–7.

—. "Standen, Sussex – II." *Country Life* 147, no. 3809 (March 5, 1970): 554–7.

—. *Sweetness and Light: The Queen Anne Movement, 1860–1900*. Oxford: Clarendon Press, 1977.

—. *The Victorian Country House*, rev. edn. New Haven and London: Yale University Press, 1979.

Glazer, Lee. *Charles Lang Freer: A Cosmopolitan Life*. Washington, D.C.: Smithsonian Institution, 2017.

—. "'A Modern Instance': Thomas Dewing and Aesthetic Vision at the Turn of the Century." PhD diss., University of Pennsylvania, 1996.

—, and Margaret R. Laster. "Introduction," in *Palaces of Art: Whistler and the Art Worlds of Aestheticism*, ed. Lee Glazer and Linda Merrill, 1–11. Washington, D.C.: Smithsonian Institution Scholarly Press, 2013

Godley, Andrew, and Oliver M. Westall, eds. *Business History and Business Culture*. Manchester and New York: Manchester University Press, 1996.

Goldstein, Malcolm. *Landscape with Figures: A History of Art Dealing in the United States*. Oxford: Oxford University Press, 2000.

Gooday, Graeme. *Domesticating Electricity: Technology, Uncertainty, and Gender, 1880–1914*. London: Pickering & Chatto, 2008.

Goodlad, Lauren. *Victorian Literature and the Victorian State*. Baltimore: Johns Hopkins University Press, 2003.

Gordon, Beverly. "Woman's Domestic Body: The Conceptual Conflation of Women and Interiors in the Industrial Age." *Winterthur Portfolio* 31, no. 4 (winter 1996): 281–301.

Gorst, Harold. *The Fourth Party*. London: Smith, 1906.

Graham, Stephen, and Simon Martin. *Splintering Urbanism: Networked Infrastructures, Technological Mobilities, and the Urban Condition*. London: Routledge, 2001.

Granovetter, Mark. "The Strength of Weak Ties," *American Journal of Sociology* 78, no. 6 (1973): 1360–80.

Gray, Nina, and Suzanne Smeaton. "Within Gilded Borders: The Frames of Stanford White." *American Art* 7, no. 2 (spring 1993): 32–45.

Green, E. H. H. "'No Settled Convictions'? Arthur Balfour, Political Economy, and Tariff Reform: A Reconsideration," in *Ideologies of*

Conservatism: Conservative Political Ideas in the Twentieth Century, 18–41. Oxford: Oxford University Press, 2002.

Greenhalgh, Paul. *Ephemeral Vistas: The Expositions Universelles, Great Exhibitions and World's Fairs, 1851–1939*. Manchester: Manchester University Press, 1988.

Grier, Katherine C. *Culture & Comfort: Parlor Making and Middle-Class Identity, 1850–1930*. Washington, D.C.: Smithsonian Institution Press, 1997.

Grogan, Arthur. *Standen, Sussex*. London: National Trust, 1977.

Gunter, Ann. C. *A Collector's Journey: Charles Lang Freer and Egypt*. Washington, D.C.: Smithsonian Institution, 2002.

Guttsman, W. *The British Political Elite*. London: MacGibbon and Kee, 1963.

Hamerton, Ian, ed. *W. A. S. Benson: Arts and Crafts Luminary and Pioneer of Modern Design*. Woodbridge: Antique Collectors' Club, 2005. Exhibition catalog.

Hamilton, Walter. *The Aesthetic Movement in England*. London: Reeves and Turner, 1882.

Hanlon, Christopher. "'The Old Race Are All Gone': Transatlantic Bloodlines and *English Traits*." *American Literary History* 19, no. 4 (winter 2007): 800–23.

Hannavy, John, ed. *Encyclopedia of Nineteenth-Century Photography*, 2 vols. New York: Taylor and Francis, 2008.

Harding, Ellen, ed. *Re-Framing the Pre-Raphaelites: Historical and Theoretical Essays*. Aldershot: Scholar Press, 1996.

Harris, John. "Lo stile Hope e la famiglia Hope." *Arte Illustra* 6, no. 55–6 (December 1973): 326–30.

Harris, Neil. *The Artist in American Society: The Formative Years, 1790–1860*. New York: G. Braziller, 1966.

—. *The Land of Contrasts: 1880–1901*. New York: G. Braziller, 1970.

Harris, Paul. *Life in a Scottish Country House: The Story of A. J. Balfour and Whittingehame House*. Whittingehame: Whittingehame House Publishing, 1989.

Harris, Susan K. *The Cultural Work of the Late Nineteenth-Century Hostess: Annie Adams Fields and Mary Gladstone Drew*. New York: Palgrave Macmillan, 2002.

Harrison, Martin, and Bill Waters. *Burne-Jones*. London: Barrie & Jenkins, 1973.

Harrison Moore, Abigail, and Graeme Gooday. "Decorative Electricity: Standen and the Aesthetics of New Lighting Technologies in the Nineteenth Century Home." *Nineteenth-Century Contexts* 35, no. 4 (2013): 363–83.

Hartmann, Sadakichi. *A History of American Art*. Boston: L. C. Page, 1901.

Harvey, Charles, and Jon Press. *Art, Enterprise, and Ethics: The Life and Works of William Morris*. London: Frank Cass, 1996.

—. *William Morris: Design and Enterprise in Victorian Britain*. Manchester: Manchester University Press, 1991.

Haselkorn, Anne M., and Betty S. Travitsky. *The Renaissance Englishwoman in Print: Counterbalancing the Canon*. Amherst: University of Massachusetts Press, 1990.

Haskell, Francis. *The Ephemeral Museum: Old Master Paintings and the Rise of the Art Exhibition*. New Haven and London: Yale University Press, 2000.

Hatt, Michael. "Space, Surface, Self: Homosexuality and the Aesthetic Interior." *Visual Culture in Britain* 8, no.1 (summer 2007): 105–28.

Haweis, Mary Eliza. *The Art of Decoration*. London: Chatto & Windus, 1881.

—. *Beautiful Houses: Being a Description of Certain Well-Known Artistic Houses*. London: S. Low, Marston, Searle, & Rivington, 1882.

Haws, Duncan. *Merchant Fleets in Profile*, vol. 2. Cambridge: Stephens, 1979.

Heald, Henrietta. *William Armstrong: Magician of the North*. Carmarthen: McNidder & Grace, 2010.

Hecker, Frank J. *Activities of a Lifetime: 1861–1923*. Detroit: privately printed, 1923.

Heckscher, Morrison H. "The Metropolitan Museum of Art: An Architectural History." *Metropolitan Museum of Art Bulletin*, new series, 53, no. 1 (summer 1995): 1–80.

Herrmann, Frank. *The English as Collectors*. New Castle, Del.: Oak Knoll Press, 1999.

Hilkey, Judy. *Character is Capital: Success Manuals and Manhood in Gilded Age America*. Chapel Hill: University of North Carolina Press, 1997.

Hobbs, Susan. *The Art of Thomas Wilmer Dewing: Beauty Reconfigured*. Washington, D.C.: Smithsonian Institution Press, 1996. Exhibition catalog.

—. "A Connoisseur's Vision: The American Collection of Charles Lang Freer." *American Art Review* 4, no. 2 (August 1977): 76–101.

—. "John Gellatly." *American National Bibliography Online*. February 2000.

—. "Nature into Art: The Landscapes of Albert Handerson Thayer." *American Art Journal* 14, no. 3 (summer 1982): 5–55.

—. "Pretty Women: Charles Lang Freer and the Ideal of Feminine Beauty." *Magazine Antiques* 170, no. 5 (November 2006): 140–7.

—. "Thomas Dewing in Cornish, 1885–1905." *American Art Journal* 17, no. 2 (spring 1985): 2–32.

—. *Thomas Wilmer Dewing: Beauty into Art; A Catalogue Raisonné*, 2 vols. New Haven and London: Yale University Press, 2018.

—. "Thomas Wilmer Dewing: The Early Years, 1851–1885." *American Art Journal* 13, no. 2 (spring 1981): 4–35.

—. "The Wings of a Butterfly: Pastels by Thomas Wilmer Dewing." *Magazine Antiques* 173, no. 2 (February 2008): 72–9.

—, Yu-tarng Cheng, and Jacqueline S. Olin. "Thomas Wilmer Dewing: A Look beneath the Surface." *Smithsonian Studies in American Art* 4, no. 3–4 (summer–autumn, 1990): 62–85.

Hobler, Margaret H. "In Search of Daniel Cottier, Artistic Entrepreneur, 1838–1891." MA thesis, Hunter College, City University of New York, 1987.

Hobsbawm, E. J. *The Age of Capital, 1848–1875*. London: Weidenfeld and Nicolson, 1975.

—. *The Age of Empire, 1875–1914*. New York: Pantheon Books, 1987.

Hobson, John Atkinson. *The Evolution of Modern Capitalism: A Study of Machine Production*. London: Walter Scott, 1894 (rev. edn., 1906).

Hofer, Matthew, and Gary Scharnhorst, eds. *Oscar Wilde in America: The Interviews*. Urbana: University of Illinois Press, 2010.

Hoganson, Kristin L. *Consumers' Imperium: The Global Production of American Domesticity, 1865–1920*. Chapel Hill: University of North Carolina Press, 2010.

—. "Cosmopolitan Domesticity: Importing the American Dream, 1865–1920." *American Historical Review* 107, no. 1 (February 2002): 55–83.

Holli, Melvin G. "Before the Car: Nineteenth-Century Detroit's Transformation from a Commercial into an Industrial City." *Michigan History* 64 (March–April 1980): 33–9.

—. *Reform in Detroit: Hazen S. Pingree and Urban Politics*. New York: Oxford University Press, 1969.

Hopkinson, Martin. "Whistler's 'Company of the Butterfly.'" *Burlington Magazine* 136, no. 1099 (October 1994): 700–4.

Howe, Winifred E. *A History of the Metropolitan Museum of Art*, 2 vols. New York: Columbia University Press, 1946.

Hughes, Thomas. *Networks of Power: Electrification in Western Society, 1880–1930*. Baltimore: Johns Hopkins University Press, 1983.

Hutchison, Stanley C. *The History of the Royal Academy*. London: Chapman & Hall, 1968.

In Pursuit of Beauty: Americans and the Aesthetic Movement. New York: Rizzoli for the Metropolitan Museum of Art, 1986. Exhibition catalog.

Inglis, Alison. "Empire of Art: The Grosvenor Gallery Intercolonial Exhibition, Melbourne, 27 October 1887–7 January 1888," in *The Victorian World*, ed. Martin Hewitt, 585–602. London: Routledge, 2012.

Jaher, Frederic Cople. *The Rich, the Well Born, and the Powerful: Elites and Upper Classes in History*. Urbana: University of Illinois Press, 1973.

—. *The Urban Establishment: Upper Strata in Boston, New York, Charleston, Chicago, and Los Angeles*. Urbana: University of Illinois Press, 1982.

James, William. *Pragmatism: A New Name For Some Old Ways of Thinking; Popular Lectures on Philosophy*. London: Longmans, 1907.

Jenkyns, Richard. *Dignity and Decadence: Victorian Art and the Classical Inheritance*. Cambridge, Mass.: Harvard University Press, 1992.

Jones, Stephen, et al. *Frederic, Lord Leighton: Eminent Victorian Artist*. New York: H. N. Abrams with Royal Academy of Arts, London, 1996.

Judd, Denis. *Balfour and the British Empire: A Study in Imperial Evolution, 1874–1932*. London: Macmillan, 1968.

Kadushin, Charles. "Networks and Circles in the Production of Culture." *American Behavioral Scientist* 19 (1976): 769–84.

Kaiser, Matthew. *The World in Play: Portraits of a Victorian Concept*. Stanford: Stanford University Press, 2012.

Kasson, John F. *Rudeness & Civility: Manners in Nineteenth-Century Urban America*. New York: Hill and Wang, 1990.

Kelvin, Norman, ed. *The Collected Letters of William Morris*. Princeton: Princeton University Press, 1987.

Kestner, Joseph A. *Mythology and Misogyny: The Social Discourse of Nineteenth-Century British Classical-Subject Painting*. Madison: University of Wisconsin Press, 1988.

—. "The Representation of Armor and the Construction of Masculinity in Victorian Painting." *Nineteenth-Century Studies* 7 (1993): 1–28.

Kim, Jongwoo Jeremy. *Painted Men in Britain, 1868–1918*. Farnham: Ashgate, 2012.

Kisluk-Grosheide, Daniëlle O. "The Marquand Mansion." *Metropolitan Museum of Art Journal* 29 (1994): 151–81.

Kitson Clark, G. S. R. *An Expanding Society; Britain 1830–1900*. Callton: Melbourne University Press, 1967.

—. *The Making of Victorian England*. Cambridge, Mass.: Harvard University Press, 1962.

Kittler, Friedrich A. *Discourse Networks 1800/1900*. Stanford: Stanford University Press, 1990.

Klonk, Charlotte. *Spaces of Experience: Art Gallery Interiors from 1800 to 2000*. New Haven and London: Yale University Press, 2009.

Knox, Hannah, Mike Savage, and Penny Harvey. "Social Networks and the Study of Relations: Networks as Method, Metaphor, and Form." *Economy and Society* 35, no. 1 (February 2006): 113–40.

Korda, Andrea. *Printing and Painting the News in Victorian London: The Graphic and Social Realism, 1869–1891*. Farnham: Ashgate, 2015.

Koziski, Stephanie. "William T. Evans." Unpublished manuscript, 1979, printed copy held Washington, D.C.: Smithsonian American Art Museum/National Portrait Gallery Library.

Kreienbrock, Jorg. *Malicious Objects, Anger Management, and the Question of Modern Literature*. New York: Fordham University Press, 2012.

Kreiner, Mary Beth. "Francis Davis Millet's 'Reading the Story of Oenone.'" *Bulletin of the Detroit Institute of Arts* (1995): 14–25.

Kresser, Katie. *The Art and Thought of John La Farge: Picturing Authenticity in Gilded Age America*. Farnham: Ashgate, 2013.

Kriegel, Lara. *Grand Designs: Labor, Empire, and the Museum in Victorian Culture*. Durham, N.C.: Duke University Press, 2007.

Kusserow, Karl. *Picturing Power: Portraiture and its Uses in the New York Chamber of Commerce*. New York: Columbia University Press, 2013.

Kynaston, David. *The City of London, Volume I: A World of Its Own, 1815–1890*. London: Chatto & Windus, 1994.

Lamb, Martha J. *The Homes of America*. New York: D. Appleton and Company, 1879.

Lambert, Angela. *Unquiet Souls: The Indian Summer of the British Aristocracy, 1880–1918*. London: Macmillan, 1984.

Lambourne, Lionel. *The Aesthetic Movement*. London: Phaidon, 1996.

Larson, Christian D. *Business Psychology*. New York: Thomas Y. Crowell and Company, 1912.

Lasdun, Susan. *Victorians at Home*. New York: Viking Press, 1981.

Laster, Margaret. "Catharine Lorillard Wolfe: Collecting and Patronage in the Gilded Age." PhD diss., City University of New York, 2013.

Latour, Bruno. *Reassembling the Social: An Introduction to Actor-Network-Theory*. Oxford: Oxford University Press, 2005.

Lawton, Thomas, and Linda Merrill. *Freer: A Legacy of Art*. Washington, D.C.: Freer Gallery of Art, 1993.

Leach, William. *Land of Desire: Merchants, Power, and the Rise of a New American Culture*. New York: Pantheon Books, 1993.

Lears, T. J. Jackson. *No Place of Grace: Antimodernism and the Transformation of American Culture, 1880–1920*. New York: Pantheon Books, 1981.

Lee, Elizabeth. "Therapeutic Beauty: Abbott Thayer, Antimodernism, and the Fear of Disease." *American Art* 18, no. 3 (fall 2004): 32–51.

Leja, Michael. *Looking Askance: Skepticism and American Art from Eakins to Duchamp*. Berkeley: University of California Press, 2004.

—. "Progress and Evolution at the U.S. World's Fairs, 1893–1915." *Nineteenth-Century Art Worldwide* 2, no. 1 (spring 2003), http://www.19thc-artworldwide.org/spring03/221-progress-and-evolntion-at-the-us-worlds-fairs-18931915 (accessed January 10, 2020).

Leoussi, Athena. "The Ionides Circle and Art." MA thesis, Courtauld Institute of Art, 1982.

—. *Nationalism and Classicism: The Classical Body as National Symbol in Nineteenth-Century England and France*. New York: St. Martin's Press, 1998.

Leventhal, Fred M., and Roland Quinault, eds. *Anglo-American Attitudes: From Revolution to Partnership*. Aldershot: Ashgate, 2000.

Levy, Bruce. "'The End of the World, The Beginners of a Nation': Edward Eggleston and the Crisis of National Meaning in the Gilded Age." *Journal of American Studies* 36, no. 3 (December 2002): 391–415.

Lewis, Arnold, James Turner, Steven McQuillin, and George William Sheldon. *The Opulent Interiors of the Gilded Age: All 203 Photographs from "Artistic Houses": With New Text*. New York: Dover, 1987.

Löcher, Kurt. *Der Perseus-Zyklus von Edward Burne-Jones*. Stuttgart: Staatsgalerie Stuttgart, 1973.

—. "William Morris' *Earthly Paradise* und Edward Burne-Jones' Stuttgarter Perseus-Zyklus." *Form und Zweck* 15 (1998): 33–47.

Lubenow, William C. *The Cambridge Apostles, 1820–1914: Liberalism, Imagination, and Friendship in British Intellectual and Professional Life*. Cambridge: Cambridge University Press, 1998.

Maas, Jeremy. *Gambart: Prince of the Victorian Art World*. London: Barrie & Jenkins, 1975.

McClaugherty, Martha Crabill. "Household Art: Creating the Artistic Home, 1868–1893." *Winterthur Portfolio* 18, no. 1 (spring 1983): 1–26.

McConachie, Alexander Scot. "The 'Big Cinch': A Business Elite in the Life of a City, Saint Louis, 1895–1915." PhD diss., Washington University, 1976.

McCoy, Garnett. "Archivist's Report and Letters of John Gellatly." *Archives of American Art Journal* 18, no. 3 (1978): 23–4.

MacDonald, Margaret F., Grischka Petri, Meg Hausberg, and Joanna Meacock. *James McNeill Whistler: The Etchings, a Catalogue Raisonné*. Online edition, University of Glasgow, 2012, http://www.etchings.arts.gla.ac.uk.

MacDonald, Margaret F., Patricia de Montfort, and Nigel Thorp, eds. *Palaces in the Night: Whistler in Venice*. Berkeley: University of California Press, 2001.

Mackay, Ruddock. *Balfour: Intellectual Statesman*. New York: Oxford University Press, 1985.

Macleod, Dianne Sachko. *Art and the Victorian Middle Class: Money and the Making of Cultural Identity*. Cambridge: Cambridge University Press, 1996.

—. "The 'Identity' of Pre-Raphaelite Patrons," in *Re-framing the Pre-Raphaelites: Historical and Theoretical Essays*, ed. Ellen Harding, 7–26. Aldershot: Scholar Press, 1996.

—. "Mid-Victorian Patronage of the Arts: F. G. Stephens's 'The Private Collections of England.'" *Burlington Magazine* 128 (August 1986): 597–607.

—. "Private and Public Patronage in Victorian Newcastle." *Journal of the Warburg and Courtauld Institutes* 52 (1989): 188–208.

McMahon, F. F., Donald E. Lytle, and Brian Sutton-Smith, eds. *Play: An Interdisciplinary Synthesis*. Lanhan, Md.: University Press of America, 2005.

Madigan, Mary Jean Smith. "The Influence of Charles Locke Eastlake on American Furniture Manufacture, 1870–90." *Winterthur Portfolio* 10 (1975): 1–22.

Mallock, W. H. "A Familiar Colloquy." *Nineteenth Century* 4, no. 18 (August 1878): 289–302.

—. *The New Republic; or Culture, Faith, and Philosophy in an English Country House*. London: Michael Joseph, 1877.

Mancini, JoAnne Marie. *Pre-Modernism: Art-World Change and American Culture from the Civil War to the Armory Show*. Princeton, N.J.: Princeton University Press, 2005.

Marks, Patricia. "'Americanus Sum': *Life* Attacks Anglomania." *Victorian Periodicals Review* 28, no. 3 (fall 1995): 217–31.

Marquand, Henry Gurdon. "The Tariff on Works of Art." *Princeton Review* (January–June 1884): 141–53.

Marvin, Carolyn. *When Old Technologies Were New: Thinking about Electric Communication in the Late Nineteenth Century*. New York: Oxford University Press, 1988.

Mattelart, Armand. *The Invention of Communication*, trans. Susan Emanuel. Minneapolis: University of Minnesota Press, 1996.

—. *Mapping World Communication: War, Progress, Culture*, trans. Susan Emanuel and James A. Cohen. Minneapolis: University of Minnesota Press, 1994.

—. *Networking the World, 1794–2000*, trans. Liz Carey-Libbrecht and James A. Cohen. Minneapolis: University of Minnesota Press, 2000.

May, Robert E. "Culture Wars: The U.S. Art Lobby and Congressional Tariff Legislation during the Gilded Age and Progressive Era." *Journal of the Gilded Age and Progressive Era* 9, no. 1 (January 2010): 37–91.

Meints, Graydon M. "Detroit's First Big Industry: Railroad Cars." *Historical Society of Michigan Chronicle* 29, no. 4 (winter 2007): 9–11.

—. *Michigan Railroads and Railroad Companies*. East Lansing: Michigan State University Press, 1992.

Meixner, Laura. "'Gambling with Bread': Monet, Speculation, and the Marketplace." *Modernism/modernity* 17, no. 1 (January 2010): 171–99.

Mendelssohn, Michele. *Henry James, Oscar Wilde, and Aesthetic Culture*. Edinburgh: Edinburgh University Press, 2007.

Merrill, Linda. *An Ideal Country: Paintings by Dwight William Tryon in the Freer Gallery of Art*. Washington, D.C.: Freer Gallery of Art, Smithsonian Institution, 1990.

—. *The Peacock Room: A Cultural Biography*. Washington, D.C.: Freer Gallery of Art, 1998.

—. *A Pot of Paint: Aesthetics on Trial in Whistler v. Ruskin*. Washington, D.C.: Smithsonian Institution Press, in association with the Freer Gallery of Art, 1993.

—. *With Kindest Regards: The Correspondence of Charles Lang Freer and James McNeill Whistler, 1890–1903*. Washington, D.C.: Smithsonian Institution Press, 1995.

Metropolitan Lives: The Ashcan Artists and their New York. New York: National Museum of American Art and W. W. Norton & Co., 1995. Exhibition catalog.

Meyer, Annie Nathan. "Collecting American Paintings." *The World's Work* 10, no. 3 (July 1905): 6389.

Miller, Lillian B. *Patrons and Patriotism: The Encouragement of the Fine Arts in the United States, 1790–1860*. Chicago: University of Chicago Press, 1966.

Milne, Graeme J. *Trade and Traders in Mid-Victorian Liverpool: Mercantile Business and the Making of a World Port*. Liverpool: Liverpool University Press, 2000.

Mirimonde, A. P. de. "Les Allégories de la destinée humaine et *La Roue de Fortune* d'Edward Burne-Jones." *Gazette des Beaux-Arts* 6, no. 99 (February 1982): 79–86.

Mitchell, Rebecca N. "Acute Chinamania: Pathologizing Aesthetic Dress." *Fashion Theory* 14, no. 1 (April 2010): 45–64.

Moffatt, James. "The Reader: Balfour as a Man of Letters." *Bookman* 42, no. 251 (August 1912): 193–201.

Moore, Charles. *History of Michigan*, vol. 3. Chicago: Lewis Publishing Company, 1915.

Moore, Sarah J. *John White Alexander and the Construction of National Identity: Cosmopolitan American Art, 1880–1915*. Newark: University of Delaware Press, 2003.

Morgan, Benjamin. "Oscar Wilde's Un-American Tour: Aestheticism, Mormonism, and Transnational Resonance." *American Literary History* 26, no. 4 (winter 2014): 664–92.

Morgan, Keith N. "The Patronage Matrix: Charles A. Platt, Architect, Charles L. Freer, Client." *Winterthur Portolio* 17, no. 2/3 (summer/ autumn 1982): 121–34.

Morris, Edward. "Edwin Austin Abbey and his American Circle in England." *Apollo* 104 (September 1976): 220–1.

—, and Timothy Stevens. *History of the Walker Art Gallery, Liverpool, 1873–2000*. Bristol: Sansom & Co., 2013.

Morris, Jr., Roy. *Declaring his Genius: Oscar Wilde in North America*. Cambridge, Mass.: Harvard University Press, 2004.

Morris, Kathleen M., and Alexis Goodin, eds. *Orchestrating Elegance: Alma-Tadema and the Marquand Music Room*. New Haven and London: Yale University Press, 2017. Exhibition catalog.

Morris, William. *The Earthly Paradise: A Poem*, 3rd edn. London: F. S. Ellis, 1868.

Munich, Adrienne. *Andromeda's Chains: Gender and Interpretation in Victorian Literature and Art*. New York: Columbia University Press, 1989.

Murphy, Kevin. "Economics of Style: The Business Practices of American Artists and the Structure of the Market, 1850–1910." PhD diss., University of California, Santa Barbara, 2005.

Murray, Richard. "Abbott Thayer's Stevenson Memorial." *American Art* 13, no. 2 (summer 1999): 2–25.

Mussell, James. *The Nineteenth-Century Press in the Digital Age*. Basingstoke: Palgrave Macmillan, 2012.

—. *Science, Time and Space in the Late Nineteenth-Century Periodical Press: Movable Types*. Aldershot: Ashgate, 2007.

Muthesius, Hermann. *The English House*, ed. Denis Sharp, trans. Janet Seligman and Stewart Spencer, first complete English edn. London: Frances Lincoln, 2007.

Neiswander, Judith A. *The Cosmopolitan Interior: Liberalism and the British Home, 1870–1914*. New Haven and London: Yale University Press for the Paul Mellon Centre for Studies in British Art, 2008.

Nemerov, Alexander. "Vanishing Americans: Abbott Thayer, Theodore Roosevelt, and the Attraction of Camouflage." *American Art* 11, no. 2 (summer 1997): 50–81.

Newall, Christopher. *The Grosvenor Gallery Exhibitions: Change and Continuity in the Victorian Art World*. Cambridge: Cambridge University Press, 1995.

Ninkovich, Frank A. *Global Dawn: The Cultural Foundations of American Internationalism, 1865–1890*. Cambridge, Mass.: Harvard University Press, 2009.

No. 49 Prince's Gate, S.W. London: Osborn & Mercer, 1892.

Noble, Mrs. Robert E. "Lord Balfour's London House: The Historic Home of the President of the British E-S.U." *The Landmark: The*

Monthly Magazine of the English-Speaking Union 4, no. 9 (September 1922): 681–4.

Novak, David A. "Sexuality in the Age of Technological Reproducibility: Oscar Wilde, Photography, and Identity," in *Oscar Wilde and Modern Culture*, ed. Joseph Bristow, 63–95. Athens: Ohio University Press, 2008.

Nye, David E. *American Technological Sublime*. Cambridge, Mass.: MIT Press, 1994.

—. *Electrifying America: Social Meanings of a New Technology, 1880–1940*. Cambridge, Mass.: MIT Press, 1990.

—. *Narratives and Spaces: Technology and the Construction of American Culture*. New York: Columbia University Press, 1997.

Olsen, Bjornar. "Material Culture After Text: Re-Membering Things." *Norwegian Archaeological Review* 36, no. 2 (2003): 87–104.

O'Malley, Michelle. "Altarpieces and Agency: The Altarpiece of the Society of the Purification and its 'Invisible Skein of Relations.'" *Art History* 28, no. 4 (September 2005): 417–41.

O'Neill, Morna. *Walter Crane: The Arts and Crafts, Painting, and Politics, 1875–1890*. New Haven and London: Yale University Press for the Paul Mellon Centre for Studies in British Art, 2010.

Oppenheim, Janet. *The Other World: Spiritualism and Psychical Research in England, 1850–1914*. Cambridge: Cambridge University Press, 1985.

Orcutt, Kimberly. "Buy American? The Debate over the Art Tariff." *American Art* 16, no. 3 (autumn 2002): 82–91.

Ormond, Leonée, and Richard Ormond. *Lord Leighton*. New Haven and London: Yale University Press for the Paul Mellon Centre for Studies in British Art, 1975.

Otis, Laura. *Networking: Communicating with Bodies and Machines in the Nineteenth Century*. Ann Arbor: University of Michigan Press, 2001.

Ott, John. "The Gilded Rush: Art Patronage, Industrial Capital, and Social Authority in Victorian California." PhD diss., University of California, Los Angeles, 2002.

—. "How New York Stole the Luxury Art Market: Blockbuster Auctions and Bourgeois Identity in Gilded Age America." *Winterthur Portfolio* 42, no. 2/3 (summer/autumn 2008): 133–58.

—. *Manufacturing the Modern Patron in Victorian California: Cultural Philanthropy, Industrial Capital, and Social Authority*. Farnham: Ashgate, 2014.

—. "Patrons, Collectors, and Markets," in *A Companion to American Art*, ed. John Davis, Jennifer A. Greenhill, and Jason D. LaFountain. Malden, Mass.: Wiley-Blackwell, 2015.

Otter, Chris. *The Victorian Eye: A Political History of Light and Vision in Victorian Britain*. Chicago: University of Chicago Press, 2008.

Paget-Tomlinson, E. W., *Bibby Line: 175 Years of Achievement*. Liverpool: Bibby Line, 1982.

Palmer, Marilyn, and Ian West. *Technology in the Country House*. Swindon: Historic England, 2016.

Parry, Linda, ed. *William Morris*. London: Philip Wilson in association with the Victoria and Albert Museum, 1996. Exhibition catalog.

Parsons, Robert Hodson. *The Early Days of the Power Station Industry*. Cambridge: Cambridge University Press, 1939.

Pater, Walter. *Studies in the History of the Renaissance*. London: Macmillan & Co., 1873 (and 3rd edn., entitled *The Renaissance: Studies in Art and Poetry*, 1888).

Pauwels, Erin. "Napoleon Sarony's Living Pictures: Photography, Performance & American Art, 1865–1900." PhD diss., Indiana University, 2015.

The Peacock Room: Painted for Mr. F. R. Leyland by James McNeill Whistler, Removed in its Entirety from the Late Owner's Residence & Exhibited at Messrs. Obach's Galleries, at 168 New Bond Street, London, W, June 1904. London: Obach & Company, 1904.

Peattie, Roger W. *Selected Letters of William Michael Rossetti*. University Park: Pennsylvania State University Press, 1990.

Pennell, Elizabeth Robins, and Joseph Pennell. *The Life of James McNeill Whistler*, 2 vols. London and Philadelphia: W. Heinemann and J. B. Lippincott, 1908.

Peters, John Douglas, and Vincent G. Robinson. *Detroit: Freight Cars before Automobiles*. Belleville, Mich.: Treasure Press, 2005.

Piggott, Jan. *Palace of the People: The Crystal Palace at Sydenham, 1854–1936*. Madison: University of Wisconsin Press, 2004.

Pisano, Ronald G. *The Tile Club and the Aesthetic Movement in America*. New York: Harry N. Abrams, 1999. Exhibition catalog.

—, Carolyn K. Lane, and D. Frederick Baker. *William Merritt Chase: Portraits in Oil*. New Haven and London: Yale University Press, 2007.

Ponder, Stephen. *Wightwick Manor and Gardens*. London: National Trust, 1993.

Poovey, Mary. *A History of the Modern Fact: Problems of Knowledge in the Sciences of Wealth and Society*. Chicago: University of Chicago Press, 2004.

Pratt, Sereno S. "Our Financial Oligarchy." *World's Work* 10 (1905): 6704–14.

Prettejohn, Elizabeth. *Art for Art's Sake: Aestheticism in Victorian Painting*. New Haven and London: Yale University Press for the Paul Mellon Centre for Studies in British Art, 2007.

—. *The Art of the Pre-Raphaelites*. Princeton: Princeton University Press, 2000.

—. "Undermining the Archive." *Art History* 20, no. 4 (December 1997): 616–22.

—, ed. *After the Pre-Raphaelites: Art and Aestheticism in Victorian England*. Manchester: Manchester University Press, 1999.

Psomiades, Kathy Alexis. *Beauty's Body: Femininity and Representation in British Aestheticism*. Stanford: Stanford University Press, 1997.

Pyne, Kathleen. *Art and the Higher Life: Painting and Evolutionary Thought in Late Nineteenth-Century America*. Austin: University of Texas Press, 1996.

—. "Classical Figures: A Folding Screen by Thomas Dewing." *Bulletin of the Detroit Institute of Arts* 59 (spring 1981): 4–14.

—. "Evolutionary Typology and the American Woman in the Work of Thomas Dewing." *American Art* 7, no. 4 (autumn 1993): 12–29.

—. "Portrait of a Collector as an Agnostic: Charles Lang Freer and Connoisseurship." *Art Bulletin* 78, no. 1 (March 1996): 75–97.

—. "Whistler and the Politics of the Urban Picturesque." *Journal of American Art* 8, no. 3–4 (summer/autumn 1994): 60–77.

The Quest for Unity: American Art between the World's Fairs, 1876–1893. Detroit: Detroit Institute of Arts, 1983. Exhibition catalog.

Quick, Michael. *George Inness: A Catalogue Raisonné*. New Brunswick, N.J.: Rutgers University Press, 2007.

Rasor, Eugene. *Arthur James Balfour, 1848–1930: Historiography and Annotated Bibliography*. Westport, Conn.: Greenwood Press, 1998.

Rathbone, Philip H. *Idealism and the Grotesque in Art: Their Limits and Functions*. Liverpool: Lee and Nightingale, 1877.

Revisiting the White City: American Art at the 1893 World's Fair. Washington, D.C.: Smithsonian Institution, 1993.

Ridley, Jane, and Clayre Percy, eds. *The Letters of Arthur Balfour and Lady Elcho, 1885–1917*. London: Hamish Hamilton, 1992.

Roberts, Jennifer. *Transporting Visions: The Movement of Images in Early America*. Berkeley: University of California Press, 2014.

Root, John David. "The Philosophical and Religious Thought of Arthur James Balfour (1848–1930)." *Journal of British Studies* 19, no. 2 (spring 1980): 120–41.

Rose, Kenneth. *Superior Person: A Portrait of Curzon and his Circle in Late Victorian England*. London: Weidenfeld and Nicolson, 1969.

Rose, Peter. "W. A. S. Benson: A Pioneer Designer of Light Fittings." *Journal of the Decorative Arts Society 1850–the Present*, no. 9: "Aspects of British Design 1870–1930" (1985): 50–7.

Rose, William Ganson. *Success in Business*. New York: Duffield and Company, 1913.

Rossetti, William Michael. *Ruskin, Rossetti, Preraphaelitism: Papers 1854–1862*. New York: Dodd, Mead, and Company, 1899.

—. *Some Reminiscences of William Michael Rossetti*, 2 vols. London: Brown, Langham & Co. Ltd., 1906.

Rotundo, E. Anthony. *American Manhood: Transformations in Masculinity from the Revolution to the Modern Era*. New York: Basic Books, 1993.

Roy, William G. "Interlocking Directorates and the Corporate Revolution." *Social Science History* 7, no. 2 (spring 1983): 143–64.

Rujivacharakul, Vimalin, ed. *Collecting China: The World, China, and a History of Collecting*. Newark: University of Delaware Press, 2011.

Rydell, Robert W. *All the World's a Fair: Visions of Empire at American International Expositions, 1876–1916*. Chicago: University of Chicago Press, 1984.

—. "London's American Exhibition of 1887: How a Cultural Farce became a Political Force." *European Contributions to American Studies* 60 (2005): 57–68.

Saarinen, Aline B. *The Proud Possessors: The Lives, Times, and Tastes of Some Adventurous American Art Collectors*. New York: Random House, 1958.

Said, Edward. *Orientalism*. New York: Vintage Books, 1979.

Saltzman, Cynthia. *Old Masters, New World: America's Raid on Europe's Great Pictures, 1880–World War I*. New York: Viking, 2008.

Sargent, David C. *Alexander Millar Lindsay*. Canton, Conn.: Lithographics, Inc., 1984.

Schaffer, Talia. *The Forgotten Female Aesthetes: Literary Culture in Late-Victorian England*. Charlottesville: University Press of Virginia, 2000.

—, and Kathy Alexis Psomiades, eds. *Women and British Aestheticism*. Charlottesville: University Press of Virginia, 1999.

Schivelbusch, Wolfgang. *The Railway Journey: The Industrialization of Time and Space in the Nineteenth Century*. Berkeley: University of California Press, 1986.

Scobey, David. "What Shall We Do with Our Walls? The Philadelphia Centennial and the Meaning of Household Design." *European Contributions to American Studies* 27 (January 1, 1994): 87–120.

Searle, G. R. *Corruption in British Politics 1895–1930*. Oxford: Clarendon Press, 1987.

Sessions, Ralph. *The Poetic Vision: American Tonalism*. New York: Spanierman Gallery, 2005. Exhibition catalog.

Sewter, A. Charles. *The Stained Glass of William Morris and his Circle*, 2 vols. New Haven: Yale University Press, 1974–5.

Sharp, William. *Dante Gabriel Rossetti: A Record and a Study*. London: Macmillan & Co., 1882.

Shipwreck! Winslow Homer and the Life Line, ed. Kathleen A. Foster. Philadelphia: Philadelphia Museum of Art, 2012. Exhibition catalog.

Showalter, Elaine. *Sexual Anarchy: Gender and Culture at the Fin de Siècle*. New York: Viking, 1990.

Simpson, Marc, ed. *Like Breath on Glass: Whistler, Inness, and the Art of Painting Softly*. Williamstown, Mass.: Sterling and Francine Clark Art Institute, 2008. Exhibition catalog.

—. "Reconstructing the Golden Age: American Artists in Broadway, Worcestershire, 1885 to 1889." PhD diss., Yale University, 1993.

—. "Windows on the Past: Edwin Austin Abbey and Francis Davis Millet in England." *American Art Journal* 22, no. 3 (autumn 1990): 65–89.

Sinnema, Peter W. *Dynamics of the Pictured Page: Representing the Nation in the "Illustrated London News."* Aldershot: Ashgate, 1998.

Skalet, Linda Henefield. "The Market for American Painting in New York: 1870–1915." PhD diss., Johns Hopkins University, 1980.

—. "Thomas B. Clarke, American Collector." *Archives of American Art Journal* 15, no. 3 (1975): 2–7.

Smith, Alison, ed. *Edward Burne-Jones*. London: Tate Britain, 2018. Exhibition catalog.

Smith, Helen. "Decorative Painting in the Domestic Interior in England and Wales, c. 1850–1890." PhD diss., Courtauld Institute of Art, 1980.

Snodin, Michael, and John Styles. *Design & the Decorative Arts: Victorian Britain 1837–1901*. London: V&A Publications, 2004.

Soros, Susan Weber. *The Secular Furniture of E. W. Godwin*. New Haven and London: Yale University Press, 1999.

Spencer, Robin. *The Aesthetic Movement: Theory and Practice*. London: Studio Vista, 1972.

—. "Whistler's Early Relations with Britain and the Significance of Industry and Commerce for his Art, Part I" and "Part II." *Burlington Magazine* 136, no. 1093 (April 1994): 212–24; no. 1099 (October 1994): 664–74.

Stafford, Barbara Maria. *Body Criticism: Imaging the Unseen in Enlightenment Art and Medicine*. Cambridge, Mass.: MIT Press, 1991.

—. *Voyage into Substance: Art, Science, Nature, and the Illustrated Travel Account, 1760–1840*. Cambridge, Mass.: MIT Press, 1984.

Staley, Allen. "The Condition of Music." *Art News Annual: The Academy* 33 (1967): 80–7.

—. *The New Painting of the 1860s: Between the Pre-Raphaelites and the Aesthetic Movement*. New Haven and London: Yale University Press for the Paul Mellon Centre for Studies in British Art, 2011.

Stark, Susanne. "A 'Monstrous Book' after All? James Anthony Froude and the Reception of Goethe's 'Die Wahlverwandtschaften' in Nineteenth Century Britain." *Modern Language Review* 98, no. 1 (January 2003): 102–16.

Stedman, Jane W. "American English in *Punch*, 1841–1900." *American Speech* 28, no. 3 (October 1953): 171–80.

Stein, Jeremy. "The Telephone: Its Social Shaping and Public Negotiation in Late Nineteenth- and Early Twentieth-Century London," in *Virtual Geographies: Bodies, Space, and Relations*, ed. Mike Crang, Phil Crang, and John May, 44–62. London: Routledge, 1999.

Stein, Roger. *John Ruskin and Aesthetic Thought in America, 1840–1900*. Cambridge, Mass.: Harvard University Press, 1967.

Stourton, James, and Charles Sebag-Montefiore. *The British as Art Collectors: From the Tudors to the Present*. London: Scala, 2012.

Swanson, Vern G. *The Biography and Catalogue Raisonné of the Paintings of Sir Lawrence Alma-Tadema*. London: Garton & Co., 1990.

Swinburne, Charles Augustus. *Essays and Studies*. London: Chatto & Windus, 1875.

Swinney, Geoffrey N. "The Evil of Vitiating and Heating the Air: Artificial Lighting and Public Access to the National Gallery, London, with particular reference to the Turner and Vernon Collections." *Journal of the History of Collections* 15, no. 1 (2003): 83–112.

Tallack, Douglas. *Visualizing Old and New New York*. New York: Berg, 2005.

Tarr, Joel A., and Gabriel Dupuy, eds. *Technology and the Rise of the Networked City in Europe and America*. Philadelphia: Temple University Press, 1988.

Taylor, David A., and Charlotte Gere. "'The Dadocracy' and other Humorous Reactions to 'Aesthetic' Interior Decoration." *Journal of the Decorative Arts Society 1850–the Present*, no. 28 (2004): 112–17.

Thomas, David Wayne. "Replicas and Originality: Picturing Agency in Dante Gabriel Rossetti and Victorian Manchester." *Victorian Studies* 43, no. 1 (autumn 2000): 67–102.

Thompson, F. M. L. *English Landed Society in the Nineteenth Century*. London: Routledge & Kegan Paul, 1963.

—. *The Rise of Respectable Society: A Social History of Victorian Britain, 1830–1900*. Cambridge, Mass.: Harvard University Press, 1988.

Thornton, Peter. *Authentic Decor: The Domestic Interior, 1620–1920*. New York: Viking, 1984.

Tibbles, Tony. "Speke Hall and Frederick Leyland: Antiquarian Refinements." *Apollo* 139 (May 1994): 34–7.

Tomkins, Calvin. *Merchants and Masterpieces: The Story of the Metropolitan Museum of Art*. New York: E. P. Dutton, 1970.

Tomlinson, Helen Nebeker. "Charles Lang Freer: Pioneer Collector of Oriental Art." PhD diss., Case Western Reserve University, 1979.

Towner, Wesley, and Stephen Varble. *The Elegant Auctioneers*. New York: Hill and Wang, 1970.

Trachtenberg, Alan. *The Incorporation of America: Culture and Society in the Gilded Age*. New York: Hill and Wang, 1982.

Treuherz, Julian. "Aesthetes in Business: The Raes and D. G. Rossetti." *Burlington Magazine* 146, no. 1210 (January 2004): 13–19.

—. *Victorian Painting*. New York: Thames and Hudson, 1993.

Troyen, Carol. "Innocents Abroad." *American Art Journal* 16, no. 4 (autumn 1984): 3–29.

Truettner, William H. "William T. Evans, Collector of American Paintings." *American Art Journal* 3, no. 2 (fall 1971): 50–79.

Tuffnell, Stephen. "'Uncle Sam is to be Sacrificed': Anglophobia in Late Nineteenth-Century Politics and Culture." *American Nineteenth Century History* 12, no. 1 (March 2011): 77–99.

Tulloch, H. A. "Changing British Attitudes towards the United States in the 1880s." *Historical Journal* 20, no. 4 (December 1977): 825–40.

Turbin, Carole. *Working Women of Collar City: Gender, Class, and Community in Troy, New York, 1864–86*. Urbana: University of Illinois Press, 1992.

Turner, Frederick Jackson. *The Frontier in American History*. New York: Henry Holt and Company, 1920.

Valance, Hélène. *Nocturne: Night in American Art*. New Haven and London: Yale University Press, 2018.

Vale, Vivian. "Trusts and Tycoons: British Myth and American Reality," in *Contrast and Connection: Bicentennial Essays in Anglo-American History*, ed. H. C. Allen and Roger Thompson, 225–44. Athens: Ohio University Press, 1976.

Van der Weyden, Rogier. "Henry Van der Weyde (1839–1924)," *History of Photography* 23, no. 1 (1999): 68–72.

Van Dijk, Jan. *The Network Society*, 2nd edn. London: Sage, 2006.

Van Hook, Bailey. *Angels of Art: Women and Art in American Society, 1876–1914*. University Park: Pennsylvania State University Press, 1996.

—. "Decorative Images of American Women: The Aristocratic Aesthetic of the Late Nineteenth Century." *Smithsonian Studies in American Art* 4, no. 1 (winter 1990): 44–69.

—. *A Mural by Thomas Wilmer Dewing: Commerce and Agriculture Bringing Wealth to Detroit*. New York: Spanierman Gallery, 1998.

—. *The Virgin & the Dynamo: Public Murals in American Architecture, 1893–1917*. Athens: Ohio University Press, 2003.

Van Rensselaer, Mariana Griswold. *Book of American Figure Painters*. Philadelphia: J. B. Lippincott, 1886.

Varriano, John. "Leonardo's Lost *Medusa* and other Medici Medusas from the *Tazza Farnese* to Caravaggio." *Gazette des Beaux-Arts* 6, no. 130 (September 1997): 73–80.

Veblen, Thorstein. *The Theory of the Leisure Class: An Economic Study in the Evolution of Institutions*. New York: Macmillan, 1899.

Venn, John. "On the Diagrammatic and Mechanical Representation of Propositions and Reasonings." *London, Edinburgh, and Dublin Philosophical Magazine and Journal of Science* 9, no. 59 (July 1880): 1–18.

Wainwright, Clive. "'A gatherer and disposer of other men's stuff': Murray Marks, Connoisseur and Curiosity Dealer." *Journal of the History of Collections* 14, no. 1 (2002): 161–76.

Walker Art Gallery, Liverpool. London: Scala, 1994.

Wallach, Alan. *Exhibiting Contradiction: Essays on the Art Museum in the United States*. Amherst: University of Massachusetts Press, 1998.

Ward, Frank. *Dynamic Sociology, or, Applied Social Science*. New York: D. Appleton and Company, 1894.

Ward, Mrs. Humphry. *A Writer's Recollections*. London: W. Collins Sons & Co., 1918.

Warner, Malcolm, and Robyn Asleson. *Great British Paintings from American Collections*. New Haven and London: Yale University Press, 2001. Exhibition catalog.

Warren, Kenneth. *Armstrong: The Life and Mind of an Armaments Maker*. Self-published, 2010.

Wasserman, Stanley, and Katherine Faust. *Social Network Analysis: Methods and Applications*. New York: Cambridge University Press, 1994.

Waterfield, Giles. *The People's Galleries: Art Museums and Exhibitions in Britain, 1800–1914*. New Haven and London: Yale University Press, 2015.

Waters, Bill. "Painter and Patron: The Palace Green Murals." *Apollo* 102 (November 1975): 338–41.

Watson, Margaretta Frederick, ed. *Collecting the Pre-Raphaelites: The Anglo-American Enchantment*. Aldershot: Ashgate, 1997.

Weightman, Gavin. *Children of Light: How Electricity Changed Britain Forever*. London: Atlantic Books, 2011.

Weinberg, H. Barbara. "The Career of Francis Davis Millet." *Archives of American Art Journal* 17, no. 1 (1977): 2–18.

—. *The Decorative Work of John La Farge*. New York: Garland, 1977.

—. "Thomas B. Clarke: Foremost Patron of American Art from 1872 to 1899." *American Art Journal* 8, no. 1 (May 1976): 52–83.

Whistler, James McNeill. *Mr. Whistler's "Ten O'Clock."* London: Chatto & Windus, 1888.

Whitaker, Jan. *Service and Style: How the American Department Store Fashioned the Middle Class*. New York: St. Martin's Press, 2006.

White, Harrison C. *Careers and Creativity: Social Forces in the Arts*. Oxford: Westview Press, 1993.

—, and Cynthia A. White. *Canvases and Careers: Institutional Change in the French Painting World*. New York: Wiley, 1965.

White, Henry C. *The Life and Art of Dwight William Tryon*. Boston: Houghton Mifflin, 1930.

Whyte, Adam Gowans. *The Electrical Industry: Lighting, Traction, and Power*. London: Methuen & Co., 1904.

Wiebe, Robert H. *The Search for Order, 1877–1920*. New York: Hill and Wang, 1967.

Wigley, Mark. "Network Fever." *Grey Room* 4 (summer 2001): 82–122.

Wilde, Oscar. *Miscellanies*. London: Methuen, 1908.

Wildman, Stephen, and John Christian. *Edward Burne-Jones, Victorian Artist-Dreamer*. New York: Metropolitan Museum of Art, 1998.

Wilkins, Mira. *The History of Foreign Investment in the United States to 1914*. Cambridge, Mass.: Harvard University Press, 1989.

Wilks-Heig, Stuart. "From World City to Pariah City? Liverpool and the Global Economy, 1850–2000," in *Reinventing the City? Liverpool in Comparative Perspective*, ed. Ronald Munck, 36–52. Liverpool: Liverpool University Press, 2003.

Williams, Raymond. *Culture and Society, 1780–1950*. London: Chatto & Windus, 1958.

—. *Keywords: A Vocabulary of Culture and Society*. New York: Oxford University Press, 1976.

Williamson, G. C. *Murray Marks and his Friends*. London: John Lane, 1919.

Williamson, Philip, ed. *The Modernisation of Conservative Politics: The Diaries and Letters of William Bridgeman, 1904–1935*. London: Historians' Press, 1988.

Wilson, A. N. *The Victorians*. London: Hutchinson, 2002.

Winseck, Dwayne. "Submarine Telegraphs, Telegraph News, and the Global Financial Crisis of 1873." *Journal of Cultural Economy* 5, no. 2 (2012): 197–212.

Wolff, Janet. *Aesthetics and the Sociology of Art*. London and Boston: George Allen and Unwin, 1983.

—. *The Culture of Capital: Art, Power, and the Nineteenth-Century Middle Class*. Manchester: Manchester University Press, 1988.

—. "The Problem of Ideology in the Sociology of Art: A Case Study of Manchester in the Nineteenth Century." *Media, Culture, and Society* 4, no. 1 (January 1982): 63–75.

—. *The Social Production of Art*. New York: St. Martin's Press, 1981.

Wood, Christopher. *Burne-Jones: The Life and Works of Sir Edward Burne-Jones*. London: Weidenfeld and Nicolson, 1998.

Woodson-Boulton, Amy. *Transformative Beauty: Art Museums in Industrial Britain.* Stanford: Stanford University Press, 2012.

Yarnall, James L. *Newport through its Architecture: A History of Styles from Postmedieval to Postmodern.* Newport, R.I.: Salve Regina University Press in association with University Press of New England, 2005.

—. "Souvenirs of Splendor: John La Farge and the Patronage of Cornelius Vanderbilt II." *American Art Journal* 26, no. 1–2 (1994): 66–105.

Young, Andrew McLaren, Margaret F. MacDonald, Robin Spencer, and Hamish Miles. *The Paintings of James McNeill Whistler.* New Haven and London: Yale University Press for the Paul Mellon Centre for Studies in British Art, 1980.

Young, Kenneth. *Arthur James Balfour: The Happy Life of the Politician, Prime Minister, Statesman, and Philosopher, 1848–1930.* London: Bell, 1963.

Yount, Sylvia. "'Give the People What They Want': The American Aesthetic Movement, Art Worlds, and Consumer Culture." PhD diss., University of Pennsylvania, 1995.

Zalesch, Saul E. "Ryder among the Writers: Friendship and Patronage in the New York Art World, 1875–1884." PhD diss., University of Delaware, 1992.

INDEX